WILLIAM WORDSWORTH AND THE AGE OF ENGLISH ROMANTICISM

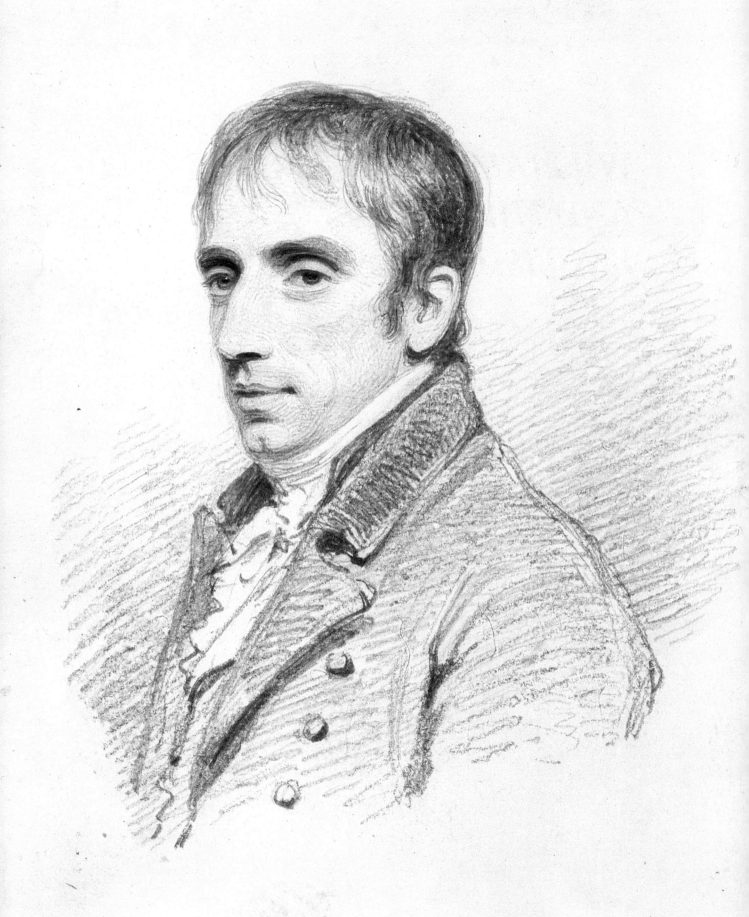

WILLIAM WORDSWORTH AND THE AGE OF ENGLISH ROMANTICISM

Jonathan Wordsworth, Michael C. Jaye, Robert Woof

with the assistance of Peter Funnell

Foreword by M. H. Abrams

Rutgers University Press, New Brunswick and London
Co-published with
The Wordsworth Trust, Dove Cottage, Grasmere, England

Copyright © 1987 by Rutgers, The State University
Third printing May 1988
All rights reserved
Designed by Gerald Cinamon, Cinamon and Kitzinger
Edited by Judith Wardman
Typeset in 11/14 Monotype Photina
and printed on Chromomat 81 lb. by
Balding + Mansell International Limited, Wisbech, England
Manufactured in Great Britain

LIBRARY OF CONGRESS CATALOGING-IN-PUBLICATION DATA

Wordsworth, Jonathan.
 William Wordsworth and the age of English
romanticism.
 1. Wordsworth, William, 1770–1850—Exhibitions.
 2. Romanticism—Exhibitions. I. Jaye, Michael C.,
1941– . II. Woof, Robert. III. Title.
 PR5885.W67 1987 821'.7 87-12669

ISBN 0-8135-1273-5
ISBN 0-8135-1274-3 (pbk.)

BRITISH LIBRARY CATALOGUING IN PUBLICATION DATA

Wordsworth, Jonathan
 William Wordsworth and the age of English
 Romanticism.
 1. Arts, Modern—18th century—England
 2. Arts, Modern—19th century—England 3. Arts, English
 4. Romanticism in art—England
 5. Romanticism—England
 I. Title II. Jaye, Michael C. III. Woof, Robert
 700'.942 NX543

ISBN 0-8135-1273-5
ISBN 0-8135-1274-3 Pbk Oct 87

Frontispiece: Henry Edridge, *William Wordsworth*, *c*. May 1806 [Cat. no. 230].
The poet at the age of thirty-six

Contents

Foreword

The "Age of Romanticism" is a title imposed by later historians on the four decades after 1790, but a number of writers who lived during that turbulent time had recognized that in both its literature and thought it constituted an era that was distinctive, vital, and innovative, and had identified its distinguishing features by the term "the spirit of the age." As Shelley wrote in *A Defence of Poetry* in 1821, "the literature of England has arisen as it were from a new birth." "We live among such philosophers and poets as surpass beyond comparison any who have appeared since the last national struggle for civil and religious liberty," and these writers manifest a common "spirit of the age." It was also recognized by his major contemporaries that William Wordsworth, whatever objections they might have to some of his opinions and achievements, was the greatest, most inaugurative, and most representative poet of his time—that, as Leigh Hunt put it in 1814, Wordsworth is "at the head of a great new age in poetry." William Blake, who vehemently attacked Wordsworth's naturalism, nonetheless accounted that poet to Henry Crabb Robinson "as a pagan, but still with great praise as the greatest poet of the age." So early as 1800 Coleridge acclaimed Wordsworth as "a greater poet than any since Milton;" eighteen years later Keats, who constantly echoed Wordsworth's poems, asserted that his older contemporary "is deeper than Milton," because Milton "did not think into the human heart, as Wordsworth has done." Shelley could be caustic about some aspects of the man and his writings; yet as his wife Mary Shelley tells us, "No man ever admired Wordsworth's poetry more—he read it perpetually." His fellow poets would have understood, and approved, putting Wordsworth at the centre of this exhibition celebrating both the spirit and the achievements of English Romanticism.

They would have approved as well the focus of the exhibition on the French Revolution. Shelley, Hazlitt, John Stuart Mill, and other commentators on "the spirit of the age" all concurred that this spirit manifested ways of thinking, imagining, and feeling formed by the outbreak, promise, and outcome of the Revolution—"the master theme," as Shelley described it, "of the epoch in which we live." For Wordsworth, the French Revolution was not only his master theme but an event that he, uniquely among contemporary poets, had known at first hand, during two sojourns in France in 1790 and 1791–1792. His first visit had been during the early festive period of the Revolution when, like many of his liberal-minded contemporaries in Germany as well as England, Wordsworth saw the events in France through the perspective of biblical prophecy, as the advent of the millennium foretold in the Book

of Revelation, heralding a bright new world and the regeneration of the
human race—

> France standing on the top of golden hours,
> And human nature seeming born again.

In his autobiographical poem *The Prelude* Wordsworth records his early
boundless hopes for France, his reluctant disillusion, and—as the
peaceful Revolution eventuated in violence, the Reign of Terror, war,
French imperialism, and English and European counter-revolution—his
dismay, horror, nightmares, and total despair; his intellectual and
emotional breakdown; and, after his recovery, his undertaking to re-
establish on new principles the grounds of hope in high human
possibilities. The theme of much of Wordsworth's major poetry, as of
the work of other Romantic writers, was what, in his long poem *The
Excursion*, he called "Despondency" and "Despondency Corrected." To
Wordsworth, as to most young intellectuals of his time, the French
Revolution was a revolution that had tragically failed; but as the cultural
commentator Thomas Noon Talfourd astutely observed in 1815, it was
the crisis precipitated by this failure—a moral and imaginative, as well as
political crisis—that in fact evoked and shaped the great new literature
of the age: "At one moment, all was hope and joy and rapture; the
corruption and iniquity of ages seemed to vanish like a dream." But on
a sudden the "sublime expectations were swept away" by "the terrible
changes of this august spectacle," in a despair proportionate to the
boundlessness of the initial hope. And the result of "this rending of the
general heart," Talfourd wrote, "was to raise and darken the imagina-
tion," and so to help "form that great age of poetry which is now
flourishing around us."

Almost all of Wordsworth's greatest poems were written within little
more than a decade following the spiritual crisis and recovery he recorded
in *The Prelude*, in the attempt to reconstitute, for himself and for his
readers, hope, courage, and a revised basis for civilized values in an age of
profound cultural demoralization—"these times of fear," as he wrote in
The Prelude,

> This melancholy waste of hopes o'erthrown,
> . . . mid indifference and apathy,
> And wicked exultation . . . this time
> Of dereliction and dismay.

In his remarkable book *The Spirit of the Age* (1825), William Hazlitt
asserted that Wordsworth's *Lyrical Ballads* (1798) and his other early
poems were a revolution in poetry equivalent to the French Revolution in
politics, in that they transferred to their stance and subject-matter the
political principles of human equality and fraternity. "Mr. Wordsworth's
genius is a pure emanation of the Spirit of the Age," and it

> partakes of, and is carried along with, the revolutionary movement of
> our age: the political changes of the day were the model on which he
> formed and conducted his poetical experiments. His Muse . . . is a
> levelling one. It proceeds on a principle of equality, and strives to
> reduce all things to the same standard.

What Hazlitt recognized was that Wordsworth had subverted the traditional European poetics, in which the scale of literary genres, up to epic and tragedy at the top, had a built-in class-structure and manifested aristocratic values, since each stage of the hierarchy of literary forms had to represent people on the correspondent stage of the hierarchy of social classes. And Wordsworth's revolution against the *ancien régime* in poetry was more than merely egalitarian; it inverted the established social hierarchy by choosing not only the lowly—a shepherd, a cottage-wife— but also the ignominious, the scorned, and the social outcasts as the protagonists in serious, and sometimes tragic poems. As Hazlitt noted in another essay, Wordsworth's poetry deals sympathetically not only with "peasants, pedlars" but also with "convicts, female vagrants, gipsies . . . idiot boys and mad mothers."

In addition to the deeply serious poetry of common and lowly human beings, Wordsworth's *Lyrical Ballads* of 1798 also inaugurated, by the addition at the last moment of the poem *Tintern Abbey*, the major theme of his next and greatest decade—the theme of the individual mind, and what it is to grow older and to pass, by way of a personal crisis, from the stage of what William Blake called "innocence" to that of "experience." "Five years have passed. . . ." Confronting the precise scene on the River Wye that he had looked on five years earlier, Wordsworth meditates on the meaning of life lived in time—a time that inevitably brings loss, disillusion, personal suffering, and the knowledge of the suffering of others, but may also bring the gain of a humane maturity forged by that very experience of loss, disillusion, and suffering. The landscape he had once seen with an unthinking joyousness he now looks upon as though to an accompaniment of sombre music—

> For I have learned
> To look on Nature not as in the hour
> Of thoughtless youth, but hearing oftentimes
> The still, sad music of humanity. . . .

As in his later poems on a life lived in time, Wordsworth manages the feat of representing that life primarily in terms of a transaction between two agencies, his mind and outer nature. In this remarkable aspect of his poetry, he is representative of the overall movement of thought in his age. For the great contemporary philosophers in Germany—Fichte, Schelling, Hegel—also represented all human experience as generated by an interaction between two agencies; and what Wordsworth called mind and Nature, they called the self and the other, or subject and object.

The theme of what it is to grow older and to experience loss and suffering, managed in terms of an interaction between the individual mind and the environing world, is the subject and tactic not only of *Tintern Abbey*, and of such later lyric poems as the *Intimations Ode* and *Elegiac Stanzas*; it is also, in immensely expanded form, the subject and tactic of the autobiographical *Prelude*. Therein Wordsworth delineates how, as an infant in his mother's arms, achieving his earliest experience of the outer world in the security of the maternal embrace and in the assurance of maternal love, he had come to be at home in a world in

which (in a great metaphor) he felt physical gravitation as the force of a familial connection. "No outcast he," for

> Along his infant veins are interfused
> The gravitation and the filial bond
> Of Nature that connect him with the world.

This integrity of self and the world was strengthened, and made to include other people than himself, by his early experience, then fragmented into alienation by the shock and disappointment attendant on his shattered hopes in the French Revolution, to be slowly recovered in a maturity in which he re-established connection to his early self and thereby discovered his identity and vocation as a poet. In the long and subtle account in *The Prelude* of what he called "the growth of a poet's mind," Wordsworth achieved the first and greatest poetic version of what the Germans call a *Bildungsgeschichte*—the account of the formation of the self, and discovery of personal identity and vocation, through the experience of suffering and spiritual crisis. This is the modern, secularized form of the Christian genre of spiritual history which had been inaugurated, late in the fourth century, by St. Augustine's *Confessions*; among the later heirs of this secular spiritual history are Proust's *Remembrance of Things Past* and Joyce's *Portrait of the Artist as a Young Man.* The form is secular in that, in *The Prelude* as in his lyrics of growing older and growing up, Wordsworth resolutely deals with the justification of evil and suffering solely in terms, as he says in *The Prelude*, of men "as natural beings in the strength of Nature"—that is, without the traditional recourse to a compensatory afterlife. Our inescapable experience of suffering is justifiable only by what, if we have the strength, it makes of us, in a life that terminates in this world,

> which is the world
> Of all of us, the place in which, in the end,
> We find our happiness, or not at all.

The Age of Romanticism, which was the age of both political and industrial revolution, ushered in the modern world, with its drastic social changes and strains, mass wars, economic cycles of inflation and depression, revolutions and reaction, the conflict of ideologies, and the continuing erosion of the traditional grounds for the beliefs and values that sustain civilized life. We too live in a time of "dereliction and dismay," and Wordsworth, in confronting such a time without a failure of nerve, speaks to us as he spoke to his contemporaries. Those current readers who can yield the fullest imaginative consent to what he expresses in his poems must share, no doubt, a common ground of temperament with the poet, as Wordsworth himself recognized when he said to Henry Crabb Robinson that "I am myself one of the happiest of men; and no man who does not partake of that happiness . . . can possibly comprehend the best of my poems." But whatever the qualifications diverse readers may make, the status of his overall achievement is beyond cavil. To reaffirm what I wrote some fifteen years ago:

> We are rediscovering what a number of Wordsworth's major con-
> temporaries acknowledged—that he has done what only the greatest

poets do. He has transformed the inherited language of poetry into a medium adequate to express new ways of perceiving the world, new modes of experience, and new relations of the individual consciousness to itself, to its past, and to other men. More than all but a very few English writers, Wordsworth has altered not only our poetry, but our sensibility and our culture.

M. H. Abrams

Acknowledgments

The exhibition to which this volume is companion was organized by Rutgers, the State University of New Jersey in Newark, and The Wordsworth Trust, Dove Cottage, Grasmere, England, in association with the exhibition sites: The New York Public Library (31 October 1987–2 January 1988), the Indiana University Art Museum, Bloomington (28 January–6 March 1988), and the Chicago Historical Society (6 April–5 June 1988).

The exhibition and its related national humanities programs throughout the United States (in association with the National Federation of State Humanities Councils) has been generously supported by a grant from the National Endowment for the Humanities, a federal agency established by Congress. The exhibition has been supported by an indemnity from the Federal Council on the Arts and the Humanities.

British Airways has been the official carrier for the exhibition, transporting the art works and manuscripts from Europe to the United States. Their assistance from the project's earliest stage, professional advice, and unfailing high standards have significantly eased the task of organizing the exhibition.

The exhibition has been made possible at The New York Public Library through the generous support of *The Economist*, and at the Indiana University Art Museum through grants from the Lilly Endowment Inc., The Clowes Fund, and Mrs. Ruth Lilly of Indianapolis.

The exhibition and its related programs would not have been possible without the unstinting help and wise counsel of literally hundreds of scholars, curators, librarians, and people working in the humanities and arts throughout the United States, Great Britain, and in France. Lenders to the exhibition, who have made the exhibition possible, are acknowledged below in the Catalogue and the list of Lenders to the Exhibition. To all of these, the organizers are deeply grateful.

From its inception, Michael C. Jaye, Robert Woof, and Jonathan Wordsworth collaborated in organizing the exhibition and shared curatorial responsibilities. They were greatly assisted in the project's later stages by Peter Funnell. Jonathan Wordsworth had the principal responsibility for writing and shaping this companion volume, integrating work written for the chapters by Michael C. Jaye and Robert Woof. The writing of the Catalogue section was shared by the co-authors and Peter Funnell, who contributed valued work towards the majority of the entries on English art; but the final responsibility for editing these was Jonathan Wordsworth's. Duncan Wu compiled the Chronology, and the preparation of the book has benefited from the assistance of James Pallot.

The Committee of Honour

Note

Though adopting the section headings of the exhibition "William Wordsworth and the Age of English Romanticism," the six chapters of this book are designed as free-standing essays that explore the political and intellectual concerns of the Romantic period. More detailed information on items in the exhibition is given in the Catalogue section on pp. 199–238 (referred to as "Cat.") and in the Chronology of the years 1770–1850 (pp. 239–249).

Quotations from the poetry of Wordsworth are drawn from the forthcoming Longman *Annotated Selections*, and like other quoted material (including titles to individual works) have usually been modernized in spelling and punctuation. References to *The Prelude* are keyed to the Norton Critical Edition, and use the following abbreviations: *1799* (the two-part version of 1798–1799), *1805* (the version completed in thirteen books in May 1805), *1850* (the first edition, published in fourteen books, July 1850, three months after the death of the poet). When no version is specified, the reference is to *1805*.

Jonathan Wordsworth

*WILLIAM WORDSWORTH
AND THE AGE OF
ENGLISH ROMANTICISM*

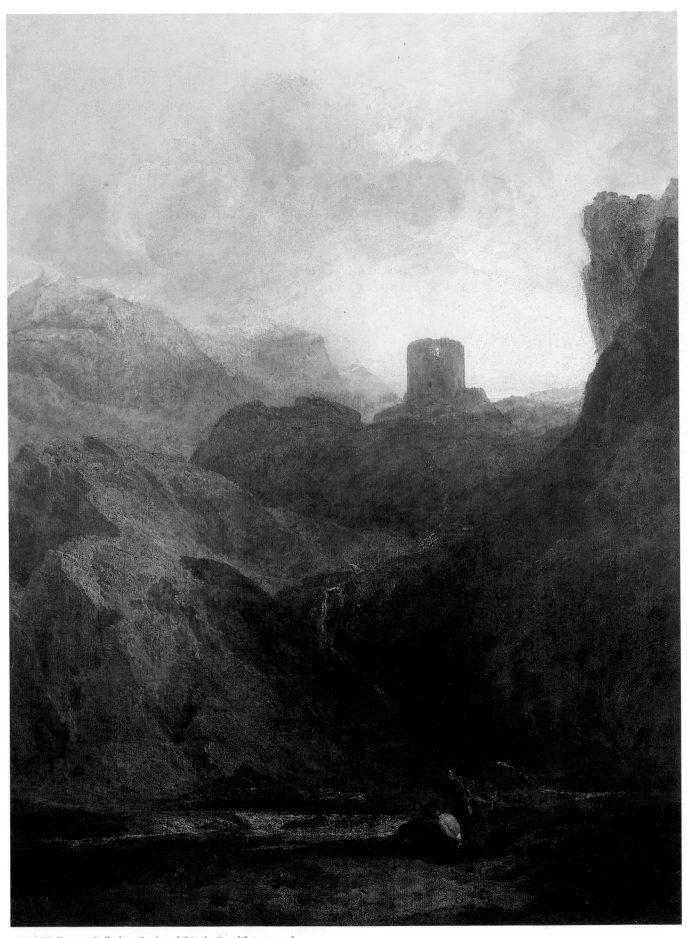

1. J. M. W. Turner, *Dolbadern Castle*, exhibited 1800 [Cat. no. 32]

1 The Age of Revolutions

The age of English Romanticism is an age of revolutions. William Wordsworth's life spans a transformation in almost every sphere of human existence: political, social, economic, and cultural. He was born in 1770 into a world on the threshold of dramatic, sometimes violent, change. Mozart was fourteen, Dr. Johnson was in his heyday, America was a British colony, the Bourbons were secure on their throne in France. 1850, the year of Wordsworth's death, saw the publication of Dickens' and Tennyson's most famous works (*David Copperfield* and *In Memoriam*); Melville's *Moby Dick* followed within months. Victoria had been queen for thirteen years; the British empire was at its height; trains had replaced the stage coach; regular steamships were crossing the Atlantic; in America, the Gold Rush had begun.

Though most of his life was spent in the Lake District, 300 miles from London, Wordsworth as a young man had first-hand experience of the French Revolution—

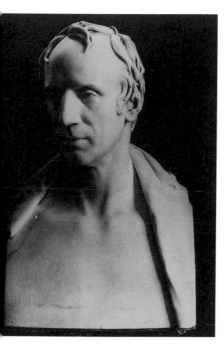

2. Sir Francis Legatt Chantrey, *William Wordsworth*, 1820 [Cat. no. 12]

> Bliss was it in that dawn to be alive,
> But to be young was very heaven!
>
> (*The Prelude*, x, 692–693)

—and he never lost his commitment to the social and political causes of the day. He told an American visitor in 1833 that "although he was known to the world only as a poet, he had given twelve hours' thought to the condition and prospects of society, for one to poetry." In his writing he asserted the values of freedom, independence, and aspiration, celebrating above all the resilience and power of the individual human mind. As the central figure of English Romanticism, he has exerted a revolutionary influence on all our lives.

The first political revolution of Wordsworth's life began when he was six [Fig. 3]. The American Declaration of Independence (1776), with its ideals of liberty and justice (despite the contradiction of slavery), gave new hope to many different parts of Europe. Before the storming of the Bastille in July 1789, rebellions of varying significance had taken place in Ireland, Geneva, Holland, and Belgium. The Declaration had its counterpart in the French Declaration of the Rights of Man and the Citizen (1789). The revolution in Belgium had its own Declaration of Independence of the Province of Flanders; and the Act of Union of the Belgian Provinces translates word for word passages of the American Articles of Confederation (1781). Patrick Henry's "Liberty or Death" was echoed in many languages—Italian, for instance, when revolutionary clubs took up the cry as "Repubblica o morte," "Libertà o morte." Tadeusz Kosciuszko, whose Polish constitution of 1791–1794 was modelled on

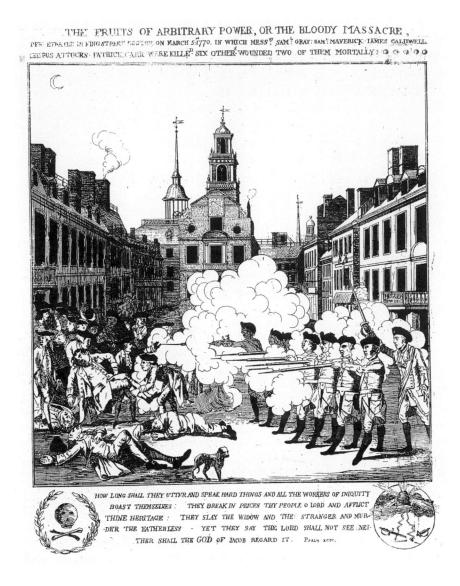

THE FRUITS OF ARBITRARY POWER, OR THE BLOODY MASSACRE,
PERPETRATED IN KINGSTREET BOSTON ON MARCH 5.1770. IN WHICH MESS.ʳˢ SAM.ˡ GRAY: SAM.ˡ MAVERICK, IAMES CALDWELL,
CRISPUS ATTUCKS, PATRICK CARR WERE KILLE.ᴰ SIX OTHER WOUNDED TWO OF THEM MORTALLY.

HOW LONG SHALL THEY UTTER AND SPEAK HARD THINGS AND ALL THE WORKERS OF INIQUITY
BOAST THEMSELVES: THEY BREAK IN PEICES THY PEOPLE O LORD AND AFFLICT
THINE HERITAGE: THEY SLAY THE WIDOW AND THE STRANGER AND MUR-
-DER THE FATHERLESS YET THEY SAY THE LORD SHALL NOT SEE NEI-
THER SHALL THE GOD OF JACOB REGARD IT. PSALM XCIV.

3. Henry Pelham,
*The Fruits of Arbitrary Power,
or the Bloody Massacre* [Cat. no. 24].
Boston, 1770; British misrule
in the year of Wordsworth's birth

the American, died with the Declaration of Independence in his posses-
sion. Even in Russia, the American Revolution was welcomed by the
liberal writers Novikov and Radischev.

Edmund Burke, later famous for his attack on the French Revolution,
attributed the American love of freedom to a natural inheritance from
England:

> This fierce spirit of liberty is stronger in the English colonies probably
> than in any other people of the earth [because] the people of the
> colonies are descendants of Englishmen. England, sir, is a nation which
> still I hope respects, and formerly adored, her freedom.
> (*Resolutions for Conciliation with the Colonies*)

Similar assumptions are represented by James Barry in an allegorical
aquatint, prompted by the Declaration of Independence and entitled *The
Phoenix or the Resurrection of Freedom* (1776) [Fig. 4]. For Barry, as for
Burke (possibly the chained figure in the foreground), liberty in America
appeared to be a "resurrection" of values which the Old World had lost.
The Phoenix is reborn on top of a classical temple. Representatives of

English liberty—Algernon Sidney, John Milton, Andrew Marvell, John Locke (and Barry himself)—mourn the death of Britannia, and witness a translation of the Graces to the new utopian world of agriculture, industry, and the arts. Barry's inscriptions ensure that there can be no misinterpretation:

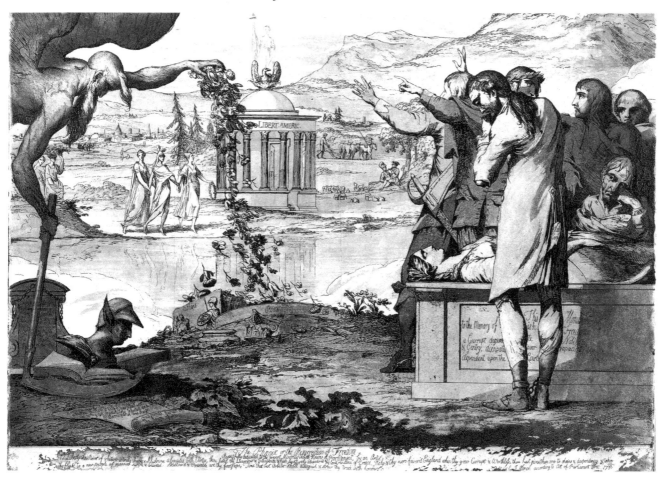

4. James Barry,
The Phoenix or the Resurrection of Freedom,
1776 [Cat. no. 6].
Allegorical picture representing the rebirth of liberty in the New World

O Liberty, thou parent of whatever is truly amiable and illustrious associated with virtue, thou hatest the luxurious and intemperate, and hast successively abandoned thy loved residence[s] of Greece, Italy, and thy more favoured England, when they grew corrupt and worthless; thou hast given them over to chains and despondency, and taken thy flight to a new people of manners simple and untainted.

Others saw the American Revolution not as the transplanting of an ideal that had been betrayed, but as a totally new beginning for mankind [Fig. 5]. For the deist Tom Paine, whose pamphlet *Common Sense* (1775) was immensely influential in America, and who went on to become a member of the French National Convention (as well as being condemned for sedition by the British in his absence), the ideal was a secular one. Richard Price, by contrast, whose *Observations on the Nature of Civil Liberty* went through ten English editions in 1776, and was reprinted six times in different American cities, was a dissenting Protestant minister. To him it seemed that, "Next to the introduction of Christianity among mankind, the American Revolution [might] prove the most important

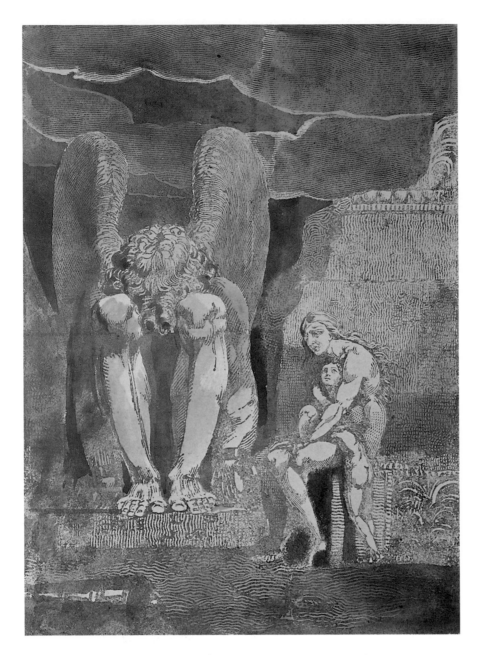

5. William Blake, Frontispiece
from *America a Prophecy*, 1793 [Cat. no. 9].
The winged spirit of Revolution, Orc,
sits manacled and bowed.
Though victorious in America, he has not
as yet been able to bring freedom
to the peoples of Europe

step in the progressive course of human improvement" (*Observations on the Importance of the American Revolution*, 1784). Price was neither a political dreamer nor a religious crank. As well as being a theologian, he was an expert on the national debt, on life insurance, and on population. In 1778 he had been offered American citizenship to come over and manage the country's finances; in 1781 he had the distinction of receiving an honorary Yale Ll.D. at the same time as Washington.

Scarcely less important in this context—and still more impressive in his intellectual range—is Price's fellow dissenter, Joseph Priestley. His *Essay on the First Principles of Government* (1768) drew on Rousseau's concept of natural and inalienable rights, and had a direct influence on American revolutionary thinking. He was a friend of Benjamin Franklin, and like him wrote a book on electricity. As a chemist, he is credited with the discovery of oxygen; as minister and theologian, he was the founder

of modern Unitarianism. Accepting the tradition that the world had been created in 4004 B.C. and would last for six thousand years, he argued in his *Letter to the Right Honourable Edmund Burke* (1790) that the American and French revolutions were a fulfilment of biblical prophecy. Creation was nearing its end, and "the progressive course of human improvement" (apparent in technical revolutions, as well as political) was leading to the millennium.

It was a view held, in one form or another, by Christians of many denominations, and it is interesting that Cowper, Blake, and Coleridge all expressed it in their writings. Wordsworth, though exulting in the hope of general future happiness, saw things in more political terms. Looking back to the early 1790s, he wrote in his great autobiographical poem *The Prelude*:

> 'Twas a time when Europe was rejoiced,
> France standing on the top of golden hours,
> And human nature seeming born again.
>
> (vi, 352–354)

The French Revolution was the momentous historical event of the age of Romanticism. Like Wordsworth, most of the important figures of the day, whatever their later disillusionment, hailed it as the dawn of human freedom and happiness. Wordsworth was the one major poet, however, to see the Revolution at close quarters. In fact he saw it in two quite different phases: the first confused, but largely peaceful, and largely constitutional; the second, a period of transition and increasing violence. As a twenty-year-old Cambridge undergraduate, he landed at Calais on 13 July 1790. He had no special interest in politics, and there is no evidence that he had planned to be in France for the anniversary of the Fall of the Bastille, held the following day. Immediately, however, he and his companion, Robert Jones, were caught up in the rejoicings.

On 14 July, the Marquis de Lafayette—one of the heroes of the American Revolution, and now hoping to be the Washington of his native France—addressed a crowd of 300,000 at the Champ de Mars in Paris. An oath was taken "binding Frenchmen to one another, and to their king, in the defence of liberty, the Constitution, and the law." Jean-Jacques Hauer's *Drawing a Plan for the Festival of the French Federation* [Fig. 6] is dated 1791, and was probably painted in March. Lafayette is shown talking to a woman traditionally identified as Madame Roland, whose famous last words at the guillotine are mentioned by Wordsworth in *The Prelude*. In the background are busts of revolutionary figures, Mirabeau, Désilles (a recent martyr), Franklin, and Rousseau; on the harpsichord is music for *Ça Ira*, the popular song whose title—"It will be okay"—is taken from a comment by Franklin on the progress of the Revolution. Barry had commemorated the passing of civilization from the Old World to the New; Hauer celebrates the dawn of a new age in Europe, inspired by the American achievement.

Jean-Louis Prieur's delicate pencil drawing of Federation Day at the Champ de Mars [Fig. 8] gives us a sense of the public rejoicing. Wordsworth and Jones, on their journey south to the Alps, "found benevolence and blessedness / Spread like a fragrance everywhere." On

6. Jean-Jacques Hauer,
*Lafayette and Madame Roland
Drawing a Plan for the Festival
of the French Federation*, 1791
[Cat. no. 19]

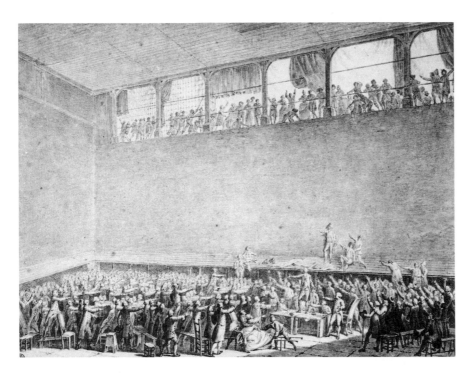

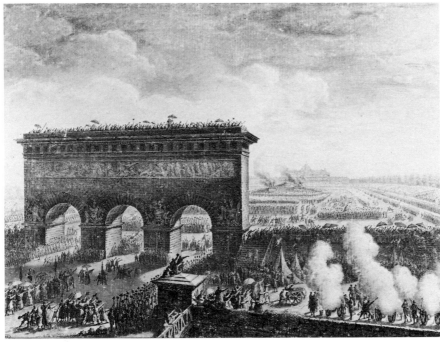

7 (*above*). Jean-Louis Prieur,
The Tennis Court Oath [Cat. no. 29].
Shut out of their normal meeting-place,
elected delegates of the French Third Estate
resolved in a neighbouring tennis court
to stay together until a constitution
was established. The Bastille fell three
weeks later

8 (*left*). Jean-Louis Prieur,
Federation Day [Cat. no. 27].
First anniversary of the Fall of the Bastille,
at which the king swore an oath
of allegiance to the new constitution

the Rhône they met delegates returning from Paris, and joined with them
in "dances of Liberty":

> With flowing cups elate and happy thoughts,
> We rose at signal given and formed a ring,
> And hand in hand danced round and round the board;
> All hearts were open, every tongue was loud
> With amity and glee.
>
> (*1805*, vi, 405–409)

France was now a constitutional monarchy, and though the king was
unreliable, and the concessions he made were limited, there was much to

celebrate in the passing of the *ancien régime*. There had been relatively little bloodshed even at the storming of the Bastille, whose importance as the symbol of tyranny far outweighed any military significance. The fortress stood for repression of civil liberties, and was associated with the dreaded *lettres de cachet*, leading to imprisonment without trial. Though it proved to contain only seven inmates, its fall was the end of an era.

Claude Cholat's amateur painting in gouache [Fig. 9] heightens the drama of the attack, and has an almost medieval liveliness. An inscription at the bottom proclaims it to be by one of the "Conquerors of the Bastille." Tradition has it that the artist is manning the cannon in the

9. Claude Cholat,
Fall of the Bastille: 14 July 1789,
1789 [Cat. no. 13].
By one of the attackers

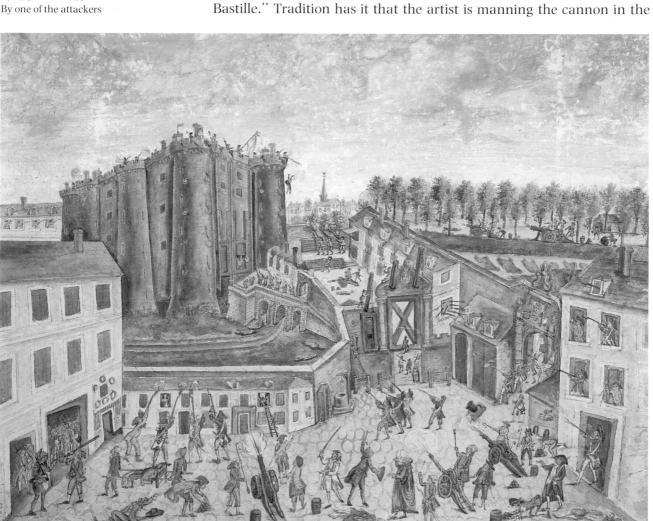

background, and has personally accounted for the defender who is falling from the Tour de Comte. The anonymous oil showing the arrest of the Marquis de Launay, governor of the Bastille, is by contrast a staged historical painting [Cat. no. 4]. In the foreground lie two bodies, significantly one a soldier, the other a civilian, since army and populace united to overthrow the symbol of tyranny. De Launay is by implication responsible for the deaths. Viewers of the painting would be aware that he had himself been murdered (and messily beheaded) shortly after the scene that is portrayed.

Cholat's title, "Conqueror of the Bastille," was awarded to 954 of the attackers, including one woman, a laundress (seen at the drawbridge in

his picture). Among those present were some who had served in America with Lafayette, who three days after the attack was appointed commander of the newly formed National Guard. Six weeks later, on 26 August 1789, the Assembly passed its Declaration of the Rights of Man

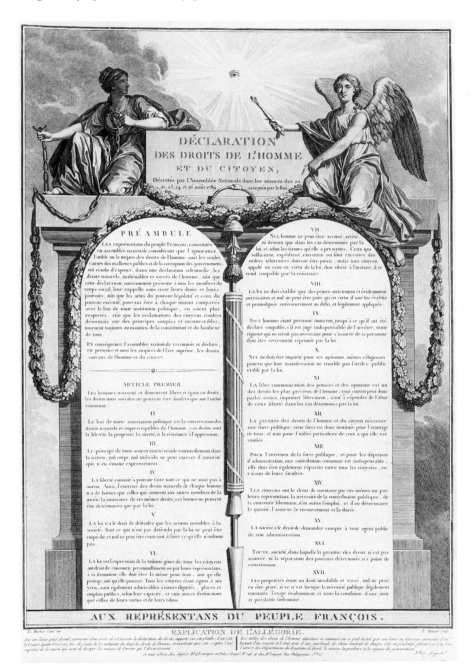

10. Jean-Jacques-François Le Barbier, *Declaration of the Rights of Man and the Citizen,* 1789 [Cat. no. 5]

and the Citizen [Fig, 10]. Echoing the American Declaration [Fig, 11], it asserted that "Men are born free, and remain free and equal in their rights." The king was reluctant to give consent, but finally did so in October, after he had been rescued by Lafayette from a mob (chiefly of women) marching on Versailles to demand bread.

By the time that Wordsworth returned to France in November 1791, Lafayette's moderate constitutional principles were out of tune with events. His strength lay in being able to work with both the king and the leaders of the Assembly. In June the royal family had been arrested at Varennes—another scene recorded in a Prieur drawing [Fig, 15]—while

attempting to reach the frontier. The king's intention had been to join forces with those fighting to restore the *ancien régime*, and though he was reinstated in September by the Girondist ministry, there could be no doubt that he had betrayed the Constitution. Political power increasingly

11. Thomas Jefferson, *A Declaration by the Representatives of the United States of America, in General Congress Assembled,* 4 July 1776 [Cat. nos. 20 and 21]

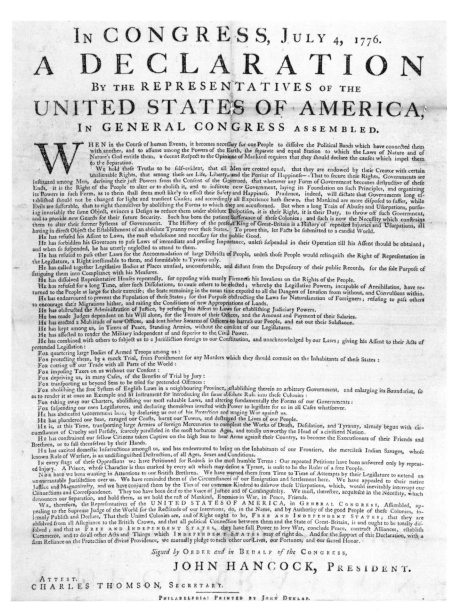

lay with the revolutionary clubs. Among the Jacobins, Robespierre was already dominant; the Cordeliers were headed by Danton and Marat. "I saw the revolutionary power," Wordsworth recollects, "Toss like a ship at anchor, rocked by storms."

Meanwhile, the Bastille had been dismantled, stone by stone. Wordsworth himself pocketed a relic "in the guise / Of an enthusiast," but adds the telling comment:

> I looked for something which I could not find,
> Affecting more emotion than I felt.

(1805, ix, 70–71)

Political commitment came early in the following year, when Wordsworth met one of the dominant influences on his life, an army

officer named Michel Beaupuy, who was thirty-six and stationed at Blois.
Though himself a nobleman, and serving in a regiment where his fellow
officers were royalists, Beaupuy converted the poet (aged twenty-two) to
the ideals of the Revolution. To judge from *The Prelude*, Wordsworth was
convinced as much by meeting "a hunger-bitten girl" on the banks of the
Loire as by political argument:

> [when] at the sight my friend
> In agitation said, "'Tis against that
> Which we are fighting," I with him believed
> Devoutly that a spirit was abroad
> Which could not be withstood, that poverty,
> At least like this, would in a little time
> Be found no more. . . .
> All institutes for ever blotted out
> That legalized exclusion, empty pomp
> Abolished, sensual state and cruel power,
> Whether by edict of the one or few. . . .
>
> (ix, 518–530)

Also living at Blois in the spring of 1792 was Annette Vallon. No mention
of her is made in *The Prelude*, but the story of her relationship with the poet
is told by implication through the star-crossed lovers, Vaudracour and
Julia [see Cat. no. 122]. The baptism of her child, Anne-Caroline
Wordsworth, is recorded in the register of Orléans Cathedral on 15
December—by which time Robespierre had gained the upper hand in
Paris, Louis XVI was on trial, and Caroline's father had been forced to
return to London. To judge from the confidence and tenderness of
Annette's two surviving letters [Fig. 12]—confiscated by the French sur-
veillance committee in 1793, and rediscovered in 1922—Wordsworth's
intention was to raise money with which to bring her back to England
and get married. In the event, however, they were separated by a war,
declared on 1 February 1793, that lasted more than twenty years, and
had no truce until 1802.

Pausing on his way through Paris at the end of October 1792,
Wordsworth saw the "black and empty area" of the Place du Carrousel,
where the bodies had been burned of the Swiss Guard who defended the
king (until told to lay down their arms) at the storming of the Tuileries on
10 August. Alone in his hotel room, he conjured up the horrors of the
September Massacres, which had been condoned—perhaps assisted—by
Danton:

> The fear gone by
> Pressed on me almost like a fear to come.
> I thought of those September massacres,
> Divided from me by a little month,
> And felt and touched them, a substantial dread. . . .
>
> (1805, x, 62–66)

An estimated 1,200–1,400 people had been taken out of Paris prisons,
and butchered after mob trials. Of these, less than a third were political
prisoners, many were priests, and thirty-seven were women—a fact that

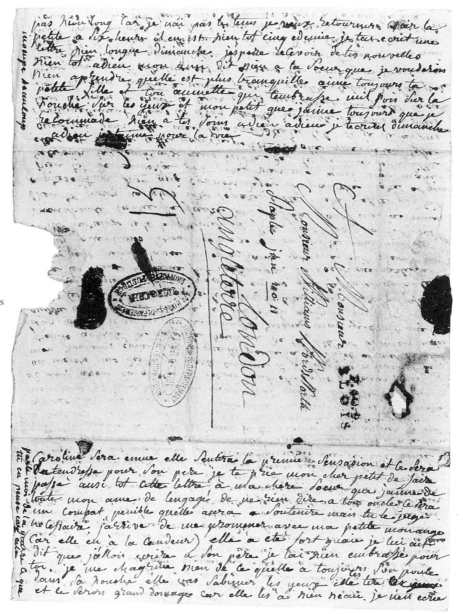

12 (*right*). Letter from Annette Vallon at Blois to William Wordsworth, 20 March 1793, expressing her sadness at their being separated by the war between France and England, sending love and tender details about their three-month-old child, Caroline, whom the poet has not yet seen [Cat. no. 102]

13 (*below left*). Anon., *Horrifying Massacre of Women, Unparalleled in History*, September 1792 [Cat. no. 3]. A particularly gruesome event in the September Massacres

14 (*below right*). Anon., *Massacre of Prisoners at the Abbey of St. Germain*, September 1792 [Cat. no. 2]. Royalists, priests, prisoners of all kinds, were executed after summary trials during a brief period of mob rule connived at (at least) by Danton

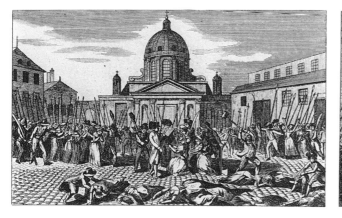

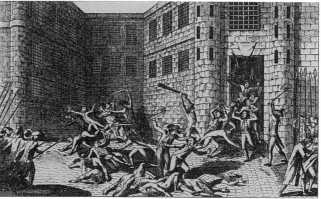

warranted a gruesome print in *Révolutions de Paris dédiée à la Nation* [Figs. 13 and 14]. To judge from contemporary accounts, cart-fulls of naked bodies, as seen in *Transport des cadavres* (attributed to Etienne Béricourt) [Fig. 16], must have been a common sight.

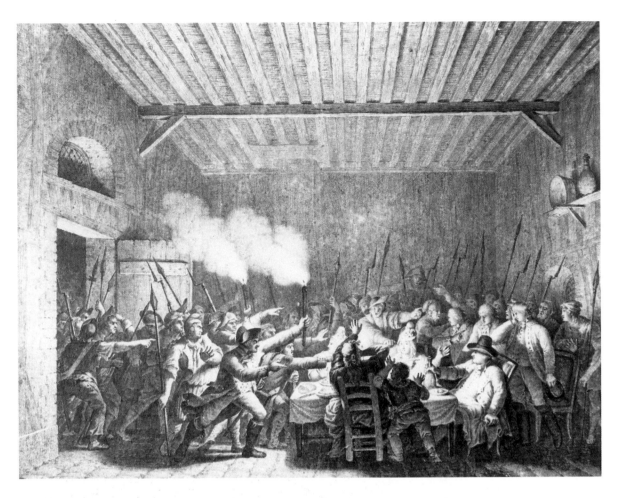

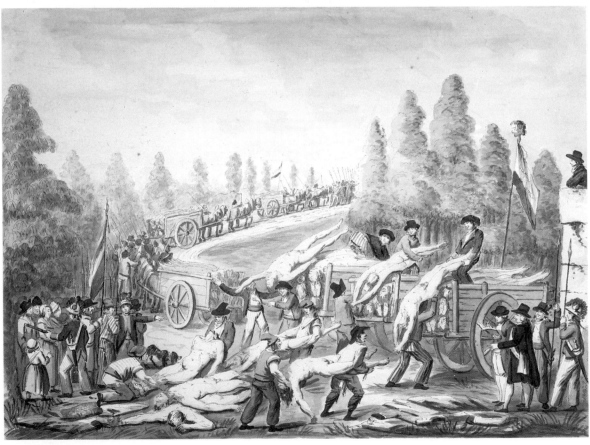

Wordsworth's confidence in the Revolution was unshaken. Back in London, he had *An Evening Walk* and *Descriptive Sketches* printed by the radical publisher Joseph Johnson, and soon afterwards composed his extreme republican *Letter to the Bishop of Llandaff*. The bishop, shocked by news of the execution of the French king on 21 January 1793, was beating his breast about having earlier supported the French:

> I fly with terror and abhorrence even from the altar of Liberty, when I see it stained with the blood of the aged, of the innocent, of the defence-less sex, of the ministers of religion. . . . My heart sinks within me when I see it streaming with the blood of the monarch himself.

His sentiments were probably shared by a majority of British liberals, and are represented, for instance, by Charles Benazech's sympathetic portrait of Louis at the foot of the scaffold [Fig. 17]. Wordsworth, however, was quite uncompromising. Violence was acceptable in the early stages of a revolution that was to bring about "a fairer order of things." The king had been a traitor, and kingship was itself indefensible:

> The office of king is a trial to which human virtue is not equal. Pure and universal representation, by which alone liberty can be secured, cannot, I think, exist together with monarchy. . . . They must war with each other, till one of them is extinguished. It was so in France. . . .

15 (*above left*). Jean-Louis Prieur, *Arrest of the king and royal family at Varennes, 22 June 1791* [Cat. no. 26]

16 (*below left*). Attributed to Etienne Béricourt, *Transporting the Bodies*, 1792 [Cat. no. 8]. The aftermath of the September Massacres

17. Charles Benazech, *Louis XVI at the Foot of the Scaffold. 21 January 1793* [Cat. no. 7]

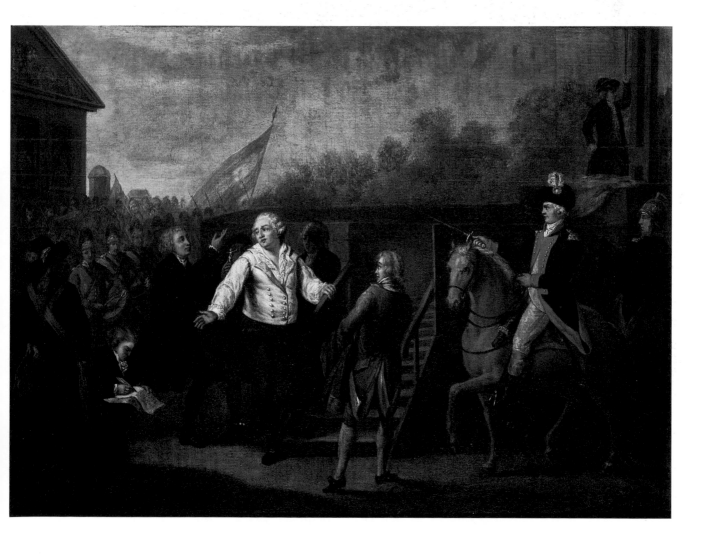

[handwritten manuscript image]

that of the whole body politic? And this brings
me to my grand objection to monarchy, which is
drawn from the eternal nature of man. The
office of king is a trial to which human virtue
is not equal. Pure and universal representation,
by which alone liberty can be secured, cannot, I

think, exist together with monarchy. It seems 27
madness to expect a manifestation of the ~~national~~
general will, at the same time that we allow
to a particular will that weight, which it must
obtain in all governments, that can, with any
propriety, be called monarchical. They must
war with each other, till one of them is extin-
guished. It was so in France, and ✳ ✳ ✳

18. Wordsworth,
A Letter to the Bishop of Llandaff
. . . *by a Republican*,
c. February–June 1793 [Cat. no. 40].
Part of a unique copy,
in an unknown hand:
"The office of king is a trial to which
human virtue is not equal"

The *Letter* [Fig. 18] was dangerously outspoken, and never published, but Wordsworth intended it as a contribution to a pamphlet-war that had been going on since November 1790 and Burke's attack on Price in *Reflections on the Revolution in France* [Fig. 19]. Price, after his comments on the American Revolution in 1785, had welcomed the events in France four years later as the natural and expected sequel. "I have lived to see a diffusion of knowledge," he proclaimed in *A Discourse on the Love of Our Country* (November 1789) [Fig. 19],

> which has undermined superstition and error. I have lived to see the rights of men better understood than ever; and nations panting for liberty which seemed to have lost the idea of it. I have lived to see THIRTY MILLIONS of people, indignant and resolute, spurning at slavery, and demanding liberty with an irresistible voice.

By contrast, Burke had changed camps, denouncing the French though he had been chief defender of the Americans. His motives were complex, and had much to do with internal differences in the Whig party. Price, though himself barred from politics as a dissenter, favoured parliamentary reform; Burke stood for government by a strong aristocracy.

The *Discourse* had been delivered as a sermon to the London Revolution Society, formed the previous year to mark the centenary of the Glorious Revolution of 1688 (claimed by radicals as an assertion of the will of the

19. The Revolution Debate, 1789–1793:
Richard Price, Edmund Burke,
Thomas Paine, Mary Wollstonecraft,
William Godwin
(photographed by permission of the Curators
of the Bodleian Library, Oxford
[see Cat. nos. 25, 11, 23, 35, 36, 17])

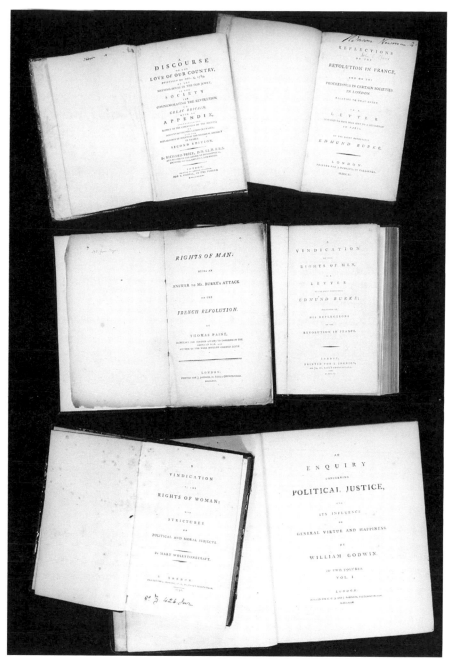

people). At a dinner that followed Price's sermon, the members had resolved to encourage the establishment of similar groups throughout the country, which by corresponding with each other would form "a grand concentrated union of the true friends of public liberty." They then voted to "offer to the National Assembly of France their congratulations on the revolution in that country," reflecting as they did so "on the tendency of the glorious example given in France to encourage other nations to assert the inalienable rights of mankind." Finally, they agreed to set down three fundamental principles (all of them later denounced by Burke):

1. That all civil and political authority is derived from the people.
2. That the abuse of power justifies resistance.
3. That the right of private judgment, liberty of conscience, trial by

jury, the freedom of the press, and the freedom of election, ought ever to be held sacred and inviolable.

The power of Burke's writing derives above all from its emotional conviction. "I intend no controversy," he wrote during the summer of 1790; "I mean to set in full view the danger from their wicked principles and their black hearts. . . ." No one could have been further from having wicked principles or a black heart than Price, but in the early part of Burke's *Reflections* he is attacked with brutal sarcasm: "Plots, massacres, assassinations, seem to some people a trivial price for obtaining a revolution. . . ." Burke exaggerates the violence in France, plays on the fears of his readers, and shocks them with his account of affronts offered to the queen. He uses rhetoric to defend property and hereditary rights, and specious argument to maintain that in 1688 kingship had not been conferred. At one point he descends—in a phrase gleefully picked up by his opponents—to characterizing followers of the Revolution as "a swinish multitude."

In a more equivocal mood, James Gillray produces on 3 December one of his most brilliantly imaginative cartoons, *Smelling Out a Rat;—or The Atheistical-Revolutionist Disturbed in his Midnight "Calculations"* [Fig. 20]. Price is surprised at his desk by an immense surrealist nose, surmounted by huge spectacles, and bearing in either hand (there is no body) symbols of Church and State. Above the spectacles is propped a copy of *Reflections*, and the apparition emerges from clouds such as more normally shield the

20. James Gillray, *Smelling Out a Rat;—or The Atheistical-Revolutionist disturbed in his Midnight "Calculations,"* 1790 [Cat. no. 15]

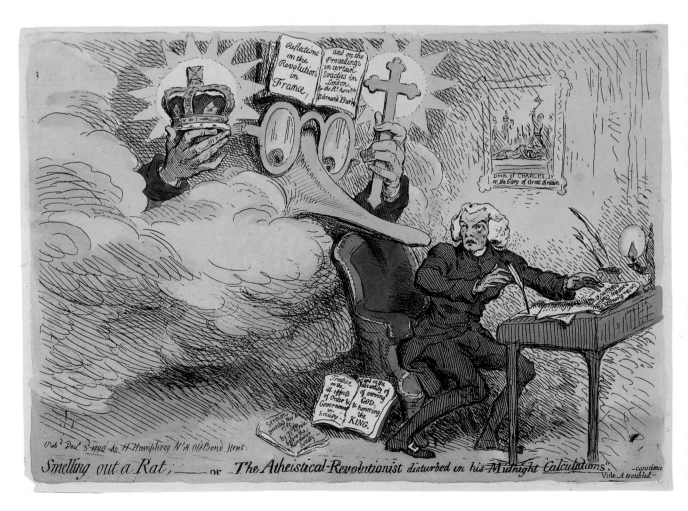

Almighty. The "Revolutionist" looks frail, human, and understandably worried. On the wall, however, is a picture of the execution of Charles I, and Price is to be seen writing a tract "on the benefits of Anarchy, Regicide, and Atheism."

Other responses to *Reflections* were more explicit. Priestley, in his *Letter to the Right Honourable Edmund Burke*, joined with Price in seeing the American and French revolutions as the beginning of a "reign of peace," "distinctly and repeatedly foretold in many prophecies, delivered more than two thousand years ago":

> These great events, in many respects unparalleled in all history, make a totally new, a most wonderful, and important era in the history of mankind. It is a . . . change from darkness to light, from superstition to sound knowledge, from a most debasing servitude to a state of the most exalted freedom.

Mary Wollstonecraft [Fig. 21]—more famous for her later *Vindication of the Rights of Woman* (1792) [Fig. 19]—was in print exactly a month after *Reflections* with *A Vindication of the Rights of Men* [Fig. 19]. Unimpressed by Burke's "haughty talk and mock dignity," she drew attention to his obsession with the "the security of property": "Behold . . . the definition of English liberty!"

The appearance in March 1791 of Thomas Paine's *Rights of Man*, Part One [Fig. 19], introduced a new voice to the debate. The concept of natural and inalienable rights, advanced in the academic context of Priestley's *Essay on the First Principles of Government*, was now put forward by the veteran of a successful revolution. As an American citizen, and a republican, Paine thought in terms of a National Convention rather than parliamentary reform. He would have abolished both the monarchy and the House of Lords. He had no patience with the radicals' harking back to golden ages of the past—the period before the "Norman yoke," or the time of Milton—and he swept aside arguments from historical precedent:

> I am contending for the rights of the living, and against their being willed away, and controlled and contracted for, by the . . . authority of the dead.

As the second anniversary of the Fall of the Bastille approached, the mood in England was very different from that of the previous year. To have comradely dealings with the National Assembly, as the Revolution Society had done, was now dangerous. A large dinner did take place in London on 14 July, but the leading Whigs were dissuaded from attending, no contentious toasts or resolutions were proposed, and the celebrations were very muted. In Birmingham events were not so peaceful. There was a three-day riot, directed chiefly against the property of dissenters. Opinions differ as to whether the mob that gathered on the 14th was incited to violence, but evidence produced in the Commons shows that local magistrates directed rioters to the Unitarian meeting-houses, and offered them protection. Priestley escaped unhurt, but his house was looted and burned down, and he lost both library and scientific apparatus. The scene is portrayed [Fig. 22] with Hogarthian energy by

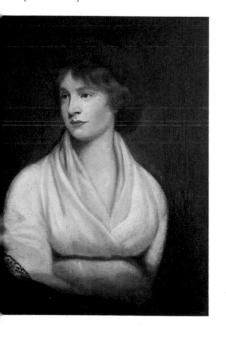

21. Mary Wollstonecraft, aged thirty-seven, by John Keenan [Cat. no. 22]

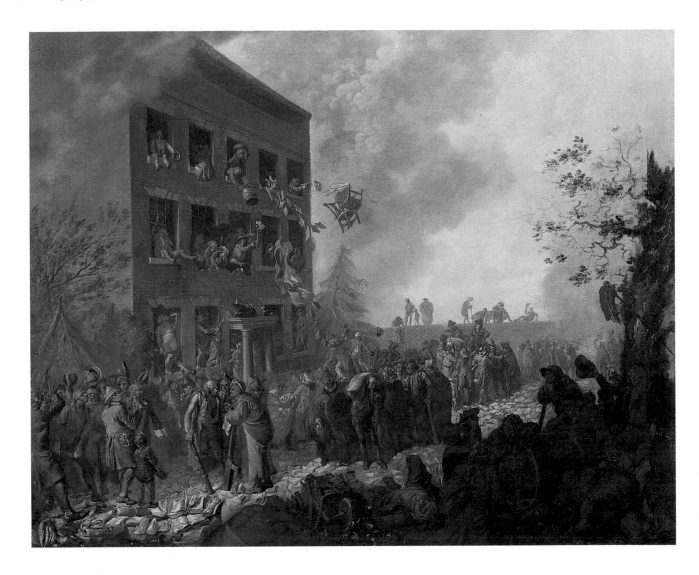

Johann Eckstein, a Mecklenberger who was living in Birmingham at the time. As the flames take hold, rioters heave furniture and books through the windows, sprawl in drunken stupor, or trample on Priestley's books (the titles clearly evident) that lie scattered on the ground—all, as their banners proclaim, in the names of Church and King. One drunken figure in the right foreground opens his mouth to receive the stream of ale shooting from a punctured barrel. In the background two authoritative figures—perhaps the conniving magistrates—survey the havoc, but fail to intervene.

Part Two of the *Rights of Man*, published on 16 February 1792, carried the Revolution Debate into practical politics. Paine was no longer concerned with answering Burke, or defending the French; he had a detailed new programme to put forward. The way ahead must be through the abolition of privilege and primogeniture (on which hereditary rights were based), the reform of taxation, and the setting up of what we should now call a welfare state:

> When, in countries that are called civilised, we see age going to the workhouse and youth to the gallows, something must be wrong in the system of government. . . . Civil government does not consist in

22. Johann Eckstein,
*Rioters Burning Dr. Priestley's House
at Birmingham, 14 July 1791*
[Cat. no. 14].

executions; but in making that provision for the instruction of youth, and the support of age, as to exclude, as much as possible, profligacy from the one, and despair from the other.

Wollstonecraft's *Vindication of the Rights of Woman* [Fig. 19] came out just before Part Two of the *Rights of Man*, and takes as its starting-point

> this simple principle, that if woman be not prepared by education to become the companion of man, she will stop the progress of knowledge, for truth must be common to all, or it will be inefficacious with respect to its influence on general practice.

Women who accept the degrading feminine role that society has imposed on them are not merely belittled as individuals, they halt the progress of humanity, which is to be achieved through reason and through education. A very similar argument is used by Wollstonecraft's future husband, William Godwin, when contemplating the need to free man from political and legal institutions in his *Political Justice* of February 1793 [Fig. 19]:

> Men are weak at present, because they have always been told they are weak, and must not be trusted with themselves. Take them out of their shackles, bid them enquire, reason and judge, and you will soon find them very different beings.

Political Justice was the last contribution to the Revolution Debate. It was an immediate success, but an extraordinary case of optimism based on false premises. Despite all that was going on around him, Godwin believed man to be innately rational. As William Hazlitt said in *The Spirit of the Age* (1825), "He conceived too nobly of his fellows . . . he raised the standard of morality above the reach of humanity." It was timing that created the impact of *Political Justice*. The book had been written over the course of sixteen months, during which events in Paris moved very rapidly. Just before its publication came the news of the execution of the king. Moderates—the Bishop of Llandaff among them— were horrified, and made public recantations. Those further to the left were disproportionately grateful for a work that based its vision of general future happiness not on revolution and political institutions, but on reason and perfectibility. "The legitimate instrument for effecting political reformation," wrote Godwin, "is truth. Let truth be incessantly studied, illustrated and propagated, and the effect is inevitable." Shelley, who became Godwin's son-in-law, was for a time actively his disciple; Wordsworth, though attracted by his emphasis on perfectibility and education, was repelled by the denial of emotional values.

The death of Louis XVI was marked by Gillray with a brutal cartoon, *The Zenith of French Glory, the Pinnacle of Liberty*, with the sarcastic sub-title *Religion, Justice, Loyalty, and all the Bugbears of Unenlightened Minds, Farewell!* [Fig. 23]. News of the execution had reached London on 24 January 1793; on 1 February, France declared war, and on the 11th England followed suit. Gillray's comment appeared the next day. Back in 1790, his response to *Reflections* had been equivocal; this time his position is clear. Louis lies on the guillotine; gloating from a lamp bracket in the foreground is a grotesque *sans-culotte*, on whose cap the

words *Ça Ira* make it plain that nothing is going to be okay. Whether or not Burke's nosing out of Price had originally been justified, he had certainly been prophetic about the dangers of power getting into the wrong hands.

By June 1793 the constitutional Girondins, with whom both Paine and Wordsworth were associated, were under arrest in Paris. They had been unable to prevent Robespierre and the Jacobins putting the king on trial, and they had been unable (by a single vote) to prevent his execution. After his death they had no coherent policy, and in October twenty-one of

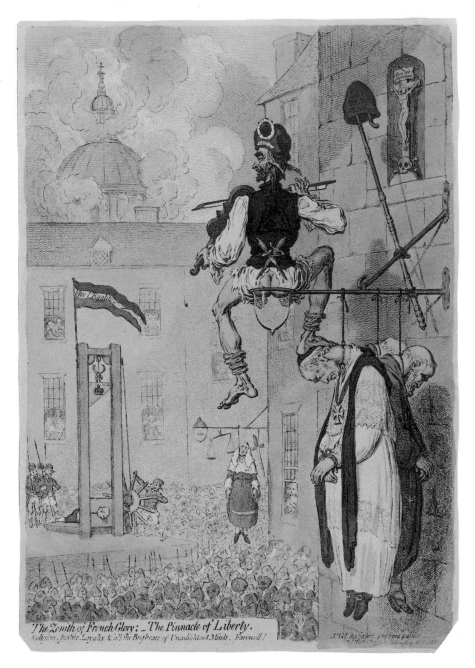

23 (*left*). James Gillray, *The Zenith of French Glory*, 1793 [Cat. no. 16]. Satirical view of the execution of Louis XVI

24 (*right*). Hubert Robert, *Corridor at the Saint Lazare Prison*, 1794 [Cat. no. 30]

their leaders went to the guillotine. The Reign of Terror had begun. Marie Antoinette died on the 16th. Madame Roland, whose last moments were recorded by the English poet Helen Maria Williams, was executed in November—after giving up the privilege of dying first to a man more frightened than herself:

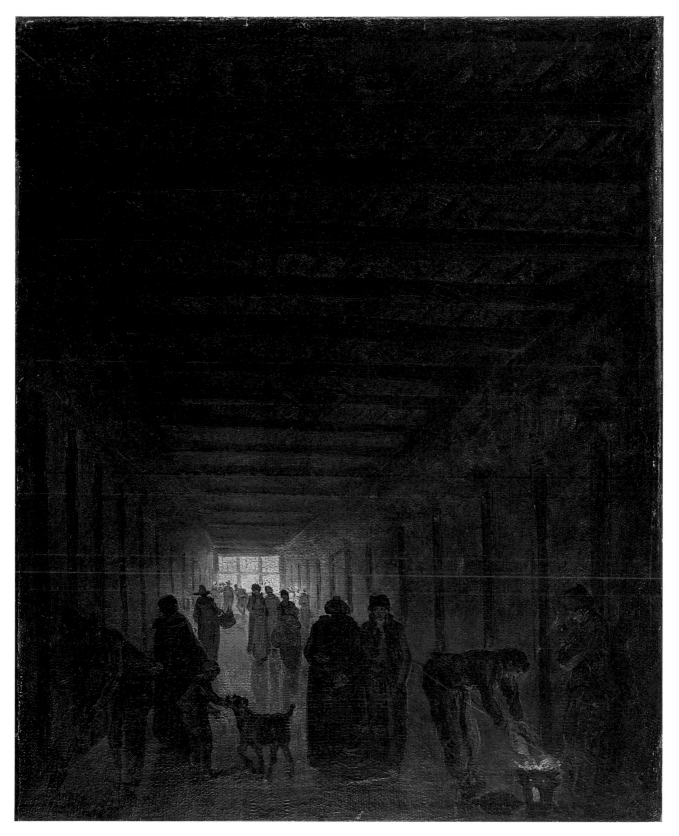

The executioner told her he had received orders that she should perish first. "But you cannot, I am sure," said she with a smile, "refuse the last request of a lady."

Her dying words, though variously reported, made her the most famous of all martyrs to the cause of the Revolution:

When she mounted the scaffold, and was tied to the fatal plank, she lifted up her eyes to the statue of Liberty, near which the guillotine was placed, and exclaimed, "Ah Liberty! How hast thou been sported with!" The next moment she perished.

Paine, who had voted with the Girondins against the execution of the king (and was thus, by French standards, a royalist), was arrested in December. Sent to the Luxembourg prison, he was among those who for no obvious reason survived the Terror. Hubert Robert, imprisoned at Saint Lazare, has left a strangely calm picture of life carrying on among those who could not know which day would be their last [Fig. 24]. In the dimly lit corridor, a child stops to play with the dog, cloaked figures with their baskets pursue some purpose, singly or in pairs, and at the far end a few prisoners look out upon the world. Some victims of the Terror died to settle political scores or personal grudges, others so that their money and possessions could be seized by the State, but often the violence seems to have been arbitrary, inconsequential. Wordsworth's sense of the pointlessness comes from a knowledge that he might so easily have been there himself:

> Domestic carnage now filled all the year
> With feast days: the old man from the chimney-nook,
> The maiden from the bosom of her love,
> The mother from the cradle of her babe,
> The warrior from the field—all perished, all—
> Friends, enemies, of all parties, ages, ranks,
> Head after head, and never heads enough
> For those who bade them fall. (*1805*, x, 329–336)

On 27 July 1794 (9 Thermidor, in the Revolutionary calendar), Robespierre, who had ruled almost as a dictator in the previous months, was outmanoeuvred and arrested. With his jaw shattered, apparently in an attempt to shoot himself, he too went to the guillotine, along with 102 of his associates. Wordsworth, in Cumbria, greeted the news with "joy / In vengeance, and eternal justice," but though the Terror ended, the war went on. The French economy had been disastrously weakened. By occupying neighbouring territories, the army could pay for itself, as well as requisitioning supplies for the civilian population. To British radicals, the invasions (which would presently turn into outright imperialism) seemed a betrayal of the Constitution; to the French they were practical politics.

In England, taxes to pay for the war had fallen, as Paine and Wordsworth had predicted, chiefly on the working classes. Owing partly to bad harvests, the price of bread had risen steeply. There were fears of revolution, and government policy became increasingly repressive. In May 1794, the secretaries of the London Corresponding Society and the Society for Constitutional Information were arrested in London, and their papers seized. A parliamentary committee decided that there had been "an open attempt to supersede the House of Commons," and to assume "the functions and powers of a national legislature." There were more arrests, and *Habeas Corpus* was suspended, allowing the government to

hold its prisoners throughout the summer without bringing them to trial.

The indictment, on 6 October, was for high treason. If convicted, the twelve accused stood to be hanged, cut down while still alive, disembowelled, and finally quartered. The full penalty had been exacted after the Jacobite Rebellion only twenty-eight years before, but on this occasion the government's case was weak. Sedition could have been proved—the societies did indeed wish to replace Parliament by an elected French-style convention—but treason was defined as an act that could be shown to "compass or imagine the death of the king," and the charge could not be made to stick. In the following year, however, the "Two Bills" were introduced, redefining treason, prohibiting seditious meetings, and effectively breaking resistance to the government. Again it was the working-class Corresponding Society that caused Pitt to intervene.

A mass open-air meeting at Copenhagen House on 26 October 1795 seems to have been attended by over 100,000 members. Among broadsheets that were distributed was Citizen Lee's *King Killing* [Cat. no. 1], printed "at the British Tree of Liberty," and asking stridently:

Shall kings alone claim exemption from the law, and impunity of wickedness? . . . Shall vice and villainy, whom accident may have encircled with a diadem, be deified and worshipped by uncomplaining impotence and servile fear?

Three days later the king's coach was stoned at the opening of Parliament; on 4 November, regicidal pamphlets were named in a royal proclamation as a cause of the stoning. On 18 December the "Two Bills" became law. Citizen Lee was one among many who chose to emigrate to America.

In France, meanwhile, the rise of Napoleon was extremely rapid. As captain of artillery in December 1793, he drew up the successful plan for the recapture of Toulon, held by the British fleet and French counter-revolutionary forces. By March 1794, he was a general with the French "Army of Italy." Ten days before the fall of the Jacobins in July, he wrote to Robespierre's brother Augustin to point out "the absolute necessity, in an immense struggle like ours, of . . . a central, stable authority." Four years later, following campaigns in Italy (1796–1797) and Egypt (1798–1799), he took over the central power that was so necessary, becoming First Consul after the *coup d'état* of 9 November 1799. In 1804, he was proclaimed emperor in May, and on 2 December summoned the Pope to crown him in Paris—but in fact set the crown on his own head. After twelve years as a republic, France had restored the monarchy. Wordsworth's disgust at this betrayal of the people was expressed in the violent, though biblical, image of "the dog / Returning to his vomit."

Baron Gros' magnificent painting, *Napoleon on the Bridge at Arcole* [Fig. 26], exhibited at the Salon in 1801, shows the rise to power as the First Consul himself preferred to view it. A turning-point in the Italian campaign is chosen to enshrine the ideal of military prowess. As the isolated leader in battle, Napoleon becomes a type of the romantic hero. Hazlitt would have applauded, Byron would have been impressed; to

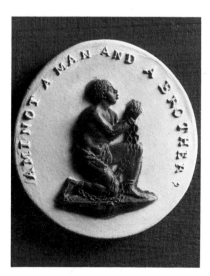

25. *Am I Not a Man and a Brother?*, 1787 [Cat. no. 34].
Medallion in black and white jasper, made by Josiah Wedgwood for the Society for the Abolition of the Slave Trade

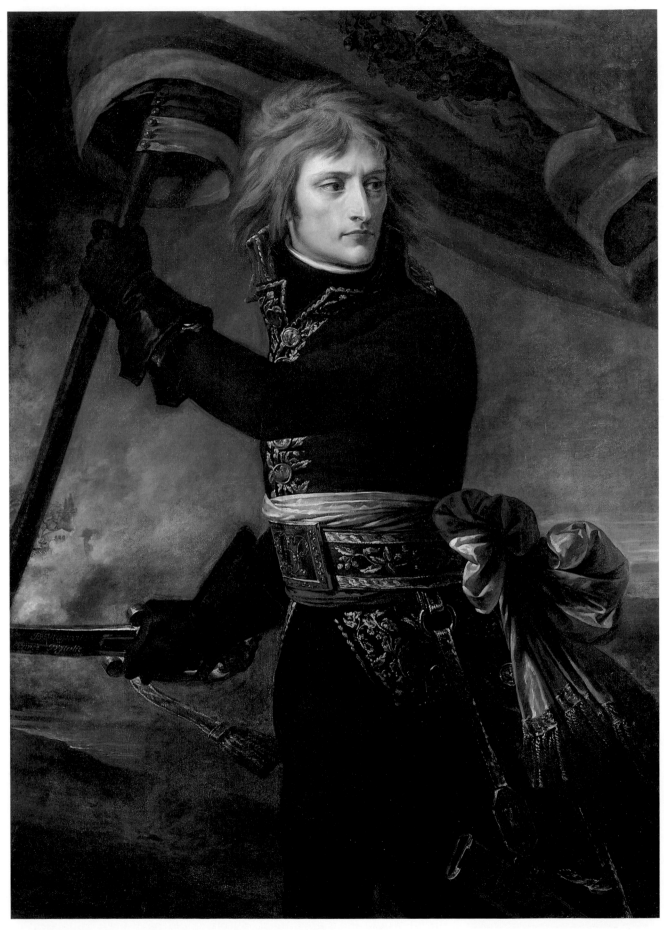

26. Jean-Antoine, Baron Gros. *Napoleon on the Bridge at Arcole. 17 November 1796* [Cat. no. 18]

Wordsworth, the portrait, for all its vivid colours and pictorial splendour, would still have shown a tyrant: "I grieved for Bonaparte," he wrote, "with a vain / And an unthinking grief. . . ."

One policy that seemed particularly heartless in its betrayal of the Revolution was Napoleon's expulsion of negroes from France. In September 1802 Wordsworth and his sister Dorothy tried to comfort "a negro woman . . . Rejected like all others of that race," and her suffering (like that of the "hunger-bitten girl" of Blois ten years before) gave a personal quality to the poet's sense of political injustice [Cat. no. 41]. British ships were still permitted to engage in the slave trade, but the campaign of Thomas Clarkson (Wordsworth's neighbour in Cumbria) and William Wilberforce was to bring about abolition in 1807. It had been long delayed. William Cowper's jaunty song, *Sweet Meat Has Sour Sauce, or The Slave-Trader in the Dumps*, had assumed that a ban was on the way twenty years earlier:

> A trader I am to the African shore,
> But since that my trading is like to be o'er,
> I'll sing you a song that you ne'er heard before,
>> Which nobody can deny, deny,
>> Which nobody can deny. . . .

> Here's padlocks and bolts, and screws of the thumbs
> That squeeze them so lovingly till the blood comes,
> They sweeten the temper like comfits or plums,
>> Which nobody, etc. . . .

It is typical of Wordsworth that he should choose for his own image of the romantic hero, not Napoleon himself, but one of his victims. In summer 1802, Toussaint L'Ouverture, black leader of the slaves' rebellion in Saint Domingue (later Haiti), was lying in prison at Fort de Joux in the French Alps. Though almost illiterate, he had emerged as a successful general and a shrewd tactician. The state he established was not egalitarian (slaves were freed, but subjected nonetheless to forced labour), but he brought stability, and was in many ways an enlightened leader. To Wordsworth, Saint Domingue was an inspiring victory for freedom and, ironically, a direct expression of the ideals of the French Revolution. His sonnet *To Toussaint L'Ouverture* was written halfway between Napoleon's invasion of the island in January 1802 and the subsequent death in prison of Toussaint himself on 7 April 1803. No statement of Wordsworth's belief in the grandeur of the human mind carries more conviction:

> There's not a breathing of the common wind
> That will forget thee! Thou hast great allies:
> Thy friends are exultations, agonies,
> And love, and man's unconquerable mind.

> (lines 11–14)

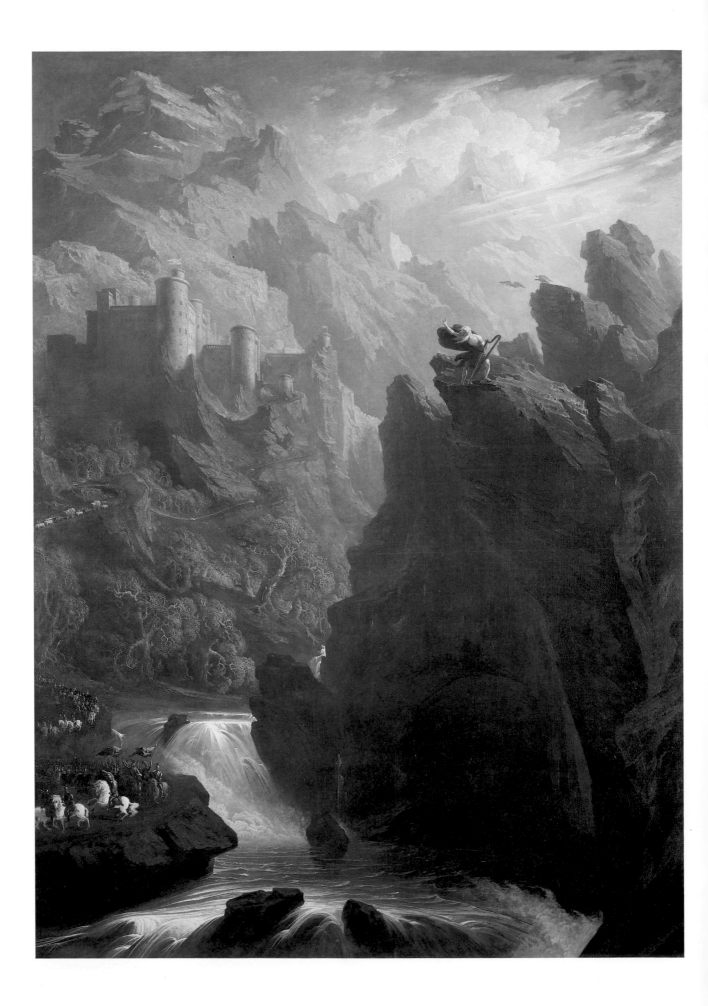

2 The Spirit of the Age

"Mr. Wordsworth's genius," Hazlitt writes in 1825, "is a pure emanation of the Spirit of the Age." Keats had died in 1821, Shelley a year later, and Byron in 1824; the great poetry of Blake, Coleridge, Wordsworth, had all been written; Hazlitt was in a position to take stock. He had his prejudices—an excessive admiration for Napoleon, for instance, and a very low opinion of Byron—but no one has matched his shrewdness about the contemporary scene. His view of Wordsworth in *The Spirit of the Age* is one that relates literature to politics, Romanticism to the Revolution:

> his poetry . . . is one of the innovations of the time. It partakes of, and is carried along with, the revolutionary movement of our age: the political changes of the day were the model on which he formed and conducted his poetical experiments. His Muse . . . is a levelling one.

In different ways all the great Romantic poets were "carried along by the revolutionary movement" of the day. They came from widely varying social groups (Byron, peer of the realm, and idol of Regency London; Burns a tenant farmer, turned customs officer), but all, at the time of their greatest work, were committed to radical views, and all were revolutionary in their poetic innovations. Their writing is a celebration of freedom and energy. Like Paine—"It is an age of Revolutions, in which everything may be looked for"—they had a sense of unbounded possibility. They believed equally in "man's unconquerable mind" and in what Keats termed "the holiness of the heart's affections." Above all they believed that life was a quest, a reaching out into new realms of experience.

Very much the same is true of the great English painters of the day, Constable and Turner. Constable has Wordsworth's quality of rootedness. His vision emerges from the particular landscapes of his childhood; his concern is with

> the very world which is the world
> Of all of us, the place in which, in the end,
> We find our happiness, or not at all. . . .
>
> (1805, x, 725–727)

"However one's mind may be elevated," he writes, "and kept up to what is excellent, by the works of the Great Masters, still Nature is the fountain's head, the source from whence all originally must spring." Turner's imagination tends more to abstraction, and in this respect he often seems closer to Shelley than to Wordsworth. In Hazlitt's view, he is "the ablest landscape painter now living;" his works "are pictures of the

27. John Martin, *The Bard*, 1817 [Cat. no. 84]:

On a rock, whose haughty brow
Frowns o'er old Conway's foaming flood,
Robed in the sable garb of woe,
With haggard eyes the poet stood;
Loose his beard and hoary hair
Streamed, like a meteor, to the troubled
air. . . .

(Gray, *The Bard*)

elements, of air, earth, and water." Turner's own comment was that he wished to paint not merely landscape, but landscape "plus a man's soul."

To William Blake, in *The Marriage of Heaven and Hell* of 1790 [Fig. 29], it seems that "If the doors of perception were cleansed everything would appear to man as it is, infinite." It is the earliest statement of the power of the Romantic imagination. Blake is responding to the optimism of the early days of the Revolution, but he sees the new age as a breaking free from the tyranny of sense perception and Lockean empiricism. His vision is political in its denouncing of institutionalized power—"Prisons are built with stones of law, brothels with bricks of religion"—yet again and again we are returned to the concept of a higher way of seeing:

> The roaring of lions, the howling of wolves, the raging of the stormy sea, and the destructive sword, are portions of eternity too great for the eye of man.

Too great, that is, until the doors of perception are cleansed. When that happens, these destructive forces will be seen as expressions of the principle of energy which unites political revolution, sexual drives, imagination, spiritual awakening—liberty of all kinds, as opposed to constriction. In *The Good and Evil Angels* (c.1793) [Fig. 30], the "good"

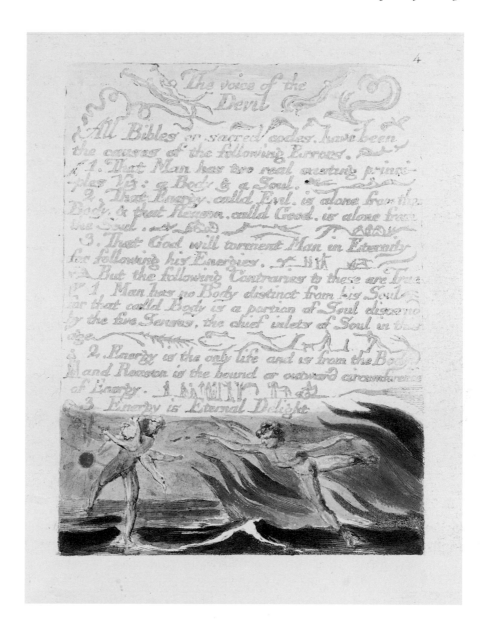

angel withholds a child (probably symbolic of the human race) from the "evil" one, who rises from the flames of hellish energy, but who is for the moment chained.

Heaven and Hell are not so much wedded in *The Marriage* as turned-on their heads in a comic inversion of *Paradise Lost.* Satan is the principle of energy, God is the "Great Forbidder" described by Eve at the Fall, and Milton ("because he was a true poet") is "of the Devil's party without knowing it." Blake is taking delight in the extreme: "Prudence is a rich, ugly old maid, courted by incapacity. . . . Exuberance is beauty." Even in this mood, however, he is aware of the need for constraint—aware, that is, of the central Romantic paradox that liberty requires to be curtailed. As a trained engraver, he thinks in terms of his art. In the *Descriptive Catalogue* of 1809, his judgment of painting is based on the use of outline ("the more distinct, sharp, and wiry the bounding line, the more perfect the work of art"); in 1790, the analogy of engraving is in his mind as he asserts the need for reason to be the outward circumference of energy. Energy does not like to be contained, but must have something to push

against. Imagination cannot have power unless it has form. For the Romantic artist, however, there is the appalling corollary that form is death. Creativity that has been personal and vital becomes, in Wordsworth's phrase, "Exposed and lifeless as a written book."

It is in *The Book of Urizen* (1794) that Blake explores the implications of this trap, but the *Songs of Experience* [Fig. 31], written chiefly in 1791–1792, show already a darkening vision of repression. There can be no return to the world of *Innocence* (1789), where children sported at liberty "on the echoing green." Even the Garden of Love has been taken over, turned into a cemetery:

> I went to the Garden of Love,
> And saw what I never had seen:
> A chapel was built in the midst,
> Where I used to play on the green.
>
> And the gates of this chapel were shut,
> And *Thou shalt not* writ over the door;
> So I turned to the Garden of Love
> That so many sweet flowers bore,
>
> And I saw it was filled with graves,
> And tomb-stones where flowers should be—
> And priests in black gowns were walking their rounds,
> And binding with briars my joys and desires.

30. William Blake, *The Good and Evil Angels*, c. 1793–1794 [Cat. no. 47]. Developed from a plate in *The Marriage of Heaven and Hell*, where the values of good and bad, heaven and hell, are reversed. The "evil" angel represents Satanic energy, the "good," repression

Urizen is less immediate in its commentary on the age. As in *The Marriage*, Blake is writing with an eye on *Paradise Lost*, but the exuberance has gone. He is making a myth of Creation that will be appropriate to the "fallen" society in which he lives. In place of Milton's loving Creator who foreknows, but somehow does not foreordain, the Fall, we see division within the original harmony that is the mind of God—the division that is implied in perfection that can create evil. In this powerful new myth, a part of the divine mind, broadly corresponding to reason (hence the pun Urizen / "Your reason"), splits off, and actually becomes the material universe. The Fall and Creation are a single event. As in the artistic process, that which was spiritual, energetic, unbounded, has

31. William Blake,
Songs of Innocence and Experience, 1794
[Cat. no. 50].
The original plate of Blake's *Tyger*

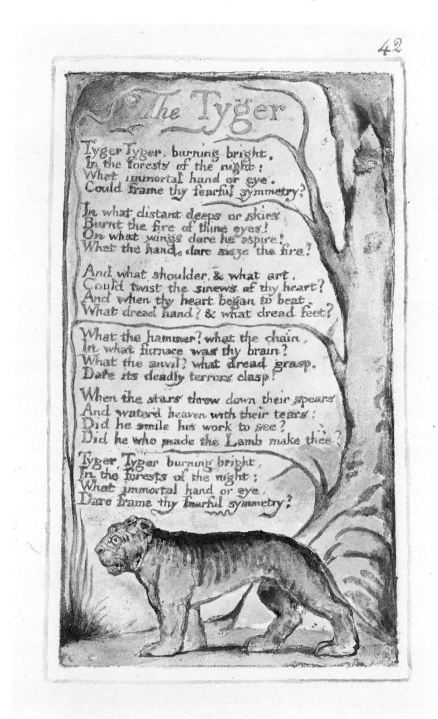

hardened into form. Nor can the process be reversed. The world as we know it, together with death, time, man and woman, comes into being in a downward spiral away from eternity.

In the last twenty-five years of his life, Blake will evolve a redemptive counter-myth, seen in the Prophetic Books, *Vala*, *Milton*, and *Jerusalem*, and in the illustrations to Dante [Fig. 32], but for the moment he sees

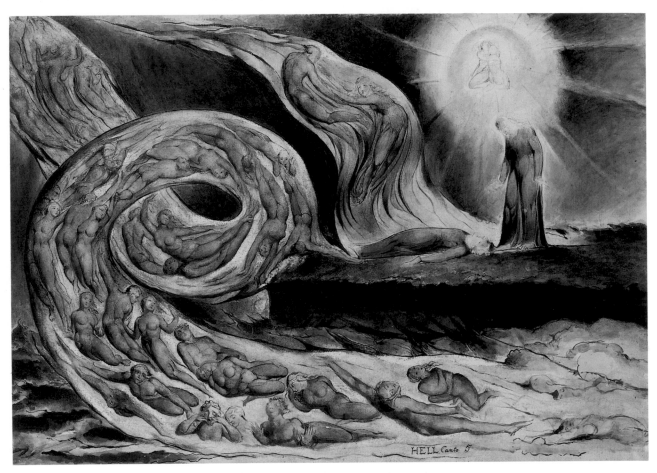

32. William Blake, *Circle of the Lustful*, *c.* 1824–1827 [Cat. no. 46].
In Blake's radical interpretation of Dante (subtitled "The Whirlwind of Lovers" in the engraving) love's whirlwind reunites the male and female principles, carrying them upwards to the harmony of eternal life

the forces of repression as triumphant. In the great coloured prints of 1794–1795 [Figs. 57 and 58], Urizen, tyrant god of rationality, measures out his universe; Newton, his disciple, gazes down at a geometrical design, which is the product of self-love, and a refusal to see the infinite. Strange as his vision is, Blake is very much a part of his age. His art is an imaginative response to a political situation. He is to be seen reacting first to hope, then to repression, then to the need (felt by so many of his fellow writers) to reassert the grandeur of the human mind, in which it had been so easy to believe when the Revolution appeared a guarantee of final happiness.

A comparable pattern in Coleridge's early life is mocked by Hazlitt in some of his most exuberant prose:

> he hailed the rising orb of liberty, since quenched in darkness and in blood, and . . . kindled his affections at the blaze of the French Revolution, and sang for joy, when the towers of the Bastille and the proud palaces of the insolent and the oppressor fell, and would have floated his bark, freighted with fondest fancies, across the Atlantic wave with Southey and others to seek for peace and freedom. . . .

Coleridge, then a very learned and very unsuccessful Cambridge undergraduate, had met Robert Southey in Oxford in June 1794. They took to each other at once, decided to form a commune in America, and wrote a verse drama (in two days) celebrating the death of Robespierre. "Sublime amid the storm," Barrère proclaims in the concluding lines, "shall France arise . . . she shall blast / The despot's pride, and liberate the world!"

Had they indeed emigrated, they would have been following in the footsteps of Joseph Priestley, who had left for America after preaching his farewell sermon at Hackney in February. Their scheme, however, was for Utopia; "Pantisocracy" was Coleridge's name for it—the rule of all as equals. Land, they were assured, was to be had in idyllic conditions on the banks of the Susquehanna. There would be twelve men, each of them married; property would be shared; work would be for the good of all, and restricted to two hours a day. "When Coleridge and I are sawing down a tree," wrote Southey, "we shall discuss metaphysics; we shall criticize poetry when hunting buffalo, and write sonnets while following the plough." It was not very practical. Southey, who had a certain worldly prudence, first horrified the egalitarian Coleridge by suggesting that they should take servants, and then pulled out of the scheme altogether, amid recriminations. The one lasting result was Coleridge's marriage to Sara Fricker, to whom he proposed in the name of Pantisocracy (though in love with someone else), and whom he married under pressure: "Mark you, Southey, I shall do my duty."

Southey would go on to become the Poet Laureate and established man of letters who, in 1817, was mortified when his republican play, *Wat Tyler* (1794) [Cat. no. 98], was printed surreptitiously by radical publishers. Coleridge, meanwhile, became in *Kubla Khan*, *The Ancient Mariner*, and *Christabel* Part One the greatest of all poets of untrammeled imagination. In Blakean terms, his three "supernatural poems" [Cat. nos. 59–61] written within six months at Alfoxden in 1797–1798—are preoccupied with innocence and experience. Though not obviously political, they deal at a fundamental level with man's relation to the world in which he lives. The god-like Kubla may "decree" his "stately pleasure-dome," his "gardens bright with sinuous rills," but his walls and towers cannot exclude the destructive tendencies of man. Deep within his paradise he is conscious of "Ancestral voices prophesying war." In *Christabel* the world of innocence and security is invaded by the evil presence of Geraldine, who (it would seem) is forced to be the cause of pain such as she herself has in the past endured:

> Geraldine nor speaks, nor stirs;
> Ah, what a stricken look was hers!
> Deep from within she seems half-way
> To lift some weight with sick assay,
> And eyes the maid and seeks delay—
> Then suddenly, as one defied,
> Collects herself in scorn and pride,
> And lay down by the maiden's side. . . .

(lines 255–262)

The story of *The Ancient Mariner* is set in motion by an act of point-less destruction. In killing the albatross that has been a companion to his fellow sailors in their polar isolation, the Mariner commits a crime against the natural order. His punishment is the appalling condition of life-in-death:

> Alone, alone, all, all alone,
> Alone on the wide, wide sea,
> And Christ would take no pity on
> My soul in agony. . . . (lines 224–227)

From this he can be rescued only by an act of love:

> Beyond the shadow of the ship
> I watched the water-snakes;
> They moved in tracks of shining white,
> And when they reared, the elfish light
> Fell off in hoary flakes.
>
> Within the shadow of the ship
> I watched their rich attire:
> Blue, glossy green, and velvet black
> They coiled and swam, and every track
> Was a flash of golden fire.
>
> O happy living things, no tongue
> Their beauty might declare!
> A spring of love gushed from my heart,
> And I blessed them unaware—
> Sure my kind saint took pity on me,
> And I blessed them unaware. (lines 264–279)

This is not the end of the story. The Mariner is marked by his guilt, and can never be wholly free of it. But, in a moment of sympathy that parallels his unpremeditated earlier cruelty, he has been capable of feeling that life is beautiful and sacred. Coleridge is writing as a Unitarian follower of Priestley—what his schoolfellow Lamb called a "one-Goddite"—but his lines can be read in terms of Blake, or Wordsworth, or even Shelley. If sense experience (the "doors" of our perception) could be "cleansed," we should know ourselves to be part of the totality that is God. Everything would both appear, and be, infinite. The message is to be heard most clearly in the address of Coleridge to his infant son, Hartley, at the end of *Frost at Midnight*:

> so shalt thou see and hear
> The lovely shapes and sounds intelligible
> Of that eternal language which thy God
> Utters, who from eternity doth teach
> Himself in all, and all things in himself. (lines 58–62)

It is *Frost at Midnight*, written at Alfoxden in February 1798, that establishes the meditative structure of Wordsworth's *Tintern Abbey*, composed in July:

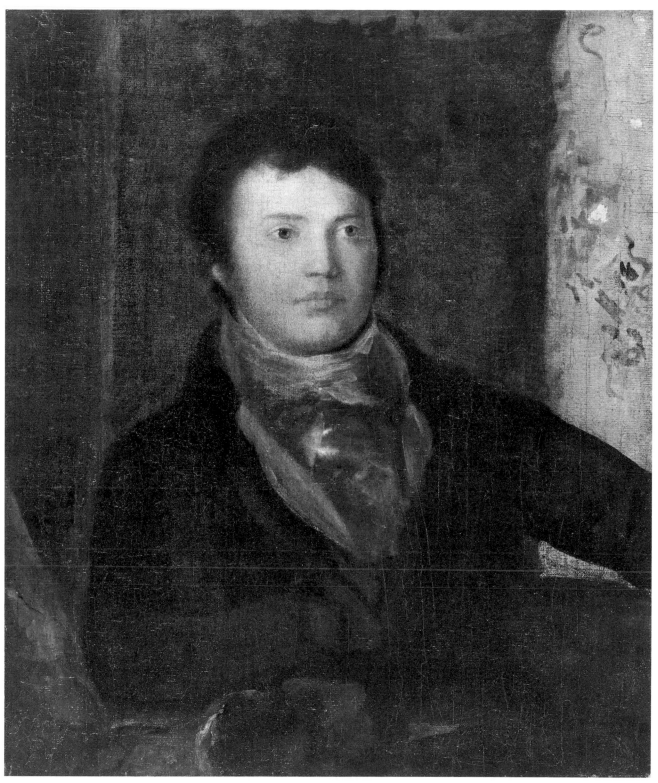

33. Washington Allston,
Samuel Taylor Coleridge [Cat. no. 45].
Painted by the American artist in 1806
when Coleridge was passing through Rome

I have felt
A presence that disturbs me with the joy
Of elevated thoughts, a sense sublime
Of something far more deeply interfused
Whose dwelling is the light of setting suns,
And the round ocean, and the living air,
And the blue sky, and in the mind of man. . . .

(lines 94–100)

And it is Wordsworth's great spiritual affirmation that leads on to the Byron of *Childe Harold*, Canto Three, and the Shelley of *Mont Blanc* (1816):

> The everlasting universe of things
> Flows through the mind, and rolls its rapid waves,
> Now dark, now glittering, now reflecting gloom. . . .
>
> (lines 1–3)

In the wake of the Revolution, these exalted statements of the spirit of the age affirm qualities in the human mind which man, as political animal, had been far from showing. Their claims could hardly have been made at another period, but cannot in any normal sense of the word be defined as "revolutionary." It is to the narrative poetry of *Lyrical Ballads* that we should look for poetical experiments, "formed and conducted" (in Hazlitt's phrase) on the model of political change. Significantly Wordsworth himself saw the Revolution as embodying ideals known to him before he became interested in politics. Privilege, he tells us in *Prelude*, Book Nine, had been so unimportant in the Cumbria of his schooldays that the Revolution

> Seemed nothing out of nature's certain course—
> A gift that rather was come late than soon.
>
> (ix, 253–254)

Cambridge too had been "something . . . Of a republic," where

> Distinction lay open to all that came,
> And wealth and titles were in less esteem
> Than talents and successful industry.
>
> (ix, 234–236)

No doubt Hawkshead was a more egalitarian community than most, but as a boy Wordsworth must have known that the Lowthers, for whom his father was agent, were among the most powerful landowners in the country. At Cambridge, both the University and the colleges were self-

34. William Westall,
St. John's College from Fisher's Lane, 1814
[Cat. no. 104].
Unchanged since Wordsworth's student days
at Cambridge (1787–1791)

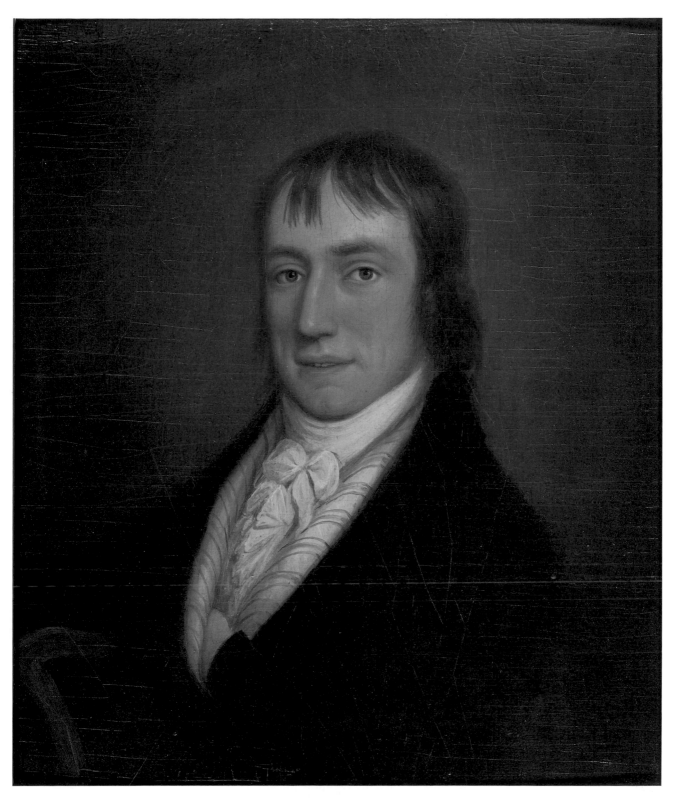

35. William Shuter, *William Wordsworth*,
April 1798 [Cat. no. 96].
The earliest portrait,
made when the poet was twenty-eight

governing, yet few academics were really in a position to disregard wealth and titles. Wordsworth is recording his own sense of things, not writing social history. His claims may be surprising, but the assumptions on which they are based tell us much about the nature of his radicalism:

> It could not be
> But that one tutored thus, who had been formed
> To thought and moral feeling in the way

> This story hath described, should look with awe
> Upon the faculties of man, receive
> Gladly the highest promises, and hail
> As best the government of equal rights
> And individual worth.
>
> (ix, 242–249)

Within the context of the early 1790s, to speak of a "government of equal rights" was to adopt an extreme republican position—and to be guilty of sedition according to British law. Taken out of that context, however, the poet's lines show a faith in human potential that transcends the political situation.

In 1837 Wordsworth told Henry Crabb Robinson

> that he did not expect or desire from posterity any other fame than that which would be given him for the way in which his poems exhibit man in his essentially human character and relations—as child, parent, husband—the qualities which are common to all men, as opposed to those which distinguish one man from another.

Hazlitt had made the same point in a still larger perspective. In Wordsworth's poetry he sees a "levelling" tendency, a habit of paring down to the essential:

> He scans the human race as the naturalist measures the earth's zone, without attending to the picturesque points of view, the inequalities of surface. He contemplates the passions and habits of men, not in their extremes, but in their first elements. . . . He only sympathizes with those simple forms of feeling, which mingle at once with his own identity, or with the stream of general humanity. To him the great and the small are the same, the near and the remote. . . . The common and the permanent . . . are his only realities. All accidental varieties and individual contrasts are lost in an endless continuity of feeling, like drops of water in the ocean-stream!

Wordsworth's essential contribution to his age—the fact that makes him central to any definition of Romanticism—is the concept of emotional permanence. This could, and did, have its political implication. In January 1801 he sent the two-volume *Lyrical Ballads* to Fox (as Whig leader of the opposition), claiming that *Michael* and *The Brothers* were written "to show that men who do not wear fine clothes can feel deeply." In *The Old Cumberland Beggar* he had gone so far as to say, "we have all of us one human heart." It was a view that marked him out for the early reviewers as a Jacobin: to suggest that all human emotion matters is a version of saying that all human beings have rights. And yet the strength of Wordsworth's thinking is its rootedness. Permanence as a concept must imply the persistence of values established in the past. The letter to Fox is a lament for Lake District "statesmen," or yeoman farmers, whose small inherited properties had provided at once independence and emotional stability. The subject-matter of *Lyrical Ballads* has been chosen from "low and rustic life" not as an act of political levelling, but because "in that situation the passions of men are incorporated with the beautiful

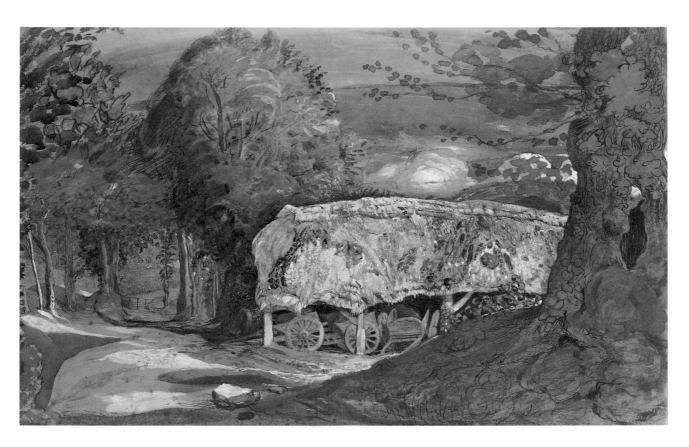

36. Samuel Palmer,
Lane and Shed, Shoreham, Kent,
1828 [Cat. no. 237]

and permanent forms of Nature." Readers are invited in the Preface to see
the volumes as containing a new kind of poetry; yet the novelty lies in a
stripping away of artifice and sophistication. Wordsworth's muse, as
Hazlitt points out,

> disdains external show and relief. It takes the commonest events and
> objects, as a test to prove that Nature is always interesting from its
> inherent truth and beauty, without any of the ornaments of dress, or
> pomp of circumstances, to set it off.

Keats puts it more briskly. For him Wordsworth is a greater poet even
than Milton, because he "thinks into the human heart."

Wordsworth's predecessor in showing the "inherent truth and
beauty" of Nature, devoid of ornament, is the Scottish poet Robert Burns.
In 1798 Wordsworth quoted as an epigraph to *The Ruined Cottage* (his
first great poem of human suffering) lines from Burns' *Epistle to J. Lapraik,
An Old Scotch Bard*:

> Give me a spark of Nature's fire,
> 'Tis the best learning I desire. . . .
> My muse, though homely in attire,
> May touch the heart.

One of Dorothy Wordsworth's earliest letters shows that her brother had
read and admired Burns' *Poems* when he was seventeen, within a year of
the rare Kilmarnock first edition, of July 1786. Instead of aping the
literary fashion of his day (the norm among uneducated poets attempting
to please their patrons: Duck the Thresher Poet, Woodhouse the
Shoemaker, Anne Yearsley the Bristol Milkwoman, and many another),

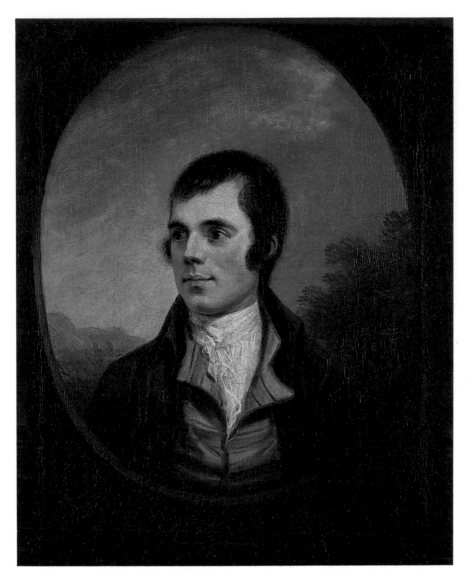

37 (*left*). Robert Burns aged twenty-eight, by Alexander Nasmyth [Cat. no. 86]

38 (*right*). Robert Burns, *Auld Lang Syne*, 1788 [Cat. no. 51].
Original manuscript of Burns' most famous poem

Burns in his best work draws on a native tradition of folk tale and popular song. *Tam o' Shanter*, so admired by Wordsworth, is based on witch stories of Aloway Kirk; *Auld Lang Syne* [Fig. 38], known to millions who are unaware that it is a personal love-lyric, was inspired by "an old man's singing."

By the time of his death in 1796, at the age of thirty-seven, Burns' love-life and drunkenness were becoming a legend. Stories gathered about his name. We shall never know if (as Lockhart reports) he really used his position as customs officer, in 1792, to buy cannons and ship them to the French. He would certainly have wished to do so. One of his last letters, describing the famine in Dumfries, places him firmly among the "swinish multitude" insulted by Burke:

> Many days my family, and hundreds of other families, are absolutely without one grain of meal, as money cannot purchase it. How long the Swinish Multitude will be quiet, I cannot tell; they threaten daily.

Wordsworth and Dorothy went to see Burns' family in August 1803, but found they were away. Dorothy, whose *Scottish Tour* [Cat. no. 107] has

much of the quality of her famous Grasmere *Journal*, tells of their visit to the churchyard:

> We looked at the grave with melancholy and painful reflections, repeating to each other his own verses—
>
> > Is there a man whose judgment clear
> > Can others teach the course to steer,
> > Yet runs himself life's mad career
> > > Wild as the wave?
> > Here let him pause, and through a tear
> > > Survey this grave.

Hazlitt commented that he "would rather have written one song of Burns" than all the epics of Scott. He would have had the Wordsworths on his side, yet been in a small minority. The *Edinburgh Review* for August 1810 commented in an essay on Scott's *Lady of the Lake*:

> We are reliably informed that nearly thirty thousand copies of *The Lay of the Last Minstrel* have already been disposed of in this country, and that the demand for *Marmion* and the poem now before us has been still more considerable.

Until displaced in 1813–1814 by the Eastern tales of Byron—*The Giaour, The Bride of Abydos, The Corsair, Lara*—Scott's romances of medieval Scotland were the most popular poetry of the day. Thinking in political terms, Hazlitt regarded them as backward-looking, and counter to the spirit of the age. The best of the *Waverley Novels* are very different. Though hardly "carried along by the revolutionary movement," they present a view of history which lifts them above the level of romance. Scott is to be

39. J. M. W. Turner,
Sir Walter Scott's House,
No. 39 Castle Street, Edinburgh,
c. 1836 [Cat. no. 100]

seen making a reconciliation between modern Scotland and the (quite recent) Jacobite past of the 1715 and 1745 Rebellions.

Byron's relationship to politics, and to his age, was altogether more equivocal. In his maiden speech in the House of Lords in February 1812, he chose to attack the government for taking new powers to crush the Luddite weavers of Nottingham:

> Are there not capital punishments enough in your statutes? Is there not blood enough upon your penal code, that more must be poured forth to ascend to Heaven and testify against you? Are these the remedies for a starving and desperate populace? Will the famished wretch who has braved your bayonets be appalled by your gibbets? . . .

The Lords can seldom have heard a more impassioned denunciation of government policy. Byron was deliberately classing himself as an extreme radical, a friend to the factory hands who in defence of their jobs were breaking up power-looms in the Midlands and the North of England.

Despite his rhetorical tones, and a wish to play up the drama of the occasion, his feelings were genuine. Two days before his speech he had written to Lord Holland: "My own motive for opposing the bill is founded upon its palpable injustice. I have seen the state of these miserable men, and it is a disgrace to a civilized country."

Less than a fortnight after Byron's maiden speech came the publication of *Childe Harold* (Parts One and Two), a verse narrative of his travels in Spain, Portugal, Greece, and Turkey during 1809–1811. The first edition, of five hundred copies, sold out in three days. Byron, who, despite the success of his *English Bards and Scotch Reviewers* (1809), was very little known, became famous overnight. He also became sought after by the most attractive titled women of Regency London. His affair with Lady Caroline Lamb was the talk of the town; Lady Oxford followed, and then the titillating (but also companionable) relationship with his half-sister, Augusta Leigh, who was five years older than him, and mother of three.

40. Lord Byron,
Don Juan, 1818 [Cat. no. 55].
Original manuscript of Byron's ironic
"Dedication" to the
Poet Laureate, Robert Southey;
suppressed before publication

Finally, in January 1815, he turned to marriage, which had always seemed inevitable as a means of paying off debts, and which might also protect him from rumours and past mistresses. The effect was to bring out in him a cruelty that bordered on madness. Annabella Milbanke, who was an accomplished mathematician as well as an heiress, was subjected to unpredictable fits of rage, tormented with allusions to incest, humiliated in many different ways. After a year she left her husband, and in April 1816 Byron left England, never to return. Almost his last action was to have printed the poignant lines of *Fare Thee Well*:

> Every feeling hath been shaken;
> Pride, which not a world could bow,
> Bows to thee—by thee forsaken,
> Even my soul forsakes me now. . . . (lines 49–52)

The manuscript [Fig. 41] is blotted with tears. The poet's contemporaries were not convinced of his sincerity, but there were no doubt many and complex emotions involved.

From this restless, extravagant way of life emerged a poetry to match. "Lord Byron's earlier productions, *Lara*, *The Corsair*, etc.," Hazlitt comments,

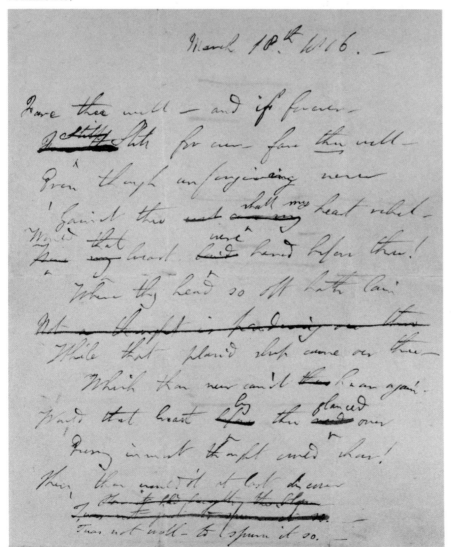

41. Lord Byron, *Fare Thee Well*, March 1816 [Cat. no. 57]

were wild and gloomy romances, put into rapid and shining verse. . . . sullen, moody, capricious, fierce, inexorable; gloating on beauty, thirsting for revenge, hurrying from the extremes of pleasure to pain, but with nothing permanent, nothing healthy or natural.

Beneath these concluding references to the permanent and natural there is the implicit comparison to Wordsworth. It is no longer possible, however, to decide with Hazlitt that Wordsworth was "a pure emanation of the Spirit of the Age," and Byron some form of alien. In many ways they seem to be at opposite poles: Byron, aristocratic, profligate, cosmopolitan, larger than life in everything he does; Wordsworth, content to spend his days in the Lake District, given to writing about shepherds and mountains rather than bull-fights, bloodshed, or romantic love. Yet it is between these two poles that the age must be defined.

For Byron, poetry is "the lava of the imagination whose eruption prevents an earthquake;" for Wordsworth, it is "the spontaneous overflow of powerful feelings." Take away the bravado from the first, and the statements are essentially similar. The two poets work within different social contexts, and write in different idioms, yet both value above all the power of imagination, and the grandeur of the mind. Manfred [Fig. 42], among the heroes of Byron—

42. John Martin, *Manfred on the Jungfrau*. 1837 [Cat. no. 85].
"Farewell, ye opening heavens"
—Manfred, about to leap to his death, is restrained by a chamois hunter

> The mind, which is immortal, makes itself
> Requital for its good or evil thoughts,
> Is its own origin of ill, and end,
> And its own place and time . . . (III. iv. 129–132)

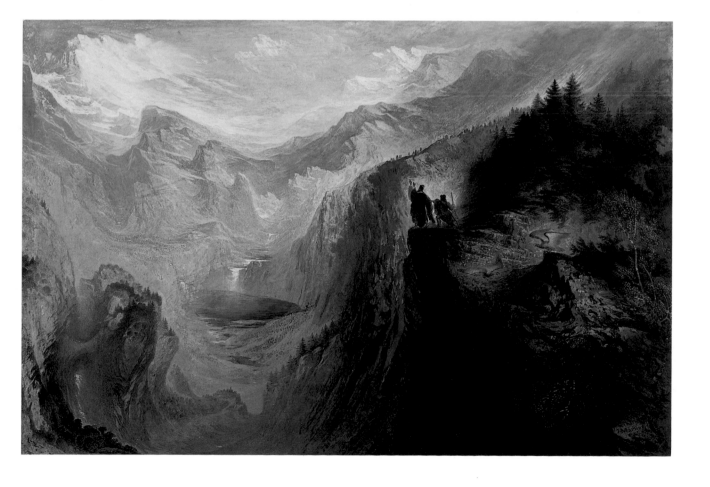

—is no less an exaltation of human potential than the Wordsworthian "egotistical sublime." "Give me a republic," Byron wrote in his *Journal* of November 1814,

> look in the history of the earth—Rome, Greece, Venice, France, Holland, America, our own short . . . Commonwealth—and compare it with what they did under masters. . . . To be the first man (not the dictator—not the Sylla, but the Washington or the Aristides), the leader in talent and truth, is next to the Divinity.

Ten years later Byron was to die at Missolonghi, seeking to be "the leader in talent and truth," and to bring back to Greece its republican independence.

As the heir to a baronetcy, educated at Eton and Oxford, Shelley came closest among contemporary writers to being Byron's social equal. Others, like Thomas Moore (author of the fashionable *Irish Melodies*, 1807) and Samuel Rogers (distinguished chiefly for *The Pleasures of Memory*, 1792), were able to move in London society, but Shelley could have done so as of right. From the first he chose not to. Byron never forgot, or allowed others to forget, that he was a nobleman; he flouted conventional values, but did so from a position of arrogant superiority. Shelley, by contrast, set himself up as a democrat and free-thinker. In March 1811 he was sent down from Oxford for his pamphlet *The Necessity of Atheism*, and in August he eloped with Harriet Westbrook, who was just sixteen, and whom he told himself he was rescuing from paternal tyranny. In 1812, while Byron was proclaiming his liberal sympathies to the House of Lords, Shelley was working (in Ireland and Wales as well as England) on schemes to educate the lower classes. He was only nineteen, and the terms in which he defined his political objectives changed very rapidly; but the commitment was genuine. In Dublin he printed *An Address to the Irish People*, talked of republishing Paine (which had been illegal for the past twenty years), and made an impassioned speech to the Committee for Catholic Emancipation, which was the nearest thing he could find to the United Irishmen, whose rebellion under Wolf Tone had been suppressed in 1798. "It is horrible," he wrote in the *Address*,

43. Antoine-Philippe D'Orléans, *Percy Bysshe Shelley as a Boy*, c. 1802–1804 [Cat. no. 87]

> that the lower classes must waste their lives and liberty to furnish means for their oppressors to oppress them still more terribly. It is horrible that the poor must give in taxes what would save them and their families from hunger and cold. . . .

Among the pieces of radical propaganda that Shelley had printed in Dublin was a *Declaration of Rights*, to be distributed as a broadsheet or poster. Thirty-one rather miscellaneous "rights" were listed. Though its tone is closer to Blake, number 27 recalls Wordsworth's *Letter to the Bishop of Llandaff* (1793) in its Painite denunciation of titles:

> No man has a right to be respected for any other possessions but those of virtue and talents. Titles are tinsel, power a corrupter, glory a bubble, and excessive wealth a libel on its possessor.

Ironically, when the *Declaration* found its way into the hands of the Home Office, the position of Shelley's grandfather as a titled member of the Whig

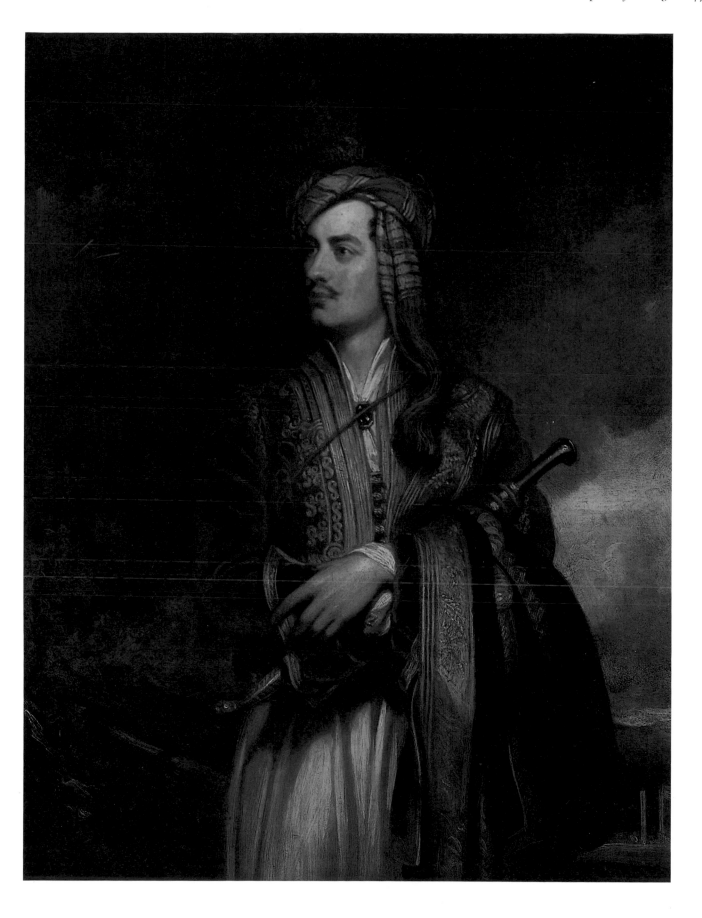

44. Thomas Phillips, *Lord Byron in Arnaout Costume* [Cat. no. 88].
Artist's copy of portrait made four years after Byron bought the costume at Epirus in 1809

aristocracy was one of the factors that saved him from prosecution. Another may have been the means of distribution adopted by the Shelley ménage. Faithfully documented by informers, these included floating copies out from the Devonshire coast in bottles and toy boats, and sending them up in homemade hot-air balloons. The more practical expedient of having them taken round by the Shelleys' Irish servant led to his being imprisoned for six months.

Shelley never lost his ideals, but despite the hot-air balloons there was a practical side to his nature. He was quick to learn from experience. Within weeks of arriving in Ireland he could describe the Dublin poor as "one mass of animated filth"—and add the self-knowing comment: "These were the persons to whom in my fancy I had addressed myself!" In 1813 he decided that *Queen Mab*, with its vehement denunciations of Christianity, should be directed, not to the people, but to the children of aristocrats, who could be shown how to use their future power. As a disciple of William Godwin (with whose daughter, Mary, he was soon to elope), he was convinced that if he could find the right people they would listen, but he seemed to have no natural audience. It was Wordsworth's view that poets who were truly revolutionary had to create the taste by which they were enjoyed. When Shelley died at the age of twenty-nine, he had written major poems of many different kinds—some overtly political (*Queen Mab, The Revolt of Islam, The Mask of Anarchy*), others aspiring to a philosophy of mind (*Alastor, Mont Blanc, Prometheus Unbound, Adonais*)—but the true audience for his work had yet to emerge.

By their early deaths the second-generation Romantics were at least relieved from the possibility of decline, or political collusion. As Poet Laureate, Southey was most vulnerable to the charge of being a turncoat, but Coleridge fought hard to deny his Jacobin earlier self, and Wordsworth, by accepting a minor civil service job from Lord Lonsdale, laid himself open to Shelley's reproachful sonnet of 1816:

> In honoured poverty thy voice did weave
> Songs consecrate to truth and liberty—
> Deserting these, thou leavest me to grieve,
> Thus having been, that thou shouldst cease to be.
>
> (lines 11–14)

Shelley's sense of betrayal serves to show how much Wordsworth's earlier poetry still meant for him.

During a period of six weeks beside Lake Geneva in summer 1816 (memorable also for Mary Shelley's *Frankenstein* [Fig. 45], which, thanks to the cinema, is more famous than any poem of the age), Shelley not only wrote *Mont Blanc* as a sequel to *Tintern Abbey*, but, according to Byron, "dosed [him] with Wordsworth." *Childe Harold*, Canto Three [Cat. no. 54 and Fig. 163] was the result:

> I live not in myself, but I become
> Portion of that around me, and to me
> High mountains are a feeling. . . . (st. 72)

It was not a vein that Byron could permit himself for long. Written three years later, the brilliantly witty account of first love in *Don Juan* [Fig. 40] is

45. Mary Shelley.
Frankenstein; or, the Modern Prometheus,
1818 [Cat. no. 91]. First edition,
with the author's manuscript revisions,
concerning the monster's education
and his rejection by mankind

a corrective for anyone who may have seen the poet in his unguarded
moment of Wordsworthian seriousness:

> Young Juan wandered by the glassy brooks
> Thinking unutterable things. . . .

(Canto I, st. 90)

Wordsworth is twice mentioned by name, but it is Coleridge whose thirst
for knowledge is mocked in the funniest stanza of all:

> He thought about himself, and the whole earth,
> Of man the wonderful, and of the stars
> And how the deuce they ever could have birth;
> And then he thought of earthquakes and of wars,
> How many miles the moon might have in girth,
> Of air-balloons, and of the many bars
> To perfect knowledge of the boundless skies—
> And then he thought of Donna Julia's eyes. (st. 92)

The feelings of Romantic wonderment which Byron could seldom
permit himself to express, and which he specially enjoyed debunking in
others, find their perfect expression in the life and poetry of Keats. "Then
felt I like some watcher of the skies," he wrote in the famous sonnet *On
First Looking into Chapman's Homer* [Fig. 46]:

> When a new planet swims into his ken,
> Or like stout Cortez, when with eagle eyes
> He stared at the Pacific, and all his men
> Looked at each other with a wild surmise—
> Silent upon a peak in Darien. (lines 10–14)

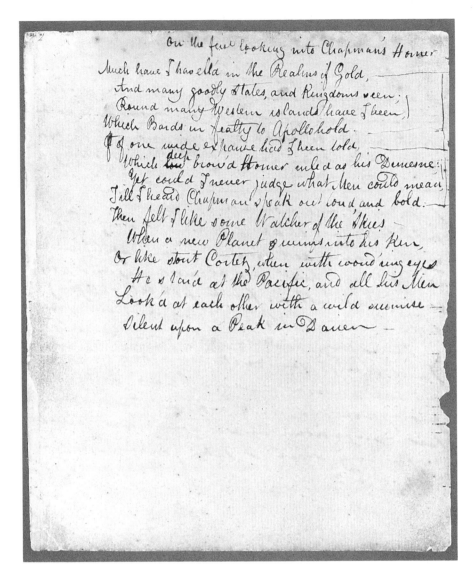

46. John Keats,
On First Looking into Chapman's Homer,
1816 [Cat. no. 80].
Probably the original manuscript sent
by Keats to Clarke

The date was October 1816; Keats was not quite twenty-one. A month later he tells us of the "discoverers" of his own day. *Great Spirits Now on Earth Are Sojourning* celebrates Wordsworth—"He of the cloud, the cataract, the lake"—alongside Leigh Hunt and the historical painter Benjamin Robert Haydon [see Cat. no. 73]. Hunt—

> He of the rose, the violet, the spring,
> The social smile, the chain for freedom's sake . . .
>
> (lines 5–6)

—was author of *The Feast of the Poets* (1815) [Cat. no. 76] and an uneasy influence on Keats' own poetic style. He was also something of a martyr, having spent two years in prison for calling the Prince Regent "a violator of his word, a libertine over head and ears in disgrace" (which was true, but not tactful). Haydon was at this time working on his immense canvas of *Christ's Entry into Jerusalem*, in which Keats and Wordsworth feature in the crowd as representatives of the age—"great spirits" who are privileged to be witnesses of a timeless apocalyptic event.

Three years later, Keats described his philosophy of history to George and Georgiana, his brother and sister-in-law, who had gone to live in

47. Benjamin Robert Haydon,
John Keats, 1816 [Cat. no. 73].
Pen and ink sketch made when Haydon
was at work on *Christ's Entry into Jerusalem*,
in which Keats and Wordsworth
appear as onlookers

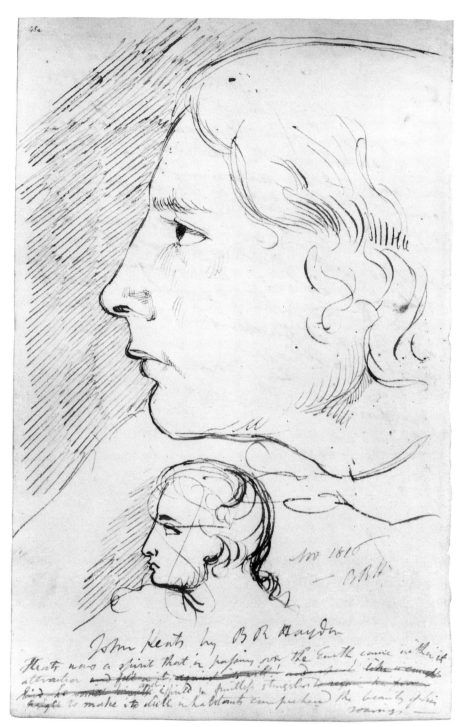

Louisville, Kentucky: "All civilized countries become gradually more enlightened, and there should be continual change for the better." This, however, is intermittent. "Liberal writers of France and England sowed the seed of opposition," which

> burst out in the French Revolution. That has had an unlucky termination. It put a stop to the rapid progress of free sentiments in England, and gave [the] Court hopes of turning back to the despotism of the sixteenth century. They have made a handle of this event in every way to undermine our freedom.

Like his more obviously political contemporaries, Keats assumes that it is in the power of liberal writers to sow "the seed of opposition." He was

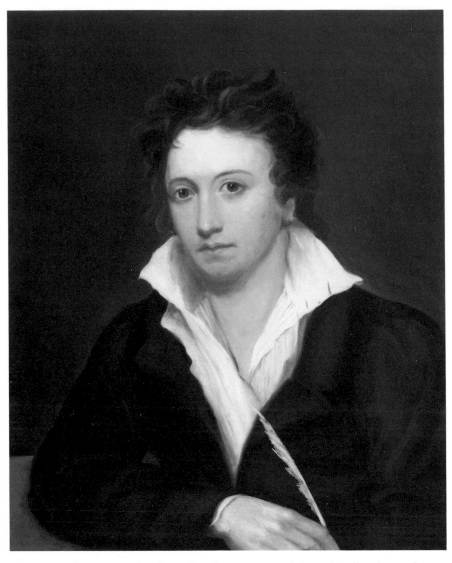

48. Shelley aged twenty-six,
by Alfred Clint after Amelia Curran
[Cat. no. 58]

writing only a month after the "Massacre of Peterloo," when eleven people were killed and 421 seriously injured as government forces arrested the speaker at a protest meeting in St. Peter's Field, Manchester.

Shelley's response, when he heard the news at Leghorn in Italy, was not so measured: "the torrent of my indignation has not yet done boiling in my veins. I await anxiously to hear how the country will express its sense of this bloody murderous oppression." Within a fortnight he had written *The Mask of Anarchy*, and posted it off to Hunt to be printed in *The Examiner*. Cast in the form of a dream, or pageant, it is a strange and highly impressive expression of Shelley's indignation. Anarchy's representatives are ministers of the Tory government:

> I met Murder on the way
> (He had a mask like Castlereagh),
> Very smooth he looked, yet grim;
> Seven bloodhounds followed him.
>
> All were fat, and well they might
> Be in admirable plight,
> For one by one, and two by two,
> He tossed them human hearts to chew. . . . (lines 5–12)

Nor is the poem impressive merely as satire. At its centre is the figure of Hope—allegorical, yet clearly based on a woman whose child had been trampled to death beneath the horses at Peterloo. Her message of encouragement contains the threat of mass revolution:

> Rise like lions after slumber
> In unvanquishable number—
> Shake your chains to earth like dew
> Which in sleep had fallen on you—
> Ye are many, they are few!

<div align="right">(lines 151–155, 368–372)</div>

Hunt received the poem in London, but had no wish to return to prison; *The Mask* did not appear until 1832, the year of the Reform Bill. Sentences on those who did publish their protests were especially harsh where—like Shelley—they had attempted to reach the people. For expressing the spirit of the age too vehemently, one pamphleteer from Macclesfield served four and a half years in chains. Real chains.

 He would not have known it, but while he was in jail, Keats, Shelley, and Byron died in succession. Keats, who had nursed his brother Tom through the same disease, and who, as a medical student, knew far too much about his own symptoms, died at Rome from tuberculosis in February 1821. He was twenty-five. In the single year of 1819 he had written some of the finest and best-loved English poetry: *The Eve of St.*

49. John Keats, *Ode on Melancholy*, 1819 [Cat. nos. 77 and 78]. The two leaves of Keats' fair-copy manuscript, brought together for the exhibition after being separated for 167 years

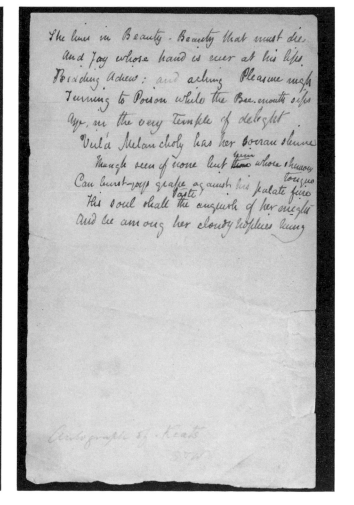

Agnes and *Lamia*, together with the great odes *To a Nightingale*, *On a Grecian Urn*, *On Melancholy* [Fig. 49], and *To Autumn*. Shelley, whose own recent poetry included *Ozymandias* and *Ode to the West Wind*, responded to Keats' death in *Adonais* [Fig. 50] with lines of apocalyptic power:

> The One remains, the many change and pass;
> Heaven's light forever shines, Earth's shadows fly:
> Life, like a dome of many-coloured glass,
> Stains the white radiance of Eternity
> Until Death tramples it to fragments.

> (lines 460–464)

Keats is now "a portion of the loveliness / Which once he made more lovely." In the concluding stanza Shelley is drawn into thoughts of his own death, and of union beyond the grave:

> The breath whose might I have invoked in song
> Descends on me; my spirit's bark is driven
> Far from the shore. . . .
> I am borne darkly, fearfully, afar. . . .

> (lines 487–492)

Shelley's lines, with their imagery of storms at sea, took on a strangely prophetic air when, the following July, his new yacht—the *Don Juan*—

went down in heavy seas off Viareggio. Shelley, it is said, refused even to furl the sails. Back in Lerici, he had been at work on an allegorical poem named *The Triumph of Life* [Fig. 51]. The manuscript is decorated with sketches for the rigging of his boat, and on the final page he had drafted a question that would have to remain unanswered: "'Then, what is life?' I said." In his pocket, when his body was finally washed ashore, was a copy of Keats' *Poems* of 1820. Byron was present as the corpse was cremated on the beach to conform with quarantine regulations. "Are we to resemble that," he had asked the previous day, at the cremation of Shelley's companion, Williams; "what a nauseous and degrading sight!" His own death two years later, in April 1824, was to be similarly pointless. Having raised troops to fight for Greek independence in a revolutionary war against the Turks, he died, not in battle, but at the hands of a doctor, who believed that marsh fever could be cured by repeated bleeding.

Hazlitt, by chance, was in the midst of writing about Byron when the news of his death reached England. "Death cancels everything but truth," he commented memorably,

> and strips a man of everything but genius and virtue. It is a sort of natural canonization. It makes the meanest of us sacred; it installs the poet in his immortality, and lifts him to the skies. . . . Lord Byron is dead: he . . . died a martyr to his zeal in the cause of freedom, for the last, best hopes of man. Let that be his excuse and his epitaph!

Forty-seven carriages followed Byron's coffin from London to the family vault at Newstead Abbey, but most were empty—sent by titled "mourners" who did not wish to associate themselves too closely with his reputation. Among his fellow poets, Moore, Rogers, and Thomas Campbell were present. On its way the procession passed Mary Shelley's house in Highgate. "Connected with him in a thousand ways," she wrote,

> admiring his talents, and (with all his faults) feeling affection for him, it went to my heart when . . . the hearse that contained his lifeless form— a form of beauty which in life I often delighted to behold—passed my window going up Highgate Hill on his last journey. . . .

Byron was thirty-six when he died. It is tempting to see his death, and the publication of *The Spirit of the Age* the following year, as the end of an epoch of brilliant young writers that had begun with the suicide of Thomas Chatterton in 1770, the year of Wordsworth's birth. As forger, poet, prodigy, Chatterton became a myth when he took arsenic at the age of seventeen. Wordsworth was not alone in linking him with Burns:

> I thought of Chatterton, the marvellous boy,
> The sleepless soul that perished in its pride;
> Of him who walked in glory and in joy
> Behind his plough upon the mountain-side.
>
> (*The Leech Gatherer*, 43–46)

"We poets in our youth begin in gladness," he adds, "But thereof comes in the end despondency and madness." It was an ominous statement. At

50 (*far left*). Percy Bysshe Shelley, *Adonais. An Elegy on the Death of John Keats*, 1821 [Cat. no. 93]

51 (*left*). Percy Bysshe Shelley, *The Triumph of Life* [Cat. no. 95]. Final leaf of the manuscript on which Shelley was working at the time of his death, 8 July 1822

the age of thirty-two, Wordsworth had sensed that if the Romantic poet did not die young, his creativity might die within him. In Blakean terms, he was the product of energy—the energy that Wordsworth himself had seen released in the dawn of revolution. Keats' early death, following upon Chatterton's, could be seen as establishing a tragic ideal. On the back of the portrait he made in 1816, Haydon added a moving later inscription:

> Keats was a spirit that in passing over the earth came within its attraction, and expired in fruitless struggles to make its dull inhabitants comprehend the beauty of his soarings.

Romantic painters, like the writers of prose, belong in general to a different pattern. The great exceptions are John Robert Cozens, who suffered a complete breakdown in 1793, at the age of forty-one, and died four years later, and Thomas Girtin, who died in 1802, aged twenty-seven. "Cozens was all poetry," Constable remarked in 1820, and fifteen years later he was to write: "I want to know when the younger Cozens was born . . . he was the greatest genius that ever touched landscape." Turner's famous comment—"If Tom Girtin had lived, I should have starved"—is perhaps apocryphal. More significant (as well as better substantiated) is Turner's singling out of Girtin's masterpiece, *White House at Chelsea* [Fig. 175], as superior to anything he himself had achieved at the time. In their imaginative response to landscape, Cozens and Girtin were never excelled, but Constable and Turner in the course of their much longer lives both achieved revolutions in technique which they had not envisaged.

Like Wordsworth, Constable was never a popular success. Byron's editions sold in thousands, Wordsworth's never went beyond 500; Wilkie had far more commissions than he could handle, Constable is thought to have sold fewer than a hundred landscapes during his lifetime, leaving 750 to his heirs (plus 1,100 watercolours and drawings). Yet the rootedness which he shares with Wordsworth makes him a central figure of his age, as well as a profound and lasting influence. Thinking of the fashionable scenes of Italy, he wrote:

> I was born to paint a happier land, my own dear old England, and when I cease to love her, may I, as Wordsworth says, "never more hear / Her green leaves rustle, or thy torrents roar."

The torrents in his quotation from the *Thanksgiving Ode* must have reminded him of his Lake District tour of 1806, but he later confessed that "the solitude of mountains oppressed his spirits." More than half the plates in his *English Landscape Scenery* (1830–1832) [Cat. no. 65] were of the rich farming-land of Dedham Vale, his birthplace on the Suffolk-Essex border.

Ironically, it was the French who were first to notice the genius of this most English of painters. In 1821 *The Hay Wain* was singled out by French critics at the Royal Academy, and admired especially by Théodore Géricault, who was in England displaying his Byronic *Raft of the Medusa*. As a result, Constable's picture was borrowed, together with *View on the Stour*, for the Paris Salon of 1824, and awarded a gold medal by the

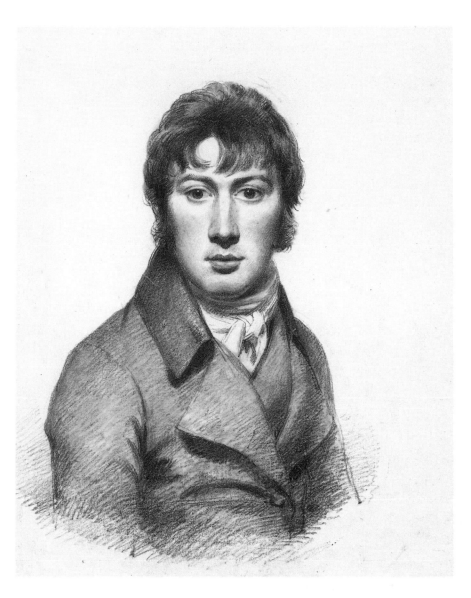

52. John Constable, *Self-Portrait*
aged about twenty-four [Cat. no. 64]

French king. Géricault—most tragic and gifted of French Romantic artists—had died, but Eugène Delacroix was inspired by Constable's ability to bring light into his canvases. The use of broken tints in *The Hay Wain* to enliven the colour, and give texture to the paint, led Delacroix to rework sections of his own Salon exhibit. The following year he visited Constable in England, probably seeing in the artist's studio the vivid full-sized oil sketches of both *The Hay Wain* and *The Leaping Horse*. Years later he was to recall:

> Constable says that the superiority of the green of his meadows comes from its being composed of a multitude of different greens. The lack of intensity and life in the foliage of most landscape paintings arises because they usually paint them with a uniform tone.

Among the great French painters to be influenced by Constable were Théodore Rousseau, Jean François Millet, and Eugène Boudin, but his technique was in fact distinct from that of the Impressionists; Camille Pissarro recorded in old age that it was Turner whom he and Claude Monet had admired. The quality he had in mind was superbly described by John Ruskin, who knew Turner as no one else has ever known him:

Turner only would give the uncertainty; the palpitating, perpetual change; the subjection of all to a great influence, without one part or portion being lost or merged in it; the unity of action with infinity of agent. And I wish to insist on this the more particularly, because it is one of the eternal principles of Nature that she will not have one line or colour, nor one portion or atom of space, without a change in it. There is not one of her shadows, tints, or lines, that is not in a state of perpetual variation. I do not mean in time, but in space.

Constable was never static, but he used the movement of tint and texture to build towards a sense of the abiding—the qualities in human experience "Which, having been, must ever be." Though no less concerned with "the eternal principles of Nature," Turner was pushing constantly towards Shelley's intuition that "the deep truth is imageless."

In his *Liber Studiorum*, published 1807–1819 [Cat. no. 99], Turner invites comparison with the *Liber Veritatis* ("Book of Truth") of Claude Lorraine. In doing so, he places himself and English landscape painting within the larger, more prestigious, European context, and at the same time defines his own Romantic art against the Italianate tradition of the picturesque. Claude more than any other painter had dominated eighteenth-century British assumptions about how to see the natural world. Through his plates, Turner was reaching out to the wider public that could not be reached through his oils, distinguishing for them the categories of landscape art, creating the taste by which (much later) he would come to be enjoyed. Like Wordsworth, and other poets of the day, he refused to be bound by "the chains of fact and real circumstance."

In his famous comments on "gusto," Hazlitt applies the term only to artists of the past. "Titian's landscapes have a prodigious gusto, both in colouring and forms." In *Diana and Actaeon*,

> The winds seemed to sing through the rustling branches of the trees, and already you might hear the twanging of bows resound through the tangled mazes of the wood.

Hazlitt identified Turner as "the ablest landscape painter now living" in 1815 (a quarter of a century before Ruskin's *Modern Painters*), but he died in 1830, before the astonishing advances of Turner's final period. The criticisms of Claude, however—"his eye wanted imagination"—show us the terms in which such masterpieces as the *Valley of Aosta* (*c*.1836–1837) [Fig. 185] would surely have been praised:

> Claude's landscapes, perfect as they are, want gusto. This is not easy to explain. They are perfect abstractions of the visible images of things . . . but they lay an equal stress on all visible impressions. They do not interpret one sense by another; they do not distinguish the character of different objects as we are taught, and can only be taught, to distinguish them by their effect on the different senses. That is, his eye wanted imagination: it did not strongly sympathize with his other faculties. He saw the atmosphere, but he did not feel it.

Turner saw, and felt, and painted, the atmosphere with a gusto that is one of the highest achievements of the spirit of his age.

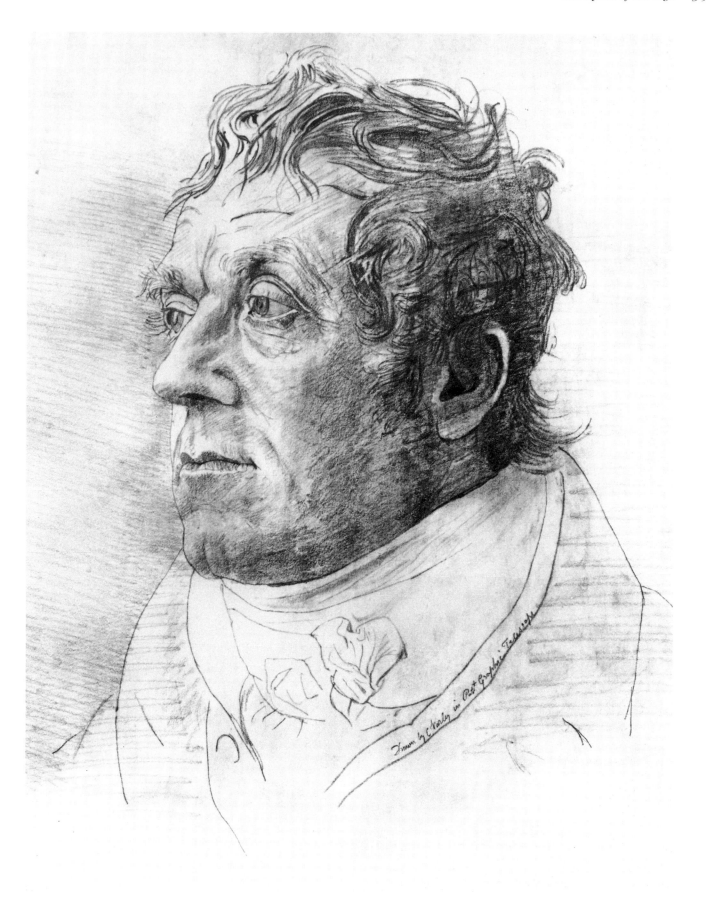

53. Cornelius Varley, *J. M. W. Turner* [Cat. no. 103]. Made *c.* 1815
with the aid of a "Graphic Telescope," which threw an outline onto the artist's paper

My heart leaps up when I behold
 A rainbow in the sky:
So was it when my life began,
So is it now I am a man,
So be it when I shall grow old,
 Or let me die!
The child is father of the man;
And I could wish my days to be
Bound each to each by natural piety.
 (William Wordsworth, *The Rainbow*)

3 "The Child Is Father of the Man"

The nine lines of *The Rainbow* are a microcosm of the Wordsworthian world. Composed in 1802 at the mid-point of Wordsworth's Great Decade, the poem is deceptively simple. Childhood is the foundation of later human experience. Wholeness and unity depend upon our continuing to respond feelingly to the natural world. In Blakean terms, we must be able to carry the vision of Innocence forward into the years of Experience. The rainbow offers for Wordsworth a beautifully appropriate symbol, linking past, present, and future, and linking also the twin ideals of his poetry: imagination and a benevolent Nature, source of inspiration and sensual largesse. The poet is reaching back into childhood as the first stage in his quest for the unity of self.

The very pattern of *The Rainbow* is typical of Wordsworth. The poem begins with an experience which we have all of us shared—an instinctual response which (in Keats' memorable phrase) shows "the holiness of the heart's affections." The poet's initial wonderment then gives place to reflection, and the ordinary comes to be seen as a kind of revelation. This particular revelation has the authority of Christian tradition. "I do set my bow in the cloud," God says to Noah after the Flood,

> and it shall be for a token of a covenant between me and the earth.
> And it shall come to pass, when I bring a cloud over the earth, that the bow shall be seen in the cloud.

For Wordsworth, the biblical symbol of God's covenant becomes the symbol of a covenant with Nature. "Heaven lies about us in our infancy," he wrote in the *Ode* (*Intimations of Immortality*), "Shades of the prison-house begin to close / Upon the growing boy." The process of aging, which is God's cloud over the earth, cannot be avoided; but in the rainbow, Nature holds up to man the possibility of sustaining the vision of childhood. Failure to do so breaks the link that makes life whole. Hence the central repetition, and central drama of the poem:

> So was it when my life began,
> So is it now I am a man,
> So be it when I shall grow old,
> Or let me die!

"So was," "So is," "So *be*"—past and present give way to thoughts of the future. We are carried by the parallel phrasing imperceptibly into the language of prayer. Death is preferable to the loss of imaginative response, which is itself a kind of death.

Among contemporary readers, no one would have understood Wordsworth's act of "natural piety" better than Constable. He copied out

54. John Constable,
Landscape and Double Rainbow,
1812 [Cat. no. 131]

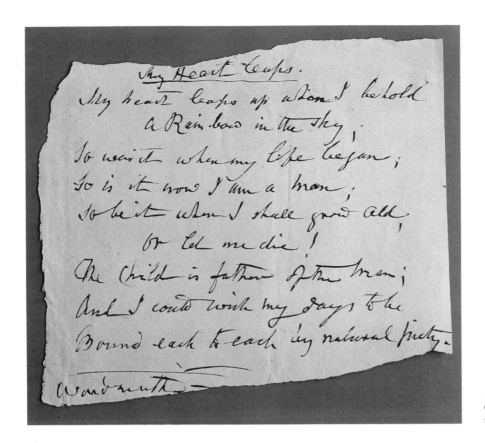

55. William Wordsworth, *The Rainbow*,
copied out by Constable
towards the end of his life [Cat. no. 140]

The Rainbow for himself around 1830 [Fig. 55], but had been fascinated
by the subject throughout his life. In the rapid oil sketch of July 1812,
Landscape and Double Rainbow [Fig. 54], the bow shoots from the deepest of
blue skies, dominating and illuminating the trees in the foreground. In
the right-hand corner is a windmill, a reminder that Constable's father
owned the windmill at East Bergholt as well as the watermills of Flatford
and Dedham. This was the familiar scenery of his childhood. Six days
before painting *Landscape and Double Rainbow*, Constable had written to
his future wife, Maria Bicknell:

> How much real delight I have had with the study of landscape this
> summer. Either I am myself much improved in "the art of seeing
> Nature" (as Sir Joshua Reynolds calls painting) or Nature has unveiled
> her beauties to me with a less fastidious hand.

A month later he wrote (a little provocatively, considering that the letter
was again to Maria), "Landscape is my mistress; 'tis to her I look for fame,
and all that the warmth of imagination renders dear to man."

Though their lives intersect at a number of points, Constable and
Wordsworth never came to know each other well, and they seem not at
first to have recognized any affinity. At their meeting in the Lake District
in 1806, Wordsworth, who had recently completed *The Prelude*,
described to Constable the intensity of his imaginative experience as a
boy. To judge from comments in Joseph Farington's *Diary*, this was not a
success:

> Constable remarked upon the high opinion Wordsworth entertains of
> himself. He told Constable that while he was going to Hawkshead

School his mind was often so possessed with images, so lost in extraordinary conceptions, that he has held by a wall, not knowing but he was part of it.

Later the two men met on different occasions through Sir George Beaumont, patron of the arts, and founder of the National Gallery in London. Their kinship, however, does not depend on biographical connections. Constable may not have been impressed by Wordsworth's "extraordinary conceptions," yet both of them traced the sources of their creative power to childhood spent in a particular landscape; both saw their identity as rooted in a particular place. Dedham Vale, with its rich pasture and winding River Stour, was as important to the one as mountains, torrents, and lakes were to the other. Differences in their mental landscape matter far less than the sharing of assumptions and emotional experience. "The reader cannot be too often reminded that poetry is passion," Wordsworth writes in his note to *The Thorn*; "it is the history or science of feelings." "I should indeed have delighted in seeing what you describe," Constable assures his friend Archdeacon Fisher, "but I should paint my own places best. Painting is but another word for feeling." To which he adds, "I associate my 'careless boyhood' to all that lies on the banks of the Stour. They made me a painter, and I am grateful."

When Wordsworth, in 1800, alluded to poetry as the "*science* of feelings," the term was in the process of acquiring its modern meaning. Derived originally from Latin *scientia*, "knowledge," it had evolved to describe the branch of learning that was chiefly associated with progress and the enquiring spirit of the age. To Coleridge it seemed that Humphry Davy might, as a chemist, solve the riddle of the universe. Wordsworth was more concerned with the changing role of poetry. The poet of the future, he tells us in the 1802 Preface to *Lyrical Ballads*,

> will be ready to follow the steps of the man of science . . . carrying sensation [feeling] into the midst of the objects of the science itself. The remotest discoveries of the chemist, the botanist, or mineralogist, will be as proper objects of the poet's art as any on which it can be employed. . . .

None of this can happen, however, until the discoveries of science become "material to us as enjoying and suffering beings"—until science is "ready to put on, as it were, a form of flesh and blood."

It was Newton [Fig. 57] above all who seemed to bar this possibility. To Blake he is a Urizenic figure, one who denies the spiritual dimension, measures out existence with mathematical precision [Fig. 58]. To Coleridge, for whom "all truth is a species of revelation," he is "a mere materialist": "Mind in his system is always passive, a lazy looker-on at an external world." Keats puts his views succinctly in *Lamia*—

> There was an awful rainbow once in heaven:
> We know her woof, her texture—she is given
> In the dull catalogue of common things . . .
>
> (lines 231–233)

56. John Constable,
Cenotaph to Sir Joshua Reynolds amongst Lime Trees in the Grounds of Coleorton Hall, 1823 [Cat. no. 63].
Monument erected by Sir George Beaumont with an inscription by Wordsworth (copied on the back of Constable's drawing)

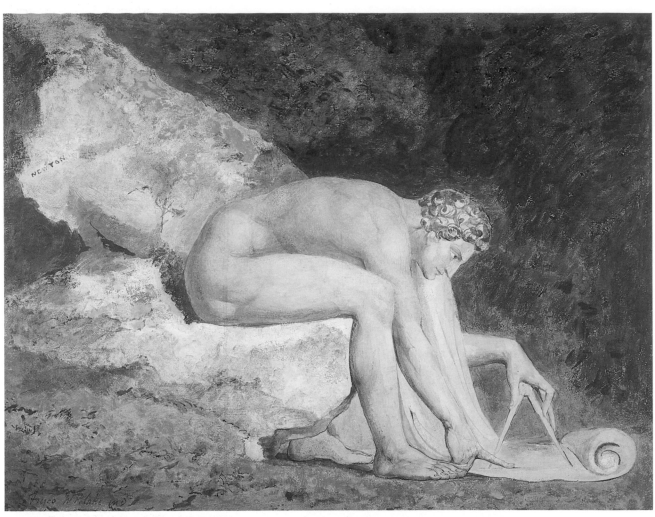

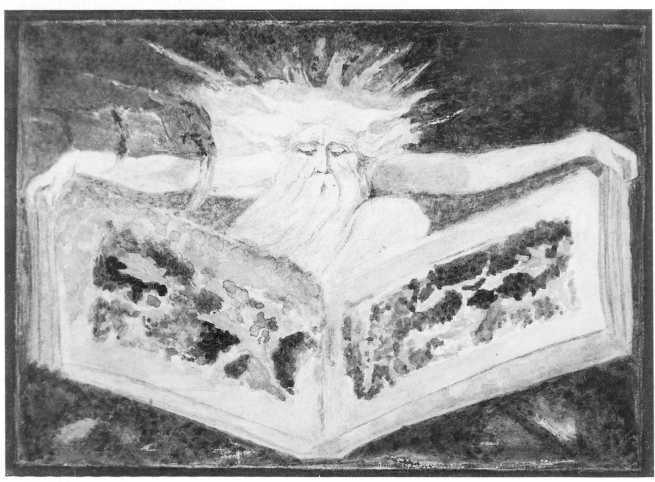

—and goes on to make them clearer still at the "Immortal Dinner" of December 1817, in the presence of Wordsworth, Haydon, and Lamb. "Do you remember Keats'," Haydon asks Wordsworth in 1842 [Cat. no. 133],

> proposing "Confusion to the memory of Newton!" and on your insisting on an explanation before you drank it, his saying, "Because he destroyed the poetry of the rainbow by reducing it to a prism."

As a painter, concerned with representing "the poetry of the rainbow" in colour, Constable was unlikely to be so scornful of Newton and the *Opticks* [Fig. 59], yet he came to very similar conclusions: "It is the soul that sees." His work is consistently informed by study of the natural world. In his sketch-books, cloud studies, oil sketches, we can see him

57 (*left*). William Blake, *Newton*, c. 1795 [Cat. no. 126]

58 (*below left*). William Blake, *Urizen*, c. 1795 [Cat. no. 127]

59 (*right*). Sir Isaac Newton, *Opticks*, first edition of 1704, with fold-out diagram of a rainbow [Cat. no. 134]

60 (*below*). John Constable, *London from Hampstead, with a Double Rainbow*, 1831 [Cat. no. 218]

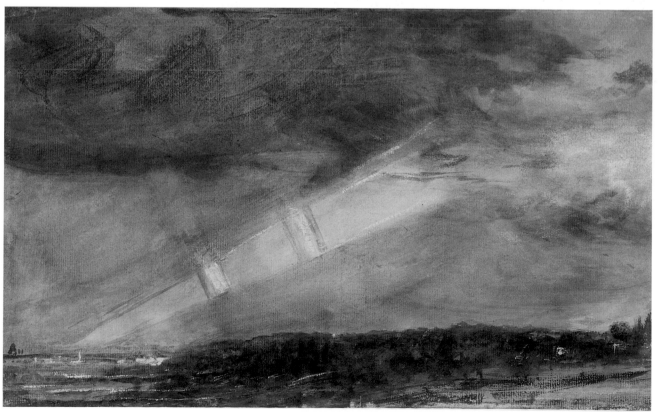

61. John Constable,
Sky Study with a Rainbow, 1827
[Cat. no. 132]

building towards his larger conceptions. The rainbow is a "phenom-
enon," one of those "accidental effects of sky [that] always attract
particularly." To paint it well he must understand it from every point of
view, see it in scientific terms, and see it as the product of a moment of
special intensity. In *London from Hampstead, with a Double Rainbow* [Fig. 60],
two prisms cut diagonally across a shaft of light, or "sun pillar,"
dividing the sky above the city. *Sky Study with a Rainbow* [Fig. 61] consists
solely of a bold arc of yellow across the blue of the sky. It has a power that
is startling, child-like—at an opposite extreme from the calm and delicate
blue-grey image of Turner's *Rainbow over Loch Awe* [Fig. 62], where the
distant Kilchurn Castle stands amidst what Dorothy Wordsworth called
"a solemn grandeur in the mountains," surrounded by the halo of its
almost circular bow. "Powers there are," Wordsworth wrote during the
same Scottish tour of 1803,

> That touch each other to the quick in modes
> Which the gross world no sense hath to perceive,
> No soul to dream of.
>
> (*Address to Kilchurn Castle*, 6–9)

62. J. M. W. Turner,
Rainbow over Loch Awe, c. 1831
[Cat. no. 136]

The lines seem to catch both Turner's exquisite sense of the numinous, and the wonderment which in Constable so often appears Wordsworthian.

In his lectures of 1836, Constable uses Poussin's *Deluge* and Rubens' *Rainbow* to make a link between the biblical symbolism of the bow and its importance as an image of natural renewal. He is speaking, he tells his audience, of something "more than the rainbow itself . . . [of] dewy light and freshness, the departing shower, with the exhilaration of the returning sun." It is all very personal, and very close to religious experience:

> The landscape painter must walk in the fields with a humble mind. No arrogant man was ever permitted to see Nature in all her beauty. If I may be allowed to use a very solemn quotation, I would say most emphatically to the student, "Remember now thy Creator in the days of thy youth."

It comes as a surprise to find Constable in 1833, at the age of fifty-seven, studying the rainbow as a "phenomenon," drawing prisms and

calculating angles [Fig. 63]. Giving Newton his due, he makes optical diagrams, lists the components of the spectrum—red, orange, yellow, green, blue, indigo, violet—and notes that there are "3 primary" and "7 prismatic" colours. Yet after all his analysis, he seems to throw up his hands, acknowledging the defeat of scientific measurement in the face of Nature's infinite variety: "There is no limit to the number of prismic colours." Elsewhere he wrote:

> The world is wide; no two days are alike, nor even two hours; neither were there ever two leaves of a tree alike since the Creation of the World; and the genuine productions of art, like those of Nature, are all distinct from each other.

Turner had no comparable allegiance to the natural world. This does not mean that he didn't at times observe it very closely, but his was a Londoner's childhood. His imagination was peopled with the jostle and bustle of riverside life, evoked by Ruskin in the vivid prose of *Modern Painters* (1843) that did so much to establish Turner's reputation:

> His foregrounds have always a succulent cluster or two of green-grocery at the corners. Enchanted oranges gleam in Covent Gardens of the Hesperides, and great ships go to pieces in order to scatter chests of them on the waves. . . . He attaches himself with the faithfullest child-love to everything that bears an image of the place he was born in. No matter how ugly it is—has it anything about it like Maiden Lane, or like Thames shore? If so, it shall be painted for their sake. . . . Dead brick-walls, blank square windows, old clothes, market-womanly types of humanity—anything fishy and muddy, like Billingsgate or Hunger-ford Market . . . black barges, patched sails, and every possible condition of fog.

It is the London of Dickens (whose first novel, *Pickwick Papers*, appeared in 1836, fifteen years before Turner's death), and it is the London also of Charles Lamb, most affectionate and irreverent of all the Romantic writers [Fig. 65].

63 and 64. John Constable, *Diagrams of the Formation of a Rainbow,* c. 1833 [see Cat. no. 129]

65. Charles Lamb,
A Dissertation upon Roast Pig, c. 1822
[Cat. no. 82].
Original manuscript of one of Lamb's
best-loved comic essays

"Separate from the pleasure of your company," Lamb wrote to Wordsworth in a letter of January 1801,

> I don't much care if I never see a mountain in my life. I have passed all my days in London, until I have formed as many and intense local attachments as any of you *mountaineers* can have done with dead Nature.

Wordsworth was not used to being teased in this way—especially in a letter that failed to be impressed by certain of the *Lyrical Ballads*—but Lamb was inspired to produce for him one of his most imaginative and delightful passages:

> The lighted shops of the Strand and Fleet Street, the innumerable trades, tradesmen and customers, coaches, wagons, playhouses, all

the bustle and wickedness round about Covent Garden . . . the very dirt and mud, the sun shining upon houses and pavements, the print-shops, the old-book stalls, parsons cheapening books, coffee-houses, steams of soup from kitchens, the pantomimes—London itself, a panto-mime and masquerade—all these things work themselves into my mind and feed me, without a power of satiating me. The wonder of these sights impels me into night-walks about her crowded streets, and I often shed tears in the motley Strand from fulness of joy at so much life.

"All these emotions must be strange to you," he adds.

They weren't. Wordsworth could at times be delighted by the "pantomime and masquerade" of London. Yet Lamb was right about the intensity of local attachments. Coleridge, writing in 1795, saw these in terms of the philosophy of David Hartley, who believed that the mind builds up from experience a pattern of associations that are either morally good or morally bad:

It is melancholy to think that the best of us are liable to be shaped and coloured by surrounding objects—and a demonstrative proof that man was not made to live in great cities. . . . The pleasures which we receive from rural beauties are of little consequence compared with the moral effect of these pleasures: beholding constantly the best possible, we at last become ourselves the best possible.

A version of this belief was to be held by Wordsworth throughout his life, but at this point he and Coleridge had never met. Coleridge is thinking partly of his own experience. Sent away to school at Christ's Hospital when he was eight, he returned to his Devonshire home at Ottery St. Mary only during the summer holidays, becoming in effect a city child. "My babe so beautiful," he wrote in *Frost at Midnight* (1798), addressing his infant son amid the "strange / And extreme silentness" of his cottage at Nether Stowey,

> it thrills my heart
> With tender gladness thus to look at thee
> And think that thou shalt learn far other lore,
> And in far other scenes! For I was reared
> In the great city, pent 'mid cloisters dim,
> And saw nought lovely but the sky and stars.
> But *thou*, my babe, shalt wander like a breeze. . . .
>
> (lines 48–54)

Wordsworth too had his views crystallized by having a child to look after. In the autumn of 1795, he and Dorothy took on the upbringing of Basil Montagu, aged two and three-quarters, whose mother was dead, and whose father worked in London. They had been lent a house at Racedown, near the Dorset-Devonshire border, in country that is still very remote. From there Dorothy wrote, in March 1797, to a married friend [Cat. no. 137]:

You ask to be informed of our system respecting Basil; it is a very simple one—so simple that in this age of systems you will hardly be like to follow it. We teach him nothing at present but what he learns from the

66. William Wordsworth, *Poems* 1815, annotated by Blake [Cat. no. 121]. Though regarding Wordsworth as the great poet of his age, Blake saw him as too often seduced by the natural world away from spiritual values

POEMS

REFERRING TO THE PERIOD OF CHILDHOOD.

I see in Wordsworth the Natural Man rising up against the Spiritual Man Continually & then he is No Poet but a Heathen Philosopher at Enmity against all true Poetry or Inspiration

VOL. I.

evidence of his senses. He has an insatiable curiosity, which we are always careful to satisfy to the best of our ability. It is directed to everything he sees, the sky, the fields, trees, shrubs, corn, the making of tools, carts, etc., etc., etc. He knows his letters, but we have not attempted any further step in the path of *book learning*. Our grand study has been to make him *happy*. . . .

"The new-born child is already a disciple," Rousseau had written in *Emile* (1763), "not of his tutor, but of Nature. The tutor merely studies under this master, and sees that his orders are not evaded."

By chance, while Wordsworth was busy at Racedown satisfying Basil's curiosity about outdoor life, he and Coleridge had been suggested to the philanthropist Tom Wedgwood as superintendents in a very different educational scheme. Wedgwood was, as he put it to Godwin, "endeavouring some master-stroke which should anticipate a century or two upon the large-paced progress of human improvement." Observing that progress depended on genius, and that geniuses were rare, he had hit on the plan of creating some. The child's mind—initially a Lockean blank, or *tabula rasa*—was to be educated from infancy. Sense impressions were to be administered to him in a regular sequence. He was to live in a

67. Francis Towne, *Elterwater, Westmorland*
[Cat. no. 241].
Two leaves from a sketch-book
of Towne's Lake District tour of 1786

nursery with plain grey walls, in which hard bodies would be hung about to simulate his sense of touch. He would be deprived completely of the natural world until he was old enough to take it. This last point, it should be said, caused Wedgwood some anxiety: "The gradual explication of Nature would be attended with great difficulty. The child must never go out of doors, or leave his own apartment."

To us it appears laughable!—doubly so if we imagine Wedgwood trying to explain to Wordsworth his views on the subject of Nature. Yet, in its millenarian hopefulness, it was an expression of the spirit of the age, and not essentially different from the plan for a great redemptive poem that Wordsworth and Coleridge themselves drew up the following spring. Though embodying a belief that was very close to Coleridge's Unitarian pantheism—"in all things / He saw one life, and felt that it was joy"—*The Recluse* was to be written by Wordsworth. A letter of March 1798 claims that 1300 lines have already been composed. The bulk of these consisted of *The Ruined Cottage*, with its tragic story of the cottage woman Margaret, its epigraph from Burns ("My muse, though homely in attire, / May touch the heart"), and its wise old narrator, later described by Wordsworth as "chiefly an idea of what I fancied my own character might have become in his circumstances."

Wordsworth's earliest attempts to describe his story-telling Pedlar are found in the drafts of the *Alfoxden Notebook* [Cat. no. 138]:

His eye was like the star of Jove
When in a storm its radiance comes and goes
As winds drive on the thin invisible cloud. . . .

The portrait is idealized, but as it develops Wordsworth begins for the first time to write the great philosophical poetry about childhood and education that we associate with *The Prelude*. Though writing in the third-person, he is drawing on memories of the past, using his own favoured Cumbrian childhood to evoke a perfect relationship with Nature, and training for the imagination:

To his mind
The mountain's outline and its steady form
Gave simple grandeur, and its presence shaped
The measure and the prospect of his soul
To majesty. Such virtue had the forms
Perennial of the ancient hills—nor less
The changeful language of their countenance
Gave movement to his thoughts, and multitude,
With order and relation.

(revised to form *1805*, vii, 722–730)

Coleridge's influence is obvious, but in place of the abstract theory— "beholding constantly the best possible, we at last become ourselves the

best possible''—Wordsworth (to use Keats' expression) feels things ''on his pulses.'' His is an affinity with the natural world which Constable would have understood, and which Coleridge could admire, but never truly feel.

In a memorable account of his own education, written three months earlier, Coleridge claimed that even during his early childhood in Devonshire he had responded chiefly to books and ideas. He had been ''habituated to the vast,'' not by the evidence of his senses (necessary if one is to be ''shaped'' by ''the forms / Perennial of the ancient hills''), but through the reading of fairy tales:

> Should children be permitted to read romances, and relations of giants and magicians and genii? . . . I know no other way of giving the mind a love of ''the great'' and ''the whole.'' Those who have been led to the same truths step by step through the constant testimony of their senses seem to me to want a sense which I possess. They contemplate nothing but *parts*, and all parts are necessarily *little* . . . the Universe to them is but a mass of *little things*.

''I have known some who have been *rationally* educated,'' he adds:

> They were marked by a microscopic acuteness, but when they looked at great things all became a blank, and they saw nothing—and denied (very illogically) that anything could be seen. . . .

Writing of the Pedlar's upbringing in *The Ruined Cottage*, Wordsworth (like Rousseau in *Emile*) is demonstrating the virtues of natural, as opposed to ''rational,'' education. Fairy tales are given their due, alongside the dominant influence of landscape, and the boy is seen also as a would-be scientist. He cannot, however, be content with the merely intellectual. ''The nakedness of austere truth'' must be clothed in the forms and hues of Nature:

> His triangles they were the stars of heaven,
> The silent stars; his altitudes the crag
> Which is the eagle's birthplace. . . .
> he scanned the laws of light
> Amid the roar of torrents, where they send
> From hollow clefts up to the clearer air
> A cloud of mist, which in the shining sun
> Varies its rainbow hues.
> (*Pedlar*, 166–168, 197–201)

Newton's work on the spectrum, his entering of the rainbow ''In the dull catalogue of common things,'' cannot be reconciled with the beauty of mist rising in the sunshine from a waterfall.

Wordsworth, for all his exalted belief that the presence of a mountain can shape the soul ''to majesty,'' is never very far from actuality. In talking about education, he never forgot what children were like. Recalling his schooldays in *The Prelude*, he saw himself as part of a group,

> not too wise,
> Too learned, or too good, but wanton, fresh,
> And bandied up and down by love and hate;

68. J. M. W. Turner,
The Upper Falls of the Reichenbach,
c. 1810–1815 [Cat. no. 297]

Fierce, moody, patient, venturous, modest, shy,
Mad at their sports like withered leaves in winds;
Though doing wrong and suffering, and full oft
Bending beneath our life's mysterious weight
Of pain and fear, yet still in happiness
Not yielding to the happiest upon earth.

(v, 436–444)

At Alfoxden, he observed in the child Basil (now five) the same contraries of love and hate, fierceness and patience, suffering and happiness. And he observed too, as Blake had done in the *Songs of Experience*, the adult willingness to interfere and moralize. *Anecdote for Fathers* is a cautionary tale, with the sub-title *How the Art of Lying May Be Taught*. *We Are Seven* is the triumph of childish instinct over adult logic. The "cottage-girl" refuses to think of the family as diminished by the death of her siblings, Jane and John, and for the poet she is right:

"How many are you then," said I,
"If they two are in Heaven?"
The little maiden did reply,
"Oh master, we are seven."

"But they are dead, those two are dead—
Their spirits are in Heaven!"

'Twas throwing words away, for still
The little maid would have her will,
And said, "Nay, we are seven!"

(lines 61–69)

In Wordsworth's admiration for the cottage child we see his regret at the passing of a time when the "natural piety" of *The Rainbow* [Fig. 69] had been a matter of intuitive response. The poet of *Tintern Abbey* is capable of "sublime and blessed" moods that lighten the burden of existence. He is able to hear the "still, sad music of humanity," which is audible only to

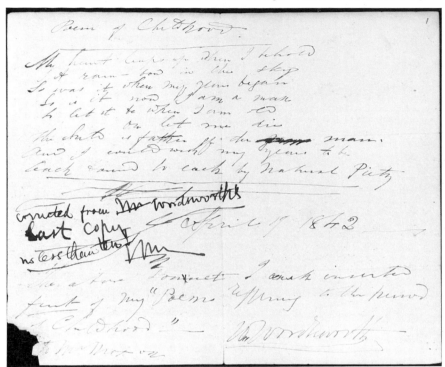

69. William Wordsworth, *The Rainbow* [Cat. no. 141].
Transcribed by Wordsworth aged seventy-two

those who have learned the lessons of experience. And yet he yearns for the earlier unthinking time when Nature had been all in all, and neither of these achievements had been possible:

I cannot paint
What then I was: the sounding cataract
Haunted me like a passion; the tall rock,
The mountain, and the deep and gloomy wood,
Their colours and their forms, were then to me
An appetite—a feeling and a love
That had no need of a remoter charm
By thought supplied, or any interest
Unborrowed from the eye.

(lines 76–84)

Keats, in his famous "simile of human life," saw *Tintern Abbey* as exploring the "dark passages" of a world "full of misery and heartbreak;" for Wordsworth himself in July 1798, adult wisdom had been small compensation for the loss of unmediated joy.

The earliest drafts of *The Prelude*, composed three months later at Goslar, in Germany, show Wordsworth preoccupied with the phase sur-

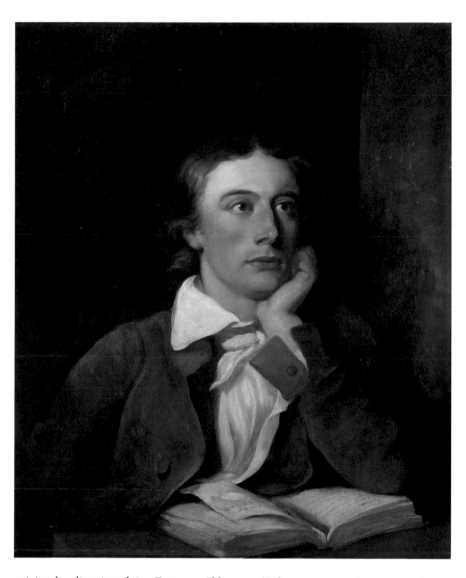

70. John Keats aged twenty-one,
by William Hilton [Cat. no. 75]

prisingly dismissed in *Tintern Abbey* as "The coarser pleasures of my
boyish days." He is no longer idealizing his childhood and conferring it
upon someone else (as he had done in *The Ruined Cottage*), or writing an
impassioned meditation in the style of Coleridge's *Frost at Midnight* (as he
had done in *Tintern Abbey*); he is for the first time conscientiously seeking
the links that will bind his days "each to each," make sense of his relation
to the child who is his former self. It was a very modern thing to do. Even
Hazlitt was not fully aware that Wordsworth's struggles to define the
self, and its continuity, were what made his genius "a pure emanation
of the Spirit of the Age." To us, though, it is this factor above all that
places Wordsworth at the centre of any attempt to explore the nature of
Romanticism.

The early *Prelude* manuscripts are especially exciting. Wordsworth is
writing with a creative urgency that we can feel as we turn the pages. As
he took up the notebook that would later be used by Dorothy for her
Journal account of the daffodils on Ullswater, he had a problem in his
mind. Why couldn't he get on and write *The Recluse*? It had seemed quite
simple in the spring, and now, in this small rather medieval German
town, he had all the time in the world to get on with it. The present
inaction was made still less explicable by his sense of having been

chosen—singled out in childhood for the very mission he was failing to accomplish. "Was it for this," he asked himself, using the end of the notebook because he was really just thinking in verse:

Was it for this
That one, the fairest of all rivers, loved
To blend his murmurs with my nurse's song,
And from his alder shades and rocky falls,
And from his fords and shallows, sent a voice
To intertwine my dreams? For this didst thou,
O Derwent, travelling over the green plains
Near my "sweet birthplace," didst thou, beauteous stream,
Give ceaseless music to the night and day,
Which with its steady cadence tempering
Our human waywardness, composed my thoughts
To more than infant softness, giving me
Amid the fretful tenements of man
A knowledge, a dim earnest, of the calm
That Nature breathes among her woodland haunts?
Was it for this . . .?

(revised to form 1799, i, 1–17 [Cat. no. 144])

And so the questions continue, each leading the poet deeper into the childhood where the answers must be found. The quotation-marks around "sweet birthplace," in line eight, tell us of the background presence of Coleridge, to whom *The Prelude* in all its forms was addressed. In *Frost at Midnight*, he too had been seeking links. "Already had I dreamt," he writes, speaking of his schooldays in London,

Of my sweet birthplace, and the old church-tower
Whose bells, the poor man's only music, rang
From morn to evening all the hot Fair-day,
So sweetly that they stirred and haunted me
With a wild pleasure, falling on mine ear
Most like articulate sounds of things to come! (lines 27–33)

71. Joseph Farington,
Cockermouth, 1816 [Cat. no. 69].
Wordsworth's birthplace
on the Cumbrian coast

Immured in the great city, Coleridge had dreamed of childhood bells that seemed prophetic of the future. Perhaps he was thinking of bells in the pantomime—

> "Turn again, Whittington,
> Thou worthy citizen,
> Lord Mayor of London!"

—but the "articulate sounds of things to come" had larger meanings for Wordsworth.

What had it been in his childhood which made him feel that his role as a poet was foreordained? Wordsworth's repeated questionings lead into a sequence of specific memories, drafted rapidly, but with such fluency that little revision was needed. They were not reassuring or comfortable memories, but showed in the child signs of the imaginative power on which the poet's sense of vocation depended. Later he was to call them "spots of time," and claim that they were not merely links with a past self, but sources of adult confidence and creativity:

> Oh, when I have hung
> Above the raven's nest, by knots of grass
> Or half-inch fissures in the slippery rock
> But ill sustained, and almost, as it seemed,
> Suspended by the blast which blew amain,
> Shouldering the naked crag, oh, at that time,
> While on the perilous ridge I hung alone,
> With what strange utterance did the loud dry wind
> Blow through my ears; the sky seemed not a sky
> Of earth, and with what motion moved the clouds!
>
> (1799, i, 57–66)

Gradually Wordsworth became aware that he was making a poem of considerable length: one can watch him in the manuscript as he stops, numbers the lines, and goes on again with new assurance. Before he and Dorothy returned to England in February 1799, he had written the first part, or book, of the short original version of *The Prelude*, including some of the most inspired poetry that he ever composed. Two of the famous boyhood episodes, the stealing of the shepherd's boat by moonlight on Ullswater and the skating scene at Hawkshead, are included in a joint letter sent to Coleridge before Christmas [Fig. 72]. With them are *Nutting* [Cat. no. 203] (at this time also intended for *The Prelude*) and two of the haunting Lucy Poems, which explore yet another aspect of Wordsworth's preoccupation with childhood:

> My hope was one, from cities far,
> Nursed on a lonesome heath,
> Her lips were red as roses are,
> Her hair a woodbine wreath.
>
> She lived among the untrodden ways
> Beside the springs of Dove,
> A maid whom there were none to praise,
> And very few to love—

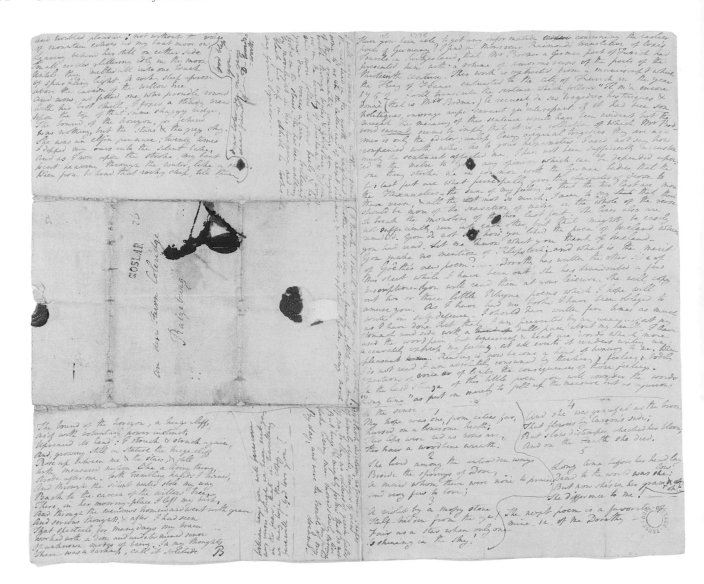

A violet by a mossy stone
 Half-hidden from the eye,
Fair as a star when only one
 Is shining in the sky.
 (revised as *She Dwelt among the Untrodden Ways*,
 lines 1–8)

73. Anon. silhouette, *Dorothy Wordsworth,*
c. 1806 [Cat. no. 43].
The only known likeness of Dorothy
as a young woman

The first of these stanzas, not in the later texts, is a reminder that these are in a sense love-poems. Yet Lucy has a beauty and fragility that are far from the erotic. She is an ideal, a being totally at one with the natural world. In some of the poems she dies; in none is there any possibility of marriage or fulfilment. Shelley, at his most mischievous (and most Byronic), hinted in *Peter Bell the Third* that really Lucy was Dorothy:

But from the first 'twas Peter's drift
To be a kind of moral eunuch;
He touched the hem of Nature's shift,
Felt faint—and never dared uplift
Her closest, all-concealing tunic.

She laughed the while, with an arch smile,
And kissed him with a sister's kiss. . . . (lines 313–319)

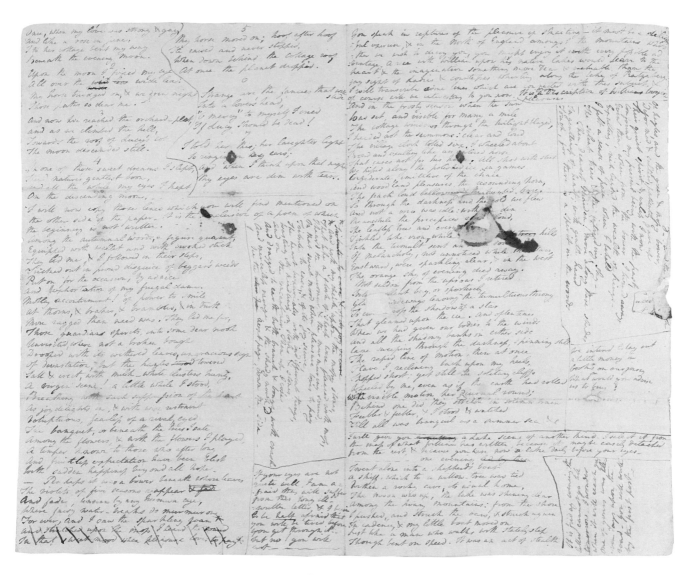

72 (*above and opposite*).
William and Dorothy Wordsworth,
to Coleridge, December 1798 [Cat. no. 139].
Joint letter containing an array of recent
Wordsworth poetry, including
boyhood scenes from *The Prelude*
and two of the Lucy Poems

It was very funny, and very naughty—especially given Byron's (probable) fathering of his half-sister Augusta's child in 1814—but contained an element of truth. In *Home at Grasmere* Wordsworth did later write an exquisite love-poetry for Dorothy ("Her voice was like a hidden bird that sang"); perhaps the figure of Lucy, in her perpetual childhood, does indeed embody the closeness and yet distance of their tender relationship.

In some not easily definable sense, Lucy, whose hair is "a woodbine wreath," must embody too a relationship between the poet and the natural world. At times, in spite of his distrust of personifications, Nature does appear in Wordsworth's poetry as the traditional goddess ("Nature never did betray / The heart that loved her," *Tintern Abbey*), at others we hear of the "presences of Nature . . . souls of lonely places," or of the "Wisdom and spirit of the Universe." Wordsworth is to be seen evoking in different ways the beneficial influence that he feels to have been at work in his past. Among the sequences of *The Prelude* drafted at Goslar, *There Was a Boy* came to be of special importance to him in defining natural education against the "microscopic acuteness" of the rationalists that Coleridge had denounced.

Standing at evening by Windermere, the boy—Wordsworth himself, in the original version—would blow

mimic hootings to the silent owls
That they might answer him. And they would shout
Across the wat'ry vale, and shout again,
Responsive to his call, with quivering peals
And long halloos, and screams, and echoes loud,
Redoubled and redoubled—concourse wild
Of jocund din.
 And when it chanced
That pauses of deep silence mocked his skill,
Then sometimes in that silence, while he hung
Listening, a gentle shock of mild surprise
Has carried far into his heart the voice
Of mountain torrents; or the visible scene
Would enter unawares into his mind
With all its solemn imagery, its rocks,
Its woods, and that uncertain heaven, received
Into the bosom of the steady lake.

(lines 10–25)

74 (*above left*). William Wordsworth, to Mary, 22 July 1810 [Cat. no. 118]. Written in a period of separation after eight years of married life

75 (*above right*). Mary Wordsworth, to William, 1 August 1810 [Cat. no. 119]. "O My William! it is not in my power to tell thee how I have been affected by this dearest of all letters . . ." [see Fig. 74]

"This very expression 'far'," Thomas De Quincey commented with his usual perceptiveness,

> by which space and its infinities are attributed to the human heart, and to its capacities of re-echoing the sublimities of Nature, has always struck me as with a flash of sublime revelation.

For Wordsworth, the voice of mountain torrents, carried *far* into the heart, like the shaping influence of "The mountain's outline and its steady form," was part of an interaction between man and Nature on

which human stability depended. Lamb, Turner, Dickens, might deny his assumption that the external world to which we respond has to be a natural one, but within their London context they are perfect examples of the imaginative sympathy which he is writing about.

Before leaving Germany, Wordsworth had decided to use *There Was a Boy* [Fig. 76] as the centrepiece of an attack on educational theory:

> There are who tell us that in recent times
> We have been great discoverers, that by dint
> Of nice experience we have lately given
> To education principles as fixed
> And plain as those of a mechanic trade.

"Fair books and pure," he continues, becoming more heavily ironical,

> have been composed, that act
> Upon the infant mind as does the sun
> Upon a flower.

76. William Wordsworth, *There Was a Boy*
[Cat. no. 143].
The poem shown in a notebook
of *c.* February 1799, as part of a discussion
of natural versus artificial education

In 1804, a version of this sequence, including *There Was a Boy*, was included in Book Five of *The Prelude*. To go alongside the representative of natural education, Wordsworth created the greatest of his satirical

portraits, the infant prodigy: "with gifts he bubbles o'er / As generous as a fountain." Again and again the language that is used reminds us of the distance between the two value-systems that are being opposed. "Gifted" the prodigy may be, but only in the most sterile, dry, unbubbling, unfountainlike of ways. Informed he certainly is, but his information is impersonal, and therefore pointless:

> He knows the policies of foreign lands,
> Can string you names of districts, cities, towns,
> The whole world over, tight as beads of dew
> Upon a gossamer thread.
>
> (v, 334–337)

The dew upon the spider's web takes us into the world from which the prodigy—like Wedgwood's hapless potential genius—is forever excluded. It perfectly implies the wonderment that he can never feel:

> All things are put to question: he must live
> Knowing that he grows wiser every day,
> Or else not live at all. . . .
>
> (v, 341–343)

In the words of Rousseau, who lies behind this whole discussion, and to whom above all Romanticism owes its awareness of the imaginative life of the child,

> When nature has been stifled by the passions [his nurses] have implanted in him, this sham article is sent to a tutor. The tutor completes the development of the germs of artificiality which he finds already well grown. . . . eventually this infant slave and tyrant, crammed with knowledge, but empty of sense, is flung upon the world. . . .

Dedicated from the first to artificiality, crammed with useless knowledge, the "rationally educated" child is doomed to see "nothing but *parts*"—to live in a universe that is "a mass of *little things*." His days are chained "each to each," in the faith that destroyed the poetry of the rainbow.

By contrast, whether he lives in town or country, the child who has been "habituated to the vast" is capable of the "natural piety" that is imaginative response. He will know—as Turner [Fig. 77] knew, and Wordsworth knew— that past and future may be linked in the emotional permanence of a moment. The rainbow, though it comes and goes, may be a covenant set amid the clouds—a sign that

> feeling comes in aid
> Of feeling, and diversity of strength
> Attends us if but once we have been strong.
>
> (xi, 325–327)

"It was a day," Wordsworth wrote in 1804, sketching a stormy scene in Constable's most agitated manner,

> Upon the edge of autumn, fierce with storm;
> The wind blew down the Vale of Coniston

77. J. M. W. Turner,
Rainbow: Osterspey and Feltzen on the Rhine,
c. 1820 [Cat. no. 135]

Compressed as in a tunnel; from the lake
Bodies of foam took flight, and everything
Was wrought into commotion, high and low—
A roaring wind, mist, and bewildered showers,
Ten thousand thousand waves, mountains and crags,
And darkness, and the sun's tumultuous light.
Green leaves were rent in handfuls from the trees. . . .
The horse and rider staggered in the blast. . . .
Meanwhile, by what strange chance I cannot tell,
What combination of the wind and clouds,
A large unmutilated rainbow stood
Immovable in heaven.

(Norton *Prelude*, p. 497)

78. John Sell Cotman, *On the Greta (Hell Cauldron)*, 1806 [Cat. no. 169]

4 The Discovery of Nature

"'My dear, dear aunt,' she rapturously cried, 'what delight, what felicity! You give me fresh life and vigour.'" The speaker is Elizabeth Bennet, in Jane Austen's *Pride and Prejudice*. Her aunt, Mrs. Gardiner, has just suggested that she should come on a tour of the Lake District. "'What are men,'" Elizabeth continues,

> "to rocks and mountains? Oh, what hours of transport we shall spend! And when we *do* return, it shall not be like other travellers, without being able to give one accurate idea of anything. . . . Lakes, mountains and rivers, shall not be jumbled together in *our* imaginations. . . ."

Though not published till 1813, *Pride and Prejudice* was written in 1796–1797. The questions that Elizabeth raises were of great topical importance: What are men to rocks and mountains? What is the value of "hours of transport," or personal emotion? What price accuracy of description, or detailed recollection? In what sense is jumbling by the imagination a failure? Does the natural world indeed give "fresh life and vigour," and if so, may it be spiritual as well as bodily?

Austen's answers to such questions would presumably have been different from Wordsworth's, but they are asked with a full awareness of their implication. As a writer she stands aside from Romanticism in many respects, but is nonetheless conscious of the social trends that lie behind it. Contemporary taste for the Gothic is parodied in *Northanger Abbey*; the picturesque has its turn chiefly in *Sense and Sensibility*. Admiring the landscape, Edward Ferrars apologizes to Marianne Dashwood for his unfashionable views:

> "Remember that I have no knowledge in the picturesque. . . . I shall call hills steep, which ought to be bold; surfaces strange and uncouth, which ought to be irregular and rugged; and distant objects out of sight, which ought only to be indistinct through the soft medium of a hazy atmosphere."

Marianne, whose sensibility is qualified by some very good sense, knows all about such affectation:

> "It is very true," said Marianne, "that admiration of landscape scenery has become mere jargon. Everybody pretends to feel, and tries to describe, with the taste and elegance of him who first defined what picturesque beauty was. I detest jargon of every kind; and sometimes I have kept my feelings to myself, because I could find no language to describe them in but what was worn and hackneyed out of all sense and meaning."

Austen does not need to mention William Gilpin by name; the periphrasis, "him who first defined what picturesque beauty was," is awkward, but makes the point that everybody knows who he is. Everybody knows too what he is assumed to stand for. Ferrars has decided views on the subject:

"I like a fine prospect, but not on picturesque principles. I do not like crooked, twisted, blasted trees. I do not like ruined, tattered cottages. I am not fond of nettles, or thistles, or heath blossoms. I have more pleasure in a snug farmhouse than a watchtower—and a troop of tidy happy villagers please me better than all the banditti in the world."

On the one hand we have the plain man, who likes his trees straight, his farms snug, and his villagers tidy; on the other, there is Marianne, who is assumed to be admiring landscape by numbers, and showing a preference for the twisted, ruinous, and unproductive. Wordsworth, rather surprisingly, might have sided with Marianne. In 1797, when *Sense and Sensibility* was written, he had just completed a play about banditti (*The Borderers*) and was at work on *The Ruined Cottage*, in which nettles are featured amid a scene of picturesque decay. A year later, he wrote *The Thorn* (about a "crooked, twisted, blasted tree"), and one of the two major "spots of time" of the 1799 *Prelude* offers a *bona fide* watchtower (used as recently as the 1745 Jacobite Rebellion).

The picturesque was by no means a ridiculous fashion. Gilpin taught people—Wordsworth among them—to discover Nature for themselves. The limitation of his way of seeing, as the term picturesque implies, was that he saw the natural world through painting. Those who read his *Tours* (the *Wye*, 1782 [Fig. 86]; the *Lakes*, 1786; the *Highlands*, 1789), or the *Essays on Picturesque Beauty* (1792) [Fig. 79], were offered a set of principles according to which landscape should be viewed, and, if necessary, reconstructed:

Nature is always great in design, but unequal in composition. She is an admirable colourist, and can harmonize her tints with infinite variety and inimitable beauty, but is seldom so correct in composition as to produce an harmonious whole. Either the foreground, or the background, is disproportioned; or some awkward line runs across the piece; or a tree is ill placed; or something or other is not exactly as it should be.

(*Wye Tour*)

The answer in such cases is judicious rearrangement. Truth to Nature lies neither in Elizabeth Bennet's "accurate" reporting of detail, nor in the "jumbling together" in the imagination which she denounces, but in the artist (or tourist) remaking the scene according to picturesque principles:

Trees he may generally plant, or remove, at pleasure. If a withered stump suit the form of his landscape better than the spreading oak which he finds in Nature, he may make the exchange. . . . He may pull up a piece of awkward paling; he may throw down a cottage; he may even turn the course of a road, or a river, a few yards on this side or that.

(*Lakes Tour*)

THREE ESSAYS:

ON

PICTURESQUE BEAUTY;

ON

PICTURESQUE TRAVEL;

AND ON

SKETCHING LANDSCAPE:

TO WHICH IS ADDED A POEM, ON

LANDSCAPE PAINTING.

By WILLIAM GILPIN, M. A.

PREBENDARY OF SALISBURY; AND
VICAR OF BOLDRE IN NEW FOREST, NEAR LYMINGTON.

London;

PRINTED FOR R. BLAMIRE, IN THE STRAND.
M.DCC.XCII.

79. William Gilpin, *Three Essays*, 1792 [Cat. no. 175].
Gilpin's attempt to define the picturesque in theoretical terms

Gilpin's principles had little theoretical basis. Readers who expected his work to be a development of Burke's *Philosophical Enquiry into the Origin of Our Ideas of the Sublime and Beautiful* (1757) [Cat. no. 266] were disappointed because it was unphilosophical, and failed to place the picturesque satisfactorily in the terms that Burke had laid down. It was left to Uvedale Price, in his *Essay on the Picturesque* (1794) [Cat. no. 182], and Richard Payne Knight (*Inquiry into the Principles of Taste*, 1805 [Cat. no. 179]), to make the more sophisticated distinctions. For Burke, the beautiful in landscape is associated with regularity, and arouses a feeling akin to love in the perceiver; the sublime is created by indistinctness and irregularity, producing fear and awe. The picturesque came to occupy a position somewhere between the two. For Price, it "corrects the languor of beauty, or the tension of sublimity" (art in either case rendering Nature

80. John White Abbott, *Canonteign, Devon*, 1803 [Cat. no. 145]

more acceptable). For Gilpin, who like Wordsworth had a mind stocked with visual memories of a Cumbrian childhood, it is more a question of preference. He likes beauty to have a "roughness" about it. The scenes he particularly admires will always tend towards the Burkean sublime.

In effect, Gilpin's own definition of sublimity is "that which art cannot reach" (and which cannot, therefore, be picturesque). "No tame country," he comments in the *Lakes Tour*,

however beautiful, can distend the mind like this awful and majestic scenery. The wild sallies of untutored genius often strike the imagination more than the most correct effusions of cultivated parts.

The likeness to Wordsworth's later views is striking. Gilpin's nephew, Bernard Farish, taught at Hawkshead Grammar School, and it is highly probable that the poet was introduced to the *Lakes Tour* at the age of sixteen, when it first came out. The work was to have a lasting influence both on his vision and on his thinking about the imagination. "Though the *eye*," Gilpin continues,

> might take more pleasure in a view (considered *merely in a picturesque light*) when a little adorned by the hand of art, yet I much doubt whether such a view would have that strong effect on the *imagination*, as when rough with all its bold irregularities about it—when beauty and deformity, grandeur and horror, mingled together, strike the mind with a thousand opposing ideas, and like chemical infusions produce an effervescence which no harmonious mixtures could produce.

Though Marianne's periphrasis, "him who first defined what picturesque beauty was," could refer to no one else, Gilpin was part of a larger trend. The term "picturesque" had been in use since the beginning of the century. The attitude to landscape that it implies is derived from late seventeenth-century continental painting, seen by British artists working in Rome during the 1740s and 1750s, and by young noblemen (their patrons) making the Grand Tour. Fifty years later, Ferrars' reference to "banditti" would automatically have brought to the minds of Austen's readers the crags and robber bands of Salvator Rosa; his allusion to "the soft medium of a hazy atmosphere" would have suggested the light effects of Claude Lorraine. Few could know what these painters were actually like, but everyone knew what they stood for—and most would have associated with them the third, more vaguely evocative name of Poussin.

Richard Wilson, whose Italianate landscapes dominated British oil painting after his Roman visits of 1751–1752 and 1757–1758, and the resourceful Alexander Cozens (in Italy from 1746 to 1749) were both directly affected by Claude and his disciple Claude Joseph Vernet. In England, Claude was known through paintings in certain major collections, and through engravings in the *Liber Veritatis*. In a slightly misleading way, he was known also because of the "Claude-glass," a tinted version of the convex hand-mirror used by tourists of the period to concentrate the features of a landscape—bring them within the confines of a picture. Gilpin concedes that such mirrors "give the objects of Nature a soft, mellow tinge, like the colouring of [the] master," but adds: "I am apt to believe that the merit of this kind of modified vision consists chiefly in its novelty."

To use a hand-mirror the viewer stood with his back to the landscape, focusing it over his shoulder. The poet Thomas Gray actually fell down while using one at Keswick in October 1769. In Borrowdale, however, he recorded, "the glass played its part divinely." His editor, William Mason (who in 1775 brought Gray's Lake District letters together to form a *Journal* [Cat. no. 234]), footnoted the mirror's dimensions, and added

81. Thomas Hearne, *Sir George Beaumont and Joseph Farington Sketching a Waterfall*, 1777 [Cat. no. 178]

informatively that the glasses could "be had of any optician." The publication of Gray had an immediate effect in pointing artists and picturesque travellers towards the Lakes. Within months of Mason's edition, Joseph Farington was at work on his *Views of the Lakes*, elaborately printed in 1783–1787, with a text (in French as well as English) almost certainly supplied by Wordsworth's uncle, William Cookson. In 1777, Farington is himself pictured by Thomas Hearne, along with Sir George Beaumont, patron and artist, in the act of painting the Falls of Lodore.

Though parallels for *Sir George Beaumont and Joseph Farington Sketching a Waterfall* [Fig. 81] are to be found in paintings of the Falls of Tivoli, it seems likely that Hearne is alluding to Claude's self-portrait landscape *Morning*. In this "Capital Picture," published in a large and handsome Boydell print, the artist is to be seen, under the shade of an umbrella, painting "an antique temple" outside Rome. Hearne shows the British artists too under prominent umbrellas (designed, it seems, to keep off glare from the fall), but they are confronting Nature that is unadorned by antiquity. Thirty-five years later, in *Doctor Syntax Sketching the Lake*

82. Thomas Rowlandson, *Doctor Syntax Sketching the Lake*, from *The Tour of Doctor Syntax in Search of the Picturesque*, 1812 [Cat. no. 184]. Dr. Syntax is a satirical portrait of William Gilpin

(1812) [Fig. 82], Thomas Rowlandson will satirize the pursuit of the picturesque; here, at the threshold of the Romantic period, the pursuit is being celebrated. Claude, who worked out of doors, bringing the Roman Campagna for the first time vividly alive, is invoked as a precedent, as British painters begin to explore the sublimities of their own northern landscape.

Wordsworth in *The Prelude* chose to show the picturesque as "a strong infection of the age." He himself had escaped lightly, but there had nonetheless been a phase at which his imagination was "impaired" by the fashion for enjoying Nature according to aesthetic principles:

> even in pleasure pleased
> Unworthily, disliking here, and there
> Liking, by rules of mimic art transferred

To things above all art. . . .
Pampering myself with meagre novelties
Of colour and proportion. . . .

(xi, 153–156, 160–161)

The period to which he refers is easily identified. It lasts a year or so longer than his not very distinguished career at Cambridge (1787–1791), and coincides with the writing of his couplet-poems *An Evening Walk* [Fig. 83]

83. William Wordsworth, *An Evening Walk*, 1793 [Cat. no. 111]. Wordsworth's first major publication, a picturesque description of Lake District scenery, written when he was a student at St. John's, Cambridge, and addressed to Dorothy

and *Descriptive Sketches* (both published in 1793). "I had once," he writes in a footnote to the second poem,

> given to these Sketches the title of "Picturesque," but the Alps are insulted in applying to them that term. Whoever, in attempting to describe their sublime features, should confine himself to the cold rules of painting, would give his reader but a very imperfect idea of those emotions which they have the irresistible power of communicating to the most impassive imaginations.

In his attempt to describe the Alps, Wordsworth, it seems, became aware of needing a vocabulary of the sublime; perception of his native

84. Joseph Wright of Derby, *Rydal Waterfall*, 1795 [Cat. no. 263].
Painted from the viewing hut below the Fall

Lake District, however, had been trained by the picturesque. The set-piece description of the Lower Fall at Rydal in *An Evening Walk* is a case in point. Below the Fall was a viewing hut, originally a seventeenth-century grotto, but from the 1770s onwards visited by a succession of artists— Joseph Farington, Francis Towne, Joseph Wright of Derby [Fig. 84], Constable, and many others—who have left their versions of the scene. Gray passed it by, but in noting his loss, Mason adds his own comment on the "effect of light and shadow beautiful beyond description." Gilpin, as might be expected, was delighted by the scene "appearing through the window like a picture in a frame," and gave a detailed analysis. Three years later, Wordsworth, aged nineteen, draws upon Gilpin while presenting in verse a study of light and shade that is picturesque at every point. There are few signs of the power and flexibility that will later emerge, but the poetry is impressive if one listens to it with sympathy as a late Augustan voice:

> Then Quiet led me up the huddling rill,
> Brightening with water-breaks the sombrous gill,
> To where, while thick above the branches close,
> In dark-brown basin its wild waves repose;
> Inverted shrubs and moss of darkest green
> Cling from the rocks, with pale wood-weeds between—

> Save that, atop, the subtle sunbeams shine
> On withered briars that o'er the crags recline;
> Sole light admitted here, a small cascade,
> Illumes with sparkling foam the twilight shade.
> Beyond, along the vista of the brook,
> Where antique roots its bustling path o'erlook,
> The eye reposes on a secret bridge
> Half grey, half shagged with ivy to its ridge.
>
> (*An Evening Walk*, 71–84)

The "sombrous gill," "dark-brown basin," "pale wood-weeds," "withered briars," "antique roots," offer the jargon of the picturesque that reduced Marianne to silence. Within its limiting frame, however, the vignette is well made, and well seen. At its centre, the waterfall becomes a source of light—

> Sole light admitted here, a small cascade
> Illumes with sparkling foam the twilight shade

—because white is needed to bring out the sombrous contrasts from which the picture is constructed. As an apprentice-poet, the Wordsworth of *An Evening Walk* is displaying the literary tricks of his trade, but at the same time training his eye. Even by the standards of the day (when the reader's pleasure depended very much on recognition of allusion), it is an imitative poem. There are borrowings from Milton, Pope, Thomson, Gray, Collins, and a great many others. Yet, looking back, Wordsworth was able to say, "There is not an image in it which I have not observed, and now, in my seventy-third year, I recollect the time and place where most of them were noticed."

It is interesting that Wordsworth's note should conclude nonetheless with a claim for imagination. The "plan" of *An Evening Walk*, he tells us,

> has not been confined to a particular walk or an individual place, a proof (of which I was unconscious at the time) of my unwillingness to submit the poetic spirit to the chains of fact and real circumstance. The country is idealized, rather than described in any one of its local aspects.

The claim is impressive, and Wordsworth is delighted at being able to show his days as "bound each to each" in the "natural piety" of unconstrained imagination. Yet Gilpin had written in the *Lakes Tour*:

> he who works from imagination, that is, he who culls from Nature the most beautiful parts of her productions— a distance here, and there a foreground—combines them artificially, and (removing anything offensive) admits only such parts as are congruous and beautiful, will in all probability make a much better landscape than he who takes all as it comes. . . .

The influence of the picturesque was on the whole a good one. There is remarkably little evidence that Wordsworth was ever guilty of "pampering" himself "with meagre novelties/Of colour and proportion," or liking and disliking "by rules of mimic art." He merely emerged, as did the great painters of his period—Girtin, Turner, Constable, Cotman—into the new and larger perspective that has come to be known as Romanticism. The

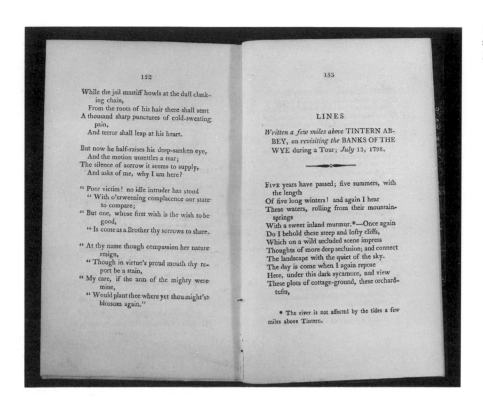

85. William Wordsworth, *Tintern Abbey,* shown in the 1802 Philadelphia edition of *Lyrical Ballads* [Cat. no. 206]

poem in which the change can most vividly be seen is *Tintern Abbey* [Fig. 85].

"The enchanting beauties of the River Wye," wrote John Thelwall (muzzled political agitator, and friend of both Coleridge and Wordsworth) in the *Monthly Magazine* for May 1798,

> are by this time pretty generally known among the lovers of the picturesque. They have acquired a due celebrity from the descriptions of Gilpin, and curiosity has been inflamed by poetry and by prose, by paintings, prints, and drawings. . . . An excursion on the Wye has become an essential part of the education . . . of all who aspire to the reputation of elegance, taste, and fashion.

Excursions started typically at Bristol, and had as their climax a visit to Tintern Abbey, in Gilpin's words, "the most beautiful and picturesque view on the river." It is important to notice that the illustrations to the *Wye Tour* are not intended to be accurate. Gilpin's drawing of the abbey (aquatinted by his nephew, William Sawrey Gilpin) shows a much longer and less blockish building than the tourist would see on arrival [Fig. 86]. To the surprise of some of his early readers, it was a picturesque idea, not a topographical representation. True to his principles, Gilpin has carried out on paper the remodelling of the ruin which he tells us he would like to have seen in practice:

> A number of gable-ends hurt the eye with their regularity, and disgust it by the vulgarity [banality] of their shape. A mallet judiciously used—but who durst use it?—might be of service in fracturing some of them, particularly those of the cross-aisles, which are not only disagreeable in themselves, but confound the perspective.

86. William Gilpin,
a picturesque view of Tintern Abbey
in *Observations on the River Wye*,
1782 [Cat. no. 176]

A comparison of the *Tour* illustration with the watercolours of Girtin and Turner will show the two younger men (aged eighteen and nineteen respectively) striving to cope with the gables that Gilpin has conveniently suppressed. Both are still topographers, working in the style of Edward Dayes, to whom Girtin had been apprenticed, and who was known chiefly for picturesque studies of buildings in blue and grey washes. Both adopt a viewpoint in the centre of the ruined church, giving prominence to the soaring arches, and featuring the "ivy, in masses uncommonly large," which, Gilpin reports, "has taken possession of many parts of the wall, and gives a happy contrast to the grey-coloured stone." Girtin's drawing [Fig. 87] is earlier and tighter, showing already great skill, but none of the breadth of vision that will come. Turner, though still a long way from the styles of his maturity, has opened up the composition, subdued the ivy, introduced light and air [Fig. 88]. There is a vista now between the arches, which in Girtin had precisely "confounded the perspective," and Girtin's token logpile has been replaced by the Turner foreground profusion, noticed by Ruskin in *Modern Painters*.

It is likely that Wordsworth and Dorothy had the *Wye Tour* with them in July 1798, when, two months after Thelwall's article, they paid their memorable visit to Tintern. Wordsworth had been there five years earlier in a very agitated state of mind, separated from Annette Vallon and their child Caroline (whom he had never seen), anguished by the injustice of the war and his own political impotence. In 1798, the separation continued, as did the war that was its cause, but much had changed. The previous year had been spent in the inspiring company of Coleridge at Alfoxden in Somerset, and the Wordsworths had just taken copy for *Lyrical Ballads* to the publisher in Bristol. The new mood is to be felt at the opening of *Tintern Abbey* in the delicacy of a borrowing from Gilpin:

> Five years have passed—five summers, with the length
> Of five long winters—and again I hear
> These waters rolling from their mountain-springs
> With a sweet inland murmur. Once again

> Do I behold these steep and lofty cliffs,
> Which on a wild secluded scene impress
> Thoughts of more deep seclusion, and connect
> The landscape with the quiet of the sky.

(lines 1–8)

Gilpin had observed that smoke from the fires of charcoal-burners, "spreading its thin veil over" the hills, "beautifully breaks their lines, and unites them with the sky." The Wordsworth of *An Evening Walk* would have worked the detail into a verbal picture, but he is now seeking harmonies that go beyond the pictorial. Few would doubt that he has created a way, or a sense, of experiencing the natural scene; and yet his lines, in their fusions and transferences, defy any logic but their own. Cliffs impress thoughts not upon the mind, but on the "wild secluded scene," and in the process connect the landscape not with the sky, but

87. Thomas Girtin, *Tintern Abbey,*
c. 1793 [Cat. no. 177].
Girtin aged about eighteen,
and still apprenticed to
the topographical draughtsman
Edward Dayes

88 (*right*). J. M. W. Turner,
Interior of Tintern Abbey, 1794
[Cat. no. 189].
Turner aged about nineteen, and working
still within the picturesque tradition

with its quietness. It is the same with the passage quoted earlier which throws into relief the gap between the picturesque and the new Wordsworthian sublime:

> I cannot paint
> What then I was: the sounding cataract
> Haunted me like a passion; the tall rock,
> The mountain, and the deep and gloomy wood,
> Their colours and their forms, were then to me
> An appetite—a feeling and a love
> That had no need of a remoter charm
> By thought supplied, or any interest
> Unborrowed from the eye.
>
> (lines 76–84)

The cataract, the tall rock, the mountain, the deep and gloomy wood, might all of them have been merely stage-props of the picturesque. For Gilpin, "Their colours and their forms" would have been the raw materials of a painting. Wordsworth has moved into quite another realm. A waterfall which in earlier days would have been part of a set-piece description has broken free and is gifted with the power to "haunt." The ghostly metaphor is surprising enough, but we are then told in the simile that follows that the cataract does its haunting like a human emotion. Rock, mountain, and wood are experienced not for themselves, or for their pictorial qualities, but as a craving for nourishment, a feeling, a form of love.

At the centre of *Tintern Abbey* is the interplay of memory and imagination. The full title of the poem—*Lines Written a Few Miles above Tintern Abbey, on Revisiting the Banks of the Wye during a Tour, July 13, 1798*—contains a number of different implications. Contemporary readers would have observed that the writer was on a picturesque tour, yet not at the established beauty-spot, which was the Abbey itself. They would also have noticed the date, which is the eve of Bastille Day, and been able to place the poem in a literary tradition of poets (Akenside, Warton, Bowles, Coleridge) "revisiting" rivers of their youth. They could not have known that for Wordsworth 13 July had special associations, as the day on which he had first landed in France (then "standing on the top of golden hours"). And they could not have guessed either what form his memories would take, or what might be their effect within the mind.

Standing beneath his dark sycamore, at a spot where he had stood five years before, Wordsworth feels (like Elizabeth Bennet) that his memory of the scene should match the facts:

> And now, with gleams of half-extinguished thought,
> With many recognitions dim and faint,
> And somewhat of a sad perplexity,
> The picture of the mind revives again
> While here I stand, not only with the sense
> Of present pleasure, but with pleasing thoughts
> That in this moment there is life and food
> For future years.
>
> (lines 59–66)

89. Cornelius Varley, *The River Wye*,
1803 [Cat. no. 194].
The landscape of
Wordsworth's *Tintern Abbey*

Tintern Abbey is a transitional poem. Later Wordsworth will answer boldly that the imagination has its own laws—that "spots" of past time, working within the mind, exert their nourishing and restorative effect positively because of the changes that go on. At this point, however, though he agrees with Gilpin that the artist may consciously decide to remodel, he is surprised by the activities of the unconscious. The more so, since these particular memories have played such an important part in his emotional life:

> Though absent long,
> These forms of beauty have not been to me
> As is a landscape to a blind man's eye;
> But oft, in lonely rooms, and mid the din
> Of towns and cities, I have owed to them
> In hours of weariness sensations sweet
> Felt in the blood, and felt along the heart. . . .
>
> (lines 23–29)

As early as his 1790 tour of France and the Alps, Wordsworth had written to Dorothy of a habit of storing his mind with pictures—putting them aside for the future. "At this moment," he concludes,

when many of these landscapes are floating before my mind, I feel a high enjoyment in reflecting that perhaps scarce a day of my life will pass in which I shall not derive some happiness from these images.

In *Tintern Abbey* something much stranger and more vital is being claimed. The memories are of a scene which he had not thought of in

picturesque terms, or consciously stored up. And instead of merely giving happiness (like mental holiday-snaps), they have induced in him— apparently at different times, and in different places—a "serene and blessed mood" of which he had not originally been capable.

The poet is telling us of powers within the human mind that he cannot himself fully comprehend, but which he feels to be of immense import- ance to us all:

> Nor less, I trust,
> To them I may have owed another gift,
> Of aspect more sublime: that blessed mood
> In which the burden of the mystery,
> In which the heavy and the weary weight
> Of all this unintelligible world,
> Is lightened—that serene and blessed mood
> In which the affections gently lead us on,

90. John Keats, *Poems*, 1817 [Cat. no. 81]. Keats' first publication, inscribed in his own hand "To W Wordsworth with the Author's sincere Reverence"

Poems,

BY

JOHN KEATS.

" What more felicity can fall to creature,
" Than to enjoy delight with liberty."
Fate of the Butterfly.—SPENSER.

LONDON:
PRINTED FOR
C. & J. OLLIER, 3, WELBECK STREET,
CAVENDISH SQUARE.

1817.

Until, the breath of this corporeal frame
And even the motion of our human blood
Almost suspended, we are laid asleep
In body and become a living soul,
While, with an eye made quiet by the power
Of harmony and the deep power of joy,
We see into the life of things.

(lines 36–50)

No wonder Keats thought of Wordsworth's imagination in *Tintern Abbey* as exploring "dark passages" in the "mansion" of human existence. "Now, if we live," he writes poignantly in 1818,

. . . we too shall explore them. He is a genius, and superior [to] us in so far as he can, more than we, make discoveries, and shed light in them. Here I must think that Wordsworth is deeper than Milton. . . .

It is a moving humbleness in the face of what, for Wordsworth's contemporaries, was the central Romantic poem. To us *The Prelude*, because of its larger scope, must seem greater still, but only Coleridge and De Quincey knew the work in manuscript, and it was not published until after Wordsworth's death in 1850. *Tintern Abbey*, with its

91. J. M. W. Turner, *Yellow Sunset*,
c. 1845–1850 [Cat. no. 192]

sense sublime
Of something far more deeply interfused,
Whose dwelling is the light of setting suns,

> And the round ocean, and the living air,
> And the blue sky, and in the mind of man . . .
>
> (lines 96–100)

was the supreme embodiment of Romantic faith.

 Man and Nature were seen to be bonded in a total harmony, permeated by a single life-force—

> A motion and a spirit that impels
> All thinking things, all objects of all thought,
> And rolls through all things.
>
> (lines 101–103)

It is, broadly speaking, the faith that Coleridge had expressed in *Frost at Midnight*:

> that eternal language which thy God
> Utters, who from eternity doth teach
> Himself in all, and all things in himself.
>
> (lines 60–62)

And it is to be found in different forms in Byron's *Childe Harold*, Shelley's *Mont Blanc* and *Adonais*. But only in *Tintern Abbey* is it associated with the human capacity to learn from experience. "For I have learned," Wordsworth tells us in his most compelling tones,

> To look on Nature not as in the hour
> Of thoughtless youth, but hearing oftentimes
> The still, sad music of humanity,
> Nor harsh, nor grating, though of ample power
> To chasten and subdue.
>
> (lines 89–94)

 A year after his discussion of the "dark passages" of *Tintern Abbey*, Keats writes to his brother and sister-in-law in America:

 Do you not see how necessary a world of pains and troubles is to school an intelligence and make it a soul?—a place where the heart must feel and suffer in a thousand diverse ways!

The heart, he continues, "is the mind's bible, it is the mind's experience." Prompted by the heart, the mind becomes fully responsive. It is the same pattern of suffering, leading to thoughtfulness and heightened aware-ness, that we find in the great final lines of Wordsworth's *Intimations*:

> The clouds that gather round the setting sun
> Do take a sober colouring from an eye
> That hath kept watch o'er man's mortality. . . .
> Thanks to the human heart by which we live—
> Thanks to its tenderness, its joys, and fears—
> To me the meanest flower that blows can give
> Thoughts that do often lie too deep for tears.
>
> (lines 199–206)

 It seems not unreasonable to associate the "sense sublime / Of something far more deeply interfused" in *Tintern Abbey* with the emergence of Romanticism; but to do so will depend upon our sense of the

sublime, our sense of Romanticism, not upon a definition of either term. As Burke put it, "A clear idea is . . . another name for a little idea," and one thing that the sublime and Romanticism certainly have in common is their association with grandeur. In general, it must be said, Burke's distinctions are not especially useful. His emphasis on terror may help us when considering the frightened child of the *Prelude* "spots of time," but more usually it is Longinus' sense of awe—"the soul is raised by true sublimity, it gains a proud step upwards"—that seems to be relevant. In the great Romantic achievements this awe, though it may initially imply human littleness in the face of the vast, comes, through the exertion of the artist himself, to be an exaltation of "man's unconquerable mind."

The poets who were Wordsworth's immediate predecessors (Gray, Collins, Goldsmith, Cowper) were all of them important to him, and all distinguished writers. Gray's *Bard* (the subject of John Martin's high Romantic painting of 1817 [Fig. 92]) does attempt the Burkean sublime—

92. John Martin, *The Bard*, 1817 [Cat. no. 84]. Detail of Figure 27

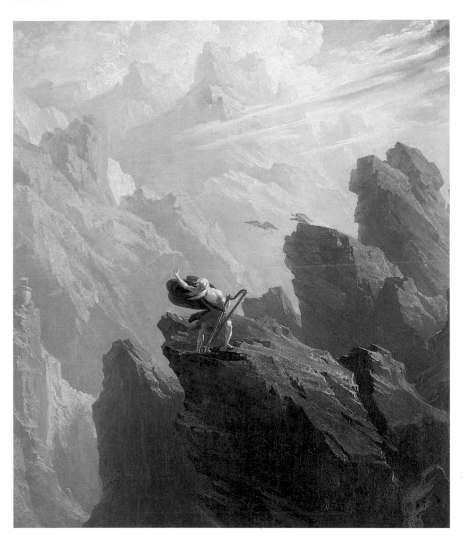

> On dreary Arvon's shore they lie,
> Smeared with gore and ghastly pale;
> Far, far aloof the affrighted ravens sail,
> The famished eagle screams and passes by . . .

(lines 35–38)

93–95 (*left and opposite*). Alexander Cozens,
*A New Method of Assisting the Invention
in Drawing Original Compositions of Landscape,*
Plates 22–24, *c*. 1785 [Cat. nos. 171–173].
Three stages of a Cozens "blot"

—but no poet in the fifty years before Blake and Wordsworth achieves the
sublimity that is found in certain of the artists. Perhaps the spirit of the
age was not conducive. Writers who attempted the sublime worked in the
shadow of Milton, finding him for the most part an inhibition rather than
a challenge. Painters could look abroad for stimulus. In Italy they found
both an opportunity to confront the natural sublime and the chance to
learn from continental predecessors.

Alexander Cozens, who arrived in Italy as early as 1746, has the dis-
tinction of exerting a powerful influence on no fewer than three great
artists: his son (John Robert Cozens), Wright, and Constable. Inspired by
the Italian light, and painting sometimes in oils, sometimes in ink and
wash, the elder Cozens created a massiveness in the handling of shadow
that was truly sublime. Though a teacher throughout his career, and
author of a series of publications that sought to hand on his experience,
he was preoccupied with the need to free the imagination. The *New
Method of Assisting the Invention in Drawing Original Compositions of
Landscape* (1785) is his final attempt. "It cannot be doubted," he writes,
"that too much time is spent in copying the works of others, which tends
to weaken the powers of invention." Then, when one expects him to say,
turn to Nature, he says the opposite: "and I do not scruple to affirm, that
too much time may be employed in copying the landscapes of Nature
herself."

The celebrated, and ridiculed, system of "blotting," which Cozens had
first described in an essay of 1759, provides the student with suggestions,
but is designed to counter the dependence on "copying." Confronted by a
series of rapid, non-representational (though not haphazard) brush-
strokes on a piece of paper, he is forced to construct a landscape of the
mind [Figs. 93–95]. It was in the massing of light and shade that Cozens'
own genius lay, and this was what the blot above all suggested. The fact
that Wright, in his fifties, bothered to develop Plate 43 of the *New
Method*, and that Constable made detailed copies of the sky studies in

1823 [Fig. 96], when he had already completed his own vastly more impressive examples, shows the power that Cozens' ideas had over established professionals as well as students. The great tribute to his teaching, however, must be the work of his son; "He was the greatest genius that ever touched landscape" was Constable's comment— "Cozens was all poetry."

John Robert Cozens visited Italy twice, in 1776–1779 with Payne Knight (later analyst of taste and the picturesque) and in 1782 with William Beckford, author of the early Gothic romance *Vathek*, and builder of the largest folly of the age, Fonthill Abbey (which collapsed). As a draughtsman, John Robert takes on where his father left off, carrying back to the scenes that his patrons wished to record the imaginative response which Alexander had thought to be deadened by the copying of

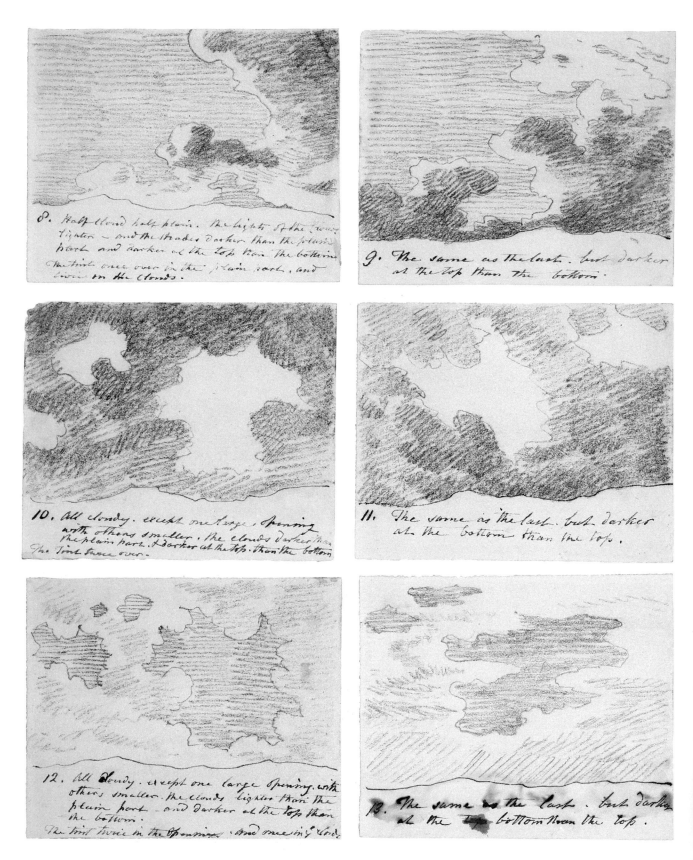

96. John Constable,
Sky Studies after Alexander Cozens (nos. 8–13),
c. 1823 [Cat. no. 160]

Nature. Adopting a subdued palette of blues, greys, and browns (and occasionally pink, to hint at the sunsets that he especially enjoyed), he caught the changes of Italian weather and light with a subtlety and sensitivity reminiscent of Claude. For Beckford especially, he produced magnificent views of Alpine storm and sublimity; but alongside these are

watercolours of the uttermost composure and tranquillity. His last dated drawings belong to 1792, when he was thirty-nine. A year later, what Farington termed "his silent, hesitating disposition and . . . grave manners" lapsed into insanity, and in December 1797, eight months before the writing of *Tintern Abbey*, he was dead.

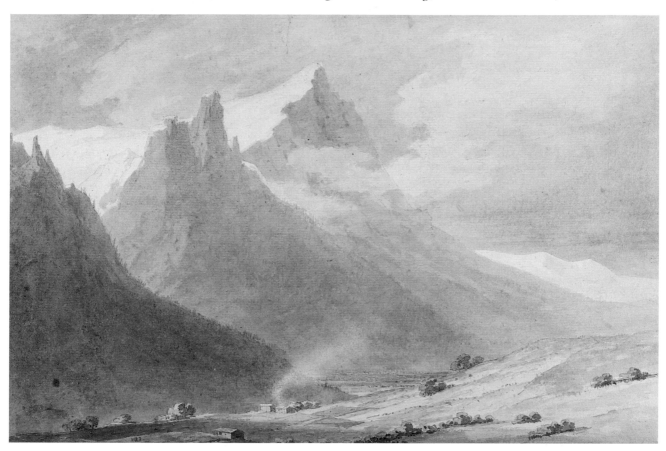

97. John Robert Cozens,
In the Canton of Unterwalden,
c. 1780 [Cat. no. 278]

It is easy to feel, as one stands before the Alpine scenes of Cozens, that "the sounding cataract" had "Haunted him like a passion." Through his father, he had grown up amid theoretical discussion, but, like Wordsworth, rooted in the picturesque, he had come to a discovery of Nature that was all his own. He had no pupils (or none to speak of), and he made only one forlorn attempt to publish. One of his finest Tyrol watercolours, however, was owned by Constable (whose patron, Beaumont, had been Alexander's pupil at Eton, and sketched with John Robert in Rome), and by an odd chance his work was an influence at an important moment in their lives on Girtin and Turner.

Dr. Thomas Monro, who ran the asylum in which Cozens spent his last years, was a distinguished collector of watercolours. In 1793 or 1794, he engaged Girtin and Turner to make copies for him in the evenings, chiefly, it seems, from the work of J. R. Cozens. Surprisingly, it was a cooperative effort. Farington notes in his *Diary* in 1798:

> They went at six and stayed till ten. Girtin drew in outlines, and Turner washed in the effects. They were chiefly employed in copying the outlines or unfinished drawings of Cozens, etc. etc., of which copies they made finished drawings. Dr. Monro allowed Turner 3s. 6d. each night. Girtin did not say what he had.

As their drawings at Tintern Abbey show, the two men were accomplished draughtsmen at the beginning of their period with Monro. Cozens' influence is not easy to pin down, but to have been exposed to the greatest of their predecessors for so long, at a time when their own skills were rapidly expanding, was an extraordinary apprenticeship.

There were of course other, less tangible, influences in this post-revolutionary moment that helped to produce a new impulse in watercolour painting, just as they helped to produce a new impulse in poetry. In a private context, Wordsworth had announced the change in *To My Sister* [Cat. no. 208], written for *Lyrical Ballads* in March 1798:

> There is a blessing in the air
> Which seems a sense of joy to yield
> To the bare trees, and mountains bare,
> And grass in the green field. . . .
>
> Love, now an universal birth,
> From heart to heart is stealing—
> From earth to man, from man to earth—
> It is the hour of feeling!
>
> One moment now may give us more
> Than fifty years of reason;
> Our minds shall drink at every pore
> The spirit of the season.
>
> (lines 5–8, 21–28)

In part, the change was one of expression. Wordsworth had—or found, because he needed it—the power of language that Marianne yearned for:

> I detest jargon of every kind; and sometimes I have kept my feelings to myself, because I could find no language to describe them in but what was worn and hackneyed out of all sense and meaning.

98. John Varley,
View from Polsden near Bookham in Surrey,
1800 [Cat. no. 195]

Wordsworth's Preface to *Lyrical Ballads*, first published in the 1800 edition, is about a quest for language that is not "worn and hackneyed out of all sense and meaning"—language that has its roots in a truer relationship to the natural world, and will therefore be the natural expression of feeling. Strangely, the moment at which he found this new unartificial mode coincides exactly with the break-through made by the watercolourists of the day. The elaborately inscribed *View from Polsden near Bookham in Surrey, Made in Company with Dr. Monro by J. Varley, Oct. 1800, Study from Nature* [Fig. 98] offers with unusual clarity the transition between eighteenth-century and Romantic watercolour. To the left stands a group of trees that might have been painted by Paul Sandby (whose *Ancient Beech-Tree, Windsor Great Park* (1797) [Fig. 99] is a loving portrait by one of the founders of English watercolour, in an idiom that has not changed dramatically in fifty years). To the right, all is Girtin. The inscription is there to tell us what has taken place. In the days when Girtin and Turner were copying for Monro, they had probably been

99. Paul Sandby,
Ancient Beech-Tree, Windsor Great Park,
1797 [Cat. no. 185].
By one of the founders
of English watercolour, and a major
influence in the fifty years leading up
to the Romantic period

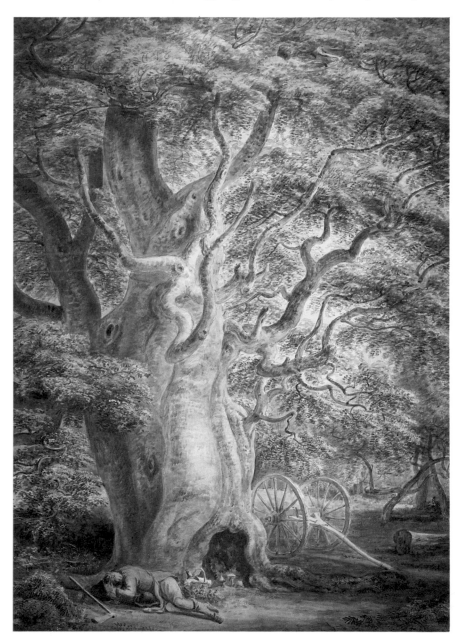

the only artists present. His evenings have expanded now to form an "academy" for young painters, at which they learned (inevitably) of the genius of Cozens, and the new developments of Girtin. On this particular occasion, Dr. Monro has extended his role; we see one of his protégés making a daylight "study from Nature."

At the beginning of Wordsworth's Great Decade, 1797–1806, Girtin and Turner (aged twenty-two) were just coming into their own;

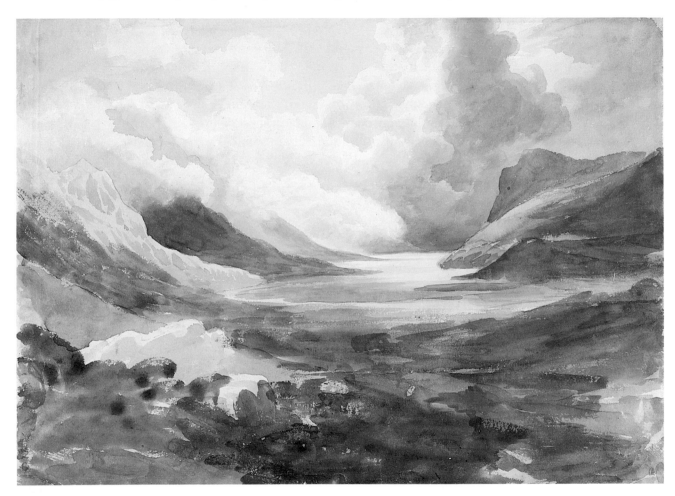

Constable was twenty-one, and a slow starter by comparison; John Varley was nineteen, and his more original younger brother, Cornelius, sixteen; John Sell Cotman was fifteen, David Cox fourteen, Peter De Wint thirteen. At the end of the Great Decade, Girtin—in some ways the most promising of them all—was dead. His influence, however, was stronger than ever, and wholly beneficial. Turner, though not admired by all, had exhibited the magnificent *Dolbadern Castle* [Fig. 1] as early as 1800, and gone on to become the major landscape painter of the day. Constable was on tour in the Lake District, creating (with Girtin in mind) some of his boldest watercolours; Cox, who had already begun to exhibit at the Royal Academy, was in Wales (scene of his late Romantic masterpieces of the 1840s and 1850s). Cornelius Varley, painter of the *River Wye* and the inspired *Llyn Gwynant, North Wales* (c.1803) [Figs. 89 and 100], was probably at his peak. John Varley had already produced his most original work, but was at this time an important link between De Wint (now his neighbour) and Girtin. For Cotman, 1806 was the year of *Hell Cauldron*

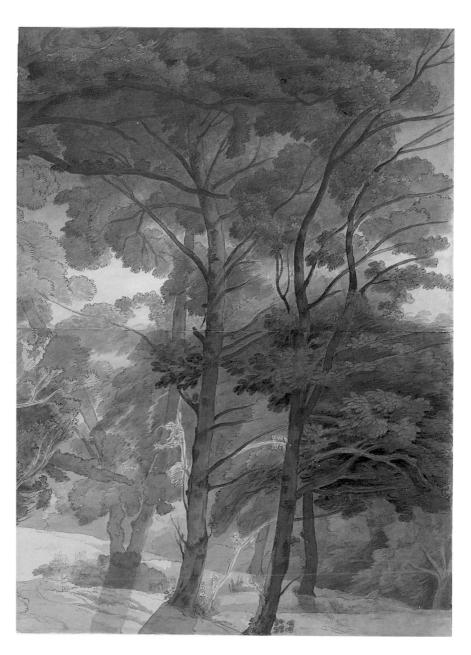

100 (*left*). Cornelius Varley,
Llyn Gwynant, North Wales,
c. 1803 [Cat. no. 300]

101 (*right*). Francis Towne,
Trees at Peamore Park,
1804 [Cat. no. 187]

[Fig. 78], based on his visit to Rokeby and the Yorkshire Greta. In the imaginative sympathy of his Duncombe Park and Greta drawings of 1805–1806 we see one of the highest achievements of Romanticism.

Of course not everything changed. George Crabbe, and a host of minor poets, continued to write in an earlier idiom. Towne (*Trees at Peamore Park,* 1804 [Fig. 101]) and his pupil John White Abbott (*Canonteign, Devon,* 1803 [Fig. 80]) were two among many watercolourists whose vision and technique were untouched, but who could at the height of the new age produce exquisite eighteenth-century drawings. To place these beside Cotman's *In Rokeby Park* or *Greta Woods* [Fig. 102] is to see an astonishing development. Cotman too is fascinated by the play of light, but where the colours of Towne and Abbott are translucent, and distance is achieved by a succession of planes, he is able to create an effect of sunlight dappled and filtered through a profusion of branches, stems, and leaves. Washes of a single colour are laid one above the other, but never permitted to merge, resulting in a gradation of colour and interplay of

102. John Sell Cotman, *Greta Woods*, 1805–1806 [Cat. no. 167]

shadow and light that catch the atmosphere of English woodland as no one else has ever done. Cotman modestly referred to his Greta drawings as "coloured from Nature, and a close copy of that fickle Dame."

"I have been running after pictures, and seeking the truth at second hand," Constable wrote in May 1802:

> however one's mind may be elevated, and kept up to what is excellent, by the works of the great masters, still Nature is the fountain's head, the source from whence all originally must spring.

Thirty-three years later, in *English Landscape Scenery* [Cat. no. 65], he was to comment:

> In art, as in literature, there are two modes by which men endeavour to attain the same end, and seek distinction. In the one, the artist, intent only on the study of departed excellence, or on what others have accomplished, becomes an imitator of their works, or he selects and combines their various beauties; in the other he seeks perfection at its PRIMITIVE SOURCE, NATURE.

It sounds as if there is no more to be said. Constable's art is drawn from the well of Nature, and that is that.

Something of the kind was perhaps true of the watercolours and woodcuts of Thomas Bewick, working in isolation in Newcastle [Figs. 103 and 104]. For the rarer birds and quadrupeds he had to follow books, but he used specimens wherever it was possible, and (as he himself recognized) his genius lay in the "*tale*-pieces" and backgrounds—*Dog and*

103 (*below left and right*).
Thomas Bewick,
Skylark, c. 1792–1797 [Cat. no. 148].
Preparatory watercolour
and wood engraving

104 (*above left and right*).
Thomas Bewick,
Dog and Pan, c. 1800 [Cat. no. 149].
Preparatory watercolour and wood engraving

Pan, The Pigsty Netty [Cat. nos. 150, 152]—for which he could turn directly to the countryside he loved. In a very different context, Samuel Palmer, though surrounded by a litany of painters (William Stothard, John Linnell, George Richmond, John Varley, William Mulready, Edward Calvert), and inspired by Blake's illustrations to Thornton's *Virgil*, does indeed during the brief Shoreham period go to Nature as the primitive source. To us the masterpieces, such as *The Bright Cloud* and *Pastoral with*

105 (*left*). Samuel Palmer, *The Bright Cloud*, c. 1830–1840 [Cat. no. 180]

106 (*right*). Samuel Palmer, *Pastoral with a Horse-Chestnut Tree*, c. 1830–1832 [Cat. no. 181]

a Horse-Chestnut Tree [Figs. 105 and 106], portray a visionary landscape; to Palmer they portrayed the world that was before his eyes. For the central Romantic figures, there was never quite this immediacy. Spontaneity was qualified. Originality consisted not least in engaging with tradition.

"All good poetry is the spontaneous overflow of powerful feelings," Wordsworth writes in the 1800 Preface. He then proceeds to modify his too attractive statement:

> but though this be true, poems to which any value can be attached were never produced on any variety of subjects, but by a man who, being possessed of more than usual organic sensibility, had also thought long and deeply.

Constable in his comments from *Landscape Scenery* follows precisely the same course. On second thoughts, the artist who "seeks perfection at its PRIMITIVE SOURCE, NATURE" is redefined as one whose study is "founded in art," but "pursued" in the more expansive field of the natural world. From a combination of the two modes of experience, he "forms a style which is original . . . adding to the art, qualities of Nature unknown to it before." It is Constable's visit to Sir George and Lady Beaumont at Coleorton Hall in autumn 1823 that best shows his relation to the past:

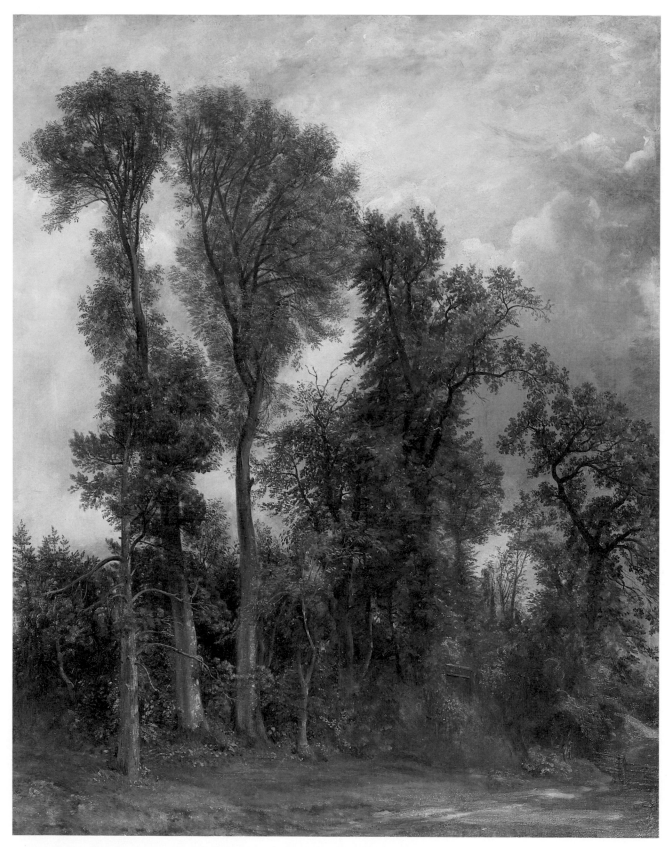

O, when I think of the "ancient masters" I am almost choked in this breakfast-room. Here hang 4 Claudes, a Cozens and a Swanevelt. The low sun in the morning sets them off to great advantage.

Two of the Claudes he had copied in the previous weeks. On the first, he comments:

I have a little Claude in hand, a grove scene of great beauty, and I wish to make a nice copy from it, to be useful to me as long as I live. It contains almost all that I wish to do in landscape.

Constable, who the previous year had painted the great *Trees at Hampstead* [Fig. 107], with its bold diagonal composition and masterly relation of tree-forms, is full of generous admiration and eagerness to learn. During the same visit he probably copied the twenty cloud studies of Beaumont's tutor, Alexander Cozens (issued with the *New Method*), together with the sixteen earlier plates of his *Various Species of Composition of Landscape in Nature*. Clearly he was making the most of this chance to stockpile information—not so much about art as about how artists of the past had responded to Nature. The willingness to learn is especially remarkable when one considers the beauty and power of Constable's own "skying" at Hampstead in 1821–1822. *Study of Sky and Trees* [Fig. 108]

107 (*left*). John Constable,
Trees at Hampstead: The Path to Church,
1822 [Cat. no. 165]

108 (*below*). John Constable,
Study of Sky and Trees,
1821 [Cat. no. 164]

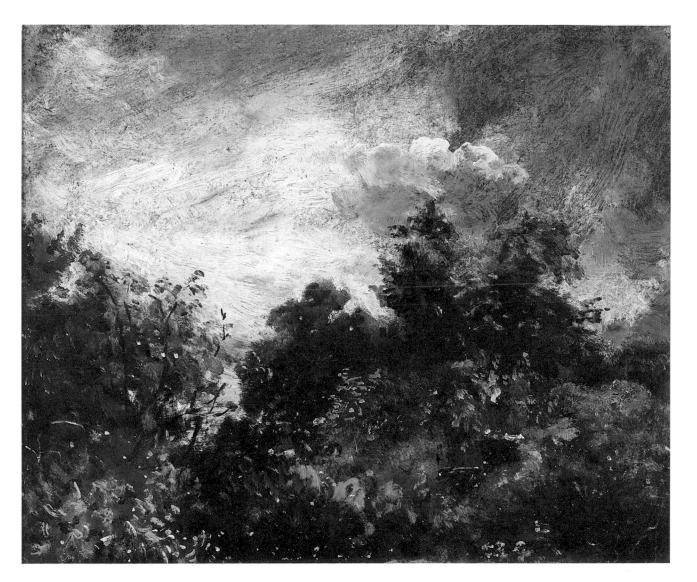

shows the potential of the oil sketch to catch a moment of fluidity and change. The whole picture is full of energy and motion. Yet it is not at all surprising that Constable should have written in the same year of the sky as "the chief organ of sentiment," the "source of light" in Nature, that

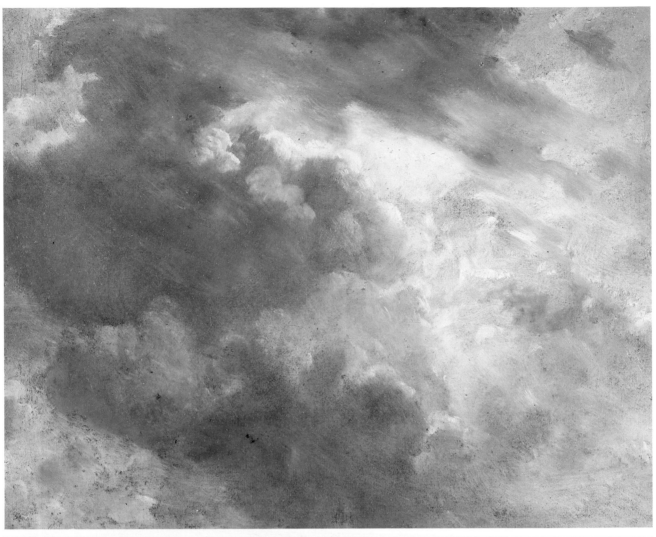

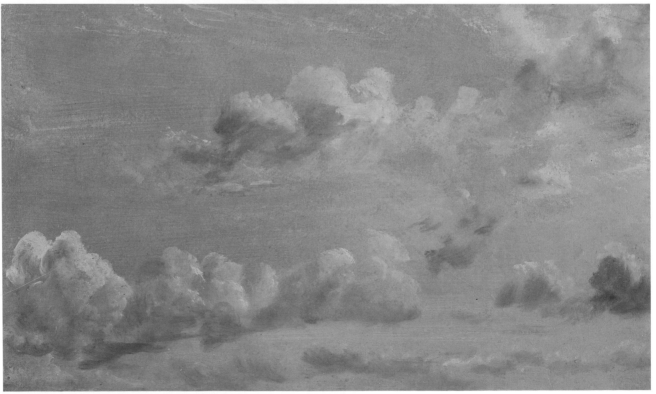

109 (*left*). John Constable,
Study of Clouds,
1821 [Cat. no. 162]

110 (*below left*). John Constable,
Study of Cumulus Clouds,
1822 [Cat. no. 163]

governs everything. *Study of Clouds* and *Study of Cumulus Clouds* [Figs. 109 and 110] are two of a magnificent series, now dispersed, that recall at times the tranquillity of Keats' *To Autumn*—

> While barred clouds bloom the soft-dying day,
> And touch the stubble plains with rosy hue . . .
>
> (lines 25–26)

—at times the passionate Shelley of *Ode to the West Wind*:

> Thou on whose stream, mid the steep sky's commotion,
> Loose clouds like earth's decaying leaves are shed,
> Shook from the tangled boughs of heaven and ocean. . . .
>
> (lines 15–17)

On the title-page of the *New Method* Cozens offered a quotation from *The Winter's Tale* that must have appealed to Constable:

> this is an art
> Which does mend Nature—change it rather; but
> The art itself is Nature.
>
> (IV. iv. 95–97)

In their cloud studies both painters were creating a natural art—an imaginative rendering that was neither scientific analysis nor the "copying" that Cozens distrusted. Wordsworth had traced in landscape "an ebbing and a flowing mind, / Expression ever varying," but it is the sky that is the obvious symbol of mental process. Thoughts pass across the mind—pause, merge, vanish—like clouds. The image is implicit in *The West Wind*, and forms the starting-point of the best-known of English poems, Wordsworth's *Daffodils*:

> I wandered lonely as a cloud
> That floats on high o'er vales and hills,
> When all at once I saw a crowd,
> A host of golden daffodils—
> Along the lake, beneath the trees,
> Ten thousand dancing in the breeze.
>
> (lines 1–6)

Dorothy, in the *Journal* entry of April 1802 that is the source for her brother's poem [Fig. 111], had described the flowers in exquisite prose, providing him ready-made with many of his images:

> I never saw daffodils so beautiful; they grew among the mossy stones, about and about them. Some rested their heads upon these stones as on a pillow for weariness, and the rest tossed and reeled and danced, and seemed as if they verily laughed with the wind that blew upon them over the lake, they looked so gay, ever glancing, ever changing.

It is hard to think that Wordsworth's poem is better than this account; but it is different in one very important way.

Daffodils, like all the greatest Romantic art, is about the mind. Dorothy is a presence in her prose—we are vividly aware of her discerning eye and

creative use of language—but Wordsworth takes the creative process as
his subject:

> The waves beside them danced, but they
> Outdid the sparkling waves in glee—
> A poet could not but be gay
> In such a laughing company.
> I gazed and gazed, but little thought
> What wealth the show to me had brought.
>
> For oft when on my couch I lie,
> In vacant or in pensive mood,
> They flash upon that inward eye
> Which is the bliss of solitude,
> And then my heart with pleasure fills
> And dances with the daffodils.

(lines 7–18)

Detaching himself entirely from the particular walk on which he and
Dorothy together had seen the daffodils of Ullswater, the poet lets his
thought float cloud-like over the landscape. Like the "forms of beauty" at
Tintern Abbey, the flowers that he encounters have their existence as a
picture in the mind—a picture that he can revisit to live again the original
pleasure of a moment. Most treasured, though, are the times when

pleasure comes unwilled, and the daffodils flash suddenly "upon that inward eye / Which is the bliss of solitude."

"Make me thy lyre, even as the forest is," Shelley implores the creative spirit of the *West Wind*:

> Drive my dead thoughts over the universe
> Like withered leaves to quicken a new birth!

> (lines 63–64)

The mind of the poet is to be seen, as in Coleridge's *Eolian Harp* (1795) [Cat. no. 157], partly as the wind-harp, played upon by inspiration (to be equated more or less directly with the breath of God), partly as the active power of imagination that is stirred to respond. Recording a moment of special importance in his poetic life, Wordsworth wrote in the "Glad Preamble" of *Prelude*, Book One [Fig. 112]:

> For I, methought, while the sweet breath of heaven
> Was blowing on my body, felt within
> A corresponding mild creative breeze,

111 (*left*). Dorothy Wordsworth, Grasmere *Journal*, 15 April 1802 [Cat. no. 196].
Dorothy's account of the daffodils by Ullswater, which two years later became the source of her brother's most famous poem

112 (*right*). William Wordsworth, the "Glad Preamble" [Cat. no. 200].
The opening of *The Prelude* in a fair-copy manuscript of 1816–1819:

Oh there is blessing in this gentle breeze,
That blows from the green fields and from
the clouds . . .

A vital breeze which travelled gently on
O'er things which it had made, and is become
A tempest, a redundant energy,
Vexing its own creation.

(lines 41–47)

At first the imagination responds to external stimulus in a way that is comparable, appropriate, but then it takes over. The poet is driven on, "vexed," by his own creative power.

By chance it was in the same year as the "Glad Preamble" that Farington noted in his *Diary*: "Turner has no settled process, but drives the colours about till he has expressed the idea in his mind." Nothing could more perfectly display a vexing creative energy. Farington is no ignorant observer. He knows all the painters of his day, and has seen all the techniques that are practised. His own rough sketches with a pencil can be astonishingly free. Yet he is left feeling helpless wonderment by the power that takes over as Turner "drives the colours about," refusing to conform to "settled process" in the laying on of washes, or the shaping of composition.

No generalizations apply to Turner's art, and no critic, save Ruskin, has begun to do him justice. Like Constable, and so many of the Romantic poets, he was too powerful, too original, to be fashionable. His many publishing ventures—the *Picturesque Views of the Southern Coast* (1814–1826), *Picturesque Tour in Italy* (1818–1820), *Provincial Antiquities of Scotland* (1819–1826), the ninety-six completed plates of *Picturesque Views in England and Wales* (1827–1838), the illustrations to

113 (*below*). J. M. W. Turner, *Llanthoney Abbey*, 1834 [Cat. no. 190]

114 (*above right*). J. M. W. Turner, *Inverary Pier, Loch Fyne, Morning*, c. 1840–1850 [Cat. no. 293]

115 (*right*). J. M. W. Turner, *Figures on a Wet Shore*, c. 1835–1840 [Cat. no. 188]

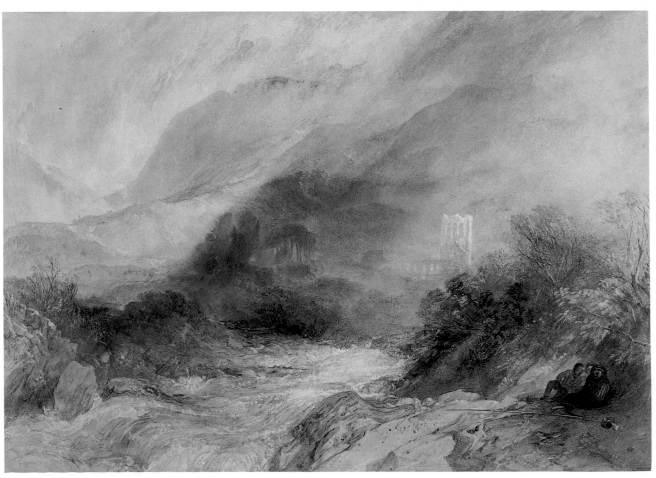

Rogers, Byron, and Scott in the 1830s—were attempts to reach out to a wider audience, but few concessions were made to popular taste. Even in a work such as *Llanthoney Abbey* [Fig. 113] that falls clearly within the topographical tradition, the building (still thought of by his publishers as "picturesque") is of far less importance than the atmosphere, and the light that cuts a diagonal swathe across the landscape. Only Ruskin, who once owned the picture, could find words to praise the "hurrying, fitful, wind-woven sunlight, which glides through the thick leaves, and paces along the pale rocks like rain."

The last twenty years of Turner's life are responsible for compositions such as *Inverary Pier* [Fig. 114] and the "colour beginnings," *Figures on a Wet Shore* and *Yellow Sunset* [Figs. 115 and 91], which show how far the artist's original and subjective vision of the world could depart from naturalism in order to reveal an underlying reality. He is no longer "driving" his colours about as in the early days, but the washes, laid on with infinite subtlety, are the portrayal of an "idea" in all its purity. At the same time—as if to show that there is nothing hasty or diaphanous in these slight but exquisite creations—Turner was at work on the great Academy oils that show his response to the changing world, *The Fighting Téméraire* (1839), *The Evening of the Deluge* (1843), *Rain, Steam and Speed* (1844), and many others.

Though his health was failing, Turner travelled a great deal in his final years, and the 1840s are a period of magnificent seascapes. At one extreme is the study of Nature's desolation, emptiness, unremitting power, in *Stormy Sea Breaking on a Shore* [Fig. 116], in which humanity is an irrelevance; at the other, natural grandeur and human depravity unite to form *Slavers Throwing Overboard the Dead and Dying, Typhoon Coming On*, which Ruskin thought "the noblest sea Turner has ever painted":

> Purple and blue, the lurid shadows of the hollow breakers are cast upon the mist of night, which gathers cold and low, advancing like the shadow of death upon the guilty ship as it labours amidst the lightning of the sea, its thin masts written upon the sky in lines of blood, girded with condemnation in that fearful hue which signs the sky with horror and mixes its flaming flood with sunlight, and—cast far along the desolate heave of the sepulchral waves—incarnadines the multitudinous sea.

We are left to complete for ourselves the *Macbeth* quotation:

> this my hand will rather
> The multitudinous seas incarnadine,
> Making the green one red.

Till slavery ceases, no washing of the hands will rid us of collusion.

Constable's final years contained no such political insights. In December 1828 Maria died, leaving him with seven children up to the age of eleven, and with an appalling personal grief: "Hourly do I feel the loss of my departed angel. . . . I shall never feel again as I have felt; the face of the world is totally changed to me." Painting was an assuagement as well as the inevitable means of supporting the children. If change is

116. J. M. W. Turner,
Stormy Sea Breaking on a Shore,
c. 1840–1845 [Cat. no. 191]

indeed to be seen in the calm and beauty of *Water-meadows at Salisbury* (1829) [Fig. 117], it can only be that love and Christian resignation have led the artist to look more closely than ever at the face of God's world. That the picture should be rejected by the Academy in 1830 as "a nasty green thing" merely added to the humiliation of Constable's being elected an R.A. the previous year by a single vote (after being turned down again and again since becoming an Associate in 1819). It cannot be said that his determination to be himself was in any way impaired. The oil sketch *A Farmhouse near the Water's Edge* [Fig. 118] shows him in this last period experimenting with colour, and a new brilliancy of light that flickers across the foliage of the riverside elms.

It tells us much about Constable's frame of mind that two of his most impressive later works should be studies of ancient monuments, seen not as picturesque views but as symbolic of human transience. Both are large exhibition watercolours, and both are reminders of happier days in and around Salisbury, before the deaths of Maria and of Archdeacon Fisher (1832). Below *The Mound of the City of Old Sarum* (1834) [Fig. 119] in the version mezzotinted for *English Landscape Scenery* are the words: "'Here we have no continuing city'—St. Paul." As Constable points out in an extended note, Sarum (the original Salisbury) had been deserted by its inhabitants in the twelfth century, when the monks decided to build a new cathedral down on the plain by the River Avon. The quotation from *Hebrews* 13.14, however, gives a far more important resonance: "For here we have no continuing city, but we seek one to come."

Sarum, with its strange silhouette on the horizon above the modern town, is a reminder that only the Eternal City of New Jerusalem withstands the force of time. Yet Constable, one feels, can trace (like the Wordsworth of *The Ruined Cottage*)

> That secret spirit of humanity
> Which, mid the calm oblivious tendencies
> Of Nature, mid her plants, her weeds and flowers,
> And silent overgrowings, still survived. . . .
>
> (lines 503–506)

Ramparts that once encircled a medieval town (and two successive cathedrals) are empty now and overgrown—desolate as the little town of Keats' *Ode on a Grecian Urn*:

> And, little town, thy streets for evermore
> Will silent be, and not a soul to tell
> Why thou art desolate can e'er return.
>
> (lines 38–40)

117 (*above*). John Constable, *Water-meadows at Salisbury*, 1829 [Cat. no. 166]

118 (*above right*). John Constable, *A Farmhouse near the Water's Edge*, 1834 [Cat. no. 158]: "I may yet make some impression with my *light*, my *dews*, my *breezes*, my *bloom* and my *freshness*, no one of which has yet been perfected on the canvas of any painter in the world" (Constable, 1833)

119 (*right*). John Constable, *The Mound of the City of Old Sarum, from the South*, 1834 [Cat. no. 159]

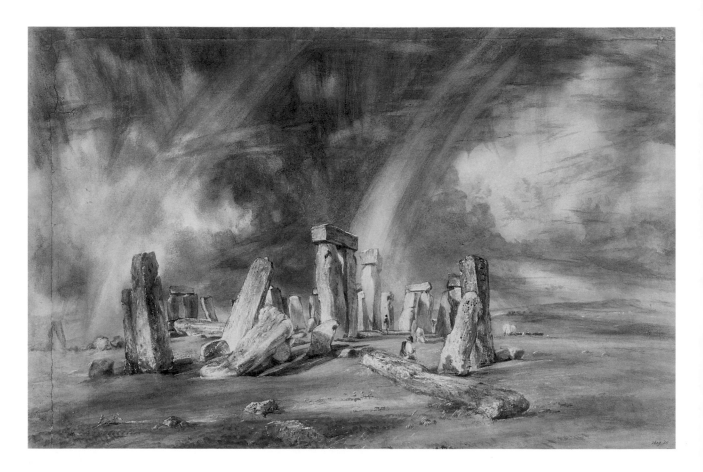

Standing bare and unencroached upon, Stonehenge is too old to be linked with history. Constable's great watercolour [Fig. 120], with its tiny figures for scale and perspective, and its double rainbow (not present in the original pencil drawing of 1820, and surely a symbol of hope), was exhibited at the Academy in 1836. Together with his final version of the Cenotaph at Coleorton (Beaumont's memorial to Sir Joshua Reynolds, with an inscription by Wordsworth [see Cat. no. 63]), *Stonehenge* was the last exhibit of Constable's lifetime. On the mount he wrote:

> The mysterious monument of Stonehenge, standing remote on a bare and boundless heath, as much unconnected with events of past ages as it is with the uses of the present, carries you back beyond all historical records into the obscurity of a totally unknown period.

The "bare and boundless heath" could hardly fail to contain a reference to *King Lear*, but the words themselves recall that greatest of all Romantic monuments to human transience in the face of dispassionate Nature, Shelley's *Ozymandias* [Figs. 121 and 122]:

> I met a traveller from an antique land
> Who said: "Two vast and trunkless legs of stone
> Stand in the desert. Near them on the sand,
> Half sunk, a shattered visage lies, whose frown
> And wrinkled lip, and sneer of cold command,
> Tell that its sculptor well those passions read
> Which yet survive, stamped on these lifeless things
> (The hand that mocked them, and the heart that fed),

120. John Constable, *Stonehenge*, 1836 [Cat. no. 161]: "Thou hoary pile, thou child of darkness deep / And unknown days . . ." (Wordsworth, *Salisbury Plain*)

121 and 122. Percy Bysshe Shelley,
Ozymandias, 1817 [Cat. no. 186].
The original draft and the poet's fair copy

And on the pedestal these words appear:
'My name is Ozymandias, king of kings;
Look on my works, ye mighty, and despair!'
Nothing beside remains. Round the decay
Of that colossal wreck, boundless and bare
The lone and level sands stretch far away.''

The king of kings is powerless now. Nature does not care. Yet there is a
kind of immortality. The sculptor's art defies the erosion of time. However
insignificant he may have seemed to Ozymandias, his has proved to be the
''unconquerable mind.''

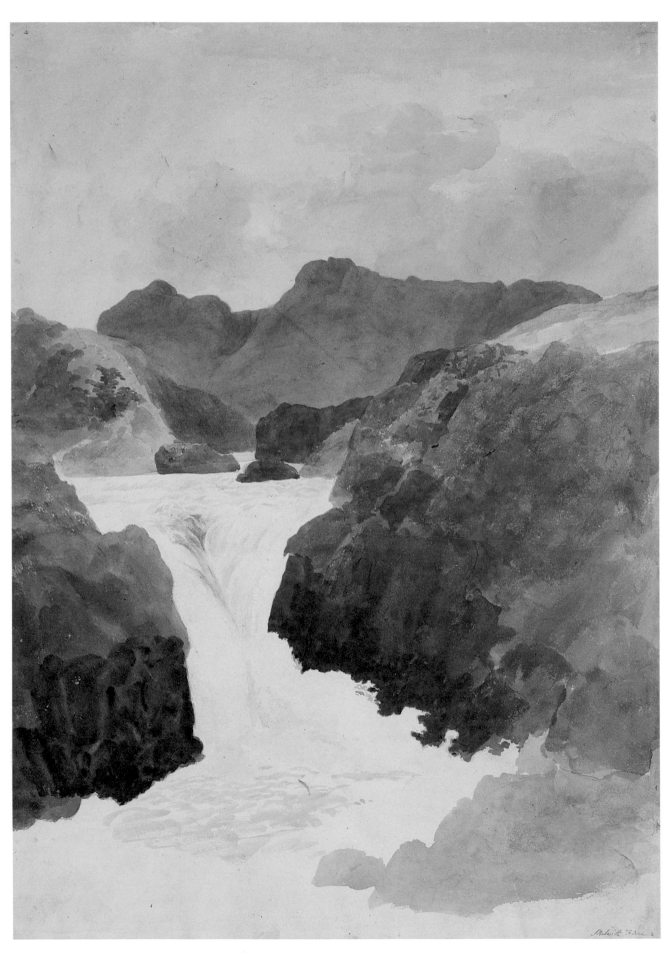

123. Robert Hills, *Skelwith Force*, 1803 [Cat. no. 236]

5 "Unity Entire"

> I wander through each chartered street
> Near where the chartered Thames does flow,
> And mark in every face I meet
> Marks of weakness, marks of woe.
>
> In every cry of every man,
> In every infant's cry of fear,
> In every voice, in every ban,
> The mind-forged manacles I hear:
>
> How the chimney-sweeper's cry
> Every blackening church appalls,
> And the hapless soldier's sigh
> Runs in blood down palace walls;
>
> But most through midnight streets I hear
> How the youthful harlot's curse
> Blasts the new-born infant's tear
> And blights with plagues the marriage hearse.
>
> (William Blake, *London*)

The chimney-sweeper is a child for whom the Church accepts no responsibility, though he will die soon of skin cancer from climbing the hot flues. The soldier's blood is shed in a war for king and country, from which his class can benefit nothing. The harlot passes on to the married world—and to generations yet unborn—the disease that blasts her youth. Blake's vision of London in the *Songs of Experience* [Fig. 124] is no exaggeration. It is the world that he saw about him in 1792. Others, of course, chose to see different things—or to see things differently. Dr. Johnson, who had died eight years earlier, is famous for having commented, "Sir, when a man is tired of London, he is tired of life; for there is in London all that life can afford." Blake was not tired of London; he was merely concerned for those who could not afford what city life afforded to their betters.

James Boswell, who recorded Johnson's remark with his usual devotion (but had the grace also to record, "Sir, you have but two topics, yourself and me. I am sick of both"), filled his *London Journal* with details of his own sexual encounters and terror of syphilis. His was a London in which anything could be had if you had money, and a good deal if you had class and no money. William Cowper—famous for the truism "God made the country, and man made the town"—would not have approved. "Thither flow," he wrote in *The Task* (1785),

> As to a common and most noisome sewer,
> The dregs and feculence of every land. . . .

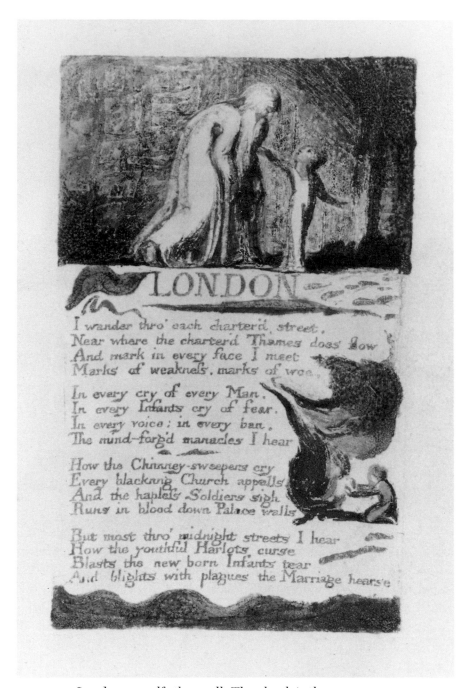

124. William Blake,
London from *Songs of Experience*, 1794
[Cat. no. 211].
A biting satire on oppression by Church
and State

> London engulfs them all. The shark is there,
> And the shark's prey; the spendthrift, and the leech
> That sucks him. There, the sycophant, and he
> Who, with bare-headed and obsequious bows,
> Begs a warm office. . . . (i, 682–683; iii, 816–820)

Yet Cowper, moralist though he is, cannot wholly check his admiration. London is too big, too exciting, too much the centre of the world, to be written off entirely:

> Oh thou, resort and mart of all the earth,
> Chequered with all complexions of mankind,
> And spotted with all crimes—in whom I see
> Much that I love, and more that I admire,
> And all that I abhor. . . . (iii, 835–840)

125. William Wordsworth,
Composed upon Westminster Bridge
[Cat. no. 249]. Printer's copy
of the famous sonnet of 1802,
with corrections in Wordsworth's hand
and wrongly dated by him

Wordsworth seems to have felt a similar ambivalence. "A weight of ages did at once descend / Upon my heart," he wrote of his first entry into London. His experience was of "weight and power, / Power growing with the weight":

> a sense
> Of what had been here done, and suffered here
> Through ages—and was doing, suffering, still. . . .
>
> (*1805*, viii, 781–782)

The problem was how to cope imaginatively with all the doing and suffering—create from it, if not a unity, such as might be experienced in the natural world, at least an overall picture that did not threaten, or dwarf, the individual. At times the city could be seen as *like* the country. In his tranquil sonnet *Composed upon Westminster Bridge* [Fig. 125], Wordsworth catches London in a moment "When the great tide of human life stands still":

> Earth has not anything to show more fair—
> Dull would he be of soul who could pass by
> A sight so touching in its majesty.
> This city now doth like a garment wear
> The beauty of the morning, silent, bare:
> Ships, towers, domes, theatres, and temples lie
> Open unto the fields and to the sky,
> All bright and glittering in the smokeless air.
> Never did sun more beautifully steep
> In his first splendour valley, rock, or hill;
> Ne'er saw I, never felt, a calm so deep
> (The river glideth at his own sweet will)—
> Dear God, the very houses seem asleep,
> And all that mighty heart is lying still!

Girtin catches just such a moment of tranquillity in the beautifully composed *Thames from Queenhithe to London Bridge* [Fig. 126]. Dispensing with the "Ships, towers, domes, theatres, and temples" of Wordsworth's poem, he presents the river gliding "at his own sweet will," with no boats, no figures, no human interest. Above the line of rather blockish riverside buildings, twenty or more of Sir Christopher Wren's City churches rise

126. Thomas Girtin,
The Thames from Queenhithe to London Bridge,
1801 [Cat. no. 233]

into the sky, some in shadow, others, the white Portland stone of their spires lit by a stormy brightness.

The City skyline is important too in the Constable studies of Waterloo Bridge (1819–1832), where the bridge itself is in every case surmounted

127. John Constable, *Waterloo Bridge, from the Left Bank of the Thames* [Cat. no. 221]. Oil sketch of 1819–1824, with no suggestion of the later pageantry [see Fig. 128]

128. John Constable, *Waterloo Bridge from Whitehall Stairs, c.* 1829 [Cat. no. 222]. One of two large oil sketches related to the exhibition painting of 1832, showing the royal barge as the Prince Regent sets out for his ceremonial opening of the bridge

by the dome of St. Paul's. Constable has chosen, however, to present a foreground crowded with boats. There is no composition over which he took more pains, or felt more anxiety. The tiny oil sketch of 1819, *Waterloo Bridge, from the Left Bank of the Thames* [Fig. 127], has an immediacy and control that could not be transferred to larger and later versions. In the event, vivacity was sacrificed to splendour and ceremonial, as Constable decided (probably in 1825) to relate his picture to the Prince Regent's opening of the bridge in 1817. Pageantry could be used to impose on the bustling scene a more formal quality, observed both in the exhibition picture of 1832 and in the closely related *Waterloo Bridge from Whitehall Stairs* of c. 1829 [Fig. 128].

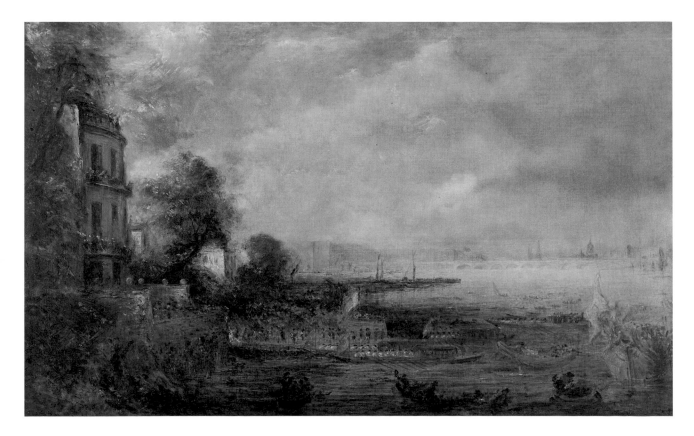

Formality has little to do with Byron's art; he delights in the chaos that London represents:

> A mighty mass of brick, and smoke, and shipping,
> Dirty and dusky, but wide as eye
> Could reach, with here and there a sail just skipping
> In sight, then lost amid the forestry
> Of masts; a wilderness of steeples, peeping
> On tip-toe through their sea-coal canopy
> (A huge dun cupola, like a foolscap crown
> On a fool's head)—and there is London Town!
>
> (*Don Juan*, Canto X, st. 82)

Unlike, for instance, Dorothy Wordsworth's vision of Hull—"a frightful, dirty, brick-housey, tradesmanlike, rich, vulgar place"—Byron's is not a disparaging view. He takes pleasure in the dirty, dusky disorder of it all. But he also takes pleasure in making the disorder into satirical poetry in which the slapdash form is tightly controlled. Subjected to his imagination, the "huge dun cupola" of smoke hanging over the city becomes a dunce's hat, and London itself (scene of *The Dunciad*, by Byron's hero Alexander Pope) becomes the dunce.

Lamb is neither overpowered, nor satirical, but in love. London is for him what the country is for Constable and Wordsworth, a source of strength and delight. Spending his days in humdrum work for the East India Company, he sustains his imagination through books, and through his sense of the life going on about him. The "youthful harlot" whom Boswell had used, and about whom Blake had felt a passionate indignation, is for Lamb a part of the vitality that is London:

> tradesmen and customers, coaches, wagons, playhouses, all the bustle and wickedness round about Covent Garden, the very women of the town, watchmen, drunken scenes, rattles—life awake, if you awake, at all hours of the night. . . .

This time the pattern-making is related to personal suffering. Like Coleridge, his schoolfellow at Christ's Hospital, Lamb was a Unitarian. As a follower of Joseph Priestley, he believed in a universe empowered by "Nature's ever acting energy," which is the immanent presence of God. His faith had been tested, but unshaken, when in September 1796 his talented and loving sister Mary had killed their mother in a fit of madness. For the rest of his life, Lamb supported Mary, taking her sadly back to the asylum when he was forced to do so, but always bringing her home when it was possible. Creating an imaginative unity from "the bustle and wickedness" of the London streets was (like the humour of his writing) an act of faith in the value of existence.

In September 1802, the Lambs seem to have acted as guides for Wordsworth and Dorothy when they paused in London after meeting Annette Vallon and Caroline in France. Among the sights they visited were Tipu's Tiger (a life-sized clockwork model of a tiger eating a white man, captured in 1799 at the fall of Seringapatam) and Bartholomew Fair. Wordsworth may have seen the fair before, but as he writes about it in *The Prelude* it is clear that it offers a special challenge to his wish for

unity. How is such "anarchy and din" to be assimilated, controlled, reduced to order for the artist's purposes? Taking up his position on "some showman's platform," he treats us to a panoramic view:

> What a hell
> For eyes and ears! What anarchy and din
> Barbarian and infernal! 'Tis a dream
> Monstrous in colour, motion, shape, sight, sound.
> Below, the open space, through every nook
> Of the wide area, twinkles, is alive
> With heads; the midway region and above
> Is thronged with staring pictures and huge scrolls,
> Dumb proclamations of the prodigies. . . . (vii, 659–667)

129. Thomas Rowlandson and Augustus Charles Pugin, *Bartholomew Fair*, 1808 [Cat. no. 240]. One of London's most ancient fairs, visited by the Wordsworths in 1802

Four years after these lines were written, Thomas Rowlandson produced for *The Microcosm of London* a delightful aquatint [Fig. 129] in which revellers at the fair are spread out across the foreground, against a rather formal backdrop supplied by the architectural draughtsman Augustus Pugin. From his vantage-point above the crowd, Wordsworth too is composing a picture, ordering its chaotic elements like a painter: "Below . . . the midway region and above. . . ."

The rhythms of Wordsworth's verse tell us of excitement and pleasure, but gradually we become aware of the horrifying depersonalization that has taken place:

 albinos, painted Indians, dwarfs,
The horse of knowledge, and the learned pig,
The stone-eater, the man that swallows fire,
Giants, ventriloquists, the invisible girl,
The bust that speaks and moves its goggling eyes,
The waxwork, clockwork, all the marvellous craft
Of modern Merlins, wild beasts, puppet-shows,
All out-of-the-way, far-fetched, perverted things,
All freaks of Nature, all Promethean thoughts
Of man—his dullness, madness, and their feats,
All jumbled up together to make up
This parliament of monsters. Tents and booths
Meanwhile—as if the whole were one vast mill—
Are vomiting, receiving, on all sides,
Men, women, three-years' children, babes in arms.

 (vii, 681–695)

"Hell is a city much like London," Shelley comments in passing; Wordsworth is thinking in more specific terms of Hell in Milton's *Paradise Lost*, where "Nature breeds, / Perverse, all monstrous, all prodigious things." In a sense the fair is creative, but what it shows is an inversion of the natural imaginative process. Man, who according to the myth was created by Prometheus out of clay, has peopled the fair with his own "Promethean thoughts"—an anarchic jumble of "out-of-the-way, far-fetched, perverted things," a "parliament of monsters." The prodigies did of course exist—or, at least, the "dumb proclamations" of the period

130. J. M. W. Turner, *Herriot's Hospital*, 1816 [Cat. no. 244]

confidently described them as existing. Toby, the Sapient Pig, who was
shown in 1817 as "The greatest curiosity of the present day," could spell,
read, do accounts, and play cards, "And, what is more astonishing . . .
discover a person's thoughts, a thing never heard of before by an animal
of the Swine Race." Wordsworth is on one level producing a marvellously
vivid account of what the Fair was like. On his platform, however, he is
also standing above it, just as Turner stands back from the milling crowd
of *Herriot's Hospital* [Fig. 130].

 Bartholomew Fair is not just a "blank confusion," but a "type" "Of
what the mighty city is itself. . . ." "How often in the overflowing streets,"
Wordsworth writes,

> Have I gone forwards with the crowd, and said
> Unto myself, "The face of every one
> That passes by me is a mystery."
>
> (vii, 595–598)

The anonymity is frightening. No one knows anyone. There is no
community. When we do come upon ordinary human beings at the fair,
they are being "received" and "vomited," as the raw materials and
produce of a factory—one of Blake's "dark Satanic mills." As he creates
his picture, Wordsworth is comparing it in his mind to another scene
(written six months before), that is the sublime alternative. Here again
there is confusion, and here again the poet is to be seen attempting to
create a unified whole. The difference is that on this occasion the
components, disparate though they may appear, are natural. They have
their own organic unity if truly perceived:

> The immeasurable height
> Of woods decaying, never to be decayed,
> The stationary blasts of waterfalls,
> And everywhere along the hollow rent
> Winds thwarting winds, bewildered and forlorn,
> The torrents shooting from the clear blue sky,
> The rocks that muttered close upon our ears—
> Black drizzling crags that spake by the wayside
> As if a voice were in them—the sick sight
> And giddy prospect of the raving stream,
> The unfettered clouds and region of the heavens,
> Tumult and peace, the darkness and the light,
> Were all like workings of one mind, the features
> Of the same face, blossoms upon one tree,
> Characters of the great apocalypse,
> The types and symbols of eternity,
> Of first, and last, and midst, and without end.
>
> (vii, 556–572 [Fig. 131])

 In the account of Bartholomew Fair (and of London as a whole),
Wordsworth's imagination is imposing order upon that which is
inherently chaotic; in "The Simplon Pass" it has the task of bringing out
the harmony which is innate, but which amid such a landscape may be
difficult to perceive. We move through the "gloomy pass," identifying

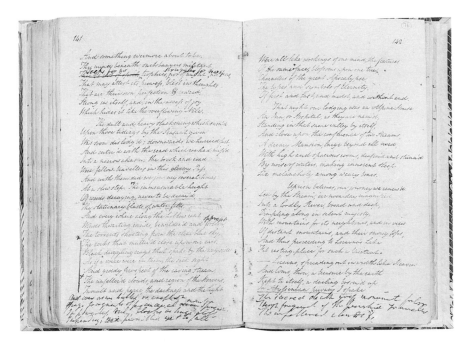

131. William Wordsworth,
"The Simplon Pass"
in *The Prelude*, Book Six, 1806
[Cat. no. 314]

with the traveller, projecting as he does human emotions onto the winds, human speech onto the rocks. We peer over the edge of the Alpine path to experience the "sick sight / And giddy prospect of the raving stream." We respond to the process by which the warring elements of the landscape are abstracted into "Tumult and peace, the darkness and the light." And then suddenly we are confronted by a new impulse in the poetry: "Were all like workings of one mind. . . ."

For Wordsworth, the sublime was an experience not so much of terror (the central definition for Burke), as of power—power that will always seem disproportionate, but always be working in fact towards that larger unity which it is the poet's task to reveal. Through his slightly bizarre similes, he is not suggesting that the disparate elements of the landscape resemble thoughts, or blossoms, or parts of a face, but offering these as startlingly different ways of looking at oneness. In each case there is a single underlying motive force. It should come as no surprise that Wordsworth's final line had been applied by Milton in *Paradise Lost* to God: "Him first, him last, him midst, and without end." Though it is no longer made explicit, the unifying factor that is to be found in the natural world is still the divine "presence" of *Tintern Abbey*. The "characters" to be seen in the Alps are the handwriting, or symbolic language, of God, that speaks of an apocalypse. The mountains are "types and symbols of eternity," just as Bartholomew Fair is a "type" of London, and of all that is transient in human existence.

The mill that is receiving and vomiting forth visitors to the fair is a reminder that the town/country opposition in the Romantic period is complicated by the developing Industrial Revolution. Among the painters, Wright, De Loutherburg, Cotman (*Bedlam Furnace*, *c.*1802–1803 [Fig. 132]), even De Wint (*View of a Harbour*, *c.*1830 [Fig. 133]), all have their industrial scenes. Representing progress, factories could be a source of pride, and they could frequently be spectacular. Blake, in his last and grandest Prophetic Book, *Jerusalem*, takes a more

132 (*top*). John Sell Cotman,
Bedlam Furnace,
c. 1802–1803 [Cat. no. 223]

133 (*above*). Peter De Wint,
View of a Harbour,
c. 1830 [Cat. no. 229]

apocalyptic view. "Black . . . cloth / In heavy wreaths, folds over every nation":

> cruel works
> Of many wheels I view, wheel without wheel, with cogs tyrannic
> Moving by compulsion each other; not as those in Eden, which
> Wheel within wheel in freedom revolve, in harmony and peace.

Wheels have for Blake a larger mythic significance, but there is no mistaking the "cogs tyrannic" of the contemporary power-looms, which spelled death (the black cloth is a funeral pall) to the hand-loom weavers whom Byron defended in his maiden speech to the House of Lords. Wheels in the Blakean paradise of Eden revolve inside each other "in harmony and peace;" those of the fallen, industrial, world are mill-wheels, locking externally into cogs that harness the water-power, and drive the looms.

The factory child of Wordsworth's *Excursion* (1814) is the victim of such a mill, where the once life-giving brook has been converted "Into an instrument of deadly bane":

> His raiment, whitened o'er with cotton flakes
> Or locks of wool, announces whence he comes.
> Creeping his gait and cowering, his lip pale,
> His respiration quick and audible. . . .
>
> (viii, 309–312)

The child is "a slave to whom release comes not, / And cannot come." Nor is he alone. Whole families are drawn into the mills:

> Lo, in such neighbourhood, from morn to eve
> The habitations empty, or perchance
> The mother left alone—no helping hand
> To rock the cradle of her peevish babe,
> No daughters round her busy at the wheel. . . .
>
> (viii, 265–269)

It may seem disproportionate that Wordsworth should be thinking of the "desolate habitations" which in *Isaiah* mark the end of a civilization, but to him the destruction of the family cuts across all that is precious. He is not unaware of the desolation of the countryside, so strongly felt in Cotman's *Bedlam Furnace*. Given that there was mining on the Cumbrian coast, he must have had some idea of the exploitation of child labour that would be revealed in the *Report of the Commissioners* (1842) [Fig. 134]. But it is the destruction of communities that chiefly weighs upon him.

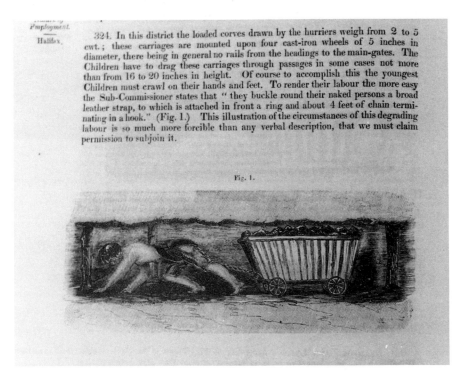

Employment.

Halifax.

324. In this district the loaded corves drawn by the hurriers weigh from 2 to 5 cwt.; these carriages are mounted upon four cast-iron wheels of 5 inches in diameter, there being in general no rails from the headings to the main-gates. The Children have to drag these carriages through passages in some cases not more than from 16 to 20 inches in height. Of course to accomplish this the youngest Children must crawl on their hands and feet. To render their labour the more easy the Sub-Commissioner states that " they buckle round their naked persons a broad leather strap, to which is attached in front a ring and about 4 feet of chain terminating in a hook." (Fig. 1.) This illustration of the circumstances of this degrading labour is so much more forcible than any verbal description, that we must claim permission to subjoin it.

Fig. 1.

134. *"Hurrying coal"*: from a parliamentary report on child labour in the mines, 1842 [Cat. no. 213]

The "birth-right" of a country childhood has gone, and with it, the education through Nature on which Wordsworth believed his own happiness to have depended:

> Economists will tell you that the state
> Thrives by the forfeiture—unfeeling thought,
> And false as monstrous! Can the mother thrive
> By the destruction of her innocent sons,
> In whom a premature necessity
> Blocks out the forms of Nature, preconsumes
> The reason, famishes the heart, shuts up
> The infant being in itself, and makes
> Its very spring a season of decay?
>
> (viii, 283–291)

The vehemence is impressive. Wordsworth is capable, as few poets are, of adopting a lofty moral tone, and carrying us along:

> The world is too much with us: late and soon,
> Getting and spending, we lay waste our powers
> (Little we see in Nature that is ours),
> We have given our hearts away, a sordid boon!
>
> (lines 1–4)

Perhaps only Milton can write with such authority. To Wordsworth he seemed to be symbolic of all the values that his own generation had allowed to waste.

Milton too had been through a revolution, and witnessed the setting up of a republic. As Cromwell's private secretary in the 1650s, he had been very close to the centre of power. Partly because of his blindness, partly because he had not been among those who signed the death warrant of Charles I (though, like Wordsworth in 1793, he thought of regicide as a justifiable step), Milton had survived the Restoration, and gone on to complete and publish *Paradise Lost* (1669). Nothing that Wordsworth wrote gives us a clearer picture of the Miltonic ideals which he himself wished to promote than his famous sonnet of 1802 [Cat. no. 256]. Unity is to be seen as a "dower" (or birth-right) of "inward happiness," leading to the unselfish exercise of "virtue, freedom, power," such as Milton exemplified in his life, and in his writing:

> Milton, thou shouldst be living at this hour,
> England hath need of thee! She is a fen
> Of stagnant waters! Altar, sword, and pen,
> Fireside, the heroic wealth of hall and bower,
> Have forfeited their ancient English dower
> Of inward happiness. We are selfish men,
> Oh raise us up—return to us again
> And give us manners, virtue, freedom, power!
> Thy soul was like a star and dwelt apart;
> Thou hadst a voice whose sound was like the sea
> (Pure as the naked heavens, majestic, free),
> So didst thou travel on life's common way
> In cheerful godliness—and yet thy heart
> The lowliest duties on itself did lay.

We have here the rationale of Wordsworth's ambition to write the philosophical *Recluse*. He will be the successor to Milton, whose "soul was

like a star and dwelt apart." Going to live in Grasmere he is regaining the paradise that has been lost. In his writing he will re-establish the values of an English republican past—so dominant in the minds of the French Girondins in 1792, when Wordsworth himself had been in France, and the Revolution had seemed the dawn of universal happiness. On his arrival at Dove Cottage in 1799, he had invoked Milton, both in style and by direct reference, in his Prospectus to *The Recluse* [Cat. no. 259] ("'fit audience let me find, though few' . . . thus prayed the bard, holiest of men"), and went on to celebrate his own paradise of everyday life:

135 (*left*). Dora Wordsworth (after Amos Green, *c.* 1806), *Dove Cottage* [Cat. no. 105]. Drawing by Wordsworth's daughter of the house in Grasmere where she was born, and where her father wrote much of his greatest poetry

136 (*right*). John Sell Cotman, *Mousehold Heath*, 1810 [Cat. no. 225]. A scene near Cotman's home at Norwich

> Beauty, whose living home is the green earth,
> Surpassing far what hath by special craft
> Of delicate poets been culled forth and shaped
> From earth's materials, waits upon my steps,
> Pitches her tents before me as I move,
> My hourly neighbour.
>
> (lines 30–35)

Poets in the past have built on personal experience to create versions of Utopia, without taking the implication that life itself could be a paradise. He, Wordsworth, will celebrate the here-and-now, "the very world which is the world / Of all of us." Happiness is a question of imaginative sympathy. As Blake had put it in *The Marriage of Heaven and Hell*, "If the doors of perception were cleansed everything would appear to man as it is, infinite." "Paradise and groves / Elysian," Wordsworth continues,

> wherefore need they be
> A history, or but a dream, when minds
> Once wedded to this outward frame of things
> In love, find these the growth of common day?
>
> (lines 37–40)

To some extent it was a shared Romantic ideal—one that may be seen, for instance, in Cotman's portrayal of the Norfolk countryside in *Mousehold Heath* [Fig. 136]—but Wordsworth was living in a part of England which had very frequently been proclaimed as paradisal. The

picturesque cult of the Lake District goes back beyond Gilpin (himself a Cumbrian) to John Brown and his *Description of Keswick in Cumberland* [Cat. no. 212], written in 1753 and first published in *The London Chronicle* in April 1766. It was Brown who had placed Derwentwater in the classical tradition of Italianate painting:

> The full perfection of Keswick consists of three circumstances, beauty, horror, and immensity, united. . . . to give you a complete idea of these three perfections as they are joined in Keswick would require the united powers of Claude, Salvator, and Poussin. The first should throw his delicate sunshine over the cultivated vales, the scattered cots, the lake and wooded islands. The second should dash out the horror of the rugged cliffs, the steeps, the hanging woods, and foaming waterfalls; while the grand pencil of Poussin should crown the whole with the majesty of the impending mountains.

Grasmere had to wait for a comparable eulogy till Mason published Gray's *Journal* of the Lakes in 1775 [Cat. no. 234], and then the terms were rather more domestic:

> Not a single red tile, no flaring gentleman's house or garden wall, breaks in upon the repose of this little unsuspected paradise; but all is peace, rusticity, and happy poverty, in its neatest and most becoming attire.

"Happy poverty" and its "becoming attire" seem closer to the condescension of Edward Ferrars, with his "snug farmhouse . . . and a troop of

137. Thomas Hearne, *View from Skiddaw over Derwentwater, c.* 1777 [Cat. no. 235].
Hearne's panorama shows the first of the Cumbrian lakes to attract the attention of tourists from the south

138. Thomas Gainsborough, *Langdale Pikes,* 1783 [Cat. no. 232].
From Gainsborough's single Lake District tour (August 1783) and showing the rapid drawing with the brush characteristic of his late style

139. Francis Towne, *A View from Rydal Park, c.* 1786 [Cat. no. 243].
Windermere, seen from above Rydal Mount, Wordsworth's home for the last thirty-seven years of his life

tidy, happy villagers," but Wordsworth would have known Gray's reference to the "little unsuspected paradise" both in Mason and in Thomas West's *Guide to the Lakes* (second edition 1780, and onwards [Cat. no. 246]). It would be interesting to know when in fact he did first notice the description. *Home at Grasmere* (1800) [Cat. no. 253] tells of his discovery of the valley while he was "yet a schoolboy," and of its seeming even then a paradise—a promised land that he could glimpse but never hope to enjoy. To some extent he was no doubt reading his present feelings back into the past, but Grasmere features in the poetry as early as *The Vale of Esthwaite*, written at Hawkshead when he was sixteen. In *Septimi, Gades*, addressed in 1791 to his future wife, Mary Hutchinson, it is firmly singled out as the ideal. His hopes for the future are fixed upon

> The lone grey cots and pastoral steeps
> That shine inverted in the deeps
> Of Grasmere's quiet vale.
>
> (lines 22–24)

In his own *Guide to the Lakes* [Cat. no. 251], first published as the Introduction to Joseph Wilkinson's *Select Views* (1810), Wordsworth referred to:

> persons of pure taste throughout the whole island, who, by their visits (often repeated) to the Lakes in the North of England, testify that they deem the district a sort of national property, in which every man has a right and interest who has an eye to perceive and a heart to enjoy.

The taste of such persons had been cultivated not only by Brown, Gray, West, Gilpin, and the literature of the picturesque, but by a series of distinguished artists who came on sketching tours during the summer, returning (typically) to London for the winter to work up, and sell, their finished watercolours. Thomas Hearne's exquisite drawing of Derwentwater from the slopes of Skiddaw [Fig. 137] was made only two years after Gray was published. Thomas Gainsborough made his sole visit to the Lakes in 1783, sketching the curmudgeonly forms of the Langdale Pikes [Fig. 138] with grey wash, extraordinary freedom, and a full wet brush. Francis Towne's delicate and peaceful *Elterwater* and *View from Rydal Park* [Figs. 67 and 139] belong to 1786; the bold *Grasmere from the Rydal Road* [Fig. 140] is probably a year later. In 1791 Towne's pupil, White Abbott, employs the same old-fashioned technique of the tinted drawing to good effect in *Helm Crag and Grasmere* [Cat. no. 209]. Among the comparatively rare visitors who painted in oils, Wright produces his glowing version of the Lower Fall at Rydal [Fig. 84] in 1795.

The succession goes on—augmented as the popularity of the district increases, and also by the fact that during the war with France (1793–1812) British artists had less opportunity to visit the continent. Joseph Farington (Lancastrian by birth, but living in the South) shows what many of the others were doing too when, *c.* 1798, he makes up an album of watercolours entitled *Lake District Views Illustrating Gray's Tour* [Cat. no. 231]. With bold, uncomplicated brush-strokes that are surely the parallel of Wordsworth's ideal of language, Robert Hills in 1803 finds

140 (*top*). Francis Towne,
Grasmere from the Rydal Road, c. 1787
[Cat. no. 242].
The "little unsuspected paradise" where
the Wordsworths lived from 1799 to 1813

141 (*right*). John Constable,
Langdale Pikes from Elterwater, 1806
[Cat. no. 217].
Constable's eye adapted rapidly
to the mountainous northern scenery,
and he refused to
limit himself to stock picturesque views

142 (*below*). John Constable, *Helvellyn*,
1806 [Cat. no. 216].
Rare example of a Constable Lake District
watercolour in which the colours have
not faded to the usual brown and pink.
The artist's inscription,
"Helvellyn in Cumberland," shows through
from the reverse

the perfect expression of his feelings in capturing the atmosphere of Skelwith Force [Fig. 123]. Constable's tour of 1806 produces some memorable pencil drawings, *Langdale Pikes* [Fig. 141] among them, but is represented now chiefly by watercolours that have faded to the pinks and browns of autumn—the season he particularly disliked. *Helvellyn* [Fig. 142] survives to show the strong blues and greens in which he originally painted. Not content with traditional viewing-points, Constable has climbed the ridge behind Thirlmere, and presents a boldly snouted Helvellyn, reminiscent of Girtin.

Wordsworth's view of the Lake District as "a sort of national property" was extraordinarily forward-looking. His thoughts were of course on the scenery, but the Cumbrian way of life also seemed to him a treasure that had to be conserved. Not only did he single out *The Brothers* and *Michael* as "written . . . to show that men who do not wear fine clothes can feel deeply," but in the same letter of 1801 he gave the Whig leader, Fox, an account of his reasoning:

> I have attempted to draw a picture of the domestic affections as I know they exist amongst a class of men who are now almost confined to the North of England. They are small independent proprietors of land (here called "statesmen"), men of respectable education who daily labour on their own little properties.

"The domestic affections," he continues, turning to an overtly political theme,

> will always be strong amongst men who live in a country not crowded with population, if these men are placed above poverty. But if they are proprietors of small estates which have descended to them from their ancestors, the power which these affections will acquire . . . is inconceivable by those who have only had an opportunity of observing hired labourers, farmers, and the manufacturing poor. Their little tract of land serves as a kind of permanent rallying point for their domestic feelings. . . .

Wordsworth is thinking especially of Michael, the Grasmere "states-man," who is faced in the poem [Fig. 143] with a choice between selling half his land (to pay off a loan he has guaranteed for his nephew) and sending his son, Luke, away to London in the hope that he will be able to make the money and return. Denied the "rallying point" for his feelings, the son gets into trouble, and seeks "a hiding-place beyond the seas." Michael, though in his eighties, labours on, even finding time to work on the sheepfold which he has promised Luke would be finished by his return:

> Among the rocks
> He went, and still looked up upon the sun
> And listened to the wind, and, as before,
> Performed all kinds of labour for his sheep
> And for the land, his small inheritance.
> And to that hollow dell from time to time
> Did he repair, to build the fold of which
> His flock had need. 'Tis not forgotten yet

143. Drafts of Wordsworth's *Michael*
in an interleaved copy
of Coleridge's *Poems* 1796 [Cat. no. 258]

> The pity that was then in every heart
> For the old man; and 'tis believed by all
> That many and many a day he thither went,
> And never lifted up a single stone.

(lines 463–474)

Quoted out of context, the lines are bound to lose much of their tragic power, but they serve to show Wordsworth's admiration of fortitude, and, above all, of integrity. Michael is, to the end, true to himself. Even when it becomes clear that the land will at his death "pass into a stranger's hand," he works on, living according to the standards which he has inherited, and which—like the land itself—he has not been able to pass down to Luke. There is for him no other way.

The world of Wordsworth's poetry is peopled by proud solitary figures who show a comparable resolution and independence. Some, like the Old Cumberland Beggar [Cat. no. 250], appear to have nothing to live for. Yet live they do, and their lives have within the village community an importance that they could not have elsewhere. As he takes his accustomed rounds, people who have very little for themselves give the Beggar food, and feel the better for doing so. He exists, and is therefore their responsibility—and because they accept their responsibility, his existence helps to sustain the community. We see why it is that Wordsworth is so shocked when family life is broken down by work in the factories, or when, in London, the face of everyone that passes by is a mystery. The functioning of a community depends upon bonds that have grown up through "the mild necessity of use." Destroy these bonds, by sending the Beggar to the workhouse, or a child to the factory, and something is lost that can never be regained.

Among Wordsworth's contemporaries, George Crabbe has a comparable earnestness, but not a comparable vision. He would have agreed about the workhouse, but, as he shows in *The Village* at the beginning of his career, his is the satirist's eye:

> yon house that holds the parish poor,
> Whose walls of mud scarce bear the broken door—
> There, where the putrid vapours, flagging, play,
> And the dull wheel hums doleful through the day;
> There children dwell who know no parents' care,
> Parents, who know no children's love, dwell there;
> Heart-broken matrons on their joyless bed,
> Forsaken wives, and mothers never wed. . . .
>
> (i, 228–235)

It is a moral vision that rises to greatness in the story of Peter Grimes and his torturing guilts (1810) [Cat. no. 227], but is hardly touched by the spirit of the age. Crabbe's *Posthumous Tales* of 1834 are as clearly Augustan verse as *The Village* had been, fifty years earlier.

John Clare, whose *Poems Descriptive of Rural Life by a Northamptonshire Peasant* (1820) [Cat. no. 214] described him as "perhaps the least favoured by circumstances, and most destitute of friends, of any [poet] that ever existed," associates himself in *Address to Plenty* with the poorest of the poor:

> 'Tis not great, what I solicit—
> Was it more, thou couldst not miss it—
> Now the cutting winter's come,
> 'Tis but just to find a home
> In some shelter, dry and warm,
> That will shield me from the storm.
> Toiling in the naked fields
> Where no bush a shelter yields,
> Needy labour dithering stands,
> Beats and blows his numbing hands,
> And upon the crumping snows
> Stamps in vain to warm his toes.
>
> (lines 29–40)

144. From William Henry Pyne, *Etchings of Rustic Figures for the Embellishment of Landscape*, 1814–1815 [Cat. no. 238]

145 (*top*). Peter De Wint,
The Hayfield
[Cat. no. 228]

146 (*above*). John Constable,
The Vale of Dedham,
1814 [Cat. no. 220].
The landscape of Constable's childhood

Touching as his poems often are, and beautifully though he catches the details of the Northamptonshire countryside, Clare is too close to it all to have a larger perspective. We read him if we wish to know of the lives that Thomas Barker's and William Pyne's "Rustic Figures" [Fig. 144] were actually living. He may tell us of the pleasures and hardships of the workers in De Wint's *Hayfield* [Fig. 145]; he may even know what causes the two labourers in *The Vale of Dedham* [Fig. 146] to be digging on their bank—but he has none of De Wint's sweeping horizon, none of Constable's power.

When, at the end of his life (immured in the town, behind the bars of the madhouse), Clare has been taken from the fields that he loves, he writes a poetry of appalling deprivation:

> I am, yet what I am none cares or knows;
> My friends forsake me like a memory lost. . . .

If one thinks in political terms, there could be no sadder case of the breaking of ties with the community. There could also be no clearer one of a Romantic artist in whom personal tragedy brings out an unsuspected strength. Anguish has found its appropriate language. To judge from his Advertisement to *The Antiquary* (1816), Sir Walter Scott was among those who would have expected it to do so. He has chosen working-class characters, he tells his readers, to exemplify "the higher and more violent passions": "because I agree with my friend Wordsworth that they seldom fail to express them in the strongest and most powerful language."

Wordsworth's position was less straightforward than Scott assumed. It is true that in the Preface to *Lyrical Ballads* he had written of "the essential passions of the heart" as being "less under restraint" in the countryside, and speaking "a plainer and more emphatic language;" and no doubt in general he would have held this to be the case. But there is a world of difference between the novelist's observation of social norms and the tendency of Romantic art to see in simplicity a guarantee of imaginative truth. Wordsworth's attempt in the Preface to establish the countryman's language as an ideal has to be seen both in terms of Rousseau and late eighteenth-century primitivism, and in the immediate context of *The Recluse*. In March 1800, six months before writing the Preface, Wordsworth had attempted in *Home at Grasmere*—headed in the manuscript, "*Recluse*, Book First"—to set up Grasmere itself as the ideal community.

Hoping that he could find among his neighbours at Dove Cottage what Hazlitt termed "passions and habits . . . in their first elements," Wordsworth set out to portray Grasmere as being for others the paradise it undoubtedly was for him and Dorothy. If this could be achieved, it would be possible to offer the life of the "statesman," not as something that was disappearing under political pressures, but as a model for general future happiness. Wordsworth's poetry would be able to look forward rather than back. *The Recluse* would be seen to have a factual rather than imaginative basis. In the event, he brought himself to admit that Grasmere shepherds were as selfish as anyone else, and *Home at Grasmere* came to a halt. If one examines the poetry in detail, it becomes clear that Wordsworth had from the first been aware of creating the paradise he wished to see. To the question, raised early in the poem, as to what constitutes Grasmere's uniqueness, his answer is entirely honest:

> 'Tis the sense,
> Of majesty and beauty and repose,
> A blended holiness of earth and sky,
> Something that makes this individual spot,
> This small abiding-place of many men . . .
> A whole without dependence or defect,

> Made for itself, and happy in itself—
> Perfect contentment, unity entire. (lines 161–170)

In a brilliant stanza of *Peter Bell the Third*, Shelley writes of Wordsworth:

> An apprehension, clear, intense,
> Of his mind's work, had made alive
> The things it wrought on; I believe
> Wakening a sort of thought-in-sense. (lines 309–312)

The concept of "thought-in-sense" understates our sense of Wordsworth's imaginative power, but draws attention to a word that he uses in a sense that is quite unusual. In what other poet could we find "a *sense sublime* / Of something far more deeply interfused"—"the *sense* / Of majesty and beauty and repose"? It is interesting that *Tintern Abbey* should also contribute the idiosyncratic "something" that appears in *Home at Grasmere*. What relationship should we perceive between the "something" that makes this individual spot into "A whole without dependence or defect," and the divine "something" which in the earlier poem had given unity to the whole of creation?

In *Tintern Abbey* we have a sublime confidence; in *Home at Grasmere* the language of confidence reappears in a context merely of wishfulness and imaginative projection. The poet yearns for the wholeness that he describes. Like all the great Romantic artists he has a passionate need to be part of a totality. We respond to such need, because it is our own, and because we are moved by those whose imagination is so powerful that we can find in their work a momentary fulfilment. That it is momentary, and

147. John Sell Cotman,
Cader Idris from Barmouth Sands,
1804 [Cat. no. 224].
Based on a sketch from his first
Welsh tour (1800)

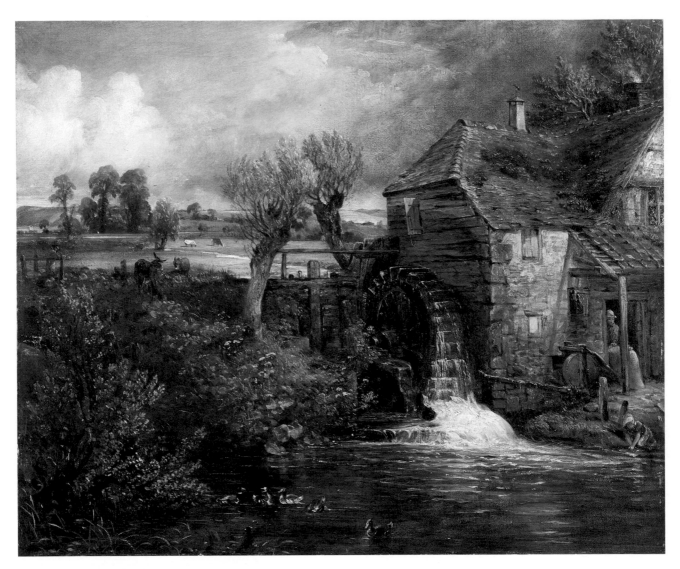

148. John Constable,
Parham Mill, Gillingham,
1826 [Cat. no. 219].
Watermill, such as those in Essex owned
by Constable's father

cannot finally produce the answers, is the condition of this art. We perceive the pathos that underlies even the grandest human assertions, and in responding to what we may choose to term imaginative truth, we respond in fact to defiance. Michael at his sheepfold, labouring in heroic integrity, or the Leech Gatherer [Cat. nos. 247 and 255], in his strange profession, pacing

> About the weary moors continually,
> Wandering about alone and silently . . .
>
> (lines 137–138)

are precious to Wordsworth because (in Hazlitt's phrase) "they mingle with his own identity." They are types of the artist who cannot cease in a quest for unity, though conscious that it will always be elusive.

Romantic art does not stereotype human activities—as, for instance, pastoralism, from Theocritus onwards, had stereotyped the shepherd—but uses them to throw into relief the greater achievements of the human spirit. Caught in a moment of suspended animation, the fishermen hoisting their nets in Cotman's *Cader Idris from Barmouth Sands* [Fig. 147] resemble the lovers on Keats' Grecian Urn. Like the boats, whose masts seem impotently to be rivalling the mountains, they serve to heighten our

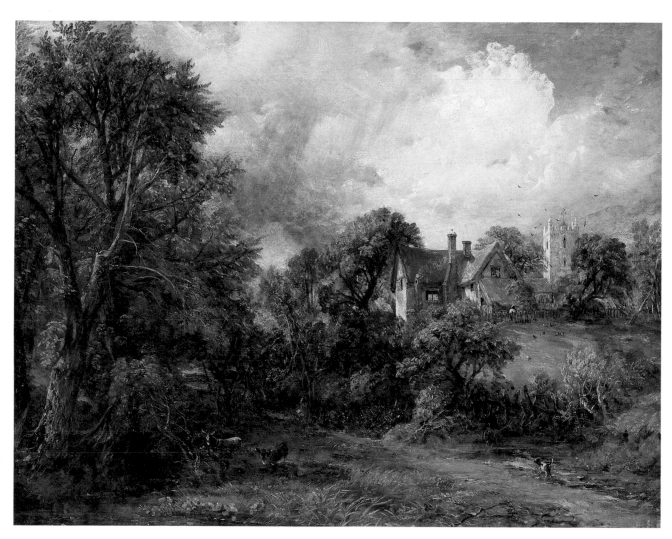

149. John Constable, *The Glebe Farm*, 1827 [Cat. no. 215]

awareness of permanence and immensity. Constable, when painting at Gillingham in 1823, wrote to Maria:

> I have done something from one of the old mills that you will like. . . . This is a melancholy place, but it is beautiful—full of little bridges, rivulets, mills, and cottages, and the most beautiful trees and verdure that I ever saw. The poor people are dirty, and to approach one of the cottages is almost insufferable.

Parham Mill, Gillingham [Fig. 148] contains no melancholy, no insufferable dirt. The miller with his sacks of flour, his daughter with her fingers in the pool, play their part in an imaginative whole that has about it the visionary gleam of Constable's own childhood. In *The Glebe Farm* [Fig. 149], painted in 1827 as a memorial to Bishop Fisher, Constable idealizes his picture by introducing the tower of Langham Church ("the poor bishop's first living") into an unrelated, but appropriately beautiful, scene. He has, as he says, "pacified" the landscape—rendered it peaceful through a quiet, Wordsworthian, transforming power.

No poem shows the power at work in Wordsworth himself more exquisitely than *The Solitary Reaper* [Cat. no. 261]. The song of a Scottish girl reaping in the harvest-field is invested by the poet with a quality

which is entirely magical—and which was echoing in Keats' inner ear as
he wrote of Ruth "in tears amid the alien corn" (*Ode to a Nightingale*):

> Behold her, single in the field,
> Yon solitary highland lass,
> Reaping and singing by herself—
> Stop here, or gently pass!
> Alone she cuts and binds the grain,
> And sings a melancholy strain:
> O listen, for the vale profound
> Is overflowing with the sound!
>
> No nightingale did ever chant
> So sweetly to reposing bands
> Of travellers in some shady haunt
> Among Arabian sands;
> No sweeter voice was ever heard
> In springtime from the cuckoo-bird,
> Breaking the silence of the seas
> Among the farthest Hebrides.
>
> Will no one tell me what she sings?
> Perhaps the plaintive numbers flow
> For old, unhappy, far-off things,
> And battles long ago;
> Or is it some more humble lay,
> Familiar matter of today—
> Some natural sorrow, loss, or pain,
> That has been, and may be again?
>
> Whate'er the theme, the maiden sang
> As if her song could have no ending;
> I saw her singing at her work
> And o'er the sickle bending;
> I listened till I had my fill,
> And as I mounted up the hill
> The music in my heart I bore
> Long after it was heard no more.

"Will no one tell me what she sings?"—it is all-important that the song
cannot, in the normal sense of the word, be interpreted. A footnote might
tell us that the girl was singing in Gaelic, but what matters is that the
ordinary has been transformed. Mystery has entered in, and leaves room
for the play of imagination. As Shelley put it in *Mont Blanc*, hers is a voice,

> not understood
> By all, but which the wise and great and good
> Interpret, or make felt, or deeply feel.
>
> (lines 81–83)

She stands for the craving in Romantic artists of all times to find in "the
very world / Which is the world of all of us" that which is strange and
numinous, that which no language can express. As the great voice of

150. J. M. W. Turner, *Ullswater,*
c. 1833–1834 [Cat. no. 245]

twentieth-century Romanticism, it is Wallace Stevens who best under-
stands, interprets, and makes felt the wonderment of his forebears:

> And out of what one sees and hears, and out
> Of what one feels, who could have thought to make
> So many selves, so many sensuous worlds,
> As if the air—the mid-day air—was swarming
> With the metaphysical changes that occur
> Merely in living as and where we live.
>
> (*Esthétique du Mal,* st. 15)

151. Francis Towne, *The Source of the Arveiron: Mont Blanc in the Background*, 1781 [Cat. no. 290].
"Remote, serene, and inaccessible. . . . / Mont Blanc yet gleams on high" (Shelley)

 Memory, Imagination, and the Sublime

At the end of *Mont Blanc* (1816) [Fig. 152], Shelley turns to the mountain and asks a question for which there is no answer:

> And what were thou, and earth, and stars, and sea,
> If to the human mind's imaginings
> Silence and solitude were vacancy? (lines 142–144)

152. Percy Bysshe Shelley, *Mont Blanc*
[Cat. no. 288].
Shelley's original manuscript
of summer 1816

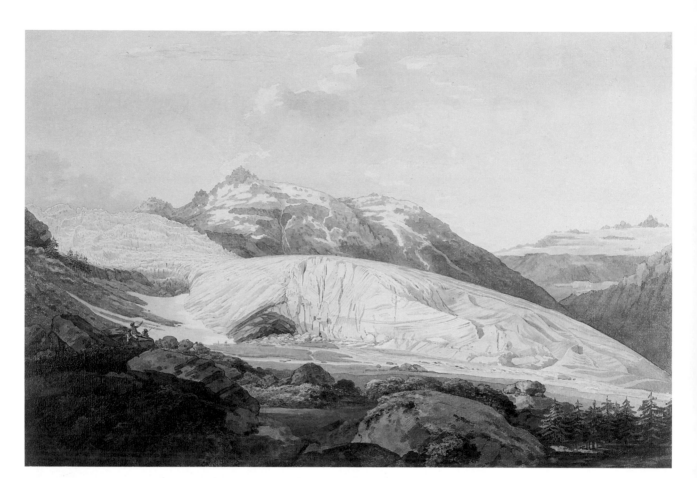

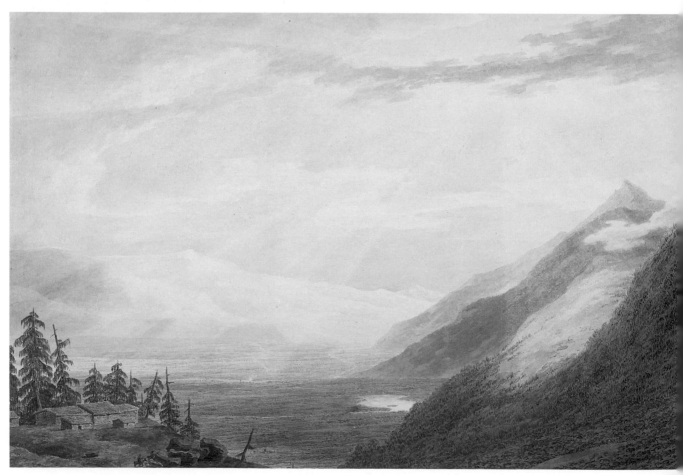

The poem has drawn a magnificent picture of Alpine remoteness and desolation—

> Far, far above, piercing the infinite sky,
> Mont Blanc appears, still, snowy, and serene
>
> (lines 60–61)

—but from the first Shelley's subject has been the perceiving and creative human imagination. On philosophical grounds, he cannot permit himself to believe in the Christian God, yet his thoughts are on *Tintern Abbey*, and he is strongly drawn to Wordsworthian pantheism. *Mont Blanc* is in part a commentary on those who have sought in the Alps a more conventional experience of the religious sublime. "O dread and silent mount," Coleridge had written in *Sunrise in the Vale of Chamouni* (1803),

> I gazed upon thee,
> Till thou, still present to the bodily sense,
> Didst vanish from my thought: entranced in prayer,
> I worshipped the Invisible alone.
>
> (lines 13–16)

153. William Pars,
*The Rhône Glacier
and the Source of the Rhône,
c.* 1770 [Cat. no. 287].
By one of the first British artists
to paint in the Alps

154. John Robert Cozens, *Pays de Valais*
[Cat. no. 279].
Alpine sublimity, 1780

For Gray, who visited the Grande Chartreuse as early as 1739, there is "not a precipice, not a torrent, not a cliff, but is pregnant with religion and poetry." In effect his words are a definition of the sublime, and publication of Burke's *Sublime and Beautiful* (1757) [Cat. no. 266] greatly increased the numbers of British tourists, writers and painters, who visited the Alps in the years that followed. Their techniques vary, but essentially, William Pars (*Rhône Glacier, c.* 1770 [Fig. 153]), Cozens (*Pays de Valais,* 1780 [Fig. 154]), and Towne (*Source of the Arveiron,* 1781 [Fig. 151]) are all followers of Burke in his sense of the infinite, if not in his sometimes rather exaggerated emphasis upon terror. In the early masterpieces of Turner's great sequence of Alpine subjects—*Passage of the St. Gothard* (1804), for instance, and *Mer de Glace* (c. 1806)—numinous suggestion is replaced by Romantic dominance of mind [Figs. 155–159]. Though responsive to the grandeur of the Alps, these are above all triumphs of colour and technique that show watercolour rivalling the oil. In the swirling vortex of the *Valley of Aosta* (1836–1837) [Fig. 185], however, the numinous returns. No picture more perfectly evokes the correspondence of inner depth and outward manifestation that is at the centre of Romantic art. To use the terms of Wordsworth's "Ascent of Snowdon" [Fig. 181], landscape has become

> The perfect image of a mighty mind,
> Of one that feeds upon infinity,
> That is exalted by an under-presence,
> The sense of God, or whatsoe'er is dim
> Or vast in its own being. . . .
>
> (xiii, 69–73)

The association of mountains and holy places has, no doubt, primitive origins that go back beyond Christ's preaching of the Sermon on the Mount and Moses' encounter with Jehovah on Mount Sinai. Allegorically, the upward path—Bunyan's "Hill of Difficulty" in *Pilgrim's*

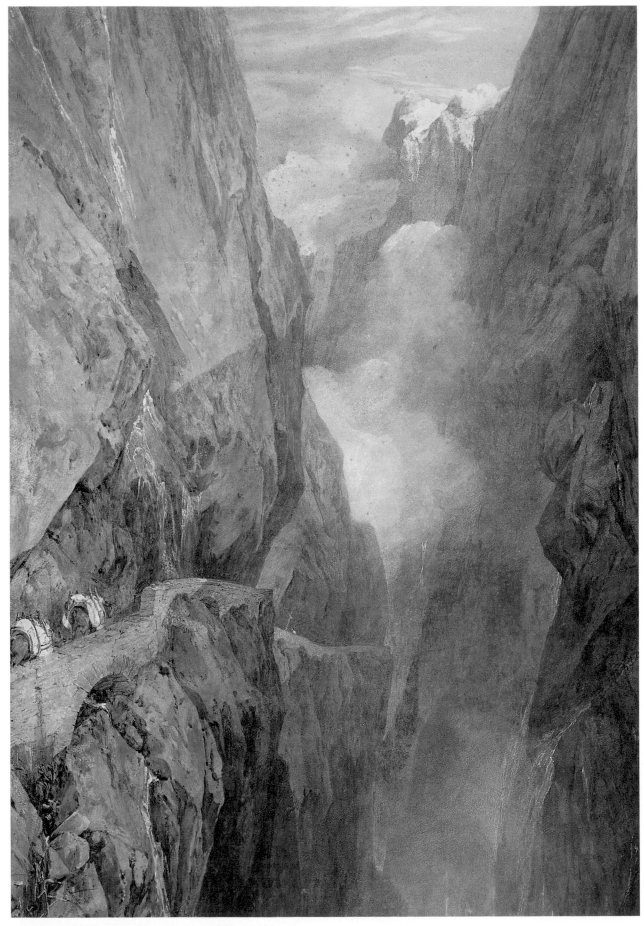

155. J. M. W. Turner, *The Passage of the St. Gothard*, 1804 [Cat. no. 295]

156. J. M. W. Turner, *The Great Falls of the Reichenbach*, 1804 [Cat. no. 292]

157 (*above left*). J. M. W. Turner,
Mer de Glace, Chamonix, with Blair's Hut,
c. 1806 [Cat. no. 294]

158 (*left*). J. M. W. Turner,
The Valley of Chamonix,
Mont Blanc in the Distance,
1809 [Cat. no. 299]

159 (*above*). J. M. W. Turner,
A Swiss Pass,
c. 1848–1850 [Cat. no. 296]

Progress—has always been the way of truth. Climbing "steep up the stony mount . . . with perilous toil," Coleridge in *Reflections on Leaving a Place of Retirement* (1796) attains a sense of the "omnipresence" of God. A year later, in *This Lime-Tree Bower, My Prison*, he offers a moment of epiphany that leads straight on to Keats:

> So my friend
> Struck with deep joy may stand, as I have stood,
> Silent with swimming sense. . . . (lines 37–39)

"Then felt I like some watcher of the skies," Keats writes in *On First Looking into Chapman's Homer*,

> Or like stout Cortez when with eagle eyes
> He stared at the Pacific, and all his men
> Looked at each other with a wild surmise—
> Silent upon a peak in Darien. (lines 11–14)

Shelley and Wordsworth have it in common that they do not reach the top of their mountains—Shelley, indeed, does not climb at all. Though working within the tradition of the sublime, they are concerned in the last resort with depths rather than heights. Looking upwards to the peak of Mont Blanc, Shelley sees "Power," that "dwells apart in its tranquillity, / Remote, serene, and inaccessible." Looking down, he sees in the "dizzy" ravine of Arve, at the foot of the mountain, an emblem of his own unrestful consciousness:

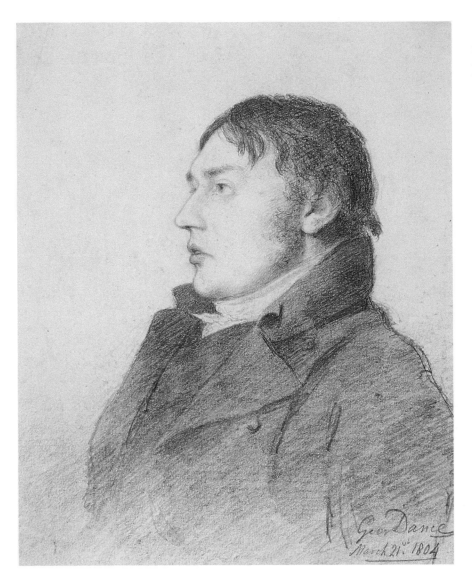

160. George Dance, *Samuel Taylor Coleridge*
[Cat. no. 281].
Drawn for Sir George Beaumont
on 21 March 1804, and known only
to the Beaumont family until 1984

> Thou art pervaded with that ceaseless motion,
> Thou art the path of that unresting sound,
> Dizzy ravine, and when I gaze on thee
> I seem, as in a trance sublime and strange,
> To muse on my own separate fantasy—
> My own, my human mind. . . .

It is indeed "a trance sublime and strange." At first sight the terms in which Shelley continues are stranger still:

> which *passively*
> Now renders and receives fast influencings,
> Holding an unremitting interchange
> With the clear universe of things around. . . .
>
> (lines 32–40)

Standing on his bridge above the roaring Arve, Shelley detaches himself, watches his own mental process at work. Paradoxically, it is the activity of imagination—the fact that it cannot cease to render as well as receive—that makes the mind in some sense passive. To Coleridge in *Biographia Literaria* [Cat. no. 268], published a year after the writing of

Mont Blanc, imagination is "the living power and prime agent of all human perception." It is also "a repetition in the finite mind" of God's "eternal act of creation." In its imaginative sympathy, the transient human mind perceives its relation to God. Becoming in the same moment god-like in its creativity, it reaches out beyond the self, transcending the limits of bodily awareness.

"Oh mystery of man," wrote Wordsworth in spring 1804 [Cat. no. 311],

> from what a depth
> Proceed thy honours! I am lost, but see
> In simple childhood something of the base
> On which thy greatness stands. . . .
>
> (1805, xi, 328–331)

The terms are honest, and carefully chosen. For Pope, in 1733, "The proper study of mankind is man," but it is a social and moral study. For the Romantics, man is a mystery, often in a nearly religious sense of the word. His "honours"—achievements, titles to fame—proceed from inner depths that show already an awareness of what Freud would term the *un*- (or *sub*)-conscious. With a moving earnestness, Wordsworth confesses himself lost. Yet it is well to remember that, in the art of this period, loss is frequently turned to gain. He sees in "simple childhood" merely *something* of the base on which man's greatness is sustained, but in the same month he writes *Ode: Intimations of Immortality from Recollections of Early Childhood* [Fig. 161], at once the most sonorous and most profound

161. William Wordsworth,
Ode: Intimations of Immortality [Cat. no. 309].
Transcribed by Mary
in the vellum-bound volume
of Wordsworth's unpublished poetry
made for Coleridge to take with him
to the Mediterranean in spring 1804

of English lyric poems. Childhood may seem a very frail basis, but if man's days are truly "Bound each to each," as in *The Rainbow* (written the day before *Intimations* was begun), there can be no other.

"But this I feel," Wordsworth continues, still addressing himself to man and his mysteriousness,

> That from thyself it is that thou must give,
> Else never canst receive. The days gone by
> Come back upon me from the dawn almost
> Of life; the hiding-places of my power
> Seem open, I approach, and then they close;
> I see by glimpses now, when age comes on
> May scarcely see at all; and I would give
> While yet we may, as far as words can give,
> A substance and a life to what I feel:
> I would enshrine the spirit of the past
> For future restoration. (xi, 331–342)

The Prelude was known throughout Wordsworth's lifetime as the "Poem to Coleridge," and sometimes appears to be a continuing discussion between the two poets. In the first version of *Dejection: An Ode* [Fig. 162] (at one stage addressed to Wordsworth himself under a pseudonym), Coleridge had written:

> O Sara, we receive but what we give,
> And in *our* life alone does Nature live—
> Ours is her wedding-garment, ours her shroud. . . .
> (lines 296–298)

Wordsworth's statement, "thou must give, / Else never canst receive," is a corrective. In his dejected mood, Coleridge had gone too far, asserting that the qualities in Nature to which we respond are projections from our own minds. We get back what we give, and no more. Wordsworth— though he too is anxious now—still holds the view that he had shared with Coleridge at the time of *Lyrical Ballads*. Imagination is not projection, but generosity, warmth, life-giving joy. Those who are able to give will be able to receive, because they have the power of imaginative sympathy.

Like Coleridge, the Wordsworth of 1804 is aware of change and loss, but he sees it characteristically in terms of the individual. Instead of denying the validity of imaginative experience, he concedes that for him personally there has been a closing-off of the inward sources of power. Much of his greatest poetry belongs to the period at which he becomes aware of his loss, and, in so doing, comes to value more intensely than ever the imagination which he perceives to be failing:

> O joy that in our embers
> Is something that doth live,
> That nature yet remembers
> What was so fugitive! (lines 132–135)

It is this ninth stanza of *Intimations*, with its haunting alternation of tone, pace, and rhythm, that tells us most about Wordsworth's understanding of the unconscious, and his sense that early traumatic experience has been transmuted within the mind to become a source of strength.

162. Samuel Taylor Coleridge,
Letter to —— April 4, 1802 [Cat. no. 269].
Manuscript of *Dejection: An Ode*
in its early form

Like anyone else, he values childhood for its optimism and unthinking happiness, but looking back into his own past he sees a Burkean world in which terror has been of greater importance:

> Not for these I raise
> The song of thanks and praise,
> But for those obstinate questionings
> Of sense and outward things,
> Fallings from us, vanishings,
> Blank misgivings of a creature

> Moving about in worlds not realized,
> High instincts, before which our mortal nature
> Did tremble like a guilty thing surprised—
>> But for those first affections,
>> Those shadowy recollections,
>>> Which be they what they may
> Are yet the fountain-light of all our day,
> Are yet the master-light of all our seeing. . . .
>
> (lines 143–156)

From *The Prelude* we can see that the "obstinate questionings" had been forced on the child, that he trembled "like a guilty thing surprised" in the face of experience which he could have no means of explaining. "When the deed was done," he writes of a poaching expedition on the fells at Hawkshead,

> I heard among the solitary hills
> Low breathings coming after me, and sounds
> Of undistinguishable motion, steps
> Almost as silent as the turf they trod. (*1799, i, 45–49*)

In February 1804, when he completed *Intimations*, Wordsworth was revising his *Prelude* "spots of time," and thinking once more about the mysterious links of memory, imagination, and the sublime. What was it that gave such power to these "shadowy recollections"? Why, after all these years, should primal emotions ("first affections") seem to him so important? One answer was that experiences of this kind—to be found lurking in the memory of every human being—are

> passages of life in which
> We have had deepest feeling that the mind
> Is lord and master. . . . (*1805, xi, 269–271*)

Yet this did not account for what Freud, a hundred years later, would term "the uncanny." Wordsworth made allowance for events within his mind that were no more explicable to the adult than to the child—events which, "be they what they may," are yet the source of adult perception. Among those that seemed especially important to him was one that took place, apparently, when he was five.

Setting out on horseback, and in high excitement, the child of *The Prelude* is for some reason separated from his "encourager and guide" (his grandparents' servant James), and wanders lost on the moor near Penrith Beacon:

> through fear
> Dismounting, down the rough and stony moor
> I led my horse, and, stumbling on, at length
> Came to a bottom where in former times
> A man, the murderer of his wife, was hung
> In irons. Mouldered was the gibbet-mast;
> The bones were gone, the iron and the wood;
> Only a long green ridge of turf remained
> Whose shape was like a grave. (*1799, i, 305–313*)

In the child's mind are the full horrors of the gallows: the corpse of a murderer, swinging from his gibbet in the iron case that was used at the time to prevent disintegration, and prolong the deterrent effect. But what did he actually see? Bones, iron, and wood—the elements that made up the execution—are all of them gone, and the moor has many such ridges of turf, whose shape is "like a grave." Though many think of the episode as "about" a gibbet; the poetry tells us delicately that it wasn't there. Wordsworth is writing about the effects of fear on the child's imagination. It is most unlikely that he saw anything connected with an execution. All that was needed to bring his terrors to life was a resemblance between the ridge of turf and the unmarked hummock-graves of Cumbrian churchyards.

In order to recreate his memory of being the lost and terrified child, the adult Wordsworth has (we happen to know) conflated two different gibbets—a recent one, near Penrith, and one dating from the seventeenth century that he passed every day in the meadows near to his school at Hawkshead. The first was still standing, corpse and all; the second was mouldered down, and had indeed belonged to "A man, the murderer of his wife." As a writer, Wordsworth refuses to be bound by the "chains of circumstance." His job is to be true to the emotion, not to the narrative fact. In these "shadowy recollections" he is concerned especially with the way in which emotions give place to one another, each charging the next with its own peculiar intensity. "I left the spot," he continues, turning away from both the ridge of turf and the association of murder,

> And reascending the bare slope I saw
> A naked pool that lay beneath the hills,
> The beacon on the summit, and more near
> A girl who bore a pitcher on her head
> And seemed with difficult steps to force her way
> Against the blowing wind. It was in truth
> An ordinary sight, but I should need
> Colours and words that are unknown to man
> To paint the visionary dreariness
> Which, while I looked all round for my lost guide,
> Did at that time invest the naked pool,
> The beacon on the lonely eminence,
> The woman and her garments vexed and tossed
> By the strong wind. (1799, i, 314–327)

Playing over twice the visual details of the pool, the beacon, and the girl, the poetry enacts a process that has gone on again and again in the mind. The girl does not stand for anything, or anyone—with her pitcher filled from the local brook, she is indeed "An ordinary sight"—yet she has become a part of the emotional life of the poet. Had he met her on another day, or at another place, this wouldn't have been the case. Wordsworth is fascinated at once by the inconsequence, and by the power that such apparently random memories retain. The child's initial excitement has given place to fear at being lost, then to superstitious terrors, and finally to the "visionary dreariness" with which his imagination has "invested" the unremarkable landscape. Few words could be less promising than

"dreary," yet Wordsworth (with the "darkness visible" of Milton's Hell in mind) has coined from it a perfect description of the child's uncanny vision. In doing so, he has implanted in the minds of countless readers a picture vivid almost as personal memory.

De Quincey once remarked that "far more of our deepest thoughts and feelings pass to us through perplexed combinations of concrete objects . . . in compound experiences incapable of being disentangled, than ever reach us directly and in their own abstract shapes." Like Coleridge, he knew *The Prelude* in manuscript, and perhaps it was really Wordsworth's intuition. In any case it exactly fits his poetry. Deep thoughts and feelings from the distant past have survived in this central "spot of time," not "in their own abstract shapes," but because a mental image attached them to the pool, the beacon, and the girl who forces her way against the blowing wind. To Wordsworth such moments, or such memories, seemed to retain "a fructifying virtue"—a power to make fruitful the adult mind. It was a strange claim, but one in which he never ceased to believe. It was not merely that they inspired his poetry (which in one sense is undoubtedly true), but that:

> feeling comes in aid
> Of feeling, and diversity of strength
> Attends us, if but once we have been strong.
>
> (*1805*, xi, 325–327)

The poet's days are "Bound each to each" by what De Quincey called "subtle links of feeling." Because the child has been abnormally imaginative, the poet is (or feels) sustained in his adult creativity.

"He who, grown aged in this world of woe," Byron writes in a Wordsworthian moment of *Childe Harold*, Canto Three [Fig. 163]—

163. Lord Byron, *Childe Harold*, 1816 [Cat. no. 267]. Part of the earliest surviving manuscript of Canto Three

164. Sir George Beaumont, *Peele Castle*,
c. May 1806 [Cat. no. 264].
The inspiration of Wordsworth's
Elegiac Stanzas

So that no wonder waits him . . .
 he can tell
Why thought seeks refuge in lone caves, yet rife
With airy images, and shapes which dwell
Still unimpaired, though old, in the soul's haunted cell. (st. 5)

For the aging creative artist it is not just refuge that is to be found in the
"lone caves" and "haunted cell" of memory. The past is inspiration, and
solace in the dearth of present feeling:

'Tis to create, and in creating live
A being more intense, that we endow
With form our fancy, gaining as we give
The life we image, even as I do now.
What am I? Nothing—but not so art thou,
Soul of my thought, with whom I traverse earth,
Invisible but gazing, as I glow
Mixed with thy spirit, blended with thy birth,
And feeling still with thee in my crushed feelings' dearth. (st. 6)

In creating the "Soul of [his] thought," Harold, on the basis of his own
personality, Byron transcends the "crushed feelings" of private ex-
perience. For the poet himself, "no wonder waits;" yet gazing with the
eyes of his creation, he can gain the life he gives —glow with a spirit that
is, and is not, his own. Loss is recognized, and to a large extent assuaged.

To the Wordsworth of *Elegiac Stanzas* (1806) [Cat. no. 306], loss seems too sharp for such reconciliation. Beaumont's dramatic "Picture of Peele Castle, in a Storm" [Fig. 164], with its ship "labouring" amid the waves, brings to the poet's mind the death of his brother John, drowned at sea the

165 (*left*). John Constable, *Weymouth Bay*, 1816 [Cat. no. 275]

166 (*below*). John Constable, *Weymouth Bay from the Downs above Osmington Mills*, 1816 [Cat. no. 276]

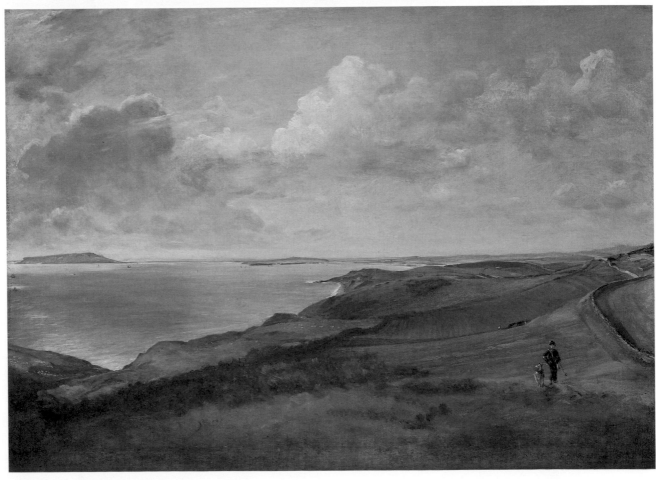

previous year. Moved to reconsider the nature of his own art, he takes farewell of an earlier self who now seems to have been deluded in his trustfulness:

> I have submitted to a new control—
> A power is gone, which nothing can restore—
> A deep distress hath humanized my soul. . . .
>
> This work of thine I blame not, but commend—
> This sea in anger, and that dismal shore. . . .
>
> Farewell, farewell, the heart that lives alone,
> Housed in a dream, at distance from the kind—
> Such happiness, wherever it be known,
> Is to be pitied, for 'tis surely blind.
>
> But welcome fortitude, and patient cheer,
> And frequent sights of what is to be borne—
> Such sights, or worse, as are before me here:
> Not without hope we suffer and we mourn.
>
> (lines 34–60 *passim*)

In his need to believe in the Christian afterlife, Wordsworth turns his back on the world of imagination that has kept him "at distance from [his] kind." For the moment, past happiness, and the poetry in which it was "consecrated," seem equally an irrelevance.

John Wordsworth, captain of the largest merchant ship in the East India Company's fleet, had been William and Dorothy's favourite brother. It is a moving thought that when Constable, on honeymoon in Dorset in October 1816, made his original paintings of Weymouth Bay— the tiny, yet brilliant oil sketch, and the large serene view *From the Downs above Osmington Mills* [Figs. 165 and 166]—he did so with John in mind. Sending the later mezzotint of Weymouth Bay to Mrs. Leslie, he quoted *Elegiac Stanzas*, "That sea in anger, and that dismal shore," adding "I think of Wordsworth, for on that spot perished his brother in the wreck of the *Abergavenny*." In July 1828 Constable was to paint another seascape of unparalleled power, *The Coast at Brighton—Stormy Evening* [Fig. 167]. Again there was a human point of reference, but this time it was closer to the painter himself. Maria's health was failing rapidly, and four months later she was dead. Among the paintings in which Constable seeks assuagement for his loss is the great *Hadleigh Castle* [Fig. 168], subtitled appropriately *Morning after a Stormy Night*.

If *The Coast at Brighton* shows Constable's sense of elemental powers, forces that cannot be withstood, *Hadleigh Castle* is his Romantic affirmation of the strength of the human spirit. The storm has gone, and light is breaking through the clouds that remain. The shepherd and his dog have a reassuring implication of life that goes on. But whatever hope there may be is muted—qualified by the presence of the castle itself, rising enigmatically above the landscape, its twin towers unbowed, yet heavily marked by the hand of time. This is not a symbolic work, an allegory like Blake's *Vala* [Fig. 170] about survival, putting together the pieces of life when they seem to have fallen apart. Yet the painting is far more than merely a projection of mood onto landscape. Like the great poets among

167. John Constable,
The Coast at Brighton—Stormy Evening,
c. 1828 [Cat. no. 272]

168. John Constable,
Hadleigh Castle,
1829 [Cat. no. 273]

his contemporaries, Constable has found a mode that will express the complexity of human experience.

"Ah, then, if mine had been the painter's hand," Wordsworth writes enviously in *Elegiac Stanzas*,

> To express what then I saw—and add the gleam,
> The light that never was on sea or land,
> The consecration, and the poet's dream—
>
> I would have planted thee, thou hoary pile,
> Amid a world how different from this. . . .
>
> A picture had it been of lasting ease,
> Elysian quiet, without toil or strife;
> No motion but the moving tide, a breeze,
> Or merely silent Nature's breathing life.

<div align="right">(lines 13–28 passim)</div>

In the act of repudiating his past vision, the poet gives it again its original beauty; attempting to deny its meaning, he recreates for us a faith at once in the human imagination and in "silent Nature's breathing life." "The light that never was on sea or land" is the light, not of illusion, but of numinous possibility [Fig. 169]:

> An auxiliar light
> Came from my mind, which on the setting sun
> Bestowed new splendour; the melodious birds,
> The gentle breezes, fountains that ran on,
> Murmuring so sweetly in themselves, obeyed
> A like dominion, and the midnight storm
> Grew darker in the presence of my eye.

<div align="right">(1799, ii, 417–423)</div>

Hard as he tries, the Wordsworth of *Elegiac Stanzas* has not been able to deny his gods. Say what he may, "the poet's dream" will always for him be sacred, a "consecration." It is "The holy life of music and of verse," to which he had been dedicated in childhood by powers beyond his own control:

169. William Wordsworth, "An Auxiliar Light" in *The Prelude*, 1799, ii, *c*. October 1799 [Cat. no. 304]

Οτι ουκ εστιν ημιν η παλη, προς αιμα και σαρκα, αλλα προς τας αρχας,
προς τας εξεσιας, προς τες κοσμοκρατορας τε σκοτες τε αιωνος τετε, προς
τα πνευματικα της πονηριας εν τοις επουρανιοις. ΕΦΕΣ. VI κεφ. 12

VALA

Night the First

The Song of the Aged Mother which shook the heavens with wrath
Hearing the march of long resounding strong heroic Verse
Marshalld in order for the day of Intellectual Battle
The heavens quake the earth way moved & shudderd & the mountains
With all their woods, the streams & valleys: waild in dismal fear

Four Mighty Ones are in every Man; a Perfect Unity
Cannot Exist. but from the Universal Brotherhood of Eden
The Universal Man. To Whom be Glory Evermore Amen

Los was the fourth immortal starry one, & in the Earth
Of a bright Universe. Empery attended day & night
Days & nights of revolving joy, Urthona was his name

John XVII c. 21 & 22 & 23

John 1 c. 14 v
και εσκηνωσεν
εν ημιν

170. William Blake, *Vala* or *The Four Zoas*, c. 1796–1807 [Cat. no. 265].
The original much-corrected manuscript, with Blake's own illustrations

> I made no vows, but vows
> Were then made for me: bond unknown to me
> Was given, that I should be—else sinning greatly—
> A dedicated spirit. (*1805*, iv, 341–344)

He may not deal in the magical terms of *Kubla Khan* [Fig. 172]—

> Weave a circle round him thrice,
> And close your eyes with holy dread,
> For he on honey-dew hath fed,
> And drunk the milk of Paradise . . . (lines 51–54)

—but, like Coleridge, Wordsworth sees the imagination as a prophetic gift. He identifies at the beginning of *The Prelude* a power that rises within himself as ''A tempest, a redundant energy;'' and in so doing he anticipates the great lines of Shelley's *Ode to the West Wind* [Fig. 171]:

> Make me thy lyre, even as the forest is—
> What if my leaves are falling like its own?—
> The tumult of thy mighty harmonies
>
> Will take from both a deep autumnal tone,
> Sweet though in sadness. Be thou, spirit fierce,
> My spirit! Be thou me, impetuous one! (lines 57–62)

171. Percy Bysshe Shelley,
Ode to the West Wind,
1819 [Cat. no. 289]

In Xannadù did Cubla Khan
A stately Pleasure-Dome decree;
Where Alph, the sacred River, ran
Thro' Caverns measureless to Man
Down to a sunless Sea.
So twice six miles of fertile ground
With Walls and Towers were compass'd round:
And here were Gardens bright with sinuous Rills
Where blossom'd many an incense-bearing Tree,
And here were Forests ancient as the Hills
Enfolding sunny Spots of Greenery.
But o! that deep romantic Chasm, that slanted
Down a green Hill athwart a cedarn Cover,
A savage Place, as holy and inchanted
As e'er beneath a waning Moon was haunted
By Woman wailing for her Demon Lover:
From forth this Chasm with hideous Turmoil seething,
As if this Earth in fast thick Pants were breathing,
A mighty Fountain momently was forc'd,
Amid whose swift half-intermitted Burst
Huge Fragments vaulted like rebounding Hail,
Or chaffy Grain beneath the Thresher's Flail:
And mid these dancing Rocks at once & ever
It flung up momently the sacred River.
Five miles meandring with a mazy Motion
Thro' Wood and Dale the sacred River ran,
Then reach'd the Caverns measureless to Man
And sank in Tumult to a lifeless Ocean;
And mid this Tumult Cubla heard from far
Ancestral Voices prophesying War.
 The Shadow of the Dome of Pleasure
 Floated midway on the Wave
 Where was heard the mingled Measure
 From the Fountain and the Cave.
It was a miracle of rare Device
A sunny Pleasure-Dome with Caves of Ice!

 A Damsel with a Dulcimer

172. Samuel Taylor Coleridge, *Kubla Khan* [Cat. no. 271].
The only surviving manuscript of Coleridge's famous poem, written in 1797, published in 1816

In a vision once I saw:
It was an Abyssinian Maid,
And on her Dulcimer she play'd
Singing of Mount Amara.
Could I revive within me
Her symphony & song,
To such a deep delight 'twould win me,
That with Music loud and long
I would build that Dome in Air,
That sunny Dome! those Caves of Ice!
And all, who heard, should see them there,
And all should cry, Beware! Beware!
His flashing Eyes! his floating Hair!
Weave a circle round him thrice,
And close your Eyes in holy Dread.
For He on Honey-dew hath fed
And drank the Milk of Paradise.———

This fragment with a good deal more, not
recoverable, composed, in a sort of Reverie brought
on by two grains of Opium, taken to check a
dysentery, at a Farm House between Porlock &
Linton, a quarter of a mile from Culbone Church,
in the fall of the year, 1797.———

S. T. Coleridge

The "auxiliar light" which in Wordsworth bestows new splendour on the setting sun, or (as the sublime alternative) causes the midnight storm to grow darker "in the presence of [his] eye," is evidence of the unusually visual quality of his imagination. His memories are pictures in the mind; he envies the visual arts ("Ah, then, if mine had been the painter's hand," "O now that the genius of Bewick were mine!"); and he uses a succession of pictorial metaphors: "I cannot paint / What then I was . . . ," "I should need / Colours and words that are unknown to man / To paint the visionary dreariness. . . ." He saw his poetry as transforming landscape through the power of mind, in a way that was analogous to the child's "investing" of the moorland scene with uncanny significance. Wordsworth's eye, we are told by Hazlitt in *The Spirit of the Age*, "does justice to Rembrandt's fine and masterly effects." It is an interesting comment from one who was himself a distinguished painter:

> In the way in which that artist [Rembrandt] works something out of nothing, and transforms the stump of a tree, a common figure, into an *ideal* object by the gorgeous light and shade thrown upon it, he perceives an analogy to his own mode of investing the minute details of Nature with an atmosphere of sentiment, and in pronouncing Rembrandt to be a man of genius, feels that he strengthens his own claim to the title.

173. John Crome, *Moonlight on the Yare*, c. 1808–1815 [Cat. no. 280]. British Romantic art at its closest to Dutch masters of the seventeenth century

Hazlitt's final observation is less than generous, but that Wordsworth himself should have claimed an affinity with Rembrandt, and his use of chiaroscuro, is important. Among his own contemporaries, we see affinities with John Crome and the silhouetted windmill of *Moonlight on the Yare* [Fig. 173], but it is Girtin whom he chiefly resembles. *On the River Wharfe* [Fig. 174], though sadly damaged by flood-water in the 1920s, still shows the "gorgeous" transforming power of light and shade. Cattle on the winding river, sparse vegetation, and background hills are united by sunlight on a drifting central column of smoke, that "connect[s] the landscape with the quiet of the sky." In *Thames from Queenhithe* [Fig. 126] it is the City steeples that are idealized, rising above the line of secular buildings, and taking the eye with their luminous intensity. It is *White House at Chelsea* [Fig. 175], however, that is the acknowledged masterpiece. Girtin must surely have been aware that the sun's last rays, as they touch into life a single unimportant house—a "common" object, by any standards—are enacting the role of the human imagination.

174. Thomas Girtin, *On the River Wharfe, Yorkshire*, 1801 [Cat. no. 282]. Faded by flood-water in 1928 but showing the sweep and power that made Girtin a dominant influence in Romantic watercolour

Attempting to describe what had first seemed to him special about Wordsworthian vision, Coleridge in *Biographia Literaria* (1817) broadens out the perspective offered by Hazlitt. One might think for a moment that he was writing of Palmer's *Cornfield by Moonlight* [Fig. 176], or the poignant beauty of Keats' *To Autumn* [Fig. 178]:

> It was the union of deep feeling with profound thought; the fine balance in observing, with the imaginative faculty in modifying the objects observed; and above all the original gift of spreading the tone, the atmosphere, and with it the depth and height of the ideal world, around forms, incidents, and situations, of which, for the common view, custom had bedimmed all the lustre—had dried up the sparkle and the dewdrops.

175. Thomas Girtin,
White House at Chelsea, 1800 [Cat. no. 283]

176. Samuel Palmer,
Cornfield by Moonlight with the Evening Star, c. 1830 [Cat. no. 286]

177. John Constable, *The Lock*,
1822–1824 [Cat. no. 274]

Constable too might have taken Coleridge's words as an account of his
method. In his great full-sized oil sketches of 1824, *The Leaping Horse* and
The Lock [Fig. 177], "the depth and height of the ideal world" are spread
vividly, yet lovingly, around the most commonplace riverside incidents.
"My picture is liked at the Academy," Constable wrote of his final version
of *The Lock*:

Indeed it forms a decided feature, and its light cannot be put out
because it is the light of Nature—the mother of all that is valuable in

Season of Mist and mellow fruitfulness
 Close bosom friend of the maturing sun;
Conspiring with him how to load and bless
 The Vines with fruit that round the thatch eaves run.
 To bend with apples the moss'd Cottage trees
 And fill all fruits with ripeness to the core
 To swell the gourd, and plump the hazle shells
With a white Kernel; to set budding more
 And still more, later flowers for the bees
Until they think warm days will never cease
 For Summer has o'er brimm'd their clammy cells —

Who hath not seen thee? &c anwa thy stores?
 Sometimes, whoever seeks abroad may find
Thee sitting careless on a granary floom
Thy hair soft lifted by the winnowing wind
While bright the sun slants through the barn;
on on a half reap'd furrow sound asleep
Or sound asleep in a half reaped field
 Dosed with read poppies; while thy reaping hook
Spares from some slumbrous minutes while warm slumbers cool
 minutes while warm slumbers creep
Or on a half reap'd furrow sound asleep
 Dos'd with the fume of poppies, while thy hook
Spares the next swath, and all its twined flowers
Spares for some slumbrous minutes the next swath;

And sometimes like a gleaner Mou dost keep
 Steady thy laden head across the brook;
Or by a Cyder-press with patent look
Mou watchest the last oozing hours by hours

178 (*above and opposite*). John Keats, *To Autumn* [Cat. no. 285].
Original manuscript of 1819

Where are the songs of Spring? Aye, where are they?
 Think not of them thou hast thy music too—
While a bared clouds bloom the soft dying day
 and Touching the the stubble plains with rosy hue—
Then in a wailful quire the small gnats mourn
 among the river sallows, borne aloft
 Or sinking as the light wind lives and dies;
And full grown lambs loud bleat from hilly bourn,
 Hedge crickets sing, and now again full soft
 The Redbreast whistles from a garden croft;
And Gathering swallows twitter in the Skies—

Original manuscript of John Keats
Poem to Autumn— Presented to
Miss A Barker by the authors Brother.
Tue Nov 15. 1839.

Given to my Grand Daughter
Elizabeth Ward May 14th 96
 from H. B. Ward

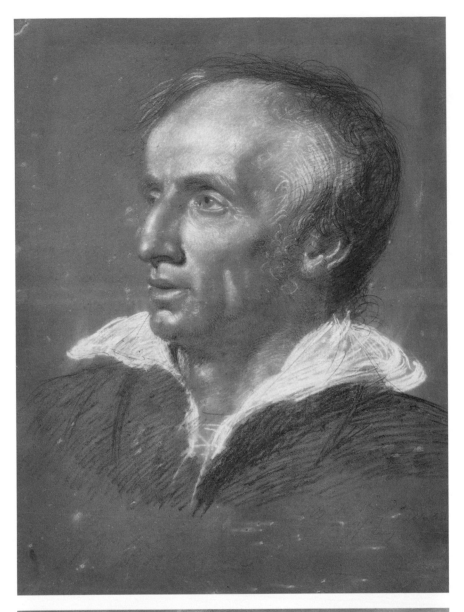

179. Benjamin Robert Haydon,
William Wordsworth, 1818 [Cat. no. 284].
The poet aged forty-eight

180. John Varley,
Snowdon from Capel Curig, c. 1805–1810
[Cat. no. 301]

poetry, painting, or anything else where an appeal to the soul is required. The language of the heart is the only one that is universal. . . . My execution annoys most of them [the critics], and all the scholastic ones. Perhaps the sacrifices I make for *lightness* and *brightness* [are] too much, but these things are the essence of landscape.

Constable's reference to "The language of the heart" may be a recollection of *Tintern Abbey*: "in thy voice I catch / The language of my former heart." Like Constable, Wordsworth both worked according to "the light of Nature" ("the mother of all that is valuable in poetry [and] paintings") and was at the same time constantly aware of her changing effects. Lightness and brightness are as much "the essence of landscape"

181. William Wordsworth, "Ascent of Snowdon" [Cat. no. 303]. The climactic episode of *The Prelude*

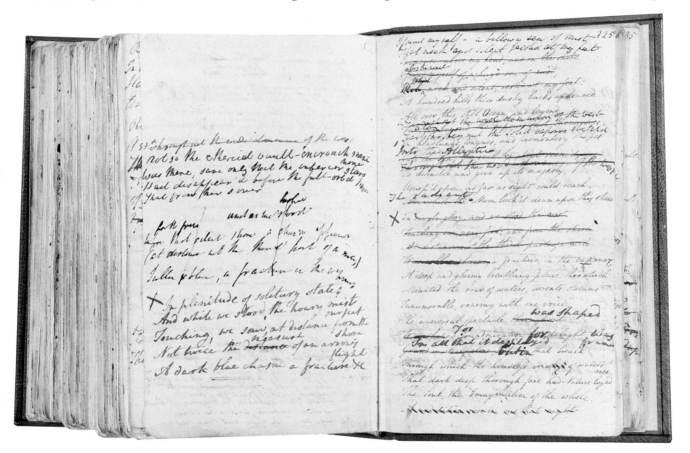

in the "Ascent of Snowdon" [Fig. 181] with which *The Prelude* ends, as they are in *The Lock*:

> With forehead bent
> Earthward, as if in opposition set
> Against an enemy, I panted up
> With eager pace, and no less eager thoughts.
> Thus might we wear perhaps an hour away,
> Ascending at loose distance each from each,
> And I, as chanced, the foremost of the band—
> When at my feet the ground appeared to brighten,
> And with a step or two seemed brighter still;
> Nor had I time to ask the cause of this,
> For instantly a light upon the turf
> Fell like a flash. (xiii, 29–40)

182. John Sell Cotman,
Road to Capel Curig, North Wales,
1807 [Cat. no. 226]

The poet and his companions are halfway up the mountain, walking in the dark, and hoping to see the sunrise from the summit. He is twenty-one, and to his older self his eagerness now seems a little ridiculous. We never hear whether in fact he, or they, got to the top. Wordsworth's shock-tactics—light used as daringly as it ever was by Girtin or Constable—are the prelude to a different kind of experience:

> I looked about, and lo,
> The moon stood naked in the heavens at height
> Immense above my head, and on the shore
> I found myself of a huge sea of mist,
> Which meek and silent rested at my feet.
> A hundred hills their dusky backs upheaved
> All over this still ocean, and beyond,
> Far, far beyond, the vapours shot themselves
> In headlands, tongues, and promontory shapes,
> Into the sea—the real sea—that seemed
> To dwindle and give up its majesty,
> Usurped upon as far as sight could reach.
>
> (xiii, 40–51)

Air travel has made the scene that Wordsworth describes a common one, but it has done nothing to lessen the beauty and subtlety of his

description. The slopes of the mountain (landscape such as Cotman evokes so powerfully in *Road to Capel Curig* (1807) [Fig. 182] and David Cox in the late but magnificent *Mountain Heights* (*c.* 1850) [Fig. 183]) have been taken over by the mist. Everything is at rest, "meek and silent."

183. David Cox,
Mountain Heights, Cader Idris,
c. 1850 [Cat. no. 277].
One of the last achievements
of Romantic watercolour

Yet there is a feeling of suppressed activity—the "dusky backs" of cloud are "upheaved" and under strain, vapours have "shot themselves" into tongues and promontories. Gradually we become aware that the mist beneath the poet's feet is another of the great Romantic emblems of imagination. Nature has transformed the landscape, turning rocks and crags into an ocean of cloud, just as poet or painter may cast over the objective facts of experience "The light that never was on sea or land." In this imaginative process, fact (like the distant and diminished Irish Channel) must "dwindle and give up its majesty" before the usurping power of mind.

"Meanwhile," Wordsworth continues, building towards his climax:

> the moon looked down upon this show
> In single glory, and we stood, the mist
> Touching our very feet; and from the shore
> At distance not the third part of a mile
> Was a blue chasm, a fracture in the vapour,
> A deep and gloomy breathing-place, through which
> Mounted the roar of waters, torrents, streams
> Innumerable, roaring with one voice.
> The universal spectacle throughout
> Was shaped for admiration and delight,

Grand in itself alone, but in that breach
Through which the homeless voice of waters rose,
That dark deep thoroughfare, had Nature lodged
The soul, the imagination, of the whole. (xiii, 52–65)

At first the poet's factual tones—"At distance not the third part of a mile"—suggest that like the moon he sees it all from a position of detachment. The "deep and gloomy breathing-place," however, catches our interest: we want to know how a rift in the cloud comes to deserve such strange and powerful language. What is the importance of these "waters, torrents, streams / Innumerable" whose noise mounts up to the poet from the countryside beneath? How do they come to be roaring with a single voice? Does the poet mean to equate the soul and imagination? And why should these human attributes be "lodged" in a "dark deep thoroughfare" of mist? It is not the sort of writing that answers all questions. Like Burke, Wordsworth is aware that "A clear idea is . . . another name for a little idea." On this occasion, however, he is prepared to offer us an extraordinary gloss on the underlying meaning:

A meditation rose in me that night
Upon the lonely mountain when the scene
Had passed away, and it appeared to me
The perfect image of a mighty mind,
Of one that feeds upon infinity,
That is exalted by an under-presence,
The sense of God, or whatsoe'er is dim
Or vast in its own being. . . . (xiii, 66–73)

Earlier, we have been shown the effects of imagination—its mist-like ability to transform the face of the natural world. Now, we hear of its source. Like the Turner vortices of *The Foot of St. Gothard* and the sublime *Valley of Aosta* [Figs. 184 and 185], the cloud-rift images for us the

184. J. M. W. Turner,
The Foot of St. Gothard,
c. 1842 [Cat. no. 291]

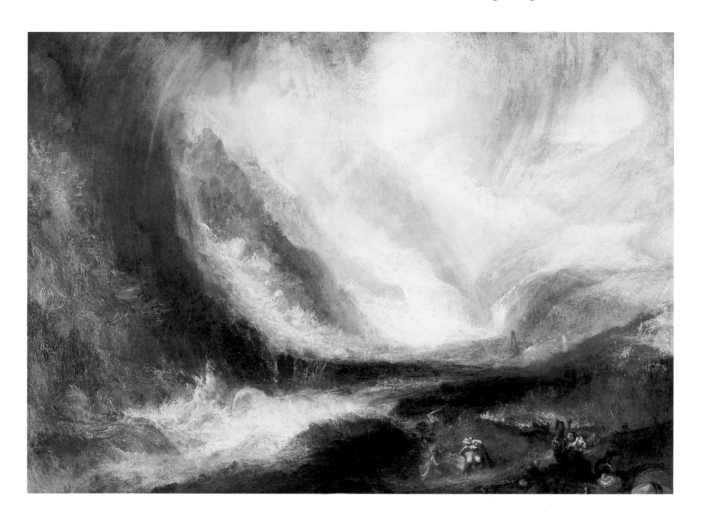

185. J. M. W. Turner,
*Valley of Aosta—Snowstorm, Avalanche,
and Thunderstorm,*
c. 1836–1837 [Cat. no. 298]

human unconscious. We cannot tell whether Turner actually thought in such terms, but Wordsworth certainly did. The voices mounting through the mist are—or can be seen as being—internal. They combine to form what the poet, in a supreme Romantic intuition, suggests may be either "'The sense of God" or the sense of an autonomous power deep within the self. But perhaps the distinction is unreal, and there is indeed an equation of soul and imagination. The poetry refuses to lay down the law. It does, however, make clear that the individual has (in De Quincey's phrase) a "latent capacity for sympathy with the infinite." As "one that feeds upon infinity," he draws nourishment from inward spiritual resources. No other faith could explain the extraordinary confidence of *The Prelude*'s final lines. "Revolutions in the hopes / And fears of men," we are told, bring about no lasting change; but yet "the mind of man" can of itself become

> A thousand times more beautiful than the earth
> On which he dwells. . . .

> (xiii, 446–448)

Catalogue

The catalogue entries were written collaboratively by Peter Funnell, Michael C. Jaye, Robert Woof, and Jonathan Wordsworth, and edited by Jonathan Wordsworth, assisted by James Pallot. Iain Bain kindly contributed the entries for the Thomas Bewick items.

The entries are listed alphabetically by exhibition section. Unless otherwise noted, works in "Oil" are on canvas, and watercolours, drawings, and engravings are on paper. Dimensions are given in inches followed by centimetres, with height before width. Where items are not shown in all three exhibition sites, The New York Public Library is abbreviated as "NYPL," Indiana University Art Museum as "IUAM," and Chicago Historical Society as "CHS."

Quotations and titles have normally been modernized.

I:

The Age of Revolutions

1

Anonymous
King Killing
London, 1794
Private collection

[See p. 23.] "Sold by CITIZEN LEE, at the British Tree of Liberty, No. 98, Berwick-Street, Soho;" an extreme radical broadside. On 17 Nov. 1795 *King Killing* and its publisher, Citizen Richard Lee, were denounced in the House of Commons. On 18 Dec. the "Two Bills"—against treasonable practices and seditious meetings—became law, having been rushed through Parliament by William Pitt the younger, the prime minister, as a means of stifling opposition. Treason was redefined in the broadest terms, and organized meetings were banned.

2 [Figure 14]

Anonymous
"Massacre des prisonniers de l'Abbaye St. Germain" in *Révolutions de Paris dédiée à la Nation*
1792
Engraving
$3\frac{1}{2} \times 5\frac{7}{8}$ (9 × 14.8)
Musée Carnavalet, Paris

[See pp. 10–11.] The threat of invasion, combined with the fear of internal subversion, led in September 1792 to the indiscriminate slaughter of prisoners from the Paris gaols. Danton spoke in the Assembly of pressing every man into service in order to save France: "the people . . . must throw themselves upon their enemies *en masse.*" Marat, in his journal *L'Ami du peuple,* proclaimed, "Let the blood of the traitors flow." Madame Roland describes the mood in a letter of 2 Sept.: "Even as I write the alarm cannon is fired, the drums beat out the call to arms, . . . The Assembly passes decrees smacking of fear; the mob proceeds to the Abbaye prison and massacres fifteen people; it talks of going to all the prisons." Twelve to fourteen hundred people were killed over a five-day period beginning on 2 Sept.

3 [Figure 13]

Anonymous
"Terrible Massacre de femmes dont l'histoire na [*sic*] jamais donné l'exemple"
in *Révolutions de Paris dédiée à la Nation*
1792
Engraving
$3\frac{5}{8} \times 5\frac{7}{8}$ (9.2 × 14.7)
Musée Carnavalet, Paris

[See p. 11.] "Horrifying massacre of women, unparalleled in history," and similar engravings [see Cat. no. 2], were part of the popular reaction condemning the excesses of revolutionary violence. About half the prison population of Paris had been slaughtered, three-quarters of them non-political prisoners. Thirty-seven were women.

4

Anonymous
Prise de la Bastille. 14 juillet 1789

Late 18th century
Oil
$28\frac{3}{4} \times 33\frac{7}{8}$ (73 × 86)
Musée national du château de Versailles

[See p. 7.] *The Times* of London responded to the news that the Bastille had fallen by declaring: "the right hand of . . . tyranny is cut off." Wordsworth in 1791 "gathered up a stone" from the dismantled building, "And pocketed the relic," whilst Lafayette sent one of the keys of the fortress to his former comrade, Washington, via Tom Paine. Thomas Carlyle, in *The French Revolution* (1837), evokes the lingering power of the Bastille as a symbol of tyranny: "Vanished is the Bastille, what we call vanished: the *body,* or sandstones, of it hanging, in benign metamorphosis, for centuries to come, over the Seine waters, as Pont Louis Seize; the soul of it living, perhaps still longer, in the memories of men."

5 [Figure 10]

Jean-Jacques-François Le Barbier (artist), Laurent (engraver)
Déclaration des droits de l'homme et du citoyen
1789
Engraving
$22\frac{3}{8} \times 16$ (56.8 × 40.7)
Musée Carnavalet, Paris

The Declaration of the Rights of Man and the Citizen was drafted by Lafayette, decreed on 26 Aug. 1789, and finally signed (under pressure) by the king on 5 Oct. Drawing on the American Declaration of Independence [Cat. no. 20] and Constitution, and their sources in the Enlightenment, the French Declaration refers in its preamble to "the natural, inalienable, and

sacred rights of man.'' Its seventeen articles begin by asserting that ''Men are born free, and remain free and equal in their rights. Social distinctions can only be founded on public utility.'' They go on to stress that ''Free expression of thought and opinions is one of the most precious rights of man,'' and insist on the ''separation of powers'' exemplified in the American Constitution.

The text of this popular engraving of the French Declaration appears on two tablets, above which are the allegorical figures of ''France breaking her chains'' and ''Law indicating the supreme Eye of Reason with her sceptre.''

6 [Figure 4]

James Barry
The Phoenix or the Resurrection of Freedom
1776
Etching and aquatint
$17 \times 24\frac{1}{8}$ (43.1 × 61.3)
Yale Center for British Art,
Paul Mellon Collection

[See pp. 2–3.] Unsigned aquatint celebrating the American Declaration of Independence. Barry's Royal Academy lectures looked to America to reinvigorate historical painting; since great art depended on political liberty, it could no longer be created in England. An advocate of greater independence for Ireland, Barry moved into the radical dissenting circles of Richard Price and Joseph Priestley, becoming a friend of William Godwin and Mary Wollstonecraft. In 1799 he was expelled from the Royal Academy for his attacks upon its members.

7 [Figure 17]

Charles Benazech
Louis XVI au pied de l'échafaud. 21 janvier 1793
1793
Oil
$16\frac{1}{2} \times 22$ (42 × 56)
Musée national du château de Versailles

A rare, and sympathetic, contemporary portrayal of Louis XVI about to ascend the scaffold, by an English artist resident in Paris. The guillotine in the right background, attended by the hereditary city executioner Charles Sanson, is ironically an egalitarian means of death, since before the Revolution only nobles had the right to be decapitated. Benazech's depiction of Louis in his white waistcoat is accurate, as is the king's shortened hair (cut so that the guillotine would not be impeded).

8 [Figure 16]

Attributed to Etienne Béricourt
Transport des cadavres
1792
Gouache over pen and ink
$15\frac{5}{8} \times 21\frac{3}{8}$ (39.8 × 54.3)
Musée Carnavalet, Paris

[See pp. 11–12.] One of many contemporary images pointing up the horror of the September Massacres [see Cat. nos. 2 and 3]. The sight of naked bodies being piled onto carts is described

by several sources, including this account by a young working-class woman: ''The carts were full of men and women who had just been slaughtered and whose limbs were still flexible because they had not had time to grow cold, so that legs and arms and heads nodded and dangled on either side of the carts.''

The September Massacres were a grim prelude to the more sustained and systematic Terror which followed as moderate Girondins such as Madame Roland lost their struggle against the Jacobins.

9 [Figure 5]

William Blake
Frontispiece from *America a Prophecy*
1793
Relief etching with brown wash
$11\frac{3}{4} \times 9\frac{1}{4}$ (29.8 × 23.5)
The Rosenbach Museum & Library,
Philadelphia

In this frontispiece to an uncoloured copy of *America*, the winged and manacled figure of Orc sits dejected among signs of a battle. Blake uses the term ''prophecy'' in the correct but old-fashioned sense of a spiritual interpretation of contemporary events; the bulk of *America* consists of an excited reading of the War of Independence in terms of the optimism generated by the French Revolution in 1791–1792. Orc's condition in the Frontispiece, however, reflects the very different mood in which the poem was completed in 1793. As the personification of revolutionary energy, he will some day rend his manacles, but for the moment he has not been able to bring American freedom to the peoples of Europe.

10

H. Blanchard, after Marcus Rainsford
Toussaint L'Ouverture
c. 1803
Engraving
$7\frac{7}{8} \times 5\frac{1}{8}$ (19.9 × 13)
Schomburg Center for Research in Black Culture, The New York Public Library

Rainsford, a major in the British army, published two accounts (1802 and 1805) of his experiences in the West Indies in the 1790s. This engraving from his drawing of the slave leader Toussaint [see Cat. no. 31] shows a scene described in his 1802 publication—a military review of Toussaint's forces, ''of the grandeur of which I had not the least conception.'' Expecting an undisciplined mob, Rainsford was much impressed when the soldiers performed a number of manoeuvres showing ''promptitude,'' ''dexterity,'' and ''the utmost regularity and attention to rank.''

11 [see Figure 19]

Edmund Burke
Reflections on the Revolution in France, and on the Proceedings in Certain Societies in London Relative to that Event in a Letter Intended to be Sent to a Gentleman in Paris
London, 1790
The Berg Collection of English and American Literature, The New York Public Library

First edition, first issue with cancellations, of Burke's attack on Richard Price's *Discourse on the Love of Our Country* [Cat. no. 25]. A supporter of the American Revolution, Burke was horrified by the fickle, violent, and often vulgar behaviour of the Paris crowds. Drawing immediate responses from Mary Wollstonecraft and Thomas Paine [Cat. nos. 23 and 35], he declared events like the march of the women of Paris on Versailles and the attack on the Bastille to be signs of a depraved human nature from which society needed protection: ''in France the elements which compose human society seem all to be dissolved, and a world of monsters is to be produced in the place of it.'' Burke's Hobbesian view of mankind was countered by those of Wollstonecraft and Godwin [Cat. nos. 17 and 35], who believed that reason would lead to eventual human happiness.

12 [Figure 2]

Sir Francis Legatt Chantrey
William Wordsworth
1820
Marble
$22\frac{7}{8}$ (58)
Courtesy of the Lilly Library,
Indiana University, Bloomington, Indiana

Commissioned by Sir George Beaumont, and exhibited at the Royal Academy in 1821 with Chantrey's bust of Scott. The sculptor's initial drawing of Wordsworth's profile, made with a *camera lucida*, has been preserved. Wordsworth regarded the bust as ''a noble work of fine art . . . fully entitled to that praise which is universally given to Mr. Chantrey,'' and had it engraved for *Poems*, 1845. Coleridge found it ''too idealized,'' remarking cryptically that it was ''more like Wordsworth than Wordsworth himself.''

13 [Figure 9]

Claude Cholat
La prise de la Bastille: le 14 juillet 1789
c. 1789
Gouache on cardboard
$20\frac{1}{16} \times 25\frac{1}{16}$ (51 × 63.7)
Musée Carnavalet, Paris

[See p. 7.] Inscribed on bottom front (in French) ''Siege of the Bastille, taken on the spot, 14 July 1789. Presented by one of the 'Conquerors of the Bastille.''' Cholat, a local wine merchant, himself took part in the assault, and presented this lively amateur painting—compressing the events of the five-hour siege—to the National Assembly in Sept. 1791.

14 [Figure 22]

Johann Eckstein
Rioters Burning Dr. Priestley's House at Birmingham, 14 July 1791
1791
Oil
31×40 (78.7 × 101.6)
Susan Lowndes Marques Collection

[See pp. 17–18.] It was probably with the connivance of local magistrates that Priestley's house, library, and laboratory were destroyed by a Church-and-King mob on the second

anniversary of the Fall of the Bastille. As one of the most prominent radicals in England, Priestley had been aware of the danger, and did not attend the Bastille Dinner in Birmingham or in any other way provoke the attack. In February 1794 he emigrated to America.

15 [Figure 20]

James Gillray
Smelling Out a Rat:—or The Atheistical-Revolutionist disturbed in his Midnight "Calculations." Vide A troubled conscience
1790
Coloured engraving
$10\frac{1}{16} \times 14$ (25.6 × 35.8)
Wallach Division of Art, Prints and Photographs, The New York Public Library

[See pp. 16–17.] An allegorical portrayal of Burke's attack on Richard Price in *Reflections on the French Revolution*. As defender of Church and State (and *status quo*), Burke takes the form of a gigantic bespectacled nose and two enormous hands—one holding a cross, the other a crown. Price, who turns from his desk in horror at the vision, is seen to be writing a tract "on the benefits of Anarchy, Regicide, and Atheism"—a violent misrepresentation of his devout and peaceable views.

16 [Figure 23]

James Gillray
The Zenith of French Glory:—The Pinnacle of Liberty. Religion, Justice, Loyalty & all the Bugbears of Unenlightened Minds, Farewell!
1793
Coloured engraving
$14 \times 9\frac{4}{5}$ (35.5 × 25)
Wallach Division of Art, Prints and Photographs, The New York Public Library

[See pp. 19–20.] Satirical cartoon, appearing on 12 Feb. 1793, the day after England declared war on France, and three weeks after news of the execution of Louis XVI reached London. The print is notable for its accurate depiction of the guillotine, naturally the subject of great curiosity in England; on it lies the body of the king, while those of a judge, a bishop, and two monks dangle from lamp brackets to represent the sweeping away of justice and religion.

17 [see Figure 19]

William Godwin
An Enquiry Concerning Political Justice, and its Influence on General Virtue and Happiness, Vol. I
London, 1793
The Carl H. Pforzheimer Shelley and his Circle Collection, The New York Public Library

[See p. 19.] First edition of Feb. 1793, in two quarto volumes, with Shelley's annotations made in Italy (March-April 1820). A former dissenting minister, Godwin believed that the individual should be freed from the restrictions imposed by society and government—"in all cases, an evil"—and left at liberty to act on entirely rational principles. "Each man should be wise enough to govern himself, without the intervention of any compulsory constraint." Although marriage was among the compul-

sory constraints he wished to see abolished, in 1797 he married Mary Wollstonecraft [see Cat. nos. 35 and 36] out of "a regard for the happiness of the individual, which I have no right to injure."

To Godwin's chagrin, Shelley put the philosopher's theory of "free love" into practice by running away with his daughter Mary [see Cat. no. 91]. (He later married her, as well as providing financial support for his father-in-law.) The poet's first letter to Godwin, written in 1812 at the age of nineteen, hints at the heady influence exerted by *Political Justice*: "To you, as the regulator and former of my mind, I must ever look with real respect and veneration."

18 [Figure 26]

Jean-Antoine, Baron Gros
Le Général Bonaparte au pont d'Arcole.
17 novembre 1796
1796
Oil
$51\frac{1}{4} \times 37$ (130 × 94)
Musée national du château de Versailles

[See pp. 23–24.] A student of David, Gros was introduced to Bonaparte in Italy through the future Empress Josephine. He followed the French army to Arcole in 1796, and watched General Bonaparte plant the flag on the bridge—the scene recorded here in unequivocally heroic terms. Napoleon rewarded him with an honorary staff post, and Gros chronicled several more campaigns, as well as serving on the commission selecting Italian works of art to be transferred to the Louvre. When David was exiled from France after the Restoration, Gros was left in charge of his studio, and later given the title of Baron by the Bourbons. He was uncomfortable maintaining the principles of Neoclassic art and, much criticized for his later work, drowned himself in the Seine in 1835.

19 [Figure 6]

Jean-Jacques Hauer
Lafayette and Madame Roland Drawing a Plan for the Festival of the French Federation
1791
Oil
$36\frac{3}{4} \times 29\frac{3}{8}$ (93.3 × 74.6)
University of Michigan Museum of Art. Bequest of Henry C. Lewis

[See p. 5.] Signed and dated "J. hauer 1791," and traditionally thought to show Lafayette and Madame Roland preparing plans for the *Fête de la Fédération* of 14 July 1790. Hauer was active in political circles and held office in the Théâtre Français, but little is known of his career as a painter. Among the revolutionary events he recorded was the *Death of Marat*; a portrait by him of Charlotte Corday is preserved at Versailles.

20 [see Figure 11]

Thomas Jefferson
In Congress, July 4, 1776. A Declaration by the Representatives of the United States of America, in General Congress Assembled
Printed by John Dunlap

4–5 July 1776
Rare Books and Manuscripts Division, The New York Public Library
NYPL only

One of sixteen remaining copies of the Declaration of Independence in its original state. Jefferson was selected to draft the text because (in John Adams' words) "of the Elegance of his pen." The Declaration was adopted by Congress on 4 July, rushed to John Dunlap at High and Market Street, Philadelphia, and printed by the following morning.

Based on a belief in "the laws of nature and of nature's God," the American Declaration became the model for European revolutionary governments [see Cat. no. 5]:

> We hold these truths to be self-evident, that all men are created equal, that they are endowed by their Creator with certain inalienable rights, that among these are life, liberty, and the pursuit of happiness. . . .

21 [see Figure 11]

Thomas Jefferson
In Congress, July 4, 1776. A Declaration by the Representatives of the United States of America, in General Congress Assembled
Printed by John Dunlap
4–5 July 1776
Courtesy of the Lilly Library, Indiana University, Bloomington, Indiana
IUAM only

One of five copies that survive of the Declaration in its second state, with the imprint reset [see Cat. no. 20].

22 [Figure 21]

John Keenan, after John Opie
Mary Wollstonecraft
1804
Oil
$29\frac{3}{4} \times 24\frac{7}{8}$ (75.6 × 63.2)
The Carl H. Pforzheimer Shelley and his Circle Collection, The New York Public Library

Copy of a portrait, made possibly on the occasion of her marriage on 29 March 1797, by Mary Wollstonecraft's long-standing friend John Opie. Keenan was commissioned by Aaron Burr, then Vice President of the United States, who is believed to have brought up his daughter Theodosia according to the principles put forward in the *Vindication of the Rights of Woman* [Cat. no. 36]. Burr went to considerable trouble to secure the portrait, having agents of the American government in London seek Godwin's permission for the copy to be made.

23 [see Figure 19]

Thomas Paine
Rights of Man: Being an Answer to Mr. Burke's Attack on the French Revolution
London, 1791
Harry Ransom Humanities Research Center, The University of Texas at Austin, The Library Collection

[See pp. 17–18.] One of very few surviving copies of the first issue, published in Feb. 1791

by Joseph Johnson [see Cat. nos. 35 and 38] and then quickly withdrawn. Re-publication in March 1791 was left to radical friends William Godwin, Thomas Holcroft, and Thomas Hollis. Dedicating his book to Washington, Paine rallies to the defence of Richard Price's *Discourse* [Cat. no. 25], attacked three months earlier by Burke in his *Reflections on the Revolution in France* [Cat. no. 11]. Paine appends the text of the French Declaration [Cat. no. 5] to support his argument for the "natural" rights of man, and voices the unbounded optimism of the age in his conclusion: "what we now see in the world, from the revolutions of America and France, are a renovation of the natural order of things. . . . It is an age of revolutions, in which everything may be looked for." Part Two of the *Rights of Man* [see pp. 18–19], dedicated to Lafayette, appeared a year later in Feb. 1792, advocating progressive taxation and the redistribution of wealth. Paine was indicted for sedition as a result, and fled to France, where he had been elected a member of the National Assembly. (Customs officials at Dover, impressed by discovering a personal letter from the American President among his possessions, let him pass; the warrant for his arrest arrived as his ship put to sea.) In Paris he advocated the formation of a republic before others were ready to take the step, but voted against the execution of the king and was himself imprisoned by the Jacobins.

24 [Figure 3]

Henry Pelham
The Fruits of Arbitrary Power,
or the Bloody Massacre
1770
Coloured etching
9¼ × 8¾ (23.5 × 22.2)
American Antiquarian Society
CHS only

One of only two surviving copies; the other, uncoloured and much damaged, is in The New York Public Library. Paul Revere seems to have plagiarized this design for his more famous print of the "bloody massacre" of 5 March 1770. Although Revere's was the first to be advertised—on 26 March—he received a letter from Pelham three days later accusing him of theft: for Revere to publish first was stealing, "as truly as if you had plundered me on the highway." "If you are insensible of the dishonour you have brought on yourself by this act," he goes on, "the world will not be so." Pelham advertised his own print a week later, but by that time Revere's engraving had flooded the market.

25 [see Figure 19]

Richard Price
A Discourse on the Love of Our Country,
Delivered on Nov. 4, 1789, at the Meeting-House
in the Old Jewry, to the Society for
Commemorating the Revolution in Great Britain
London, 1789
Courtesy of the Lilly Library,
Indiana University, Bloomington, Indiana

[See p. 14.] Delivered as a sermon to the Revolution Society, formed the previous year to mark the centenary of the constitutional reforms of 1688, and concluding in a message of congratulation to the French National Assembly which led directly to Burke's composition of *Reflections on the French Revolution*.

Price closed his sermon with a warning to the forces of oppression:

> Tremble all ye oppressors of the world! Take warning all ye supporters of slavish governments, and slavish hierarchies! . . . You cannot now hold the world in darkness. Struggle no longer against increasing light and liberality. Restore to mankind their rights; and consent to the correction of abuses, before they and you are destroyed together.

A text of the French Declaration of the Rights of Man [Cat. no. 5] was included as an appendix in the published version of Price's sermon.

26 [Figure 15]

Jean-Louis Prieur
Arrestation du roi et de la famille royale
à Varennes, 22 juin 1791
n.d.
Charcoal, stump
8⅛ × 10⅙ (20.6 × 26.4)
Musée Carnavalet, Paris

The royal family fled Paris on 20 June 1791, in an attempt to cross the frontier and enlist the help of Marie Antoinette's brother, the Emperor of Austria. Lafayette, while publicly maintaining that Louis had "been removed by the enemies of the Revolution," sent National Guardsmen in pursuit, and he was arrested at Varennes, about 140 miles from the capital, on the morning of 22 June. France did not become a republic for another fifteen months (21 Sept. 1792), but the king's treachery seriously weakened Lafayette and others who were attempting to work within the framework of a constitutional monarchy.

Prieur's depiction of a crowd of armed men entering the room is dramatic but less than accurate. The king's return to Paris was quietly negotiated inside the grocer's house where he had been taken the previous night.

27 [Figure 8]

Jean-Louis Prieur
Fête de la Fédération
n.d.
Charcoal, stump, heightened
8⅛ × 10⅞ (20.6 × 27.5)
Musée Carnavalet, Paris

[See pp. 5–6.] Federation Day, the first anniversary of the Fall of the Bastille, was celebrated in France, England, America, and elsewhere. In Philadelphia (for the French *philosophes* the very model of a revolutionary city) *Ça Ira* was sung in the streets. Landing at Calais on the previous day (13 July 1790), Wordsworth and his companion travelled south

> through hamlets, towns,
> Gaudy with relics of that festival,
> Flowers left to wither on triumphal arcs
> And window-garlands.

> (*Prelude,* vi, 361–364)

28

Jean-Louis Prieur
Journées de septembre. Massacres des prisonniers
de l'Abbaye
n.d.
Charcoal, stump, grey wash, and black ink
8⅞ × 14 (22.5 × 35.6)
Musée Carnavalet, Paris

Titled "The September Days. Massacre of the Prisoners from the Abbey," and thus associated with the massacres at the Abbey St. Germain in Sept. 1792 [see Cat. no. 2]. It has been suggested, however, that the drawing portrays the arrest of Robespierre and his associates on 27 July 1794 rather than the September Massacres.

29 [Figure 7]

Jean-Louis Prieur
Le Serment du Jeu de Paume
n.d.
Charcoal, stump, heightened with black ink
7⁷⁄₁₆ × 9⅙ (18.3 × 23.7)
Musée Carnavalet, Paris

On 20 June 1789 the Third Estate—the commons as distinguished from the Second and First Estates (clergy and nobles)—were locked out of their meeting-hall at Versailles after voting themselves to be the National Assembly. At the suggestion of Dr. Guillotin (after whom the instrument of execution was named), they adjourned to a nearby indoor tennis court, where an oath was proposed that they would not disperse until a constitution had been established. There was only one dissentient vote. Ordered to disperse three days later they refused, voting 493 to 34 that "the assembled nation cannot be given orders." The Bastille fell three weeks later.

30 [Figure 24]

Hubert Robert
Couloir à Saint Lazare
1794
Oil
15¾ × 12¹¹⁄₁₆ (40 × 32)
Musée Carnavalet, Paris

[See p. 22.] Robert spent several years in Italy, where he was a friend of Piranesi, and is sometimes known as "Robert des Ruines" for his idealized drawings of Roman ruins. Made a member of the French Royal Academy in 1766, he exhibited at the Salons from 1767. He was arrested in 1793 and imprisoned, first at Sainte Pélagie and then at Saint Lazare, where he was transferred on 31 Jan. 1794, at the height of the Terror. Here he was able to continue painting, capturing scenes of everyday life within the prison, as in the *Corridor at Saint Lazare*.

31

François Dominique Toussaint L'Ouverture
Letter to Gabriel Hédouville
11 July 1798
Manuscript
Private collection

[See p. 25.] From the black leader of the revolution in Saint Domingue (later Haiti) to Citizen General (formerly Count) Gabriel Hédouville, representative of the French Directory: signed letter in the hand of a secretary, on writing-paper bearing Toussaint's name, rank, and—by implication—allegiance to *La République française, une et indivisible.* Hédouville has been sent out from France to restore control of the colony, and hopes to do so by undermining Toussaint's authority. As a government agent, he is technically Toussaint's superior, and the letter shows that he has pulled rank by writing to confirm him in the office of commander-in-chief, which (as the writing-paper shows) he already holds. Toussaint, though almost illiterate—hence the dictating of his letter—is not merely a successful general but an impressive tactician. At this stage he regards himself as loyal to the French republic; but he fears the reimposition of slavery, and has no intention of accepting directives from Paris. His letter marks an important moment in the struggle for autonomy. Hédouville's confirmation of his rank is briskly acknowledged, and Toussaint notes without comment an order for the dismissal of one of his officers. Three months later, on 22 October, Hédouville returned to France completely out-manoeuvred. Toussaint did not live to see the establishment of independent Haiti in 1804, having died the previous year in a French prison.

32 [Figure 1]

J. M. W. Turner
Dolbadern Castle
1800
Oil
$47 \times 35\frac{1}{2}$ (119.4 × 90.2)
Royal Academy of Arts, London

Presented by Turner as his diploma picture on being elected to the Royal Academy in 1802, but exhibited at the Academy two years earlier, when he was an Associate. *Dolbadern Castle* is the culmination of a series of works resulting from trips to Wales in 1798 and 1799 and influenced by Richard Wilson. A large water-colour in the British Museum sets the castle low amongst the surrounding mountains, while a set of six small coloured-chalk studies foreshadow the tonal contrasts and the composition of the oil; in this final version Turner silhouettes the stumpy form of the castle against the brightly lit sky, and contrasts the flesh of the shirtless, kneeling prisoner with the darkness at the foot of the valley. The historical associations of the scene are emphasized by verse printed in the Academy catalogue and possibly written by Turner, recalling the imprisonment of the Welsh prince Owain Goch in Dolbadern in the thirteenth century:

How awful is the silence of the waste,
Where nature lifts her mountains to the sky,
Majestic solitude, behold the tower
Where hopeless OWEN, long imprisoned, pined
And wrung his hand for liberty, in vain.

Turner's desire to give his landscape the status of a history painting is in line with contemporary academic doctrine, and points to his growing professional aspirations. The figures

in the foreground are reminiscent of the seventeenth-century Italian painter Salvator Rosa.

33

Villeneuve (engraver)
M. M. J. Roberspierre [sic]
1793
Engraving
$8\frac{1}{2} \times 6$ (21.6 × 15.2)
Musée Carnavalet, Paris

[See p. 22.] Contemporary engraving of Robespierre, "incorruptible legislator," in 1793. As chairman of the Committee of Public Safety, he intensified the Reign of Terror, before himself going to the guillotine on 29 July 1794. A Paris newspaper reported: "The tyrant is dead."

34 [Figure 25]

Josiah Wedgwood
Am I Not a Man and a Brother?
1787
Black jasper on white jasper
$1\frac{3}{16} \times 1\frac{1}{8}$ (2.8 × 2.6)
Pretzfelder Collection

Made for the Society for the Abolition of the Slave Trade [see Cat. no. 41]. Wedgwood sent a batch of these cameos—showing a chained and manacled slave, and bearing the plea "Am I Not a Man and a Brother?"—to Benjamin Franklin for distribution among American abolitionists. "I have seen in their countenances," Franklin wrote back, "such mark of being affected by contemplating the figure of the suppliant (which is admirably executed) that I am persuaded it may have an effect equal to that of the best written pamphlet in procuring favour to those oppressed people." The image was engraved for Erasmus Darwin's *Botanic Garden* (1791), and copies of the medallion were made well into the nineteenth century.

35 [see Figure 19]

Mary Wollstonecraft
A Vindication of the Rights of Men, in a Letter to the Right Honourable Edmund Burke; Occasioned by his Reflections on the Revolution in France
London, 1790
Harry Ransom Humanities Research Center,
The University of Texas at Austin,
The Library Collection

[See p. 17.] First edition, published anonymously on 29 Nov. by Joseph Johnson (a fellow dissenter [see Cat. nos. 23 and 38]), and followed by a second, acknowledging Wollstonecraft's authorship, in Jan. 1791. *A Vindication* was the first major reply to Burke, appearing within a month of *Reflections* [Cat. no. 11]. Burke's chivalric concern for Marie Antoinette draws the comment that he cares only

for the downfall of queens, whose rank alters the nature of folly and throws a graceful veil over vices that degrade humanity; whilst the distress of many industrious mothers, whose helpmates have been torn from them, and the hungry cry of helpless babes, were vulgar sorrows that could not move your commiseration, though they might extort an alms.

Wollstonecraft went to France in 1792 and witnessed the Revolution at first hand. Her optimism about the perfectibility of man was qualified by the excesses of the Terror, but never abandoned.

36 [see Figure 19]

Mary Wollstonecraft
Vindication of the Rights of Woman: with Strictures on Political and Moral Subjects
London, 1792
The Berg Collection of English and American Literature, The New York Public Library

[See p. 19.] First edition in original grey boards and paper label. The first extensive and considered statement about the role of woman in society, written in 1791, published in 1792 by Joseph Johnson [see Cat. nos. 23, 35, and 38]. Wollstonecraft extends contemporary discussion of the rights of mankind specifically to women [see Cat. no. 35], linking their emancipation to more general reform: "We shall not see women affectionate till more equality is established in society." Dismissing Rousseau's view of women as little more than attractive ornaments, she argues for a national system of education enabling women to become the rational, independent companions of men. Her work was denounced as immoral, and her death in Sept. 1797 (six months after her marriage to Godwin [see Cat. no. 17], and ten days after the birth of her daughter, the future Mary Shelley) was regarded by many as punishment for daring to question the subordination ordained by God.

37

William Wordsworth
"Bliss was it in that dawn to be alive"
in *The Friend*, no. 11
26 Oct. 1809
Harry Ransom Humanities Research Center,
The University of Texas at Austin,
The Library Collection

The poet's most famous lines on the French Revolution, written for *The Prelude* in 1804, but first published in Coleridge's periodical, *The Friend*:

Oh! pleasant exercise of hope and joy!
For mighty were the auxiliars, which then stood
Upon our side, we who were strong in love!
Bliss was it in that dawn to be alive,
But to be young was very heaven!
(x, 689–693)

Wordsworth was the one major poet to have first-hand experience of the events in France, making a brief visit in July-August 1790, and staying for almost a year from Nov. 1791. It was the second visit that led to his political commitment to the Revolution.

38

William Wordsworth
Descriptive Sketches. In Verse. Taken during a Pedestrian Tour in the Italian, Grison, Swiss, and Savoyard Alps by "W. Wordsworth, B.A. / of St. John's, Cambridge"
London, 1793

The Wordsworth Collection,
Cornell University Library

Published by Joseph Johnson 28 Jan. 1793,
with *An Evening Walk* [Cat. no. 111], less than
two months after Wordsworth's return from
France. Inscribed "To S. T. Coleridge from D.
Wordsworth," and containing a second in-
scription from Henry Reed [see Cat. no. 208],
Wordsworth's American editor, to Coleridge's
daughter Sara, "Mrs. Henry Nelson Coleridge."
Discovering the book among several from
Southey's library bought from a Bristol dealer's
catalogue in 1845, Reed was moved, after
Wordsworth's death in 1850, to send it back
across the Atlantic on a "homeward voyage."

Descriptive Sketches was based on
Wordsworth's walking tour of France and the
Alps during the summer vacation of 1790 [see
Cat. no. 27], and written in France in 1792.
The poem's conclusion probably celebrated the
establishment of the French republic on 21
Sept., rising phoenix-like from the ashes of the
ancien régime:

> Lo! from th'innocuous flames, a lovely birth!
> With its own virtues, springs another earth:
> Nature, as in her prime, her virgin reign
> Begins, and Love and Truth compose her
> train.

39

William Wordsworth
"The Fall of the Bastille" in *The Excursion*,
Book Three
Holograph manuscript, *c.* 1813
The Wordsworth Trust

Written almost a quarter of a century after the
Fall of the Bastille, Wordsworth's account of the
Solitary in *The Excursion* captures a sense of the
expectation felt in 1789:

> The horrid tower
> Where wretched mortals, seldom seen or
> heard,
> From age to age had been deposited
> As in a treasure house (by prime command,
> And for the secret joy of sovereign power)
> Fell to the ground—by violence overthrown
> Of indignation, and with shouts that
> drowned
> The crash they made in falling! From this
> wreck
> A golden palace rose, or seemed to rise,
> The appointed seat of equitable law
> And mild paternal sway....
> (cf. iii, 709–716)

The Excursion [Cat. no. 199] addresses the
problems caused by the failure of revolutionary
promise. The drama of the poem centres on
whether the Solitary, a cynical recluse after the
collapse of his early idealism, can be redeemed
by the values of rural society advocated by
the Wanderer. The poem ends without the
Solitary's conversion.

40 [Figure 18]

William Wordsworth
*A Letter to the Bishop of Llandaff on the
Extraordinary Avowal of his Political Principles
Contained in the Appendix to his Late Sermon,
by a Republican*
Manuscript with holograph corrections,

c. Feb. 1793
The Wordsworth Trust

[See pp. 13–14.] Never printed by Wordsworth
himself (prosecution of author or publisher
would very probably have followed), and sur-
viving only in a single manuscript, corrected by
the poet, but in an unidentified hand. Llandaff's
recantation of his earlier support for the French
Revolution was occasioned by the death of
Louis XVI, and included fulsome praise for the
British Constitution:

> The poorest man amongst us, the beggar at
> our door, is governed by the fixed, impartial,
> deliberate voice of law, enacted by the
> general suffrage of a free people.

"I congratulate your lordship," Wordsworth
replied ironically, "upon your enthusiastic
fondness for the judicial proceedings of this
country." There was, he pointed out, neither
general suffrage nor impartial law, and the poor
had no chance whatever if their interests came
into conflict with those of the rich.

41

William Wordsworth
Manuscript sonnet *To Thomas Clarkson
on the Final Passing of the Bill for the Abolition
of the Slave Trade, March, 1807*, entered
on the flyleaf of Thomas Clarkson, *The History
of the Rise, Progress, and Accomplishment
of the Abolition of the African Slave-Trade
by the British Parliament*
London, 1808
The Beinecke Rare Book and Manuscript
Library, Yale University

Presentation copy of Clarkson's *History*, in-
scribed on the flyleaf to "Mrs. Cookson from
S. T. Coleridge," containing a transcription of
Wordsworth's sonnet of March 1807, entered
and dated by Mary ("Rydal Mount / 1844 Decb
19th") but signed by the poet.

First published in *Poems* 1807, the sonnet
praises Clarkson's final success in bringing
about the abolition of slave trading in British
ships:

> The blood-stained writing is for ever torn;
> And thou henceforth wilt have a good man's
> calm,
> A great man's happiness. Thy zeal shall find
> Repose at length, firm friend of human kind!

A founder of the Society for the Abolition of
the Slave Trade in 1787, Clarkson had written
An Essay on the Impolicy of the Slave Trade
as early as 1785. He retired to Ullswater in
1794 after his health broke down and later
became a friend of the Wordsworths and
Coleridge.

42

William Wordsworth
"Wordsworth in Paris" in *The Prelude*,
Book Ten, composed 1804
Prelude MS. B, *c.* Feb. 1806,
hand of Mary Wordsworth
The Wordsworth Trust

In poetry of apocalyptic dread not elsewhere
present in his work, Wordsworth responds to
the onset of violence in a revolution that for
three years had been largely peaceful and
constitutional:

> The fear gone by
> Pressed on me almost like a fear to come.
> I thought of those September massacres,
> Divided from me by a little month,
> And felt and touched them, a substantial
> dread.
> (x, 62–66)

2:

The Spirit of the Age

43 [Figure 73]

Anonymous
Dorothy Wordsworth
c. 1806
Oval portrait-silhouette on black paper,
with chinese white
$3 \times 2\frac{1}{2}$ (7.6 × 6.3)
The Wordsworth Trust

Inscribed "Miss Wordsworth / Sister of WW."
on the reverse in the hand of Elizabeth Cookson
(Dora Wordsworth's friend who helped her in
transcription of the final *Prelude* manuscript
[see Cat. no. 308]). This only known likeness of
Dorothy as a young woman was brought to
light in 1969, and came to The Wordsworth
Trust from the descendants of the Cooksons of
Kendal. Infra-red photography reveals that the
silhouette was originally marked with chalk,
picking out the peak of the cloth cap which
covers Dorothy's hair, the prominent buttons
and high neckline of the blouse (resembling an
Elizabethan ruff), and the design on the bodice.

44

Anonymous (signed with initials ETB)
Rydal Mount
1846
Pen and ink drawing
$9\frac{3}{8} \times 5\frac{1}{4}$ (23.5 × 13.5)
The Wordsworth Trust

One of many drawings of the Poet Laureate's
much-visited home where he lived from 1813
till his death, authenticated at the bottom: "A
correct Drawing of Rydal Mount, William
Wordsworth," and inscribed on reverse,
"Rydal Mount, the residence of Wm
Wordsworth, 23rd of 11th Mo. 1846, ETB."
Wordsworth had built an attic room over the
south corner of the house *c.* 1839, giving him a
study with a view towards Windermere in the
distance.

45 [Figure 33]

Washington Allston
Samuel Taylor Coleridge
1806
Oil
$29\frac{1}{2} \times 24\frac{5}{8}$ (75 × 62.5)
Harvard University Art Museums (Fogg Art
Museum), Washington Allston Trust

Coleridge met the American painter
Washington Allston in Rome, on his way back
from Malta in Dec. 1805, and moved into his
house at Olevano Romano, some thirty miles
outside the city, on hearing rumours of a

French invasion. Allston's portrait was left unfinished when Coleridge continued his journey in May 1806. Describing the time he spent with Coleridge in Rome, Allston later wrote: "I am almost tempted to dream that I once listened to Plato, in the groves of the Academy." A finished portrait of Coleridge by the same artist, dated 1814, is exhibited at the Wordsworth Museum, Grasmere, by courtesy of the National Portrait Gallery, London.

46 [Figure 32]

William Blake
Circle of the Lustful
c. 1824–1827
Pen, ink, and watercolour over pencil
$14\frac{7}{16} \times 20\frac{9}{16}$ (36.8 × 52.2)
Birmingham Museum and Art Gallery

A scene from Canto V of Dante's *Inferno*, describing the region of hell where carnal sinners are condemned to be eternally swept about in a whirlwind. Blake is faithful to Dante's account in showing the poet prostrate on the ground, having fainted with pity for the plight of Paolo and Francesca; but he also shows a vision of the two lovers united in a re-enactment of their first kiss, and apparently now in Eden (heaven). Dante's whirlwind, meanwhile, has become a redemptive force: it reunites the male and female principles (spectres and emanations in Blake's vocabulary), separated at the fall-into-division portrayed in *Vala* [Cat. no. 265], and carries them upwards to become part of the totality of eternal life.

Commissioned by John Linnell, Blake produced 102 watercolours as illustrations for *The Divine Comedy*. Samuel Palmer records seeing him at work on them, propped up in bed because of a scalded foot: "there he was making in the leaves of a great book (folio) the sublimest designs from . . . Dante"—"He designed them (100 I think) during a fortnight's illness in bed."

47 [Figure 30]

William Blake
The Good and Evil Angels
c. 1793–1794
Watercolour
$11\frac{1}{2} \times 17\frac{1}{2}$ (29.2 × 44.5)
By kind permission of the Trustees,
Cecil Higgins Art Gallery, Bedford
CHS only

An intermediate stage between Plate 4 of *The Marriage of Heaven and Hell* [Cat. no. 48] and the large colour-print *Good and Evil Angels* of 1795, but closer to the spirit of *The Marriage*, where the values of good and bad, heaven and hell, are reversed in a parody of Milton's *Paradise Lost*. The "good" angel, standing for repression, is withholding from his "evil" counterpart a child, representative probably of the human race. The "evil" one is an early version of Orc, the spirit of liberty, revolution, sexual potency, and love [see Cat. no. 9]. He is shackled for the moment, but surrounded by flames of hellish energy and soon to break free.

48 [Figure 29]

William Blake
The Marriage of Heaven and Hell
1790–1793
Illuminated poem, hand-printed and individually coloured by the author
$15\frac{1}{2} \times 10\frac{3}{4} \times 2$ (39.3 × 27.3 × 5)
Lessing J. Rosenwald Collection,
Library of Congress, Washington, D.C.

Written chiefly in 1790, *The Marriage* is partly a comic reversal of the values of *Paradise Lost*—"Milton is of the Devil's party without knowing it," and thus his hell is the true heaven—and partly a satire of the mystical writings of Emanuel Swedenborg (who never in fact ceased to be a major influence on Blake's thinking). Swedenborg's angels become the conceited proponents of "systematic reasoning," and "hell" is the source of wisdom necessary to liberate man from priesthood and repression: "Energy is Eternal Delight."

Among the nine known complete copies of *The Marriage of Heaven and Hell*, the Rosenwald copy (Copy D) contains many unique variants. The colouring, especially rich and elaborate, was probably done c. 1794–1795 on the commission of its first owner, Isaac D'Israeli.

49

William Blake
Songs of Innocence
1789
Volume of illuminated poems, hand-printed and individually coloured by the author
Syracuse University Library

Blake's first major publication. After 1793, *Songs of Innocence* was normally bound together with *Songs of Experience* [see Cat. no. 50], but independent copies were sold as late as 1818. Copy Q consists of *Innocence* plates only, several bearing watermarks for 1802 or 1804. The colouring is especially rich, and the printing has been reinforced with pen.

50 [Figure 31]

William Blake
Songs of Innocence and Experience
1826
Bound volume of relief etchings
hand-coloured by the author
Lessing J. Rosenwald Collection,
Library of Congress, Washington, D.C.

Copy Z, with sixteen sheets watermarked 1825, commissioned by Henry Crabb Robinson (Blake produced copies on demand throughout his life), and inscribed by him on the flyleaf: "This copy I received from Blake himself—And coloured in his own hand." A magnificent example of the richly coloured later copies, printed in orange, with gold added to the watercolour of several plates. Robinson records in his *Diary* for 18 Feb. 1826: "he told me my copy of his songs would be 5 guineas, and was pleased by my manner of receiving the information."

Blake announced *Songs of Experience* in Oct. 1793 as a separate publication, but all known copies are bound with *Songs of Innocence*. Presumably he decided that, while *Innocence* could stand on its own, *Experience* needed to be defined as the "contrary state" of the human soul. Images of life, joy, and freedom are replaced by those of death, sadness, and constraint.

51 [Figure 38]

Robert Burns
Auld Lang Syne
1788
Holograph manuscript
Courtesy of the Lilly Library,
Indiana University, Bloomington, Indiana

Burns' famous love-song, in its earliest text, sent in a letter to his friend Mrs. Dunlop, 7 Dec. 1788. The poem is introduced as "an old song and tune which has often thrilled through my soul," and Burns later referred to it as taken down "from an old man's singing;" how much he in fact wrote himself is uncertain. He may well have been claiming antiquity for work that is wholly, or largely, his own.

52

Robert Burns
Poems Chiefly in the Scottish Dialect
Kilmarnock, 1786
The Berg Collection of English and American Literature, The New York Public Library

Rare first edition, published when Burns was twenty-seven. Sold by subscription at a price of three shillings, the volume contains many of his most famous poems: *The Twa Dogs, The Holy Fair, The Cotter's Saturday Night, To a Mouse, To a Mountain-Daisy*, and *To a Louse*. Burns' knowledge of rural working life and his use of Scots dialect gave his poetry wide popular appeal, but he was far from being the "simple bard" suggested by the lines printed on the title-page:
unbroke by rules of art,
He pours the wild effusions of the heart—
And if inspired, 'tis Nature's powers inspire;
Hers all the melting thrill, and hers the
kindling fire.
Wordsworth admired "the simplicity, the truth, and the vigour of Burns;" as early as Dec. 1787 Dorothy wrote that he "had read and admired many pieces very much" [see p. 39]. Her own copy of the *Poems* (at the King's School, Canterbury) is heavily annotated.

53

Robert Burns
Song: O My Love's like the Red, Red Rose
n.d.
Holograph manuscript
Courtesy of the Lilly Library,
Indiana University, Bloomington, Indiana

First published by Peter Urbani, *A Selection of Scots Songs* (Edinburgh, 1793), as collected by "a celebrated Scots poet" from a country girl's singing. As with *Auld Lang Syne* [Cat. no. 51], it is unclear how much Burns depended on an actual folk song. Analogues have been found, such as *The Wanton Wife of Castle Gate*:
Her cheeks are like the roses
That blossom fresh in June;

O, she's like a new-strung instrument
 That's newly put in tune . . .
but no version of the song itself has been recorded.

54

Lord Byron
Childe Harold's Pilgrimage, Canto Three
London, 1816
The Berg Collection of English and American Literature, The New York Public Library

First edition, first issue, in paper wrappers. Composed in 1816 during the period Byron spent with Shelley and Mary Godwin in Switzerland [see p. 48]. Byron later recalled, "Shelley, when I was in Switzerland, used to dose me with Wordsworth physic even to nausea." He added grudgingly, "I do remember then reading some things of his with pleasure." Stanza LXXII shows the influence of Wordsworth at its strongest:
 I live not in myself, but I become
 Portion of that around me; and to me
 High mountains are a feeling, but the hum
 Of human cities torture. I can see
 Nothing to loathe in Nature, save to be
 A link reluctant in a fleshly chain,
 Classed among creatures, when the soul
 can flee,
 And with the sky, the peak, the heaving
 plain
 Of ocean, or the stars, mingle—and not in
 vain.
[See also Cat. no. 267.]

55 [Figure 40]

Lord Byron
Don Juan, Dedication, Stanzas 1–4
1818
Holograph manuscript
The Pierpont Morgan Library, New York

[See pp. 48–49.] Inscribed "Venice July 3d 1818," the first draft of *Don Juan* begins with an ironic "Dedication" to Robert Southey, Poet Laureate, who has betrayed his early revolutionary beliefs [see Cat. no. 97]. Coleridge is mocked for "Explaining metaphysics to the nation," and Wordsworth for his "rather long" *Excursion* [Cat. no. 199]. In more vehement tones, Byron then turns his attention to the "Cold-blooded, smooth-faced, placid miscreant," Castlereagh, who as Tory foreign minister has guided the Congress of Vienna in restoring the Bourbons to the throne of France. *Don Juan* was published anonymously, and at the last minute the Dedication was suppressed: "I won't attack the dog in the dark," Byron told his publisher, John Murray.

56

Lord Byron
Don Juan, Canto One, Stanza 1
1818
Holograph manuscript
The Pierpont Morgan Library, New York

Another leaf from the first draft of *Don Juan* [see Cat. no. 55]. Byron's casual beginning—"I want a hero"—sets the informal tone of his satirical epic. Although the role ostensibly goes to Juan—passive, naive, an *ingénu*—the poem brilliantly exploits the differences between him and the real hero of the piece, Byron himself; a worldly, sophisticated narrator whose digressions wander as far, in their way, as Juan does, and who perhaps reveals more about himself than any other Romantic poet. As Shelley commented in 1821:
 It is a poem totally of its own species, and my wonder and delight at the grace of the composition no less than the free and grand vigour of the conception of it perpetually increase. . . . This poem carries with it at once the stamp of originality and a defiance of imitation. Nothing has ever been written like it in English, nor, if I may venture to prophesy, will there be.

57 [Figure 41]

Lord Byron
Fare Thee Well
18 March 1816
Holograph manuscript
The Carl H. Pforzheimer Shelley and his Circle Collection, The New York Public Library

[See p. 44.] First draft of the highly personal lyric written for Byron's estranged wife Annabella, shortly before his departure for the continent in April 1816 (an exile from which he would never return, dying during the struggle for Greek independence in 1824). As well as sending the poem to his wife, Byron had John Murray print fifty copies for private circulation, and he allowed publication in *The Champion* (14 April) and in Leigh Hunt's *Examiner* (21 April). Further editions, and musical settings of the lyric, sold in thousands. Here as elsewhere, Byron's private life becomes part of his public persona:
 Fare thee well—thus disunited,
 Torn from every nearer tie,
 Seared in heart, and lone, and blighted,
 More than this I scarce can die.
The poem should be compared to *Stanzas to Augusta*, written at the same time for Byron's half-sister Augusta Leigh, and to the opening stanzas of *Childe Harold*, Canto Three [Cat. no. 54].

58 [Figure 48]

Alfred Clint, after Amelia Curran
Percy Bysshe Shelley
c. 1829
Oil
24 × 20 (61 × 50.8)
National Portrait Gallery, London

Amelia Curran's original portrait of Shelley was made in Rome in 1819, less than three years before his death. Its inadequacies were remarked upon at the time, and when Mary Shelley was asked to advise on an image of the poet to be used in Galignani's *Poetical Works of Coleridge, Shelley and Keats* of 1829, she proposed an "improved" version. The image eventually used was from a drawing by P. R. Davis, but Clint's highly accomplished copy was probably made at this date.

59

Samuel Taylor Coleridge
Christabel
1798–1800
Manuscript, hands of Dorothy Wordsworth and Mary Hutchinson
The Wordsworth Trust

The earliest surviving manuscript of *Christabel* in the red leather pocket notebook used by Wordsworth for his own poetry between 1798 and 1800. The fair copy of Part One, headed "Christabel—Book the First," is transcribed by Dorothy Wordsworth, and dates from the original period of composition in April 1798. Part Two, headed "Book the Second," is copied by Mary Hutchinson, probably soon after it was composed in early autumn 1800. Coleridge was never able to complete the poem, but it had an important influence on Scott when still in manuscript, and through him on Byron. It was finally published in 1816 together with *Kubla Khan* [Cat. no. 60], another great Romantic "fragment."

60

Samuel Taylor Coleridge
Christabel: Kubla Khan, A Vision; The Pains of Sleep
London, 1816
Courtesy of the Lilly Library, Indiana University, Bloomington, Indiana

First publication, in original brown wrappers, of two of Coleridge's great "supernatural" poems, *Christabel* and *Kubla Khan* [see Cat. nos. 59 and 271], published at Byron's suggestion by John Murray. "Kubla Khan: or a Vision in a Dream" is prefaced by a note explaining the circumstances of composition, headed "Of the Fragment of Kubla Khan." This has aroused some scepticism, but it is an important, if perhaps metaphorical, account of the frailty of the creative process. Falling asleep in his chair while reading a passage in *Purchas's Pilgrimage*—"Here the Khan Kubla commanded a palace to be built, and a stately garden thereunto. And thus ten miles of fertile ground were inclosed with a wall"—Coleridge (it seems) woke three hours later having composed 200–300 lines of poetry in his sleep. He "appeared to himself to have a distinct recollection of the whole, and taking his pen, ink, and paper, instantly and eagerly wrote down" the poem as we know it. At this point, however, he was disastrously interrupted by "a person on business from Porlock," and found himself to have forgotten the rest of the dream. There is no means of testing Coleridge's statements, but the aura of mystery with which they surround *Kubla Khan* has helped to build up its unique reputation. Whatever the circumstances, the poem was composed in early November 1797.

61

Samuel Taylor Coleridge
The Rime of the Ancyent Marinere
in *Lyrical Ballads, with a Few Other Poems*
London, 1798
Private collection

[See p. 34.] In his great ballad of sin and redemption, Coleridge took as his source a passage in Shelvocke's *Voyage Round the World* (1726), suggested by Wordsworth:

> one would think it impossible that any living thing could subsist in so rigid a climate; and, indeed, we all observed that we had not [seen] one fish of any kind . . . nor one sea-bird, except a disconsolate black albatross, who accompanied us for several days, hovering about us as if he had lost himself, till Hatley (my second Captain) observ[ed] that it might be some ill omen. That which, I suppose . . . encourage[d] his superstition, was the continued series of contrary tempestuous winds, which had oppressed us ever since we had got into this sea. . . . [he] at length shot the albatross, not doubting (perhaps) that we should have a fair wind after it.

Looking back to the period of *Lyrical Ballads*, Coleridge recalled that Wordsworth's aim was "to give the charm of novelty to things of every day," while his endeavours had been "directed to persons and characters supernatural, or at least romantic." For one reason or another both Coleridge and Wordsworth came to regard *The Ancient Mariner* as too divorced from the everyday. In 1800 the pseudo-medieval spelling was tidied up, and in 1817 prose glosses were added in a misguided attempt to clarify details of the narrative.

62

Samuel Taylor Coleridge
"And is shot by the Mariner," Plate 6 in
The Rime of the Ancient Mariner illustrated by David Scott, R.S.A.
Edinburgh, 1837
The Wordsworth Trust

A striking interpretation of *The Ancient Mariner*, lines 79–82, by the earliest illustrator of Coleridge's ballad:

> "God save thee, ancient Mariner!
> From the fiends, that plague thee thus!—
> Why look'st thou so?"—With my cross-bow
> I shot the ALBATROSS.

The albatross plunges towards the sea, as the Mariner's shipmates show their horror at his crime. Among later artists inspired by Coleridge's haunting story are Gustave Doré (1876), William Strang (1896), and David Jones (1929).

63 [Figure 56]

John Constable
Cenotaph to Sir Joshua Reynolds amongst Lime Trees in the Grounds of Coleorton Hall
28 Nov. 1823
Pencil and grey wash
$10\frac{1}{4} \times 7\frac{1}{8}$ (26 × 18.1)
The Trustees of the Victoria and Albert Museum, London

"In the dark recesses of these gardens," Constable wrote from Sir George Beaumont's house at Coleorton, Leicestershire, in Oct. 1823, "I saw an urn, and bust of Sir Joshua Reynolds—and under it some beautiful verses by Wordsworth." Wordsworth's poem, *Ye Lime-trees, Ranged before this Hallowed Urn*, was written by Constable on the back of his drawing, and printed in the exhibition catalogue when in 1836 a finished painting (replete with stag, and busts of Raphael and Michelangelo flanking the monument) was shown at the Royal Academy. Beaumont had been a frequent visitor to Dedham in Constable's early years, and it was through him that the poet and artist were first introduced.

64 [Figure 52]

John Constable
Self-Portrait
c. 1800
Pencil and black chalk
$9\frac{3}{4} \times 7\frac{5}{8}$ (24.8 × 19.4)
National Portrait Gallery, London

Probably dating from about a year after Constable's arrival in London, and enrolment in the Royal Academy Schools, in 1799. The careful modelling of the drawing suggests the sort of formal training he would have received from his instructors. Constable's later portraits, including the pencil self-portrait of 1806, are very much freer in their handling.

65

John Constable
Various Subjects of Landscape, Characteristic of English Scenery, Principally Intended to Mark the Phenomena of the Chiaroscuro of Nature: from Pictures Painted by John Constable, R.A.
London, 1833
Yale Center for British Art,
Paul Mellon Collection

Constable's only publication is influenced by Turner's *Liber Studiorum* [Cat. no. 99], and attempts Turner's arrangement of plates according to categories of landscape. *English Landscape Scenery* is also a kind of retrospective *apologia* for Constable's career, emphasizing the importance of his native Suffolk landscape, and expressing his wish

> to increase the interest for, and promote the study of, the rural scenery of England . . . with her climate of more than vernal freshness, and in whose summer skies, and rich autumnal clouds, the observer of Nature may daily watch her endless varieties of effect. . . .

The first mention of this scheme appears in a letter of May 1829, and Constable contracted with the young, inexperienced mezzotint engraver David Lucas at about this time. The work, totalling twenty-two plates, appeared in parts between 1830 and 1832, with the artist himself as publisher. A second edition was issued in 1833, including notes to four of the plates and a brief introduction, the only published statement of Constable's views on his art. He advocates seeking "perfection at its PRIMITIVE SOURCE, NATURE" rather than in the old masters, and describes what he calls the "chiaroscuro of Nature"—the capacity of light and shade to capture those transient effects "which are ever occurring in the endless varieties of Nature, in her external changes" [see pp. 115–116].

66

Samuel Cousins and William Walker after Alexander Nasmyth
Robert Burns
1830
Mezzotint
$21\frac{3}{16} \times 16\frac{1}{2}$ (53.8 × 41.8) (sheet)
Yale Center for British Art,
Paul Mellon Collection
IUAM and CHS only

One of several prints made after Nasmyth's portrait [Cat. no. 86]. John Beugo in 1787 was the first to engrave from Nasmyth, and had the advantage of adjusting the plate after further sittings by Burns himself. Cousins and Walker drew on the work of both Nasmyth and Beugo, and seem to have achieved a remarkable likeness. Nasmyth said to Walker of his engraving, "It conveys to me a more true and lively remembrance of Burns than my own picture does, it so perfectly renders the spirit of his expression."

67

Thomas De Quincey
Confessions of an English Opium Eater
London, 1822
The Wordsworth Trust

De Quincey's great autobiography was written in London, but described opium-dreams and drug-induced suffering experienced at Dove Cottage, where he followed Wordsworth as tenant in 1809. In one dream, typical of the associative blending of different levels of experience, the gate in Grasmere opens onto a vision of the fifteen-year-old prostitute, Ann, who had befriended the writer in his London days of poverty and desperation. Though instantly recognizable, she is sitting amid the domes and cupolas of Jerusalem:

> And not a bow-shot from me, upon a stone, shaded by Judean palms, there sat a woman; and I looked, and it was Ann! She fixed her eyes upon me earnestly, and I said to her at length: "So then I have found you at last." I waited, but she answered me not a word.

Like Wordsworth, De Quincey is fascinated by the workings of the mind. Though he frequently boasts of his addiction, opium is for him chiefly valuable as an entrance to the world of pure imagination—a world in which he hopes to find the causes and meaning of human suffering.

68

Thomas De Quincey
Letter to William Wordsworth
31 May 1803
Holograph manuscript
The Wordsworth Trust

Written when De Quincey was seventeen, after his experiences in London [see Cat. no. 67], and before he went up to Oxford in December 1803.

His terms may seem extravagant, but he is entirely sincere:

I have no other motive for soliciting your friendship than what, I should think, every man who has read and felt the *Lyrical Ballads* must have in common with me.... the whole aggregate of pleasure I have received from some eight or nine other poets that I have been able to find since the world began falls infinitely short of what those two enchanting volumes have singly afforded me . . . your name is with me for ever linked to the lovely scenes of nature. . . .

De Quincey did not actually meet Wordsworth until 1807. Though not an easy one, their relationship was of immense importance to De Quincey's career as a writer.

69 [Figure 71]

Joseph Farington
Cockermouth
1816
Engraving
9 × 11 (22.7 × 27.8)
The Wordsworth Trust

One of Farington's late engravings, from *Britannia Depicta*, showing the castle that dominates Cockermouth, Wordsworth's birthplace, and the River Derwent, described so memorably in *The Prelude* [see Cat. no. 144]. Wordsworth's father, who was a lawyer and agent for the powerful landowner Sir James Lowther, lived in one of the grandest houses in the town, with a garden backing onto the river. "Oh, many a time," the poet recollected,

have I, a five years' child,
A naked boy, in one delightful rill,
A little mill-race severed from his stream,
Made one long bathing of a summer's day,
Basked in the sun, and plunged, and basked
 again,
Alternate, all a summer's day. . . .
 (i, 291–296)

70

Joseph Farington
Hawkshead
1786, revised 1808
Pencil drawing
4¼ × 9 (10.7 × 22.7)
The Wordsworth Trust

Inscribed bottom left, "Hawkshead / Esthwaite Water, Lancashire. / Aug. 9th 1786 & Sept. 28th 1808" and signed bottom right, "jos. Farington." Farington's original sketch was made while Wordsworth was still at Hawkshead Grammar School. The drawing was then revised in 1808 (presumably to take account of new building in the village) before being used in the final engraving of 1816 [Cat. no. 71].

71

Joseph Farington
Hawkshead and Esthwaite Water
1816
Engraving
9 × 11 (22.7 × 27.8)
The Wordsworth Trust

Farington's engraving for *Britannia Depicta*, based on Cat. no. 70. Colthouse, where Wordsworth lived as a boy, is a small group of houses out of sight to the left of the picture, but his school is visible below the church.

72

Margaret Gillies
William and Mary Wordsworth
1859
Watercolour on ivory in case
11⅞ × 11 (30.2 × 27.9)
The Wordsworth Trust

Replica of an 1839 portrait, made by the artist in 1859 for Jemima Quillinan, daughter of Wordsworth's son-in-law, Edward Quillinan. The original had been destroyed by fire in India while in the possession of the poet's grandson, William Wordsworth. Though Wordsworth is seen apparently dictating to his wife, the artist has combined two separate portraits into one. The resulting stiffness was recognized by the family, to whom the picture was known as "Darby and Joan."

73 [Figure 47]

Benjamin Robert Haydon
John Keats
1816
Pen and ink drawing
12½ × 8 (31.7 × 20.3)
National Portrait Gallery, London

[See p. 50.] Sheet torn from one of Haydon's journals, signed and dated "Nov 1816 / BRH," and later inscribed in Haydon's hand, "Keats was a spirit that in passing over the earth came within its attraction, and expired in fruitless struggles to make its dull inhabitants comprehend the beauty of his soarings." A journal entry on the reverse contains vituperative criticisms of the Royal Academicians, reflecting Haydon's own struggles with those he saw as the world's "dull inhabitants." Keats compared Haydon with Raphael in his sonnet *Great Spirits Now on Earth Are Sojourning*, and listed as the "three great things to rejoice at in the age" Haydon's paintings, Wordsworth's *Excursion*, and Hazlitt's "depth of taste."

74

William Hazlitt
The Spirit of the Age: or Contemporary Portraits
London, 1825
Courtesy of the Lilly Library,
Indiana University, Bloomington, Indiana

[See p. 27.] A brilliant, witty, incisive guide to the great political and literary figures of the Romantic period. Hazlitt's shrewdness and insight emerge through prose of unfailing elegance. Jeremy Bentham "has a great contempt for out-of-door prospects, for green fields and trees, and is for referring everything to Utility. There is a little narrowness in this. . . ." Byron "says of Mr. Wordsworth's poetry that 'it is his aversion.' That may be, but whose fault is it?" Wordsworth is "a pure emanation of the Spirit of the Age," but no one in this sharply perceptive work receives unqualified praise.

75 [Figure 70]

William Hilton, after Joseph Severn
John Keats
c. 1822
Oil
30 × 25 (76.2 × 63.5)
National Portrait Gallery, London

Posthumous portrait, probably commissioned by Keats' friend, the lawyer Richard Woodhouse. Though Hilton knew Keats fairly well, and had drawn the poet during his lifetime, he based his portrait on a miniature by Joseph Severn now in the Fitzwilliam Museum, Cambridge. Severn, who attended Keats in his last days, was highly critical of Hilton's portrait, but on the evidence of the life-mask made by Haydon in 1816, it seems a good likeness.

76

Leigh Hunt
The Feast of the Poets
London, 1815
Brewer Leigh Hunt Collection,
University of Iowa Libraries, Iowa City

Leigh Hunt's corrected, revised copy of the second edition, inscribed to his sister-in-law, "Bessy Kent," with a sonnet to the Polish revolutionary Kosciuszko entered opposite the half-title: "To Kosciusko, who never fought either for Bonaparte or the Allies" [see pp. 1–2]. *The Feast of the Poets*, a verse satire on Hunt's contemporaries, first appeared in 1811 in his journal *The Reflector*, and was published as a separate work in 1814. Wordsworth was attacked in the early version, but given qualified praise in the next edition.

Hunt, like Coleridge and Lamb, had been a student at Christ's Hospital. He was a friend of Shelley and Keats (on whose style he had a strong, and on the whole bad, influence), and was tolerated by Byron. A founder with his brother John of *The Examiner*, and a political activist [see p. 50], he survived well into the Victorian era (1859), becoming a valuable source of first-hand knowledge of the Romantic poets. Dickens ruthlessly satirizes him as Skimpole in *Bleak House*.

77 [Figure 49]

John Keats
Ode on Melancholy, Stanzas 1 and 2
1819
Holograph manuscript
Robert H. Taylor Collection,
Princeton University Library

Fair copy of the first two stanzas of Keats' ode, which together with Cat. no. 78 (bearing stanza three) forms the earliest surviving manuscript, probably transcribed in May 1819. Keats' brother George brought Stanzas 1 and 2 to America in 1820; Stanza 3 remained in England until 1932, and was acquired by the Berg Collection in 1940. The two leaves of the manuscript are thus reunited in this exhibition for the first time in 165 years.

Ode on Melancholy is the strongest expression of Keats' paradoxical realization that joy is indivisible from sorrow, pain an integral part of pleasure:

She dwells with Beauty—Beauty that must
 die;
And Joy, whose hand is ever at his lips
 Bidding adieu; and aching Pleasure nigh,
Turning to poison while the bee-mouth sips:
Aye, in the very temple of Delight
 Veiled Melancholy has her sovran shrine,
 Though seen of none save him whose
 strenuous tongue
Can burst Joy's grape against his palate fine.

78 [Figure 49]

John Keats
Ode on Melancholy, Stanza 3
1819
Manuscript
The Berg Collection of English and American
Literature, The New York Public Library

The third and final stanza on the half-sheet
originally joined to Cat. no. 77, and the pro-
perty of Keats' friend Charles Brown until
1838.

79

John Keats
Ode to a Nightingale
1819
Manuscript, hand of George Keats
The British Library Board, Egerton MS. 2780

Manuscript notebook, inscribed "George Keats
1820," made by the poet's brother, who had
settled at Louisville, Kentucky, in 1818, and
visited England two years later. In compiling
his collection of his brother's poems, George
often drew, as he does here, on copies belonging
to Keats' friend Charles Brown. The opening
two stanzas of the *Nightingale* (p. 53) face the
closing lines of *Melancholy* (p. 52).

80 [Figure 46]

John Keats
On First Looking into Chapman's Homer
1816
Manuscript
The Houghton Library, Harvard University

Headed "On the first looking into Chapman's
Homer," and dating from Oct. 1816. Composed
after Keats had stayed up all night with Charles
Cowden Clarke reading "A beautiful copy of the
folio edition of Chapman's translation of
Homer;" this is probably the manuscript sent to
Clarke the next morning. Clarke describes how,
when I came down to breakfast the next
morning, I found upon my table a letter with
no other enclosure than his famous sonnet,
On First Looking into Chapman's Homer. We
had parted . . . at day-spring, yet he contrived
that I should receive the poem from a dis-
tance of maybe two miles by ten o'clock.
The poet has made one correction in the manu-
script, changing "low" to "deep" in "deep-
browed Homer."

81 [Figure 90]

John Keats
Poems
London, 1817
Robert H. Taylor Collection,
Princeton University Library

Presentation copy of Keats' first volume of
poems, inscribed on the title-page, "To W
Wordsworth with the Author's sincere
Reverence." Keats' reverence for Wordsworth
was indeed sincere. In November 1816 he had
been overwhelmed at the thought of Haydon's
passing on a copy of *Great Spirits Now on Earth
Are Sojourning* [see Cat. no. 73]: "The idea of
your sending it to Wordsworth put me out of
breath. You know with what reverence I would
send my well-wishes to him." To Keats,
Wordsworth seemed "deeper than Milton,"
who "did not think into the human heart as
Wordsworth has done." There could be no
higher praise.

82 [Figure 65]

Charles Lamb
A Dissertation upon Roast Pig
c. 1822
Manuscript
The Pierpont Morgan Library, New York
NYPL only

Last sheet of a folio-size manuscript, neatly
corrected, and signed "Elia," the name under
which Lamb's essays appeared, first in the
London Magazine (1820) and then in the two
collected volumes, *Essays of Elia* and *Last Essays
of Elia* [see Cat. no. 83]. Lamb was an accoun-
tant with the East India Company and a friend
of Haydon and Hunt. He had been to school at
Christ's Hospital with Coleridge, through
whom he met Wordsworth at Alfoxden in July
1797. The previous year, when Lamb was
twenty-one, his sister Mary had stabbed their
mother to death in a fit of insanity; for the rest of
his life he took care of her, and his writing was
conditioned by the underlying sadness which
they shared.

 Lamb's essays combine memories, reflec-
tions, and extravagant humour. *A Dissertation
upon Roast Pig* tells how the method of roasting
pig was discovered through the accidental
burning of a house—the practice continuing
until some sage worked out that pork "might be
cooked (*burnt* as they called it) without the
necessity of consuming the whole house to
dress it."

83

Charles Lamb
Oxford in the Vacation in Elia, *Essays
which Have Appeared under that Signature
in The London Magazine*
London, 1823
The Berg Collection of English and American
Literature, The New York Public Library

First edition, first issue, inscribed "Mr. John
Clare with Elia's regards" (Lamb had the same
publisher, Taylor and Hessey, as the poet John
Clare [Cat. no. 214]). *Oxford in the Vacation*, the
second essay in the volume, demonstrates
Lamb's ability to immerse himself completely in

his subject: "I can here play the gentleman, and
act the student. To such a one as myself, who
has been defrauded in his young years of the
sweet food of academic institution, nowhere
is so pleasant, to while away a few idle weeks
at, as one or other of the Universities." The
Bodleian Library, especially, brings his quiet
sympathies to life:
 What a place to be in is an old library! It
 seems as though all the souls of all the
 writers, that have bequeathed their labours
 to these Bodleians, were reposing here, as in
 some dormitory, or middle state. I do not
 want to handle, to profane the leaves, their
 winding-sheets. I could as soon dislodge a
 shade. I seem to inhale learning, walking
 amid their foliage; and the odour of their old
 moth-scented coverings is fragrant as the
 first bloom of those sciential apples which
 grew amid the happy orchard.

84 [Figures 27 and 92]

John Martin
The Bard
1817
Oil
$85 \times 61\frac{3}{4}$ (215.5 × 157)
Laing Art Gallery, Newcastle upon Tyne,
Tyne and Wear Museums Service

Thomas Gray's poem *The Bard* (1757) drew on
traditional accounts of Edward I's conquest of
Wales, and his slaughter of all but one of the
Welsh bards—heroic figures who "boldly cen-
sure tyranny and oppression." The scene illus-
trated by Martin is set in highly pictorial terms,
Edward's forces marching beneath a rocky
outcrop on which the last of the bards is
perched. Drawing closely on an earlier work by
Richard Corbauld, Martin extracts the full
melodrama from the scene, the immensity of
the mountains threatening to overwhelm his
subject; the boldly unrealistic landscape and
figures anticipate his late treatment of biblical
episodes. A smaller version of *The Bard* is in the
Yale Center for British Art.

85 [Figure 42]

John Martin
Manfred on the Jungfrau
1837
Watercolour, bodycolour, chalk, and gum
$15\frac{1}{8} \times 22\frac{5}{8}$ (38.4 × 57.5)
Birmingham Museum and Art Gallery

[See p. 45.] One of two watercolours, exhibited
in 1838, based on Byron's dramatic poem
Manfred. Here the Faustian anti-hero, con-
demned to perpetual life without sleep, is
restrained from suicide by a passing chamois
hunter:
 Hold, madman!—though aweary of thy life,
 Stain not our pure vales with thy guilty
 blood.
With its use of opaque bodycolour, chalks, and
gums, Martin's watercolour achieves some-
thing of the drama and impressiveness of *The
Bard* [Cat. no. 84] and his other oils.

86 [Figure 37]

Alexander Nasmyth
Robert Burns
1787
Oil
15⅛ × 12¾ (38.4 × 32.4)
Scottish National Portrait Gallery
NYPL only

Inscribed on the reverse, "Painted from Mr. Robert Burns by his friend Alexr. Nasmyth, Edinr. 1787." Nasmyth's painting was commissioned by the publisher William Creech, to be engraved by John Beugo for the Edinburgh edition of Burns' *Poems Chiefly in the Scottish Dialect*, 1787 [see Cat. no. 66].

87 [Figure 43]

Antoine-Philippe D'Orléans, Duc de Montpensier
Percy Bysshe Shelley as a Boy
c. 1802–1804
Pencil, watercolour, and silverpoint in original frame
3¾ × 2¹³⁄₁₆ (9.6 × 7.2)
By permission of the Curators of the Bodleian Library, Oxford

A label on the back of the frame notes, "Bought at the Sale at Langollen: Portrait of Percy Bysshe Shelley drawn by Antoine, the Duc de Montpensier and presented by him to the Ladies of Langollen." The complex provenance of this miniature, and its authenticity as a portrait of Shelley aged between ten and twelve, have been established by Winifred Gérin. The artist was the second of three sons of the Duke of Orléans (Philippe Egalité, who despite embracing the revolution was executed in the Terror in Nov. 1793). After five years' imprisonment at Marseilles, and two years' hardship in America, the brothers came to England in 1800, settling at Twickenham, west of London. Gérin argues that the miniature must have been made between 1802 and July 1804, during which time Shelley attended Sion House Academy at nearby Brentwood. The portrait agrees with Shelley's cousin Medwin's description of him at the time as having "a complexion fair and ruddy, a face rather long than oval. . . . His features . . . were set off by a profusion of silky brown hair, that curled naturally. The expression of countenance was one of exceeding sweetness and innocence. His blue eyes were very large and prominent."

The miniature probably came into the hands of the celebrated "Ladies of Llangollen," Lady Eleanor Butler and the Honourable Sarah Ponsonby, after Montpensier's death in 1807. They lived in retreat at Llangollen but were much fêted as bluestockings. Visitors to their house in North Wales included Scott, De Quincey, Wellington, Burke, and Pitt. Wordsworth visited them in 1824 and composed a sonnet to them.

88 [Figure 44]

Thomas Phillips
Lord Byron in Arnaout Costume
1840
Oil on panel
18 × 14½ (45.0 × 37)
John Murray Collection

Byron bought his Arnaout costume at Epirus in 1809, and was painted in it by Phillips in 1813. (The Arnaout are an Albanian tribe.) The original portrait hangs in the British Embassy in Athens, and Phillips made two later versions, of which this is considerably the smaller. It was commissioned by Byron's publisher, John Murray, to be engraved for a new edition of *Childe Harold*. Phillips, by this time President of the Royal Academy, changed the landscape in the background, including a flash of lightning in the top left corner. Classical ruins can be seen on the right.

89 [Figure 28]

Thomas Phillips
William Blake
c. 1843
Oil
23½ × 19½ (59.7 × 49.6)
The Houghton Library, Harvard University

Probably a replica made by Phillips in 1843 of his earlier portrait of Blake (in the National Portrait Gallery, London). Blake sat for the original in April 1807 at the age of fifty.

90

Sir Walter Scott
Ivanhoe; A Romance
c. July 1819
Holograph manuscript
The Pierpont Morgan Library, New York

Parts of Scott's most successful novel (published in Edinburgh, 1820) written in his own hand, though the bulk was dictated from his sick bed. "The portion of the manuscript which is his own," writes Lockhart (Scott's son-in-law and biographer), "is beautiful to look at—many pages together without one alteration." Though himself rating *Waverley* and *The Heart of Midlothian* still more highly, Lockhart records that *Ivanhoe*, Scott's first book with an English setting, "was received throughout England with a more clamorous delight than any of the *Scotch novels* had been."

91 [Figure 45]

Mary Shelley
Frankenstein; or, the Modern Prometheus
London, 1818
The Pierpont Morgan Library, New York
NYPL and IUAM only

First edition, in three volumes bound as one, inscribed by Mary Shelley to Mrs. Thomas (whose note in the volume indicates that she "aided" the author after Shelley's death), with numerous revisions in Mary's hand. At the end of Chapter Two she comments: "If there were ever to be another edition of this book, I should re-write these two first chapters. The incidents are tame and ill-arranged—the language sometimes childish. They are unworthy of the rest of the narration." The third edition of 1831 revised the first two chapters and included a number of other changes, but did not incorporate those entered here.

Frankenstein is dedicated to Mary's father, William Godwin [see Cat. no. 17], and reflects his view of man as shaped by his social environment; her manuscript addition, shown here, points up the misery of the monster's isolation: "if by moonlight I saw a human form, with a beating heart I squatted down amid the bushes fearful of discovery. . . . It was in intercourse with man alone that I could hope for any pleasurable sensations and I was obliged to avoid it. . . ."
[See also Cat. no. 92.]

92

Mary Shelley
Frankenstein
London, 1818
The Newberry Library
CHS only

First edition of Mary Shelley's classic Gothic novel, begun in 1816 when Byron, his travelling companion Polidori, Shelley, and Mary (then Mary Godwin) spent the summer together on the shores of Lake Geneva. When it was suggested they each try their hand at a ghost story, Mary was at first unable to think of a suitable idea. A scene now familiar to millions finally came to her in a nightmare: "I saw the pale student of unhallowed arts kneeling beside the thing he had put together. I saw the hideous phantasm of a man stretched out, and then . . . show signs of life and stir with an uneasy, half-vital motion."
[See also Cat. no. 91.]

93 [Figure 50]

Percy Bysshe Shelley
Adonais. An Elegy on the Death of John Keats, Author of Endymion, Hyperion, Etc.
Pisa, 1821
The Carl H. Pforzheimer Shelley and his Circle Collection, The New York Public Library

Rare first edition, untrimmed, in original blue paper wrappers. Shelley composed the poem as an elegy for Keats four months after his death, and had this small edition printed in Pisa (using the fine Didot typeface) so that he could correct it before sending it to his publisher, Ollier, in London. Accepting the view that Keats had been hounded to death by hostile critics, Shelley described his poem as "a lament on the death of poor Keats, with some interposed stabs on the assassins of his peace and of his fame." Keats is not simply dead; in dying, he has "awakened from the dream of life" and "outsoared the shadow of our night." Immortalized in his poetry, he has been "made one with Nature," becoming "a portion of the loveliness / Which once he made more lovely":

 burning through the inmost veil of Heaven,
 The soul of Adonais, like a star
 Beacons from the abode where the eternal are.

After her husband's death, Mary Shelley would write, "there is much in the *Adonais* which seems now more applicable to Shelley himself than to the young and gifted poet whom he mourned. The poetic view he takes of death, and the lofty scorn he displays towards his calumniators, are as a prophecy on his own destiny. . . ."

94

Percy Bysshe Shelley
*Prometheus Unbound, a Lyrical Drama
in Four Acts, with Other Poems*
London, 1820
The Carl H. Pforzheimer Shelley and his Circle
Collection, The New York Public Library

First edition in original blue-grey boards.
Shelley refashions classical mythology in order
to create an apocalyptic verse drama on the
coming of the reign of love. Prometheus,
chained like Orc [see Cat. no. 9] to a rock, and
suffering eternal torture on behalf of mankind,
is released by Hercules at the appointed hour
when destined forces (represented by Demo-
gorgon) bring about the end of Jupiter's re-
pressive power:

> man remains,
> Sceptreless, free, uncircumscribed, but
> man—
> Equal, unclassed, tribeless and nationless,
> Exempt from awe, worship and degree, the
> king
> Over himself, just, gentle, wise—but
> man. . . .

Poets will have a special part to play in effecting
such change. "The great writers of our own
age," Shelley writes in the Preface, "are . . . the
companions and forerunners of some unimag-
ined change in our social condition or the
opinions which cement it. The cloud of mind is
discharging its collected lightning. . . ."

95 [Figure 51]

Percy Bysshe Shelley
The Triumph of Life
1822
Holograph manuscript
By permission of the Curators of the Bodleian
Library, Oxford

[See pp. 54–55.] Final leaf from the unfinished
Triumph of Life, on which Shelley was working
at the time of his death. Having framed the
question, "And what is life, I cried," he changed
"And" to "Then" and "cried" to "said," and
composed the opening lines of a reply: "Happy
those for whom the fold / Of." These were the
last words he wrote. On 8 July 1822, his new
boat, the *Don Juan*, sank in a storm off
Viareggio; Shelley, aged twenty-nine, was
drowned, along with his two companions.

96 [Figure 35]

William Shuter
William Wordsworth
1798
Oil on panel
11 × 9⅜ (27.9 × 23.8)
The Wordsworth Collection,
Cornell University Library

The earliest known likeness of the poet, signed
and dated, "W. Shuter 1798." Shuter is known
to have exhibited in London between 1771 and
1791, and was commissioned in this case by
the Bristol publisher Joseph Cottle. Dorothy
records in the Alfoxden *Journal* (26 April 1798)
that "William went to have his picture taken."
Cottle presumably thought of Wordsworth as a
new author with whose future work he would

publish a portrait. In the event, however,
Lyrical Ballads was published anonymously
(and at once transferred to a London firm), and
no engraving was made. The portrait was sold
by a Bristol bookseller in 1894 to Cynthia
Morgan St. John, founder of the Cornell
Wordsworth Collection. Wordsworth is shown
with his left hand tucked into his coat—
according to Leigh Hunt, a "habitual" gesture.

97

Robert Southey and Lord Byron
The Two Visions: or, Byron v. Southey
New York, 1823
Harry Ransom Humanities Research Center,
The University of Texas at Austin,
The Library Collection

Southey's eulogy of George III, *A Vision of
Judgment* (1821), published alongside Byron's
parody, *The Vision of Judgment*, first published in
the following year. Southey's narrator, in a
trance, sees the dead king rise from his grave
and proceed to Heaven, where, after receiving a
testimonial from Washington, he is admitted to
Paradise. The poem was in any case ridiculed,
but Southey made the mistake of attacking
Byron's works in the Preface as "monstrous
combinations of horrors and mockery, lewd-
ness and impiety." Byron responds with a
wickedly funny and highly disrespectful paro-
dy, deriding George III—

> It seemed the mockery of hell to fold
> The rottenness of eighty years in gold

—and taking delight in recalling Southey's
revolutionary youth, when he had planned a
communist "Pantisocracy" with Coleridge [see
p. 33] and written the radical play *Wat Tyler*
[Cat. no. 98]. Byron's *Vision* first appeared in
The Liberal (edited by Leigh Hunt's brother
John) in 1822. Its description of George III was
so derogatory that Hunt was prosecuted and
fined.

98

Robert Southey
Wat Tyler
London, 1817
The Wordsworth Collection,
Cornell University Library

Rare copy, in original blue wrappers, of a
dramatic poem written by Southey in the
summer of 1794 but not printed until 1817,
when the manuscript came into the hands
of radical publishers who saw an opportunity
to embarrass the Poet Laureate. "King of
England," Tyler asks at one point, expressing
the democratic views on which Southey later
turned his back,

> Why are we sold like cattle in your markets,
> Deprived of every privilege of man?
> Must we lie tamely at our tyrant's feet
> And, like your spaniels, lick the hand that
> beats us?

99

J. M. W. Turner
*Liber Studiorum: Illustrative of Landscape
Compositions, viz. Historical, Mountainous,
Pastoral, Marine and Architectural*

London, 1807–1819
Bound volume of etchings and mezzotints
16 × 9¾ × 2 (40.6 × 24.8 × 5.1)
Yale Center for British Art,
Paul Mellon Collection

Turner's first publication, a treatise dis-
tinguishing different categories of landscape
art. An attempt is made to locate English
landscape painting within a European tradi-
tion, the title and design of the *Liber Studiorum*
inviting comparison with the *Liber Veritatis* of
Claude Lorraine. Years later Turner would
insist in his will that two of his paintings hang
next to Claudes at the National Gallery. The
mechanics of producing the *Liber Studiorum*
were as ambitious as its conception. A total of
seventy-one plates was published, appearing in
fourteen parts over the period 1807–1819.
Turner prepared monochrome wash drawings
as the initial stage, etching the design onto the
plates himself in many cases, and also helping
to finish the plates. A number of engravers
worked on the project: their names are recorded
on the scroll on the left side of later states of the
frontispiece.

100 [Figure 39]

J. M. W. Turner
*Sir Walter Scott's House, No. 39 Castle Street,
Edinburgh*
c. 1836
Watercolour and pencil
5½ × 3¼ (14.1 × 8.3)
The Pierpont Morgan Library, New York.
Gift of Mr. DeCoursey Fales
NYPL and IUAM only

Made as the basis of an engraving in Lockhart's
Life of Sir Walter Scott, and showing the house
where Scott lived between 1801 and 1825.
Turner's drawing reveals that he has taken
sides in the debate that took place after Scott's
death in 1832 as to what kind of monument
should be erected to his memory. In the fore-
ground is a group of figures holding plans, and
work has started on a large obelisk (one of the
contending designs) in the middle distance. In
the event, a Gothic cross was chosen instead,
and erected on a different site. The engraving
finally published by Lockhart omits the work-
men, and replaces the obelisk with a brazier.

101

Annette Vallon
Letter to Dorothy Wordsworth
20 March 1793
Holograph manuscript
Département de Loir-et-Cher Archives

One of two letters [see also Cat. no. 102]
confiscated by the French surveillance com-
mittee in March 1793 and rediscovered in
1922. Wordsworth was twenty-one and
Annette four years older when they met
in December 1791 at Orléans. When he
left France in late 1792, she was pregnant;
their child was baptized Anne-Caroline
Wordswodsth (sic) in Orléans Cathedral on 15
December. Annette's letters make it clear that
she expects William to return, or that she and
the child will be reunited with him in England.
She sees an ally in Dorothy, sending her the
longer and more emotional of the two letters,

and through her addressing to William a tender fantasy of their future which is astonishingly like the scene at Dove Cottage ten years later:

> When you will live in the constant presence of your sister, your wife, your daughter, who breathe only for you, who have but a single emotion, a single heart, a single soul—and all for the sake of my dear William.

Because of the war between their two countries (declared in Feb. 1793) Wordsworth and Annette did not meet again until the Peace of Amiens, in 1802, by which time he was engaged to Mary Hutchinson.

102 [Figure 12]

Annette Vallon
Letter to William Wordsworth
20 March 1793
Holograph manuscript
Département de Loir-et-Cher Archives

The second of the two letters discovered in 1922 [see Cat. no. 101], this one addressed to William himself:

> I would be happier if we were married, but I realize it's almost impossible for you to risk the journey in wartime. You might be taken prisoner.... Come, my love, my husband, accept the kisses of your wife, of your daughter. She is so pretty, this poor little thing, so pretty that if she weren't always in my arms I would go out of my mind. She gets more like you every day.... When her little heart beats against mine, I try to imagine it's her father's heart I can feel.... keep on loving your little daughter, and your Annette, who kisses you a thousand times on the mouth and on the eyes.... I commend my little one, whom I love always, to your care.... I love you for life.

103 [Figure 53]

Cornelius Varley
J. M. W. Turner
c. 1815
Pencil drawing
$19\frac{1}{2} \times 14\frac{1}{2}$ (49.5 × 36.8)
Sheffield City Art Galleries

Drawing made by the inventive Cornelius Varley using his "Patent Graphic Telescope." A refinement of the *camera lucida*, the device cast an image of the subject—which could then be traced—onto a sheet of paper. Varley made a portrait of Cotman by the same method. Turner did not like being drawn; this is a rare image, as well as a very striking one.

104 [Figure 34]

William Westall, engraved by J. C. Stadler
St. John's College from Fisher's Lane,
from *History of Cambridge*
London, 1814
Coloured engraving
10 × 12 (25.5 × 30.3)
The Wordsworth Trust

The River Cam, on which Wordsworth recalls that as an undergraduate he

> sailed boisterously, and let the stars Come out perhaps without one quiet thought ...

is seen flowing peaceably along the "Backs" behind his college. Although Westall's view belongs to 1814, it was unchanged since the poet's time at Cambridge (1787–1791).

105 [Figure 135]

Dora Wordsworth, after Amos Green
Dove Cottage
c. 1826
Pencil and blue and grey wash
5 × 8 (13 × 22.7)
The Wordsworth Trust

[See p. 146.] Made by the poet's daughter from the earliest known image of Dove Cottage, a sepia-wash drawing of c. 1806 by Amos Green. Dora had herself been born in the cottage in 1804, and it was her father's home in the years 1799–1808, to which much of his greatest poetry belongs. Formerly an inn called The Dove and Olive Branch, Dove Cottage is shown with the original windows, which were so small that De Quincey considered them dangerous (if there were a fire, people would not be able to "egress" through them). In 1849 enlarged windows were fitted centrally in all five rooms.

106

Dorothy Wordsworth
Description of a Birch Tree, Grasmere *Journal*
24 Nov. 1801
Manuscript
The Wordsworth Trust

Dorothy's Grasmere *Journal*, unpublished in her lifetime, was made largely for the benefit of her brother, who drew on it for his poetry on a number of important occasions. She is now recognized, however, as a writer of individual genius. Though lacking the grandeur of Wordsworth's vision, her prose is constantly alive and responsive. Her powers of observation are seen here at their most imaginative, singling out a "favourite birch tree" as it yields to the wind on a blustery, showery, winter morning: "it was a tree in shape, with stem and branches, but it was like a spirit of water." Six months later, in the *Intimations Ode*, her brother was to write:

> But there's a tree, of many one,
> A single field which I have looked upon,
> Both of them speak of something that is gone ...

107

Dorothy Wordsworth
Recollections of a Tour Made in Scotland
11 Sept. 1803
Manuscript
The Wordsworth Trust

[See pp. 40–41.] Dorothy's account of the Scottish tour she made with her brother (and, for part of the way, with Coleridge), 14 Aug.– 25 Sept. 1803, is a little-known masterpiece. Her prose, in its more finished way as vivid and remarkable as that of the Grasmere *Journal*, once again inspired the poet to composition. "I cannot describe," Dorothy writes of a chance greeting heard beside Loch Lomond, "how affecting the simple expression was in that remote place, with the western sky in front, *yet* glowing with the departed sun. Wm. wrote the following poem long after, in remembrance of his feelings and mine." Appropriately, the poem that follows—*What, You Are Stepping Westward?*—is among the most touching that Wordsworth ever wrote.

108

Dorothy Wordsworth
Letter to Jane Pollard
16 Feb. 1793
Holograph manuscript
The Wordsworth Trust

Letter from Dorothy giving her closest friend a tender, but very shrewd, account of her brothers. Christopher—later Master of Trinity College, Cambridge—"is like William" but "not so ardent in any of his pursuits." He is "steady and sincere in his attachments;" William, by contrast,

> has both these virtues in an eminent degree, and a sort of violence of affection, if I may so term it, which demonstrates itself every moment of the day when objects of his affection are present with him, in a thousand almost imperceptible attentions to their wishes—in a sort of restless watchfulness which I know not how to describe, a tenderness that never sleeps, and at the same time such a delicacy of manners as I have observed in few men.

109

William Wordsworth
Address to the Sons of Burns after Visiting their Father's Grave August 14th 1803
10 Nov. 1806
Manuscript
The Berg Collection of English and American Literature, The New York Public Library

Copied out by the poet at the request of a visitor, to be sent to Burns' brother. The accompanying letter notes that Wordsworth "thought the subject . . . was of too private and sacred a nature for the public eye." The poem was composed, in its first form, between June 1805 and Feb. 1806, and published in 1807:

> Let no mean hope your souls enslave;
> Be independent, generous, brave!
> Your father such example gave,
> And such revere!

It includes a warning to the sons not to imitate their father's dissolute behaviour,

> But be admonished by his grave,
> And think, and fear!

William and Dorothy visited Burns' grave during their tour of Scotland in 1803. In *The Ruined Cottage* [Cat. no. 204], Wordsworth says of the Pedlar:

> His eye
> Flashing poetic fire, he would repeat
> The songs of Burns, . . .

110

William Wordsworth
Anacreon,——: Imitation
7 Aug. 1786
Manuscript
The Wordsworth Trust

The poet's earliest surviving holograph manuscript, remarkable for a simile showing that Grasmere—Wordsworth's home in the central creative period of his life—has already assumed a special place in his imagination:

> As silvered by the morning beam
> The white mist curls on Grasmere's stream
> Which like a veil of flowing light
> Hides half the landscape from the sight. . . .

111 [Figure 83]

William Wordsworth
An Evening Walk. An Epistle; in Verse. Addressed to a Young Lady, from the Lakes of the North of England
London, 1793
The Wordsworth Trust

[See pp. 93–95.] The poet's first book, a picturesque evocation of the Lake District in heroic couplets, completed in the Cambridge summer vacation of 1789, and printed in Jan. 1793 with *Descriptive Sketches* by the radical publisher Joseph Johnson [see Cat. no. 38]. Inscribed by Wordsworth, aged seventy-five, to his son William:

> Part of this Poem was composed at School and was published at the same time as the "Descriptive Sketches" a good deal of which latter Piece was composed in France during the year 1792. Previous to the appearance of these two Attempts I had not published any thing, except a Sonnet printed in the European Magazine June or July 1786 when I was [a] School-Boy. The Sonnet was signed Axiologus—Wm Wordsworth 16 March 1846. Rydal Mount.

[See Cat. no. 120.]

112

William Wordsworth
It Is a Beauteous Evening, Calm and Free in *The Poetical Works of William Wordsworth*, Vol. III
London, 1836, composed 1802
Lent by gracious permission
of Her Majesty Queen Elizabeth II
NYPL only

Wordsworth's sonnet to his French daughter Caroline, shown with revisions in the hand of his clerk, John Carter, in Vol. III of *Poems* 1836. The original opening line of 1802 ("It is a beauteous evening, calm and free") had been changed in the 1836 text to "Air sleeps,—from strife or stir the clouds are free;" now this in turn is corrected in pencil to "A fairer face of evening cannot be" [see Cat. no. 113]. It was an almost consistent pattern in Wordsworth that he revised his earlier poetry for the worse.

113

William Wordsworth
It Is a Beauteous Evening, Calm and Free

in *The Sonnets of William Wordsworth*
London, 1838, composed 1802
Dartmouth College Library,
Gift of John W. Little II
IUAM and CHS only

Inscribed to "The Lady Frederick Bentinck from her Friend Wm Wordsworth," and dated 8 Nov. 1838. Wordsworth corrected a number of sonnets in this volume. He restored the original opening line of "It is a beauteous evening, calm and free," in place of the 1836 revision, "Air sleeps,—from strife or stir the clouds are free;" and he changed lines 9–10 from "Dear happy Girl! If thou appear / Heedless—unawed, untouched with serious thought," to "Dear Girl! that walkest with me here / If thou appear'st untouched with solemn thought" [see Cat. no. 112].

114

William Wordsworth
Lines Left upon a Seat in a Yew-tree
Composed *c.* May 1797
Manuscript, hand of Dorothy Wordsworth
The Berg Collection of English and American Literature, The New York Public Library

A rare example of manuscript material of a poem included in *Lyrical Ballads* 1798, authenticated in the hand of Joseph Cottle, Wordsworth's publisher ("W. Wordsworth: J. Cottle"). The spot referred to in the full title, "a seat in a yew-tree which stands near the lake of Esthwaite on a desolate part of the shore, yet commanding a beautiful prospect," was later described by the poet as "my favourite walk in the evenings during the latter part of my school-time." "The site," he continues, "was long ago pointed out by Mr. West in his *Guide* as the pride of the Lakes" [see Cat. no. 246].

The second half of Wordsworth's manuscript, comprising lines 33–60, is preserved at the Houghton Library, Harvard.

115

**William Wordsworth
and Samuel Taylor Coleridge**
Lyrical Ballads, with a Few Other Poems
Bristol, 1798
The Berg Collection of English and American Literature, The New York Public Library

Bristol first issue of *Lyrical Ballads* 1798, published by Longman and printed by Biggs and Cottle. A rarity among rarities, this is one of only four of the Bristol copies to include Coleridge's *Lewti* on pp. 63–67, replaced in the other nine by *The Nightingale* [see Cat. nos. 116 and 117] to preserve the anonymity of the authors. The existence of the thirteen known copies of *Lyrical Ballads* with the Bristol imprint presumably implies that the book was on sale for a very short time before being transferred to J. Arch, whose name appears on the London imprint.

116

**William Wordsworth
and Samuel Taylor Coleridge**
Lyrical Ballads, with a Few Other Poems

Bristol, 1798
The Berg Collection of English and American Literature, The New York Public Library
NYPL only

One of the nine copies of the Bristol edition, first issue, to include *The Nightingale* in place of *Lewti* [see Cat. nos. 115 and 117].

117

William Wordsworth and Samuel Taylor Coleridge
Lyrical Ballads, with a Few Other Poems
Bristol, 1798
Courtesy of the Lilly Library,
Indiana University, Bloomington, Indiana
IUAM and CHS only

First edition, first issue, bound in green half-leather with marbled boards, with the errata sheet at the end of the volume, and Coleridge's *The Nightingale* in place of *Lewti* [see Cat. nos. 115 and 116]. The volume carries the bookplate of Frank J. Hogan and the wax seal of "J Smedley, bookseller." A pencil note above the book-plate observes, "Swinburne said of the Bristol edition: 'I do break the tenth commandment into shivers when I think of that book.'" The quotation comes from Swinburne's letter to T. J. Wise of 2 May 1888: "Dr. Grosart lent me for a day the black tulip of that sort of book—the *very* first edition of 'Lyrical Ballads'."

118 [Figure 74]

William Wordsworth
Love-letter to Mary Wordsworth
22 July 1810
Holograph manuscript
The Wordsworth Trust

The first of a series of thirty-one personal letters between the poet and his wife (seven dating from 1810, twenty-four from 1812) [see Cat. no. 119] offered for sale at Sothebys in 1977 along with a previously unknown manuscript of Coleridge's *Dejection Ode* and a mass of Wordsworth family papers. It seems that this holding had become separated from the rest of the family archive in 1919 at the death of the poet's grandson Reginald, and that its existence was not known to Reginald's younger brother, Gordon Graham Wordsworth, when in 1934 he bequeathed all papers and manuscripts in his possession to The Wordsworth Trust. Purchased at auction by Cornell University, then denied an export licence by the British authorities, the papers were finally reunited with the main archive at the Wordsworth Library in 1978, as the result of a public appeal and with the friendly cooperation of Cornell.

Wordsworth's letter was written in a rare period of separation while visiting his patron Sir George Beaumont at Coleorton [see Cat. no. 63]. It shows his relationship with Mary, hitherto thought to have been a fairly conventional marriage, to have been one of exceptional tenderness:

> When I am moving about I am not so strongly reminded of my home, and you, and our little ones, and the places which I love. . . . I cannot help being anxious that I were gone, as when I move I shall feel myself moving towards you, though by a long circuit. O my

beloved, how my heart swells at the thought —and how dearly should I have enjoyed being alone with you so long! But I must go hence into Wales; surely, sweet love, this is very unlucky!

119 [Figure 75]

Mary Wordsworth
Love-letter to William Wordsworth
1 Aug. 1810
Holograph manuscript
The Wordsworth Trust

Addressed to the poet at Hindwell, her brother's Radnorshire farm; full of details of day-to-day life in Grasmere, but overcome with emotion at her husband's expression of love [Cat. no. 118]:

O my William! it is not in my power to tell thee how I have been affected by this dearest of all letters—it was so unexpected—so new a thing to see the breathing of thy inmost heart upon paper, that I was quite over-powered, and now that I sit down to answer thee in the loneliness and depth of that love which unites us, and which cannot be felt but by ourselves, I am so agitated and my eyes are so bedimmed that I scarcely know how to proceed.

They had been married almost eight years, and known each other since childhood.

120

William Wordsworth
On Seeing Miss Helen Maria Williams Weep at a Tale of Distress, in *The European Magazine*, xl, p. 202
March 1787
The Wordsworth Trust

Printed over the Latin pseudonym "Axiologus" (literally, "the worth—or value—of the word"), and acknowledged by the poet in 1846 to have been his first published work [see Cat. no. 111]. Helen Maria Williams was a successful minor poet, whose elaborate style is imitated in the sonnet, and whom Wordsworth later hoped, but failed, to meet in Orléans (Dec. 1791). It was from Williams' recollections of the events of the Revolution, published in 1795, that Wordsworth drew his account of Madame Roland's execution [see pp. 20–22].

121 [Figure 66]

William Wordsworth
Poems by William Wordsworth: Including Lyrical Ballads, and the Miscellaneous Pieces of the Author. With Additional Poems, a New Preface, and a Supplementary Essay, Vol. 1, annotated by William Blake
London, 1815
The Wordsworth Collection, Cornell University Library

Henry Crabb Robinson's copy of Wordsworth's 1815 *Poems*, with vehement comments by Blake which have been erased and then re-traced in ink. Annotations are concentrated in the first few pages of Vol. 1, and in the *Essay, Supplementary to the Preface*, suggesting that Blake began working through the poems, but was soon led to quarrel with the theory of the

imagination set out in the essay. His note on the title-page to the "Poems Referring to the Period of Childhood" is an attack on Wordsworth's dependence on Nature:

I see in Wordsworth the Natural Man rising up against the Spiritual Man Continually & then he is No Poet but a Heathen Philosopher at Enmity against all true Poetry or Inspiration

Robinson recalls Blake saying that "The eloquent descriptions of Nature in Wordsworth's poems were conclusive proof of Atheism, for whoever believes in Nature . . . disbelieves in God—For Nature is the work of the Devil." Like Wordsworth, Blake believes in the primacy of the imagination, writing on p. vii, "One Power alone makes a Poet—Imagination The Divine Vision." But he opposes the assumption that the faculty is fed by material reality. To Wordsworth's title for Section XV of his *Poems*, "INFLUENCE OF NATURAL OBJECTS In calling forth and strengthening the Imagination in Boyhood and early Youth," Blake retorts:

Natural Objects always did & now do Weaken deaden & Obliterate Imagination in Me Wordsworth must know that what he writes Valuable is not to be found in Nature

Blake was right. Nature did not, except in rare instances, obliterate imagination in Wordsworth, but his subject, like Blake's, was the aspiring human mind.

122

William Wordsworth
Vaudracour and Julia
c. 1819, composed 1804
Manuscript
The Wordsworth Trust

First composed for *The Prelude* in autumn 1804, and here revised for separate publication in 1820. *Vaudracour and Julia* was reworked in a notebook earlier devoted to *The White Doe of Rylstone* (1815). Although Wordsworth claimed that his account of "star-crossed" lovers separated by class distinctions under the *ancien régime* was based on fact, the details of the story—the birth of an illegitimate child, the mother's confinement to a convent, the father's subsequent care of the infant, and the child's death—are clearly not a reflection of the poet's own experience. In the context of *The Prelude*, however, the episode stands in lieu of a first-person account of Wordsworth's relationship with Annette Vallon ("Oh, happy time of youthful lovers") at Blois in 1792:

Arabian fiction never filled the world
With half the wonders that were wrought
 for him.
Earth breathed in one great presence of the
 spring;
Life turned the meanest of her implements
Before his eyes to price above all gold;
The house she dwelt in was a sainted
 shrine;
Her chamber window did surpass in glory
The portals of the dawn; all paradise
Could, by the simple opening of a door,
Let itself in upon him. . . .

123

William Wordsworth
Spectacles and leather case
The Wordsworth Trust

Wordsworth's eyesight began to get worse in 1801, making composition more difficult and increasing his dependence upon his faithful amanuenses: Dorothy, Mary, and Sara Hutchinson. On the evidence of the British College of Ophthalmic Opticians, the glasses on display were made by Bradberry, patent spectacle-maker, of 332 Oxford Street, London, in the period 1799–1805. Two out of three later pairs belonging to Wordsworth prove to have been bought from the same maker.

124

William Wordsworth
William Wordsworth's ink stand and Sara Hutchinson's quill pen
The Wordsworth Trust

Brass and *papier mâché* ink stand with original glass bottles, c. 1840, belonging to Wordsworth at Rydal Mount. Rook-quill pen of the period, comparable to those used by Wordsworth and his circle for copying manuscripts; said to have belonged to Wordsworth's sister-in-law Sara Hutchinson, on the grounds that it turned up between the leaves of Dorothy's *Recollections of a Tour in Scotland*, of which Sara was the copyist.

125

William and Mary Wordsworth
Locks of hair in silver snuff box
The Wordsworth Trust

Silver box of uncertain date containing entwined locks of hair belonging to William and Mary Wordsworth, probably dating to c. 1840.

3:

"The Child Is Father of the Man"

126 [Figure 57]

William Blake
Newton
c. 1795
Colour print finished in tempera, watercolour, yellow resinous medium, and traces of graphite
$17\frac{3}{8} \times 22\frac{3}{4}$ (44.2 × 57.8)
The Lutheran Church in America, the gift of Florence Foederer Tonner in memory of her dear parents, Robert H. Foederer and Caroline Fischer Foederer
NYPL only

[See pp. 32 and 63.] Influenced by Adamo Ghisi's engraving after Michelangelo's Abias in the Sistine Chapel, copied by Blake c. 1785. Plate 10 of *There Is No Natural Religion* (c. 1788) shows a similar figure, compasses or dividers in hand, illustrating the text "He who sees the Infinite in all things sees God. He who sees the Ratio [an abstraction created on the basis of

sense perception] only sees himself only." The tyrannical figure of the "Ancient of Days" in the frontispiece to *Europe a Prophecy* (1794) also wields a pair of compasses. Blake saw Newton and Locke as expounding "the Philosophy of the Five Senses," by which man is enslaved to the material world and denied his spiritual capacities. The compasses symbolize his ability to measure the physical world, which at the same time blinds him to the "infinite" dimensions of the imagination. A version of the figure in the Tate Gallery, London, indicates that Newton is working on a diagram from the *Opticks* [Cat. no. 134], turning the rainbow, symbolic of God's covenant with man, into its mathematical components.

Inscribed "NEWTON" and "Fresco WBlake inv.," this image was almost certainly made in 1795, along with eleven more large colour prints, in a medium which Blake regarded as that used by Renaissance fresco painters. The Tate version, though inscribed by Blake "1795 WB inv.," is watermarked 1804.

127 [Figure 58]

William Blake
Urizen
c. 1795
Colour-printed relief etching finished in pen and watercolour
3 × 4 3/16 (7.6 × 10.6)
Harry Ransom Humanities Research Center,
The University of Texas at Austin,
The Iconography Collection

[See pp. 30–32.] Blake produced two sets of colour-printed plates, known as the *Small* and *Large Book of Designs*, which gathered together images from his Prophetic Books. The origin of this print, from the *Small Book*, is Plate 5 of *The Book of Urizen* (1794), Blake's equivalent of Genesis in what he termed his own "Bible of Hell." Urizen, whose name puns on "your reason," stands for the repressive force of rationalism. Blake associates him with the tyrannical God of orthodox Christianity, and his "book of eternal brass" with the Ten Commandments:

Lo! I unfold my darkness and on
This rock place with strong hand the book
Of eternal brass, written in my solitude.
It is the solitude of Urizen (the fact that reason is not acting in concert with the other faculties) that leads to his spreading the darkness of religious mystery rather than shedding light.

Blake's colour-printing is particularly effective in the "obscure" pages of Urizen's book. Only two other impressions of this plate are recorded, one in the British Museum (which has complete copies of both books), the other at Yale.

128

Samuel Taylor Coleridge
Frost at Midnight in *Fears in Solitude, Written in 1798, during the Alarm of an Invasion. To which Are Added, France, an Ode; and Frost at Midnight*
London, 1798
The Wordsworth Trust

The longer, original version of *Frost at Midnight*, written in Feb. 1798, and printed at the end of the year in a quarto pamphlet of three

of Coleridge's poems. The last six lines, describing the excited response of Coleridge's infant son, Hartley, were omitted from later editions, so that the poem could conclude, as it began, with the "secret ministry of the frost." Though *Frost at Midnight* is a Conversation Poem, conveying the poet's sense of peace, and of man's potential to be at one with the God in Nature, the other two poems in the quarto are political works. *France, an Ode* is important for Coleridge's recantation of sympathy with France, following the French invasion of Switzerland—Europe's oldest republic—in Jan. 1798; in *Fears in Solitude*, written in April, his thoughts turn to the threatened invasion of England.

129 [Figure 64]

John Constable
Diagram of the Formation of a Rainbow
c. 1833
Pen and ink and pencil
6 3/8 × 7 3/4 (16.2 × 19.7)
Private collection

[See pp. 67–68.] Part of a series of diagrams, taking up both sides of two pieces of paper, once part of the same single sheet, watermarked 1832 [see Cat. no. 130]. Constable has diagrammed the principles of reflection and refraction, and, on the left, shown how these principles contribute to the formation of a rainbow.

130 [Figure 63]

John Constable
Diagram of the Formation of a Rainbow
c. 1833
Pencil
6 1/8 × 6 3/8 (15.5 × 16.2)
Private collection

Superimposed over faint indications of clouds, and interspersed with little circles indicating the millions of droplets of water in the atmosphere, the rainbow sketched by Constable is divided by thick pencil lines into the three primary colours. Although he lists on the left the seven colours of the Newtonian prism, and notes that there are "3 primary" and "7 prismatic" colours, at the bottom of the sheet he concludes: "There is no limit to the number of prismic colours."

131 [Figure 54]

John Constable
Landscape and Double Rainbow
1812
Oil on paper laid on canvas
13 1/4 × 15 1/8 (33.7 × 38.4)
The Trustees of the Victoria and Albert Museum, London

Constable's earliest known treatment of the double rainbow, dated by him "28 July 1812," and painted during a visit to Suffolk on which he regarded himself as "improved in the art of seeing Nature." Later treatments of the image include *London from Hampstead, with a Double Rainbow* and *Stonehenge* [Cat. nos. 218 and 161]. Constable's fullest statement on the

rainbow appears in the note to *Stoke by Neyland* in the 1833 edition of *English Landscape Scenery* [Cat. no. 65]: "Nature, in all the varied aspects of her beauty, exhibits no feature more lovely nor any that awaken a more soothing reflection than the rainbow. 'Mild arch of promise'."

132 [Figure 61]

John Constable
Sky Study with a Rainbow
1827
Watercolour
8 7/8 × 7 1/4 (22.5 × 18.4)
Yale Center for British Art,
Paul Mellon Collection
NYPL only

Once thought to be from the same period as the oil sketch *Landscape and Double Rainbow* [Cat. no. 131] of 1812, which it clearly resembles, but in fact faintly inscribed "May 20th 1827" at the top right. This is the only Constable study to show a rainbow without any landscape details at all in the foreground. The directness of execution matches the simplicity of design; the bands of the rainbow have been swiftly laid over the light blue ground, which is over-washed in parts to an intense, and very well-preserved, deep blue. It has been pointed out that Constable is inaccurate in making the area of sky within the arc of the rainbow darker than that outside. The opposite is the case in nature, as the artist notes in his *Stoke by Neyland* letterpress of 1833, quoting the lines: "And all within the arch appeared to be / Brighter than that without."

133

Benjamin Robert Haydon
Letter to Wordsworth
16 Oct. 1842
Holograph manuscript
The Wordsworth Trust

Recollections of the "Immortal Dinner" of 28 Dec. 1817 in Haydon's London studio, when Leigh Hunt, Lamb, Keats, Wordsworth, and Mary Wordsworth's cousin Thomas Monkhouse were present [see p. 65], and Keats proposed a toast of "Confusion to the memory of Newton!" on the grounds that "he destroyed the poetry of the rainbow by reducing it to a prism." The scene, as Haydon's *Diary* records, took place in front of the enormous canvas of *Christ's Entry into Jerusalem*, in which Keats, Wordsworth, and Newton were all portrayed:
my picture of *Christ's Entry* towering up behind them, occasionally brightened by the gleams of flame that sparkled from the fire . . . the voice of Wordsworth repeating Milton with an intonation like the funeral bell of St. Paul's, and the music of Handel mingled —and then Lamb's wit . . . sparkling in between, and Keats' rich fancy of satyrs and fauns and doves and white clouds. . . . It was an evening worthy of the Elizabethan age, and will long flash upon "that inward eye which is the bliss of solitude."
Haydon's grand historical paintings have yet to find an audience, but as well as being an engaging diarist he was a draughtsman of genuine ability [see Cat. nos. 73 and 284 for his drawings of Keats and Wordsworth]. Within

four years of writing this letter, in debt and depressed that his paintings had not been chosen to decorate the new House of Commons, he committed suicide.

134 [Figure 59]

Sir Isaac Newton
Opticks: or, a Treatise of the Reflexions, Refractions, Inflexions and Colours of Light
London, 1704
The University Library, Newcastle upon Tyne

[See p. 65.] First edition of the work that dominated thinking on the subject for 200 years. By the time Newton was twenty-five, he had discovered the binomial theorem and the differential and integral calculuses, had measured the area of the hyperbola, and had understood the notion of universal gravitation. Two years later, in 1669, he was elected Lucasian professor of mathematics at Cambridge, and he went on to revolutionize the study of optics.

Response to Newton among the Romantics was mixed. Constable's studies on the formation of rainbows are clearly indebted to the *Opticks* [see Cat. nos. 129 and 130]. To Wordsworth, Newton was "perhaps the most extraordinary man that this country ever produced," and even a kind of Romantic hero: his statue at Trinity seemed

> The marble index of a mind for ever
> Voyaging through strange seas of thought
> alone.

Other Romantics linked Newton to materialism and empiricism, and damned him, as Keats did in the toast recorded in Haydon's letter [Cat. no. 133], for destroying "the poetry of the rainbow." Blake sees him as an arch-villain with Locke and Bacon, a geometric measurer reducing the world to a visible system and destroying the human capacity for transcendence [see Cat. no. 126]. Coleridge, though praising "his severer eye" in *Religious Musings* (1796), dismisses him five years later as "a mere materialist"—"the souls of five hundred Sir Isaac Newtons would go to the making up of a Shakespeare or a Milton."

When Einstein was compared to his greatest predecessor, he protested that Newton had perceived that all colours were contained in white—an act of scientific imagination that put him out of reach of all rivals.

135 [Figure 77]

J. M. W. Turner
Rainbow: Osterspey and Feltzen on the Rhine
c. 1820
Watercolour
$7\frac{5}{16} \times 11\frac{7}{16}$ (18.8 × 29.2)
Museum of Art, Rhode Island School of Design, Anonymous Gift
CHS only

Osterspey and Feltzen, showing one of the sharpest bends on the river, is slightly larger, brighter, and more finished than the original watercolour, which is now at the Stanford University Museum of Art. Made by Turner c. 1820 from one of the series of fifty-one small watercolours bought by his friend and patron Walter Fawkes [see Cat. no. 292] after the tour of the Rhine in Aug.-Sept. 1817. Turner seems

to have planned a series of Rhineland engravings, but the scheme fell through.

136 [Figure 62]

J. M. W. Turner
Rainbow over Loch Awe
c. 1831
Watercolour
$9 \times 11\frac{1}{4}$ (22.9 × 28.6)
Private collection

Landscape in blue and grey washes, probably from a sketch-book used on the Scottish tour of 1831. Turner has ringed the distant Kilchurn Castle in an almost circular bow.

137

Dorothy Wordsworth
Letter to Jane Marshall
19 March 1797
Holograph manuscript
The Wordsworth Trust

[See pp. 70-71.] Letter to Jane Marshall (née Pollard)—Dorothy's friend from her days at Halifax, where she lived for ten years after her mother's death in 1778—setting out the principles which she and the poet have adopted in bringing up the four-year-old Basil Montagu, committed to their care by his father in 1795: "We teach him nothing at present but what he learns from the evidence of his senses." Although Basil served as a living model for Wordsworth's explorations of childhood experience, his "natural education" did not bring him happiness or success. He escaped a turbulent home life by going to sea, suffered from mental illness, and looked back with (probably unfounded) bitterness to the time he spent with the Wordsworths.

138

William Wordsworth
Alfoxden Notebook
1798
Holograph manuscript
The Wordsworth Trust

[See pp. 72-73.] Draft in the *Alfoxden Notebook*, c. Feb. 1798, of important lines that were later embedded in *The Prelude* (vii, 722-730), but which had been designed originally to characterize the Pedlar who tells the story of Margaret in *The Ruined Cottage* [Cat. no. 204]. In its portrayal of the direct influence of Nature on a passive mind, the fragment shows the poet at his closest to the associationism of David Hartley (*Observations on Man*, 1749, reissued 1791), after whom Coleridge named his infant son, and on whose philosophy his Unitarian thinking depended. It should be noted that *The Ruined Cottage* (finally published as *Excursion*, Book One, 1814) formed part of Wordsworth's original scheme for *The Recluse*, planned with Coleridge at this period as the great redemptive poem of the age:

> To his mind
> The mountain's outline and its steady form
> Gave simple grandeur and its presence
> shaped
> The measure and the prospect of his soul

> To majesty, such virtue had the forms
> Perennial and the aged hills, nor less
> The changeful language of their
> countenance
> Gave movement to his thoughts and
> multitude
> With order and relation.

139 [Figure 72]

William and Dorothy Wordsworth
Goslar letter to Coleridge
Dec. 1798
Holograph manuscript
The Wordsworth Trust

Joint letter written from Goslar to Coleridge at Ratzburg, probably 21 Dec. 1798, containing an astonishing selection of recent poetry, written, as Wordsworth said, "in self-defence" because he had no books. Included are two Lucy Poems ("little rhyme poems"), not elsewhere preserved in early manuscript versions, two of the most important childhood episodes from *The Prelude*, and *Nutting*:

1. *She Dwelt among the Untrodden Ways*, in a version of five stanzas (against the published three), beginning,

> My hope was one, from cities far,
> Nursed on a lonesome heath;
> Her lips were red as roses are,
> Her hair a woodbine wreath.

2. *Strange Fits of Passion* (headed, "The next poem is a favourite of mine—i.e. of me, Dorothy"), without the published opening stanza, but with a conclusion, later omitted:

> I told her this; her laughter light
> Is ringing in my ears;
> And when I think upon that night
> My eyes are dim with tears.

3. The Skating episode ("And in the frosty season"), 1799 *Prelude*, i, 150-185, sent to Coleridge because

> A race with William upon his native lakes
> would leave to the heart and imagination
> something more dear and valuable than the
> gay sight of ladies and countesses whirling
> along the Lake of Ratzeburg.

4. The moonlit adventure on Ullswater ("one evening / I went alone into a shepherd's boat'), 1799 *Prelude*, i, 81-129: "I will give you a lake scene of another kind. I select it from the mass of what William has written. . . .'

5. *Nutting* (at this stage regarded as part of *The Prelude*, but published separately in *Lyrical Ballads*, 1800), preserved in a text with many interesting variants, and introduced by Dorothy with an invitation to visit the North of England the following summer: "I would once more follow at your heels, and hear your dear voices again."

With copy crammed on both sides of the sheet, vertically and horizontally, this is one of the primary documents of English Romanticism. Not least important is the fact that it describes the mental and physical distress that accompanied one of the poet's most creative periods:

> I should have written five times as much as I
> have done but that I am prevented by an uneasiness at my stomach and side, with a dull
> pain about my heart. I have used the word
> pain, but uneasiness and heat are words

which accurately express my feeling.... I am absolutely consumed by thinking and feeling and bodily exertions of voice or of limbs, the consequences of those feelings.

140 [Figure 55]

William Wordsworth
The Rainbow
Post 1829
Manuscript, hand of John Constable
Private collection

Possibly from the same period as Constable's rainbow diagrams [Cat. nos. 129 and 130], and certainly post 1829, as he uses the letters "R.A." after his name. Constable's copying out of Wordsworth's poem points to a shared interest in childhood experience and its relation to the natural world. The artist associated his "careless boyhood" with "the banks of the Stour." "They made me a painter . . . that is I had often thought of pictures of them before I had ever touched a pencil." For both men the rainbow symbolized a link between man and Nature, just as in the Bible it represented a covenant between man and God.

141 [Figure 69]

William Wordsworth
The Rainbow
17 April 1842, composed 26 March 1802
Manuscript
The British Library Board, Ashley MS. 2265

Wordsworth's short lyric, later prefaced to the *Intimations Ode*, expressing his belief that childhood experience is the source of our continuing ability to respond to Nature:
> The child is father of the man;
> And I could wish my days to be
> Bound each to each by natural piety.

Dorothy's Grasmere *Journal* shows that *Intimations* and *The Rainbow* had been connected from the first: Friday, 26 March 1802— "While I was getting into bed he wrote *The Rainbow*;" Saturday, 27 March—"A divine morning. At breakfast William wrote part of an ode." In this manuscript, transcribed forty years after *The Rainbow* was composed, Wordsworth writes to his publisher, Moxon, "The above sonnet I wish inserted *first* of my 'Poems Referring to the Period of Childhood.'" Making use of the obsolete definition of "sonnet" as "lyric," the seventy-two-year-old Wordsworth substitutes "years" for "days" in the penultimate line, "And I could wish my days to be," and changes the order of the last line from "bound each to each" to "each bound to each." He seems to have had second thoughts about the corrections, but *The Rainbow* was given pride of place in future editions.

142

William Wordsworth
"The Raven's Nest" in *The Prelude*, 1799, i
Late 1799
Manuscript, hand of Dorothy Wordsworth
The Wordsworth Trust

"The Raven's Nest," composed in Oct. 1798, and transcribed by Dorothy in early Dec. 1799

in *Prelude* MS. V, base text for the original two-part version of the poem. Ravens, on the fells near Hawkshead, were a danger to lambs. Parish records show that village boys were rewarded for destroying nests; boys at the Grammar School, however, were forbidden to seek payment "for destroying vermin." The adult poet, looking back, recalls experience of quite another kind:
> While on the perilous ridge I hung alone,
> With what strange utterance did the loud
> dry wind
> Blow through my ears; the sky seemed not a
> sky
> Of earth, and with what motion moved the
> clouds!

(1799, i, 63–66)

143 [Figure 76]

William Wordsworth
There Was a Boy
c. Feb. 1799
Holograph manuscript
The Wordsworth Trust

[See pp. 81–84.] Fair copy of *There Was a Boy* in one of the two red-leather notebooks in use at Goslar, winter 1798–1799. Published as a separate poem in *Lyrical Ballads* 1800, yet also forming a part of *The Prelude* (v, 389–413). *There Was a Boy* has a complex textual history. At the stage preserved in this notebook, the basic poem (composed the previous autumn among the earliest *Prelude* drafts) has been rewritten in the third-person as the centrepiece of a discussion of natural and artificial modes of education. It is in this context that *There Was a Boy* is finally incorporated in *The Prelude* (in spring 1804). In 1799, however, Wordsworth does not think of the poem as belonging to his autobiography; he probably intends it for *The Recluse*.

In *Poems* 1815, Wordsworth placed *There Was a Boy* (in its separate form) at the head of the "Poems of the Imagination," commenting in his heavy but thoughtful prose:
> Guided by one of my own primary consciousnesses, I have represented a commutation and transfer of internal feelings, co-operating with external accidents to plant, for immortality, images of sound and sight, in the celestial soil of the imagination. The boy, there introduced, is listening, with something of a feverish and restless anxiety, for the recurrence of the riotous sounds which he had previously excited; and, at the moment when the intenseness of his mind is beginning to remit, he is surprised into a perception of the solemn and tranquillizing images which the poem describes.

144

William Wordsworth
"Was it for this" in *The Prelude*, 1799, i
Late 1799
Manuscript, hand of Mary Hutchinson
The Wordsworth Trust

[See p. 78.] Opening lines of the original two-part *Prelude* of 1799 (MS. U), composed in Goslar, late 1798, and transcribed after completion of the poem in early Dec. 1799. Wordsworth's insistent questioning reveals a

conflict in his mind that proved extremely creative. On the one hand, there is self-reproach at his failure to begin work on the central section of *The Recluse* (the great philosophical work planned with Coleridge the previous March); on the other, there is his sense of having enjoyed a specially favoured childhood that marked him out as a poet:
> Was it for this
> That one, the fairest of all rivers, loved
> To blend his murmurs with my nurse's
> song....

4:
The Discovery of Nature

145 [Figure 80]

John White Abbott
Canonteign, Devon
1803
Pen and ink with watercolour,
on three joined sheets of wove paper
$17\frac{5}{8} \times 14\frac{3}{8}$ (44.7 × 36.4)
Birmingham Museum and Art Gallery

[See p. 113.] Dated Sept. 1803. Abbott exhibited mainly in Exeter and London, and made only one tour, of the Lake District and Scotland in 1791 [see Cat. no. 209]. His principal subject was the South Devon countryside, and he often drew this noted beauty-spot near the River Teign. His sharp outlines and clean washes, and his use of the pen on details, owe much to his teacher, Francis Towne; the trailing vines and rock formations suggest the "picturesque" influence of writers such as Uvedale Price and Richard Payne Knight [see Cat. nos. 179 and 182].

146

Jane Austen
Sense and Sensibility, Vol. 1
London, 1811
D. H. Warren Collection

[See pp. 87–88.] First edition of Jane Austen's first published novel. Begun in 1797, but left unfinished for many years, *Sense and Sensibility* shows Austen's emergence from late eighteenth-century ways of thinking. Sensibility and the picturesque are laughable in their extremes, yet Austen's sympathy as a writer goes out to Marianne in her quest for a language to express her emotion: "I detest jargon of every kind; and sometimes I have kept my feelings to myself, because I could find no language to describe them in but what was worn and hackneyed out of all sense and meaning."

147

Thomas Bewick
History of British Birds, Containing the History and Description of Water Birds, Vol. 2
Newcastle, 1804
Iain Bain Collection

Thomas Bewick, the father of English wood engraving, was born at Cherryburn in the

Northumbrian hamlet of Eltringham on the south bank of the River Tyne. At the age of fourteen, after a hardy country boyhood on his father's eight-acre farm, he was apprenticed to Ralph Beilby of Newcastle, an "engraver in general" who worked principally on metal. Between 1777 and 1796 he was partner to his former master, and throughout that time the main part of their trade continued in metal engraving, although Bewick's affinity for using the metal engraver's tools on end-grain box-wood brought him illustration work for numerous children's books published by the local printers and booksellers. On these his skills developed to such good effect that when his first great book, *General History of Quadrupeds*, was published in 1790, its success was immediate, and the beauty of its engravings set in train a rapid increase in the book trade's respect for wood as a medium for quality illustration.

By the time his greatest work, the *History of British Birds*, was published, his reputation had spread to Europe and America, and the influence of his books on the rising popular interest in natural history in Britain equalled that of Gilbert White's *Natural History of Selborne*. The publication of *Land Birds* in 1797 was followed in 1804 by a second volume, *Water Birds*, of which the first edition, in large paper, is displayed in the exhibition. Wordsworth, among Bewick's many admirers, begins his poem *The Two Thieves* with a tribute to Bewick: "O now that the genius of Bewick were mine."

148 [Figure 103]

Thomas Bewick
Skylark
c. 1792–1797
Watercolour and wood engraving
$2\frac{1}{2} \times 3\frac{4}{5}$ (6.1 × 9.5)
Iain Bain Collection

The *Skylark* along with three other watercolour drawings [Cat. nos. 149–151] was originally given to the amateur naturalist J. F. M. Dovaston in 1825 when he visited Bewick in Newcastle. All of them show evidence that they were used to transfer the basic outline of the design to the wood block before engraving began.

149 [Figure 104]

Thomas Bewick
Dog and Pan
c. 1800
Watercolour and wood engraving
2×4 (5.1 × 10.1)
Iain Bain Collection

The narrative content of this street scene is typical of many of Bewick's *tale*-pieces, as he called them. The participation of the laughing workman in the cruel but common juvenile prank of teasing a dog by tying a pan to its tail, adds an edge to Bewick's disapproval of the scene.

150

Thomas Bewick
The Pigsty Netty
c. 1792–1797

Watercolour
$1\frac{4}{5} \times 3$ (4.2 × 7.6)
Iain Bain Collection

Original watercolour design for Cat. no. 152.

151

Robert Johnson, after Thomas Bewick
The Over-long Grace before Meat
c. 1794
Watercolour
$2\frac{1}{10} \times 2\frac{1}{2}$ (5.4 × 6.2)
Iain Bain Collection

The drawing in which the cat is seen helping itself to the praying man's supper is a jibe at the overly pious. Religiosity gets its just deserts. The drawing was developed from Bewick's preliminary by Robert Johnson, one of his most talented apprentices.

152

Thomas Bewick
"The Pigsty Netty" from *British Birds*
c. 1792–1797
Engraved boxwood block
$1\frac{1}{2} \times 2\frac{4}{5}$ (3.8 × 7.2)
Iain Bain Collection

Seen together with the preliminary watercolour design [Cat. no. 150], Bewick's woodblock shows how the original drawing of the earth-closet (or "netty") was modified in the engraving. The artist's unsmiling view of the countryman as no better than the beasts he keeps, has been freed of association with the distant view of St. Nicholas' Church, Newcastle. The block was itself later modified as a concession to nineteenth-century taste: two partly concealing planks were engraved across the countryman's previously bare behind.

153

Thomas Bewick (with Henry Hole)
Whimbrel from *British Birds*
(*Water Birds*, 1804)
1801
Engraved boxwood block
$3 \times 3\frac{4}{5}$ (7.3 × 9.7)
Thomas Bewick Birthplace Trust, Cherryburn, Northumberland

154

Thomas Bewick
Lesser Redpole from *British Birds*
(*Land Birds*, 1797)
c. 1792–1797
Engraved boxwood block
2×3 (5.1 × 7.4)
Iain Bain Collection

155

Thomas Bewick
Modern engraving tools, boxwood rounds, repro-drawings, and modern print
from original block of the *Lesser Redpole*
Iain Bain Collection

Three engraving tools, with points of varying functional shape, together with a "round" of boxwood, cut across the grain to a thickness equalling the height of printing types. A further untrimmed round of box shows the silvery outline of a lead pencil transfer, and the clear mark of a broad graver stroke beginning the clearing of the bird's outline. The original block for the *Lesser Redpole* is shown with a reproduction of the original transfer drawing, folded and with the underside leaded by a soft pencil to aid the process of transfer. Fine-pointed pressure is applied to the outline only. The original creamy colour of the boxwood is blackened by ink in printing.

156

Robert Bloomfield
Aeolian harp
1808
Box-shaped wooden instrument,
with metal fittings and catgut strings
$4\frac{5}{8} \times 31\frac{1}{2}$ (11.6 × 80.7)
Moyse's Hall Museum, Bury St. Edmunds

Made by Robert Bloomfield, the unschooled "natural" poet whose *Farmer's Boy* (1800) sold over 20,000 copies in three years. The Aeolian harp was a favourite Romantic symbol for spontaneous creation [see Cat. no. 157]. Shelley likened its workings to those of the human mind: "Man is an instrument over which a series of . . . impressions are driven, like the alternations of an ever-changing wind over an Aeolian lyre, which move it by their motion to ever-changing melody."

157

Samuel Taylor Coleridge
The Eolian Harp
c. 1796
Manuscript
Harry Ransom Humanities Research Center,
The University of Texas at Austin,
The Manuscript Collection

Fair copy, sent to the Bristol publisher Joseph Cottle, for Coleridge's *Poems 1796*. *The Eolian Harp* is the first of the informal, meditative lyrics now known as Conversation Poems. The harp would have been placed in an open window, and stirred into song by the breeze [see Cat. no. 156]. Coleridge, at this stage, sees Nature as similarly animated by a pantheist God:

> And what if all of animated Nature
> Be but organic harps diversely framed
> That tremble into thought, as o'er them
> sweeps,
> Plastic and vast, one intellectual breeze,
> At once the soul of each, and God of all?

The view is essentially similar to that of Wordsworth in *Tintern Abbey*.

158 [Figure 118]

John Constable
A Farmhouse near the Water's Edge
1834
Oil
$10 \times 13\frac{3}{4}$ (25.4 × 34.9)
The Trustees of the Victoria and Albert Museum, London

[See p. 127.] One of a series of late, expressionistic works, freely reinterpreting a particular view on the River Stour, and related to *The White Horse* (1819). An initial pencil sketch of 1829 is followed in turn by a watercolour (*c.* 1832), this oil sketch of 1834, and two larger oils. At each stage the elements of the composition are rearranged, but the sequence never results in a finished picture. The scumbling of white, opaque paint over the surface—Constable's "snow"—is characteristic of the last phase of his work.

159 [Figure 119]

John Constable
The Mound of the City of Old Sarum, from the South
1834
Watercolour and scraping out
$11\frac{7}{8} \times 19\frac{1}{8}$ (30 × 48.7)
The Trustees of the Victoria and Albert Museum, London

[See p. 127.] In 1829 Constable made pencil drawings of this scene, followed by an oil sketch mezzotinted for *English Landscape Scenery* [Cat. no. 65]. He explains in the 1833 edition of the book that Sarum had once been the political and religious centre of the kingdom; but the "proud and 'towered city'" was now reduced to a barren waste, "tracked only by sheep-walks." The character of the scene is "so awful and impressive" that it is naturally associated with "the grander phenomena of Nature," and even with "conflicts of the elements": hence, in this watercolour, made the following year, the lowering sky, and, on the strip of paper added on the right, the edge of a rainbow.
Old Sarum, the largest, most finished watercolour Constable had made by 1834, was one of three he sent to the Academy in that year.

160 [Figure 96]

John Constable
Sky Studies after Alexander Cozens (nos. 8–13)
c. 1823
Pencil on wove paper (six drawings on one mount)
Each drawing approx. $3\frac{11}{16} \times 4\frac{1}{2}$ (9.3 × 11.5)
Courtauld Institute Galleries, London
NYPL and IUAM only

[See pp. 106–107.] Constable copied twenty of the "sky studies" in Alexander Cozens' *New Method* [Cat. no. 174], probably during his stay at Sir George Beaumont's house at Coleorton in 1823 (Beaumont had been a pupil of Cozens' at Eton). Constable's own cloud studies made at Hampstead the previous year are far more impressive, yet he feels that there are lessons to be learned from a distinguished precursor.

161 [Figure 120]

John Constable
Stonehenge
1836
Watercolour
$15\frac{1}{4} \times 23\frac{1}{4}$ (38.7 × 59.1)
The Trustees of the Victoria and Albert Museum, London

[See p. 130.] Constable sketched Stonehenge on the spot on 15 July 1820; two views survive, both used as the basis for later work. One, showing the monument in the distance, was engraved by David Lucas after Constable's death. The other, a close-up study, is the direct source for this watercolour, exhibited at the Royal Academy in 1836.
Constable sets the massive stones in a barren, seemingly endless landscape, adding strips of paper to his sheet to increase the sense of scale. The double rainbow is used to similar effect in *Old Sarum* [Cat. no. 159].

162 [Figure 109]

John Constable
Study of Clouds
1821
Oil on paper on board
$8\frac{3}{8} \times 11\frac{1}{2}$ (21.3 × 29)
Yale Center for British Art,
Paul Mellon Collection

[See pp. 119–121.] Inscribed by Constable, "25th. Septr 1821 about from 2 to 3 afternoon looking to the north—Strong Wind at west, bright light coming through the Clouds which were lying one on another." One of the marvellously accurate, fluid studies made at Hampstead, 1821–1822; each one took about an hour of rapid work, in difficult conditions, with the artist's sheet pinned to the inside cover of his paint box. In a letter to Fisher of Oct. 1821, Constable describes the sky as the "chief '*organ of sentiment*'" in a landscape, because it is "the '*source of light*' in Nature—and governs everything."

163 [Figure 110]

John Constable
Study of Cumulus Clouds
1822
Oil on paper on panel
$11\frac{1}{4} \times 19$ (28.5 × 48.5)
Yale Center for British Art,
Paul Mellon Collection

[See pp. 119–121.] The fall of 1822 was Constable's most intense period of "skying." He wrote to Fisher in Oct.: "I have made about fifty careful studies of *skies*, tolerably large." Most of the surviving studies are completely without landscape, and larger than those made the previous year [see Cat. no. 162]. This one, inscribed "Sepr. 21. 1822. $\frac{1}{2}$ pst. one o clock. looking south. Wind very fresh at East, but warm," is somewhat unusual in showing a fair-weather cloud formation. Constable made a further study (looking south) one and a half hours later.

164 [Figure 108]

John Constable
Study of Sky and Trees
1821
Oil on paper
$9\frac{1}{2} \times 11\frac{3}{4}$ (24.1 × 29.8)
The Trustees of the Victoria and Albert Museum, London

[See p. 119.] Inscribed on the back: "September

3d. Noon. very sultry. with large drops of Rain falling on my palate [*sic*] light air from S.W." Like most of the 1821 studies [see Cat. no. 162], this oil shows freely painted trees and bushes against an intense skyscape, capturing a sense of the constantly shifting atmospheric conditions.

165 [Figure 107]

John Constable
Trees at Hampstead: The Path to Church
1822
Oil
$36 \times 28\frac{1}{2}$ (91.4 × 72.4)
The Trustees of the Victoria and Albert Museum, London

[See p. 119.] Probably the subject of Constable's letter to Fisher of 20 Sept. 1821:
[I have] done some studies, carried further than I have yet done any, particularly a natural (but highly elegant) group of trees, ashes, elms, an oak etc.—which will be of quite as much service as if I had bought the field and hedgerow which contains them, and perhaps one time or another will fetch as much for my children.
Leslie records an exchange between Blake and Constable (in a rather humourless mood) on the subject of another group of Hampstead trees:
The amiable but eccentric Blake, looking through one of Constable's sketch-books, said of a beautiful drawing of an avenue of fir trees on Hampstead Heath, "Why, this is not drawing, but *inspiration*," and he replied, "I never knew it before; I meant it for drawing."

166 [Figure 117]

John Constable
Water-meadows at Salisbury
1829
Oil
$18 \times 21\frac{3}{4}$ (45.7 × 55.3)
The Trustees of the Victoria and Albert Museum, London

[See pp. 126–127.] The product of one of Constable's last visits to Fisher at Salisbury (1829). His friend was to die in 1832, an event which, following Maria's death in 1828, intensified the sadness of the painter's last years.
Though intended for exhibition, *Water-meadows at Salisbury* was turned down by the Royal Academy in 1830. Constable had been elected a full member the previous year, and was entitled to have eight works hung without question. It appears, however, that *Water-meadows* was mixed up with the pictures submitted by outsiders, and rejected by a fellow Academician as "a nasty green thing." When the mistake was realized, apologies were offered and the decision was reversed; Constable, it is said, would have none of this, and walked out of the building with the picture under his arm.

167 [Figure 102]

John Sell Cotman
Greta Woods
1805–1806

Pencil and watercolour
$17\frac{1}{8} \times 13\frac{1}{8}$ (43.5×33.4)
Mrs. Bridget Salisbury Gibbs Collection

[See p. 113.] One of a series of watercolours resulting from Cotman's stay at Rokeby Park as a guest of J. B. S. Morritt, a friend of the Cholmeleys [see Cat. no. 168], during the artist's last visit to Yorkshire in 1805. The park was noted for its outstanding natural beauty; this particular view is from a spot on the Greta River near Rokeby Hall, looking into Mortham Woods. *Greta Woods* demonstrates Cotman's unrivalled ability to capture the play of light and shadow across dense foliage, and is justly regarded as one of his highest achievements.

168

John Sell Cotman
Near Brandsby, Yorkshire
1805
Watercolour
13×9 (33×22.8)
Lent by the Visitors of the Ashmolean Museum, Oxford

Dated 16 July 1805. In summer 1803, Cotman and Paul Sandby Munn visited Yorkshire, armed with a letter of introduction from the antiquarian and patron Sir Henry Englefield to his sister's family, the Cholmeleys of Brandsby. Cotman stayed in the area around Brandsby until the fall, and returned in the two following summers as a guest of the Cholmeleys. He was introduced by younger members of the family to the local gentry, and made numerous short tours of the surrounding countryside. These were undoubtedly the happiest summers of a life later marred by gloom and disappointment, and they mark the emergence of the watercolour style for which Cotman is now famous. This example, with its flat, clean washes, muted colours, and areas of uncoloured paper, transforms a simple, everyday scene into one of great charm and beauty.

169 [Figure 78]

John Sell Cotman
On the Greta (Hell Cauldron)
1806
Watercolour
$17\frac{1}{4} \times 13\frac{5}{16}$ (43.7×33.9)
Leeds City Art Galleries

[See pp. 112–113.] Another Rokeby drawing [see Cat. no. 167]. This study—and a more finished version of the scene (now in Edinburgh)—shows a tranquil section of the Greta, upstream from the narrow, turbulent passage referred to in the title. Writing to Francis Cholmeley [see Cat. no. 168], Cotman described Rokeby as "a delicious spot," recounting his walks along the banks of the river and his daily bathing in its waters. Some of his drawings were coloured on the spot, but it is likely that these carefully worked watercolours were produced after his return from Yorkshire in November 1805. Cotman was still hoping to establish himself in London, and showed a number of works at the Royal Academy in May 1806. His application for membership of the Watercolour Society was, however, turned down, and in the summer he decided to open a drawing-school in his home town of Norwich.

170

Alexander Cozens
The Cloud
c. 1785
Wash
$8\frac{1}{2} \times 12\frac{1}{2}$ (21.6×30.5)
Private collection, U.K.

[See p. 106.] Cozens' sky studies often give an impression of cool objectivity, and descriptive notes in the *New Method* [Cat. nos. 171–173] suggest a concern with the formal qualities of cloud patterns, rather than what Constable was to call "the bolder phenomena of Nature." *The Cloud*, however, explores the dramatic possibilities of unusual atmospheric effects: a craggy landscape is silhouetted against a spectacular configuration of clouds with a bank of stormy cumulus, sharply lit at its edges by the evening sun.

171 [Figure 93]

Alexander Cozens
A New Method of Assisting the Invention in Drawing Original Compositions of Landscape (Plate 22)
c. 1785
Aquatint strengthened with etching
$9\frac{7}{16} \times 12\frac{3}{8}$ (24×31.6)
Davison Art Center, Wesleyan University

[See p. 106.] A Cozens "blot," developed in Cat. nos. 172 and 173 into a finished landscape. Though advertised in 1784, the *New Method* was apparently not published in London until the following year. Important though it is in theoretical terms, the book soon vanished from sight, and of the few copies that remain several are incomplete.

Cozens taught drawing at Eton from 1766, and was described by William Beckford in 1781 as "almost as full of systems as the universe." The origins of his *New Method* are explained in the introduction: while teaching a gifted pupil, and pondering the lack of any "method . . . to draw forth the ideas of an ingenious mind," he roughly sketched a design on a piece of soiled paper. He noticed that, "insensibly," the stains on the paper had influenced his drawing. Cozens then made similar "rude forms" on another sheet, and presented them to his student, who turned them into an "intelligible sketch." In addition to practical hints on how to use the method, the introduction speculates interestingly on the nature of invention.

172 [Figure 94]

Alexander Cozens
A New Method of Assisting the Invention in Drawing Original Compositions of Landscape (Plate 23)
c. 1785
Aquatint
$9\frac{7}{16} \times 12\frac{3}{8}$ (24×31.6)
Davison Art Center, Wesleyan University

Listed in Cozens' "Table of Examples" as "A print, representing a sketch made out with a brush, from the preceding blot."

173 [Figure 95]

Alexander Cozens
A New Method of Assisting the Invention in Drawing Original Compositions of Landscape (Plate 24)
c. 1785
Aquatint and mezzotint
$9\frac{7}{16} \times 12\frac{3}{8}$ (24×31.6)
Davison Art Center, Wesleyan University

The final plate in this series of three, described by Cozens as "A print, representing the same sketch, made into a finished drawing."

174

Alexander Cozens
Study of Sky No. 1
c. 1785
Wash on varnished paper
$8\frac{11}{16} \times 12\frac{1}{16}$ (21.9×30.8)
Private collection, U.K.

One of a set of twenty-four cloud studies, which also includes Cat. no. 170. The paper in all cases is the same as that used for the blots in the *New Method*, and it is probable that these studies date from the same period. Cozens presumably intended them as the basis for a further work. *Sky Study No. 1* is one of four which omit landscape and concentrate solely on the formations of clouds, anticipating Constable's sky studies of 1821–1822 [Cat. nos. 162–164].

175 [Figure 79]

William Gilpin
Three Essays: on Picturesque Beauty; on Picturesque Travel; and on Sketching Landscape: to which Is Added a Poem, on Landscape Painting
London, 1792
Courtesy of the Lilly Library,
Indiana University, Bloomington, Indiana

[See pp. 88–89.] Remarkable chiefly for Gilpin's attempt, in the *Essay on Picturesque Beauty* (written originally in 1776), to define his theoretical position against that of Edmund Burke. *A Philosophical Enquiry into the Origin of Our Ideas of the Sublime and Beautiful* (1757) [Cat. no. 266]. Gilpin, like Wordsworth a Cumbrian, takes exception to Burke's belief that "smoothness" determines the beauty of objects; he contends, on the contrary, that "roughness" is "that particular quality which makes objects chiefly pleasing in painting." To drive the point home, he includes two illustrations of what is essentially the same scene: the outlines of the landscape are smooth and unbroken in one, rugged and irregular in the other. In the second of the *Three Essays*, "the mode of amusement is pointed out, that may arise from viewing the scenes of nature in a picturesque light," and in the third, "a few rules are given for sketching landscape after Nature."

176 [Figure 86]

William Gilpin
Observations on the River Wye and Several Parts of South Wales &c. Relative Chiefly

to *Picturesque Beauty Made in the Summer
of the Year 1770*
London, 1782
Yale Center for British Art, Paul Mellon
Collection

[See pp. 88–89.] The first edition of Gilpin's highly important first publication on the picturesque. Gilpin toured the Wye Valley in June 1770, and his manuscript account was circulated among a small but distinguished group, including Thomas Gray, before its eventual appearance (with 1782 on the title-page) in the summer of 1783. Delay in the final year is explained by problems with the aquatints, made by Gilpin's nephew, William Sawrey Gilpin, not altogether to his uncle's liking. William Mason was among many who failed to understand that these illustrations were picturesque ideas as opposed to detailed representations. "As a drawer of existing scenes," he wrote to Gilpin, "you are held as the greatest of *infidels*. If a voyager down the River Wye takes out your book, his very boatman cries out, 'Nay sir, you may look in vain there. Nobody can find one picture in it the least like!'" To which Gilpin replied, "I did all I could to make people believe they were *general ideas*, or *illustrations*, or anything but what they would have them to be, exact portraits."

177 [Figure 87]

Thomas Girtin
Tintern Abbey
c. 1793
Watercolour
15 × 10½ (38.5 × 27)
Blackburn Museum & Art Gallery

[See p. 97.] Signed "T Girtin" on one of the pieces of fallen masonry in the foreground, and showing the south transept and part of the choir of the abbey. *Tintern Abbey* was almost certainly made after a sketch by the topographical draughtsman Edward Dayes, to whom Girtin had been apprenticed in 1788. Another drawing, almost the same size and again probably after Dayes, shows a view looking down the nave of the abbey from the choir.

178 [Figure 81]

Thomas Hearne
*Sir George Beaumont and Joseph Farington
Sketching a Waterfall*
1777
Pen and brown and grey washes
17½ × 11½ (44.5 × 29.2)
The Wordsworth Trust

[See p. 92.] Probably drawn in summer 1777 at Lodore, Derwentwater, where Beaumont, Farington, and Hearne stayed at the inn. It is likely that all three had come to the Lakes as the result of reading Gray's *Journal* (1775 [Cat. no. 234]); Beaumont and Farington had both been taught by Richard Wilson, who on his return from Rome had applied the arcadian vision of Claude to British subject-matter—though never to the Lake District. Beaumont had a lifetime commitment to the Lakes, and well over two hundred of his drawings (chiefly in the collection of The Wordsworth Trust) and paintings of the area survive. Farington published

his *Views of the Lakes* in 1783–1787, and a newly engraved collection in 1816, as well as planning, *c.* 1798, a series of full-colour illustrations to Gray's Lake District tour [see Cat. no. 231].

179

Richard Payne Knight
An Analytical Inquiry into the Principles of Taste
London, 1805
Harry Ransom Humanities Research Center,
The University of Texas at Austin,
The Library Collection

Written as part of a long-running dispute with his friend Uvedale Price [see Cat. no. 182] over the precise meaning of the term "picturesque." Knight undermines the Burkean basis of Price's arguments, disproving and dismissing them all with relish. Price was reported "hurt" by the attack, and the book caused some unease among mutual friends such as Sir George Beaumont. Knight had published a lengthy poem on the picturesque, *The Landscape* (1794), and his activities also extended to ancient art, numismatics, philology, and architecture. The *Inquiry* reflects these interests, and shows a grasp of aesthetics that sets him above Price and Gilpin [Cat. no. 175]. The book quickly went into four editions. Knight complained that this first edition had been "abominably printed" and insisted on a different printer for the second.

180 [Figure 105]

Samuel Palmer
The Bright Cloud
c. 1830–1840
Watercolour and pencil
6 × 7¼ (15.2 × 18.4)
Yale Center for British Art,
Paul Mellon Collection

[See p. 116.] Inscribed by Palmer along the bottom: "On those bright Italian days middle dist. white cloud near horizon lower edges or base obscure / Effect made by cloud cast shadow over landscape—the rest as sunny / as possible—The gray shadows of cloud almost as cold as azure," and on the reverse by his son, A. H. Palmer: "a version of the Bright Cloud, but more modern in date." Palmer went to Italy in 1837, and his reference to "those bright Italian days" suggests that the drawing dates from the two years he spent there, although the billowing mass of cumulus has affinities with several finished works from his earlier Shoreham period, including *The White Cloud* (Ashmolean Museum, Oxford) and *The Bright Cloud* (Manchester City Art Gallery).

181 [Figure 106]

Samuel Palmer
Pastoral with a Horse-Chestnut Tree
c. 1830–1832
Water and bodycolour, mixed in place
with gum arabic and heightened with white
13¼ × 10½ (33.7 × 26.7)
Lent by the Visitors of the Ashmolean
Museum, Oxford

[See p. 116.] The horse-chestnut clearly appealed to Palmer's imagination for the size of its candle-like blossom and leaves: there are drawings of the tree in his 1824 sketchbook, and a note remarking on "large clumps of chestnut trees perhaps with leaves as long as a man's arm."

This watercolour is usually grouped with two other works of the period, both taking trees as their central subject: the *Magic Apple Tree* (Fitzwilliam Museum, Cambridge) and *In a Shoreham Garden* (Victoria and Albert Museum, London). *Pastoral with a Horse-Chestnut* lacks the overt symbolism of *Shoreham Garden*, but with its unusual mixture of mediums, and its inclusion of the piping shepherd and his flock, it has the heightened vision characteristic of Palmer's greatest work.

182

Uvedale Price
*An Essay on the Picturesque as Compared with
the Sublime and the Beautiful and on the Use
of Studying Pictures for the Purpose of Improving
Real Landscapes*
London, 1794
Yale Center for British Art,
Paul Mellon Collection

Price's *Essay* condemns the shorn and artificial landscaping styles of "Capability" Brown and Humphry Repton, as well as attempting a broad definition of the picturesque as a distinct aesthetic category. Drawing on Burke's *Philosophical Enquiry* [Cat. no. 266], Price attempts to give this category the widest possible application: he even suggests there might be such a thing as "picturesque" music. His descriptions of landscape are both imaginative and closely observed, and it was probably this more practical side of his book which gave it its lasting popularity. It went into an expanded, three-volume edition in 1810, and further editions as late as 1842.

It was Price, a frequent visitor to Sir George Beaumont's house at Coleorton, who first introduced him to the poetry of Wordsworth.

183

Thomas Rowlandson and William Combe
*The Tour of Doctor Syntax
in Search of the Picturesque: A Poem*, Vol. 1
London, 1812
The Wordsworth Trust

Second edition, with hand-coloured plates. The frontispiece shows Dr. Syntax, a parodic version of the Rev. William Gilpin [see Cat. no. 175], gazing out over the natural scene, his finger upon his brow in an attitude of rapt contemplation. In the title-page vignette, the first three letters of "PICTURESQUE" are formed by two fragments of a Gothic ruin, with a central classical column. Lines from Horace at the foot of the page proclaim the affinity of poetry and painting—"*Ut pictura poesis*"—on which the cult of the Picturesque depended. In the case of *Doctor Syntax*, the relationship of the "sister arts" was a little arbitrary. For its original publication (as *The Schoolmaster's Tour*) in *The Poetical Magazine*, 1809–1812, Rowlandson sent his collaborator, William Combe, an etching or drawing every month.

Artist and writer never met, and Combe did not know in advance what would be the subject of his next instalment. The work was immensely successful, its satire (like that of Jane Austen [see Cat. no. 146]) showing how widespread Gilpin's readership continued to be.

184 [Figure 82]

Thomas Rowlandson
Doctor Syntax Sketching the Lake;
Plate 16 in *The Tour of Doctor Syntax in Search of the Picturesque: A Poem*, Vol. I
1812
Private collection

Seated precariously on his feeding horse at the edge of a lake, the Doctor sketches the view with eyes uplifted, watched on one side by a boating-party, on the other by a disbelieving fisherman.

185 [Figure 99]

Paul Sandby
Ancient Beech-Tree, Windsor Great Park
1797
Watercolour
$24\frac{3}{4} \times 17\frac{1}{2}$ (63 × 44.3)
Private collection

[See p. 111.] Suggesting human littleness beside a sublime work of Nature, a woodman sleeps at the foot of the tree, his axe discarded on the ground. Above, the branches snake and twist against a pale blue light; there is something here of Wordsworth's vision of the yews in Borrowdale:

each particular trunk a growth
Of intertwisted fibres serpentine
Up-coiling and inveterately convolved. . . .

Sandby is shown at the height of his powers, producing a very large drawing almost entirely in clear colour, at a period when he was experimenting not merely with gouache but with oils. A nineteenth-century hand has added the signature of Copley Fielding, and partially erased Sandby's initials. The tree, which was of exceptional age, is identified by William Sandby in *Thomas and Paul Sandby* (1892).

186 [Figures 121 and 122]

Percy Bysshe Shelley
Ozymandias
1817
Manuscript
By permission of the Curators of the Bodleian Library, Oxford

Shelley's single notebook leaf, with rough drafts on the recto, the fair copy on the verso. Scarcely a handful of readers will know that "Ozymandias" was the tyrannic pharaoh of Egypt who opposed Moses—which is as it should be: tyrants are forgotten, their works reduced to nothingness.

187 [Figure 101]

Francis Towne
Trees at Peamore Park
1804
Watercolour

$12\frac{1}{4} \times 8\frac{3}{4}$ (31.2 × 22.2)
Whitworth Art Gallery,
University of Manchester

[See p. 113.] Though he travelled extensively, and was based in London for much of his life, Towne came from Devonshire, and exhibited watercolours of the countryside around Exeter at various times from 1767 till 1815. Peamore Park, three miles south of the town, seems to have been a favourite subject of his from as early as 1775, the year in which he first exhibited at the Royal Academy. The catalogue for his one-man London exhibition of 1805 claims that all his landscapes were "drawn on the spot," but this late study of sunlight penetrating a wood seems especially to depend on an immediate personal response.

188 [Figure 115]

J. M. W. Turner
Figures on a Wet Shore
c. 1835–1840
Watercolour
$8\frac{3}{4} \times 11\frac{5}{8}$ (22.2 × 29.5)
Private collection

[See p. 126.] One of the swiftly coloured sheets, with no easily discernible subject, christened "colour beginnings" by A. J. Finberg. Technically, these are indeed "beginnings"— the laying in of broad bands of colour in preparation for finished compositions. Examples are found as early as 1800, and increase in number after about 1819–1820, when Turner's theoretical investigations of light and colour become more complex. In the last fifteen years of his life, it appears that these studies begin to serve as an end in themselves— as impressionistic, experimental works constructed out of pure colour. With its discernible figures and reflections on the wet sand, this study is more "finished" than most. A related work, in bodycolour on coarse buff paper, is in the same collection; see also Cat. no. 192.

189 [Figure 88]

J. M. W. Turner
Interior of Tintern Abbey
1794
Watercolour
$12\frac{5}{8} \times 9\frac{7}{8}$ (32.2 × 25.1)
The Trustees of the Victoria and Albert Museum, London

[See p. 97.] Probably the version of *Tintern Abbey* which Turner exhibited, along with four other watercolours, at the Royal Academy in 1794. An unfinished preparatory study (now in the British Museum), and several other views of the abbey, from different angles, date from the years 1794–1795. Turner's early training included spells with the architectural and topographical draughtsmen Thomas Malton and Edward Dayes. With its low viewpoint, this scene looking towards the east window owes much to the tradition in which they worked, and bears a close similarity to Girtin's drawings of the period [Cat. no. 177]. Unlike Girtin, however, Turner on this occasion is not making a copy. The composition is his own, based on a pencil sketch dating probably from a tour of South Wales and the Wye Valley in 1792.

190 [Figure 113]

J. M. W. Turner
Llanthoney Abbey
1834
Watercolour and bodycolour over pencil
$11\frac{5}{8} \times 16\frac{5}{8}$ (29.6 × 42.2)
Indianapolis Museum of Art: Bequest of Kurt F. Pantzer, Sr.

[See p. 126.] Drawn as the basis of an engraving (1836) for the series *Picturesque Views in England and Wales* (1827–1838). Turner made a tour in 1830 to gather materials, but many of the drawings used for the series were based on much earlier studies: this one draws directly on a 1794 watercolour in the British Museum, itself based on a sketch-book drawing of 1792. John Ruskin once owned *Llanthoney Abbey*, and cited it as a remarkable example of the artist returning to an "early impression" and setting "all his gained strength and new knowledge at work on the well-remembered shower of rain, that had fallen thirty years before, to do it better." Elsewhere, Ruskin praises Turner's treatment of the scene, with the shower "half exhausted, half passed by," the torrent flinging up "its hasty jets of springing spray to meet the returning light," and the marvellous shafts of sunlight, "hurrying, fitful, wind-woven sunlight, which glides through the thick leaves, and paces along the pale rocks like rain."

191 [Figure 116]

J. M. W. Turner
Stormy Sea Breaking on a Shore
c. 1840–1845
Oil
$17\frac{1}{2} \times 25$ (44.5 × 63.5)
Yale Center for British Art,
Paul Mellon Collection

One of a loosely grouped set of seascapes from the period *c.* 1830–1845. Works of this kind were probably made during Turner's visits, frequent throughout this period, to Margate, where he stayed with his mistress, Mrs. Booth. Like the Tate Gallery's *Waves Breaking on a Shore* of *c.* 1835, it is a pure seascape, with no obvious focus, and barely a trace of land. Turner is concerned with the combined effect of sea and sky in blustery weather; his interest centres on the cresting wave—its spray, caught in the wind, marked by rich impasto.

192 [Figure 91]

J. M. W. Turner
Yellow Sunset
c. 1845–1850
Watercolour
$7\frac{1}{8} \times 10\frac{3}{8}$ (18.1 × 26.4)
Private collection

[See p. 126.] A "colour beginning," like Cat. no. 188, dating from the last years of Turner's life, and capturing a generalized effect of sunset over water, rather than any specific subject or scene.

193

Cornelius Varley
Mountain Panorama in Wales
c. 1803
Pencil
$10\frac{3}{8} \times 18\frac{1}{4}$ (26.4 × 46.3)
Yale Center for British Art,
Paul Mellon Collection

Perhaps dating from Cornelius Varley's Welsh tour with Joshua Cristall in 1803. Inscribed top right, "sun over here / Clouds colour of drawing paper" and, along the bottom, "Fine weather wind S.E. Clouds coming towards me (all the morning) but dissolv'd into transparent atmosphere as fast as they come so that I had constant blue sky over head / sun shine yet the hills came forward darker." Varley's notations should be compared with those of Constable and Palmer [Cat. nos. 162 and 180]. A journal survives from his 1805 tour of Wales, recording his scientific concern with atmospheric effects in detailed, but also slightly mysterious and awestruck, terms.

194 [Figure 89]

Cornelius Varley
The River Wye
1803
Pencil and watercolour
$9\frac{1}{4} \times 14\frac{5}{16}$ (23.5 × 36.3)
Michael Pidgley Collection

From Cornelius Varley's 1803 Welsh tour [see Cat. no. 193], and dated 14 July—exactly five years after Wordsworth's visit to Tintern Abbey and the Wye Valley. Varley's 1803 tour produced remarkably accurate studies of shifting atmospheric effects.

195 [Figure 98]

John Varley
View from Polsden near Bookham in Surrey
1800
Watercolour
$16 \times 21\frac{1}{8}$ (40.5 × 53.5)
Laing Art Gallery, Newcastle upon Tyne,
Tyne and Wear Museums Service

Inscribed bottom right, "View from Polsden near Bookham in Surrey Made In Company with Dr. Monro by J. Varley Oct. 1800 Study from Nature." Like Turner and Girtin, John Varley learnt a great deal by copying drawings in the collection of Dr. Thomas Monro [see p. 109]. *View from Polsden* was made during a visit, recorded by Varley's brother Cornelius, to Monro's country home at Fetcham in Surrey. John Varley published a *Treatise* on landscape painting in 1816. It was for his later *Treatise on Zodiacal Physiognomy* that Blake drew his series of "Visionary Heads" (heads of the long dead, whom Varley at least believed that Blake could see) in 1819–1825.

196 [Figure 111]

Dorothy Wordsworth
Description of daffodils, *Journal*
15 April 1802
Holograph manuscript
The Wordsworth Trust

Notebook containing both Dorothy's *Grasmere Journal* for 1802, and the earliest drafts of *The Prelude* written by Wordsworth at Goslar in 1798. In a passage of exquisite prose Dorothy describes the wild daffodils by Ullswater that became in Feb. 1804 the subject of her brother's most famous poem [see pp. 121–122]:

> I never saw daffodils so beautiful; they grew among the mossy stones, about and about them. Some rested their heads upon these stones as on a pillow for weariness, and the rest tossed and reeled and danced, and seemed as if they verily laughed with the wind that blew upon them over the lake, they looked so gay, ever glancing, ever changing.

"She gave me eyes, she gave me ears," Wordsworth wrote in 1802; she gave him also a lifetime's support and some wonderful source-material.

197

William Wordsworth
Daffodils in *Letter to Sir George Beaumont*
February 1808, composed 1804–1807
Holograph manuscript
The Wordsworth Trust

Wordsworth defends himself against a friend of the Beaumonts who, on reading *Daffodils* (published the previous year), assumed the flowers to be reflected in the water:

> My language is precise, and therefore it would be false modesty to charge myself with blame.

> —Beneath the trees
> Ten thousand dancing in the *breeze*
> The *waves beside* them danced, but they
> Outdid the *sparkling waves* in glee.

> Can expression be more distinct? And let me ask your friend how it is possible for flowers to be *reflected* in water when there are *waves*. They may be reflected in still water—but the very object of my poem is the trouble or agitation both of the flowers and of the water.

No other part of *Daffodils* is preserved in the poet's hand.

198

William Wordsworth
Daffodils in *The Poems of William Wordsworth*
London, 1845
The Wordsworth Trust

Wordsworth's *Poems* in the single-volume edition of 1845, with additions and corrections in the hands of Mary, Dora, and Edward Quillinan (Dora's husband). Inscribed by the poet on the first end-paper after the advertisements, "Rydal Mount. / 17th Decr 1845 / William Wordsworth," and by his wife, "To Dora Quillinan / from her Mother / Mary Wordsworth / July 30th. 1846."

199

William Wordsworth
The Excursion, Being a Portion of the Recluse, a Poem, annotated by B. R. Haydon
London, 1814
The Wordsworth Collection,
Cornell University Library

First edition, published in quarto by Longman, of the longest Wordsworth poem to appear in his lifetime. This copy has annotations by Benjamin Robert Haydon [see Cat. no. 73]. The passage shown here, describing the way Nature speaks "to social reason's inner sense, / With inarticulate language," reworks earlier (and more powerful) lines written at Alfoxden, Feb. 1798:

> Why is it we feel
> So little for each other but for this,
> That we with Nature have no sympathy,
> Or with such things as have no power to hold
> Articulate language.

In the margin of Book Four, Haydon has written "Poor Keats used always to prefer this passage to all others." Opposite is a description of Apollo—"A beardless youth, who touched a golden lute, / And filled the illumined groves with ravishment"—which is drawn on in *Endymion*. Haydon was perhaps unaware that *To Autumn* [Cat. no. 285] was influenced by lines from Book Five:

> Yet where is glowing Summer's long rich day,
> That *ought* to follow faithfully expressed?
> And mellow Autumn, charged with bounteous fruit,
> Where is she imaged? in what favoured clime
> Her lavish pomp, and ripe magnificence?
> (v, 398–402)

200 [Figure 112]

William Wordsworth
"Glad Preamble" in *The Prelude*, Book One
1816–1819, composed late 1799
Manuscript, hand of John Carter
The Wordsworth Trust

[See pp. 123–124.] Lines 1–17 of the "Glad Preamble" (the opening of *The Prelude*), in the text of MS. C, transcribed by John Carter, Wordsworth's clerk, in 1816–1819. Originally composed as a free-standing effusion, on (or soon after) 18 Nov. 1799, the "Glad Preamble" expresses the poet's sense of liberation as he walks towards Grasmere, where he has recently discovered that Dove Cottage is to let. As in the Prospectus to *The Recluse*, written a month or two later [see Cat. no. 259], Miltonic echoes—"The earth is all before me..."—show a mood of exceptional confidence. Leaving behind him not an actual city, but a state of mind that he associates with city life—"That burthen of my own unnatural self"—he moves towards the "Paradise" of Grasmere. Here (he assumes), his life's work will be fulfilled in writing *The Recluse*.

201

William Wordsworth
Lines Written in Early Spring in *Lyrical Ballads, with Pastoral and Other Poems*
London, 1802
Courtesy of the Lilly Library,
Indiana University, Bloomington, Indiana

Lines Written in Early Spring was first published in the 1798 *Lyrical Ballads*, and gives expression to the acute perceptions that were shared with Coleridge and Dorothy at

Alfoxden. Stirred to a consciousness of his connections with Nature—"To her fair works did Nature link / The human soul that through me ran"—Wordsworth reflects, with Burns in mind, upon "Man's inhumanity to man":

> If this belief from heaven be sent,
> If such be Nature's holy plan,
> Have I not reason to lament
> What man has made of man?

202

William Wordsworth and Samuel Taylor Coleridge
Lyrical Ballads, with a Few Other Poems
1798
The Wordsworth Trust

The London second issue of *Lyrical Ballads* 1798, inscribed by Wordsworth to his nephew, John:

> This Volume was published in conjunction with Mr. Coleridge at Bristol, by our common Friend Mr. Cottle, and immediately before its publication Mr. Coleridge, my Sister and I went into Germany.
> The above memorandum is written to gratify my dear Nephew John Wordsworth. Rydal Mount March 6th 1844.
> Wm Wordsworth.

203

William Wordsworth
Nutting in *Lyrical Ballads,
with Pastoral and Other Poems*, Vol. 2
London, 1805
Courtesy of the Lilly Library,
Indiana University, Bloomington, Indiana

Copy in original boards of the fourth and last edition of *Lyrical Ballads*. *Nutting* was drafted along with the earliest passages of *The Prelude* at Goslar in 1798 [see Cat. no. 139] but not included in the two-part version of the poem completed a year later. In 1800 it was published separately in Volume 2 of *Lyrical Ballads*. Delighting in his spoils, the poet as a boy ravishes the hazel-bushes, gloating over their milk-white clusters of nuts—only to be overtaken by a "sense of pain":

> When from the bower I turned away,
> Exulting, rich beyond the wealth of kings,
> I felt a sense of pain when I beheld
> The silent trees and the intruding sky.
> (lines 48–51)

204

William Wordsworth
The Ruined Cottage, Part One
c. late May 1797
Holograph manuscript
The Wordsworth Trust

The making of Wordsworth's first great poem—read to Coleridge when he appeared suddenly at Racedown on 5 June 1797—is shown in drafts that capture the poet's original creative intensity:

> Many a passenger
> Has blest poor Margaret for her gentle looks

When she upheld the cool refreshment drawn
From that forsaken well. . . .
> She
> Is dead and in her grave—and this poor hut
> Stripped of its outward garb of household flowers,
> Of rose and jasmine, offers to the wind
> A cold bare wall whose top you see is tricked
> With weeds and the rank speargrass. . . .

205

William Wordsworth
A Night on Salisbury Plain
1794, composed 1793
Manuscript, hands of William
and Dorothy Wordsworth
The Wordsworth Trust

Transcribed *c*. May 1794 by Dorothy—and in part by the poet himself—in the *Windy Brow Notebook*. Stone Age life on Salisbury Plain and the horrors of human sacrifice (associated with the Druids, and assumed to have taken place at Stonehenge) form the backdrop of a poem about war and the barbarism of contemporary society:

> Hard is the life when naked and unhoused
> And wasted by the long day's fruitless pains
> The hungry savage, mid deep forests, roused
> By storms, lies down at night on unknown plains
> And lifts his head in fear while famished trains
> Of boars along the crashing forests prowl—
> And, heard in darkness as the rushing rains
> Put out his watch-fire, bears contending growl
> And round his fenceless bed gaunt wolves in armies howl. . . .

206 [Figure 85]

William Wordsworth
Tintern Abbey in *Lyrical Ballads,
with Other Poems: in Two Volumes*, Vol. 1
Philadelphia, 1802
The Wordsworth Trust

[See pp. 96–105.] *Lines Written a few miles above Tintern Abbey, on Revisiting the Banks of the Wye during a Tour; July 13, 1798*: the central poem of English Romanticism, in the first American edition of Wordsworth's poetry, reproduced from the London text of 1800, "Printed and sold by James Humphreys. At the N.W. Corner of Walnut and Dock-street." The copy is inscribed by Professor Henry Reed of the University of Pennsylvania, editor of *The Complete Poetical Works* (Philadelphia, 1837):

> To / Mr Wordsworth / this copy of the first American / Edition of his Poems—a proof of the / early appreciation of them in the / United States—is communicated by his Affectionate Friend (as / it is his privilege to call himself) / Henry Reed. / Philadelphia / April 1839.

207

William Wordsworth
Tintern Abbey
1825, composed 1798
Holograph manuscript
Harry Ransom Humanities Research Center,
The University of Texas at Austin,
The Manuscript Collection

A late fair copy of *Tintern Abbey*, lines 122–134, signed by Wordsworth and dated "27th Augst 1825 / Rydal Mount." Very little manuscript material has survived from *Lyrical Ballads* 1798, and this is the only known text of *Tintern Abbey* in the poet's hand.

208

William Wordsworth
To My Sister in *The Complete Poetical Works*
Philadelphia, Boston, and Pittsburgh, 1837
The Wordsworth Trust

[See p. 110.] Henry Reed's American edition of the *Complete Works*, showing *To My Sister*, first published in *Lyrical Ballads* 1798:

> Love, now an universal birth,
> From heart to heart is stealing—
> From earth to man, from man to earth—
> It is the hour of feeling.

Reed wrote to Wordsworth in 1836 that his motives as editor were to protect the works themselves from errors and abuse, and to associate his own name with "productions which had long been regarded . . . with the most affectionate veneration." The two men corresponded, but never met. When in 1854 Reed was at last able to visit Rydal Mount, he was drowned on the return voyage.

5:

"Unity Entire"

209

John White Abbott
Helm Crag and Grasmere Lake
1791
Watercolour
$7\frac{7}{16} \times 11\frac{1}{2}$ (18.8 × 29.4)
The Wordsworth Trust

Initialled and inscribed on reverse, "Hill Cragg [*sic*] on Grasmere Lake—JWA July 12. 1791." The drawing—from White Abbott's single tour of the Lake District—should be compared with that made by his master, Francis Towne, at the same spot, with a view of Helm Crag from the southern end of the lake [Cat. no. 242]. Abbott is concerned with the whole pyramid of Helm Crag, whereas Towne, by his use of pen over the blocks of watercolour, suggests the hill has a clear architectural structure. Both pictures use the church-tower to indicate the size and grandeur of Helm Crag, and perhaps (subliminally) a religious feeling for the landscape.

210

Thomas Barker
Forty Lithographic Impressions from Drawings

by Thomas Barker, Selected
from his Studies of Rustic Figures after Nature
Bath, 1813
Bound volume of lithographs
Yale Center for British Art,
Paul Mellon Collection

The artist became known as Barker of Bath after settling there in 1793. His freely drawn rustic scenes, influenced by Gainsborough, were highly popular, selling as prints, and also used as designs for pottery, china, and printed fabrics. Barker stresses in the Advertisement that his figures, shown going about their everyday tasks or relaxing after work, are "sketched from the life." The relatively new method of lithography will, he asserts, "maintain all the freedom and spirit [of] the original sketches." The subscription list to *Forty Lithographic Impressions* includes Sir George Beaumont, Sir Richard Colt Hoare, Benjamin West (President of the Royal Academy), and the poet William Lisle Bowles. The edition was limited to two hundred, at a cost of three guineas to subscribers, and five guineas to others.

211 [Figure 124]

William Blake
London from *Songs of Experience*
1794
Colour-printed relief etching
$7\frac{1}{2} \times 5\frac{1}{8}$ (19.2 × 13.1)
Private collection

[See p. 133.] Single sheet from the disbound copy H of *Songs of Innocence and Experience* [see Cat. nos. 49 and 50]. One of only three copies which are colour-printed rather than hand-coloured, and probably belonging to the period 1794–1796 when Blake was experimenting with colour printing in such works as *The Book of Urizen* and *Newton*. Scholars have seen the bearded figure on crutches as Urizen himself, succumbing to the "mind forged manacles" of his own rule. Yet the fact that he and the child who leads him are enveloped in light suggests that behind the door to which the child is pointing lies a way out of the horrors of contemporary society. It is the mind that gives power to Church and State, the agents of repression. Here, as elsewhere, the child possesses a clearer perception, and is able to point the imaginative way.

212

John Brown
Description of Keswick in Cumberland,
in a Letter from a Gentleman to his Friend
in London in *The London Chronicle*
24–26 April 1766
The Wordsworth Collection,
Cornell University Library

[See p. 147.] Brown's celebrated comparison of Derwentwater with Dovedale was made in a letter to Lord Lyttelton of 1753, and first published anonymously in 1766 in *The London Chronicle*:

> Were I to analyse the two places into their constituent principles, I should tell you that the full perfection of Keswick consists of three circumstances, beauty, horror, and immensity united; the second of which alone

is found in Dovedale . . . to give you a complete idea of these three perfections as they are joined in Keswick, would require the united powers of *Claude, Salvator,* and *Poussin.*

Probably the earliest prose description of Lake District scenery in "picturesque" terms, Brown's letter was published five times as an independent tract, first in Newcastle, 1767. His reference to Claude, Salvator Rosa, and Poussin establishes the pictures by these seventeenth-century painters working in Italy which tourists for the next fifty years would bring to mind when viewing English landscape.

213 [Figure 134]

Children's Employment Commission
First Report of the Commissioners. Mines.
Presented to both Houses of Parliament
by Command of Her Majesty.
London, 1842
Northwestern University Library

Parliamentary report which led in 1842 to the abolition of child labour in the mines. Detailed statistical analysis is combined with graphic illustrations—half-naked children, male and female, "hurrying" coal through narrow tunnels—and testimonials from the children themselves. Among many reformers to be influenced by the comprehensiveness and realism of the report was Engels, in his *Condition of the Working Class in England* (1845).

214

John Clare
Poems Descriptive of Rural Life and Scenery.
By John Clare, a Northamptonshire Peasant
London, 1820
Harry Ransom Humanities Research Center,
The University of Texas at Austin,
The Library Collection

[See pp. 154–156.] First edition of Clare's first published work, which brought him instant but patronizing success:

> The first publication of my poems brought many visitors to my house, out of mere curiosity, I expect—to know whether I really was the son of a thresher, and a labouring rustic, as had been stated—and when they found it really was so, they looked at each other as a matter of satisfied surprise, asked some gossipy questions, and on finding me a vulgar fellow that mimicked at no pretensions but spoke in the rough way of a thoroughbred clown, they soon turned to the door. . . .

The same wry humour is apparent as Clare describes the brief period when he was taken to the fashionable parties in London. On the subject of contemporary writers, many of whom he met, he is particularly shrewd: Lamb "is very fond of snuff, which seems to sharpen up his wit every time he dips his plentiful fingers into his large bronze-coloured box;" "Wordsworth has had little share of popularity, though he bids fair to be as great in one species of poetry as Byron was in another."

215 [Figure 149]

John Constable
The Glebe Farm
1827
Oil
$18\frac{1}{4} \times 23\frac{1}{2}$ (46.3 × 59.7)
Detroit Institute of Arts,
Gift of Mrs. Joseph B. Schlotman

[See p. 159.] Probably the first of three versions of *The Glebe Farm*, painted as a memorial to Bishop John Fisher, and loosely based on an oil sketch of *c.* 1810–1815. To Archdeacon John Fisher, the bishop's nephew (and his own closest friend), Constable wrote on 9 Sept. 1826: "My last landscape [is] a cottage scene, with the church of Langham—the poor bishop's first living. . . . It is one of my best—very rich in colour, and fresh and bright—and I have 'pacified it,' so that it gains much by that in tone and solemnity." The view is a composite, rendered peaceful ("pacified") by the insertion of the church-tower, which could not be seen from this viewpoint, and which gives the picture its title. The "glebe" was land farmed by the vicar; by implication the house next to the church is therefore both farm and vicarage.

216 [Figure 142]

John Constable
Helvellyn
1806
Watercolour
$7\frac{3}{4} \times 14\frac{1}{4}$ (19.4 × 36.2)
The Wordsworth Trust

[See pp. 151–152?] A product of Constable's 1806 tour of the Lake District (during which he first met Wordsworth), and one of the very few unfaded drawings of the period, in which his original blue and green washes may still be seen. An inked inscription in the artist's hand, "Helvellyn in Cumberland," shows through from the verso. On the evidence of other drawings made the same day, this study can be dated to 21 Sept.

On hearing of Constable's death, Wordsworth regretted that he had not stayed longer in the Lakes and left pictures of the region behind him; like most, Wordsworth was unaware of the large numbers of unsold works the artist had accumulated.

217 [Figure 141]

John Constable
Langdale Pikes from Elterwater
1806
Pencil on paper
$9\frac{5}{16} \times 14\frac{3}{4}$ (23.6 × 37.4)
The Wordsworth Trust

Dated bottom left in the artist's hand "4 Sept. 1806," with a label of Charles Golding Constable attached to the frame: "This view in the English lake district was taken by my father, John Constable R.A., when he was 30 years of age. The date on the sketch is in his own handwriting. C. G. Constable." If the date is correct, this is one of Constable's earliest treatments of mountain scenery. He avoids the conventional presentation of Langdale Pikes as the dominant feature, instead sculpting with

his pencil a wide panorama of uneven rocky ground.

218 [Figure 60]

John Constable
London from Hampstead, with a Double Rainbow
1831
Watercolour
7¾ × 12¼ (19.7 × 32.4)
The Trustees of the British Museum
NYPL only

[See pp. 65–66.] Probably taken, like other drawings of this period, from a back window of Constable's Hampstead home. He described the view in an 1827 letter to Fisher: "our little drawing room commands a view unequalled in Europe—from Westminster Abbey to Gravesend. The *dome* of *St. Paul's* in the air, realizes Michael Angelo's idea on seeing that of the Pantheon: 'I will build such a thing in the sky.'" Inscribed on the back, "between 6 & 7 oclock Evening June 1831," the picture dates from the time when Constable was studying rainbows. On this occasion he includes a double bow, which appears through a shaft of light descending diagonally across the sky. This unusual phenomenon was known at the time as a "sun pillar."

219 [Figure 148]

John Constable
Parham Mill, Gillingham
1826
Oil
19¾ × 23¾ (50.2 × 60.2)
Yale Center for British Art,
Paul Mellon Collection
IUAM and CHS only

[See pp. 158–159.] The latest of three versions of a watermill known as "Perne's" or "Parham's" mill, just outside Gillingham, the Dorsetshire village where Archdeacon Fisher held a living. Constable saw the mill first in 1820, sketched it when he returned to Gillingham in 1823, and made Fisher a replica of his study in the following year. It seems that Fisher's picture was seen by a Mrs. Hand, who in 1825 commissioned this final version. On 14 Jan. 1826 Constable described it as "one of my best pictures . . . very rich and pleasing." Parham Mill was burned down in 1825. Fisher reports that "A huge misshapen, new, bright, brick, modern, improved, patent monster is starting up in its stead." Constable replies sadly: "I am vexed at the fate of the poor old mill. There will soon be an end to the picturesque in the kingdom."

220 [Figure 146]

John Constable
The Vale of Dedham
1814
Oil
15½ × 22 (39.4 × 55.9)
Leeds City Art Galleries

Inscribed "5 Sepr 1814." Probably the first study for *View of Dedham*, commissioned by Thomas Fitzhugh as a wedding present for his future wife. This sketch was followed by further small studies in pencil and oil, many made out of doors, and the finished picture was "almost done" by 25 Oct. The scene shows a wide panorama of the Stour Valley, with the church as a focal point in the distance; as a child, Constable had walked across this valley on his way to school in Dedham. The inclusion of the prominent "dunghill" in the foreground is remarkable, given the relatively formal nature of the commission.

Fitzhugh's bride-to-be, Philadelphia Godfrey, was known to the Constables; in a letter to his own future wife, Maria Bicknell, the artist described the painting as "a present for Miss. G. to contemplate in London."

221 [Figure 127]

John Constable
*Waterloo Bridge, from the Left Bank
of the Thames*
1819–1824
Oil on paper laid on canvas
8½ × 12½ (21.5 × 31.7)
Royal Academy of Arts, London

[See p. 137.] Constable may have watched the state opening of Waterloo Bridge on 18 June 1817, which is central to later versions of his picture; but this tiny oil sketch, begun apparently in 1819, contains no hint of the ceremony. Endless pains were expended on the composition. In May 1822, Maria tells her husband that Bishop Fisher "was quite in raptures with your *Waterloo*, sat down on the floor . . . said it was equal to Canaletto." In Jan. 1824 Constable himself is delighted by his progress: "I have just completed my little *Waterloo Bridge*. It looks very well indeed." Six months later he is in despair: "I have no inclination to pursue my Waterloo . . . I am impressed with an idea that it will ruin me." It has proved impossible to transfer the vivacity and drama of the small original composition onto the full-sized canvas of an exhibition picture [see Cat. no. 222].

222 [Figure 128]

John Constable
Waterloo Bridge from Whitehall Stairs
c. 1829
Oil
23 × 38¼ (58.5 × 97)
Private collection

[See p. 137.] Large oil sketch from the Waterloo Bridge series, incorporating the Prince Regent's opening of the bridge in 1817, central to Constable's Academy picture of 1832. In Oct. 1825 Thomas Stothard had suggested "a very capital alteration" to the original composition [see Cat. no. 221], which would, in Constable's words, "increase its consequence, and do everything for it." The new idea was presumably that order and impressiveness could be given to the scene by associating it with the pageantry of the opening. The viewpoint is now moved a little down river to include Pembroke House, from which the Regent had embarked. The original patterning of small boats is replaced by the royal barge and attendant flotilla.

223 [Figure 132]

John Sell Cotman
Bedlam Furnace
c. 1802–1803
Watercolour
10¼ × 18⅜ (26.0 × 48.6)
Private collection

One of the earliest sites of the Industrial Revolution, at Ironbridge Gorge on the River Severn. Cotman probably drew the scene in the winter of 1802–1803, on the basis of a sketch made the previous summer on his way to (or from) Wales in the company of Sandby's godson, Paul Sandby Munn. Munn exhibited a watercolour of the site in 1803, entitled *Bedlam Furnace*, and the name has been given also to Cotman's untitled picture. In contrast to the grandeur of the natural scenes resulting from the Welsh tours of 1800 and 1802 (the basis of many later drawings, though Cotman never returned to the mountains), we have in *Bedlam Furnace* the paradox of industrialization: a tortured and desolate landscape invested with atmospheric power by flames and smoke from the furnaces by which it is ravaged.

224 [Figure 147]

John Sell Cotman
Cader Idris from Barmouth Sands
1804
Pencil and watercolour
14⁷⁄₁₆ × 24¼ (36.6 × 54)
The Provost & Fellows of Eton College
IUAM and CHS only

Probably one of seven works exhibited by Cotman at the Royal Academy in 1804. The Welsh tour of 1800 took him through Barmouth some time between 18 and 30 July, and several sketches of the estuary survive; *Cader Idris* draws on one now in the Castle Museum, Norwich, signed and dated 1801. Cotman has enlarged the scene, adding the cowherd on the left and the fishermen in the right foreground.

225 [Figure 136]

John Sell Cotman
Mousehold Heath
1810
Pencil and watercolour
11¾ × 17⅛ (29.9 × 43.6)
The Trustees of the British Museum
NYPL only

An area of common land outside Norwich, deeply incised by tracks which in Cotman's drawing converge, in the manner of Girtin, upon a focal point on the horizon. Foreground interest is provided by the highly coloured clothing of the shepherd, and the dialogue that is taking place between his dog and a pair of donkeys. Cotman has gone to unusual pains to mark each of the sprinkled sheep with a clear patch of red. The drawing was intended for translation into oil and, like several from this period, shows him moving towards richer and more varied use of the palette. There is a preparatory sketch in the British Museum, and two related watercolours are preserved at the Castle Museum, Norwich.

After revisiting the scene some thirty years later, Cotman described his delight in having "galloped over Mousehold Heath . . . through a heavy hail-storm," and exclaimed, "Oh! rare and beautiful Norfolk."

226 [Figure 182]

John Sell Cotman
Road to Capel Curig, North Wales
1807
Pencil and watercolour
$13\frac{3}{8} \times 17\frac{3}{8}$ (34 × 44.1)
The Trustees of the Victoria and Albert Museum, London

One of several impressive Welsh scenes drawn by Cotman the year after he was rejected by the newly formed Society of Painters in Watercolour in London, and returned to be a drawing master in Norwich. No sketch is preserved, but Cotman—except perhaps in some of the Greta drawings—worked up his watercolours indoors from pencil outlines. The stylistic developments of the Greta period [see Cat. nos. 167 and 169] are evident in *Capel Curig* in the clean outlines and the treatment of shadows falling on the rocks.

227

George Crabbe
The Borough: a Poem, in Twenty-four Letters
London, 1810
Private collection

[See p. 154.] Letter XXII, Crabbe's masterpiece *Peter Grimes*, is the only portrait of a tortured imagination that can be placed beside the *Ancient Mariner*, and it is not irrelevant that like Coleridge (and De Quincey) Crabbe was an opium-eater. Guilty of consistent cruelty, and of murdering at least two of his three apprentices, the East Anglian fisherman Grimes might seem to deserve little sympathy. Yet Crabbe, who normally works from the detached Augustan viewpoint of the social observer and satirist, has succeeded to an extraordinary degree in getting into his character's mind. His moods are evoked in descriptions of the landscape that have astonishing power:

> There anchoring, Peter chose from man to hide,
> There hang his head, and view the lazy tide
> In its hot slimy channel slowly glide;
> Where the small eels that left the deeper way
> For the warm shore, within the shallows play;
> Where gaping mussels, left upon the mud,
> Slope their slow passage to the fallen flood.
> Here dull and hopeless he'd lie down and trace
> How sidelong crabs had scrawled their crooked race. . . .

228 [Figure 145]

Peter De Wint
The Hayfield
n.d.
Watercolour
$9 \times 26\frac{1}{8}$ (22.8 × 66.4)
The Provost & Fellows of Eton College

Typical of De Wint in being neither dated nor signed, *The Hayfield* shows his unrivalled ability to catch the life of the English countryside. John Clare [see Cat. no. 214], who was closer to the soil than any of his Romantic contemporaries, commented that in De Wint we "see natural objects not placed for effect and set off by the dictates of the painter's fancy but as they are, just as Nature placed them. . . ." "Nothing," he once wrote to the artist, "would appear so valuable to me as one of those rough sketches, taken in the fields, that breathe the living freshness of open air and sunshine."

229 [Figure 133]

Peter De Wint
View of a Harbour
c. 1830
Watercolour
$10 \times 25\frac{1}{2}$ (25.3 × 64.7)
Laing Art Gallery, Tyne and Wear Museums Service, Newcastle upon Tyne

De Wint was one of the most prolific watercolourists of the age, the brother-in-law of William Hilton [see Cat. no. 75], and an acquaintance of Keats; he contributed funds to help the dying poet travel to Italy. The little-known *View of a Harbour* (which has been identified as Whitehaven) is a remarkable blending of a semi-industrial scene into a landscape of pristine beauty. The dappled colouring of the land in the foreground is echoed in the deeper, blended shades of the sails and masts in the middle distance.

230 [frontispiece]

Henry Edridge
William Wordsworth
c. May 1806
Pencil and watercolour
$6\frac{1}{16} \times 4\frac{15}{16}$ (15.4 × 12.6)
The Wordsworth Trust

Probably drawn in May 1806, while Wordsworth was a guest of Sir George Beaumont in London. As a society painter, Edridge has tidied up Wordsworth's strong but inelegant features, producing the poet who would have been at home in the drawing-rooms of Jane Austen. It was the nose—rendered acceptably Roman by Haydon and Chantrey [Cat. nos. 284 and 12]—that had chiefly to be remodelled.

231

Joseph Farington
Grasmere in *Album, Lake District Views Illustrating Gray's Tour*
c. 1798
Bound volume of watercolours
$20\frac{1}{4} \times 22$ (49.6 × 55.9)
Yale Center for British Art, Paul Mellon Collection

[See p. 150.] Watercolour view of Grasmere—Gray's "little unsuspected paradise"—resembling a colour version of the engraving of 1784. Farington made his first visit to the Lakes with Beaumont and Hearne [see Cat. no. 178] in 1777, two years after Gray's *Journal* appeared, and he published his engraved *Views of the Lakes* in 1783–1787; here, almost a quarter of a century later, he uses the *Journal* as the basis for a new project. For some reason his illustrations to Gray's tour were never produced. The new series of engravings published in 1816 are uncoloured and unrelated.

232 [Figure 138]

Thomas Gainsborough
Langdale Pikes
1783
Pencil and grey wash
$10\frac{1}{2} \times 16\frac{1}{2}$ (26.7 × 42)
The Wordsworth Trust

One of three known drawings from Gainsborough's single tour of the Lakes (Aug. 1783), all of them drawn very freely with the brush, and clearly made on the spot. *Langdale Pikes* is an untypical attempt at topographical accuracy; as Constable noted of another Gainsborough work, "With particulars he had nothing to do, his object was to deliver a fine sentiment. . . ."

233 [Figure 126]

Thomas Girtin
The Thames from Queenhithe to London Bridge
1801
Watercolour
$9\frac{1}{2} \times 21\frac{1}{4}$ (24 × 53.9)
The Trustees of the British Museum
NYPL only

[See p. 136.] One of the six watercolour studies made by Girtin while he was engaged on his *Eidometropolis*, or panorama of London. The *Eidometropolis*, which does not survive, was on show at the time of Girtin's death in 1802, and, to judge from Book Seven of *The Prelude*, may well have been among the sights of the city to which Lamb took the Wordsworths in September. It was painted in tempera (or perhaps oils), from the vantage-point of Blackfriars Bridge, and completely encircled the viewer. One estimate puts it at 9 ft high and 216 ft in circumference (about 3 and 66 metres). It seems to have been sold to a Russian nobleman in 1825.

This scene shows the north bank of the river, from the churches of St. Augustine's and St. Benet's on the left, to the Monument and the Tower of London on the right. Girtin's early architectural training is evident, as is the influence of Canaletto's Thames views. The *Monthly Magazine* remarked of the finished panorama that the artist had "paid particular attention to representing objects of the hues which they appear in nature," as in the river, where "the water is pellucid and, contrary to what we have seen in pictures of this description, varies in colour."

234

Thomas Gray
The Poems of Mr. Gray. To which are Prefixed Memoirs of His Life and Writings By W. Mason M.A.
York, 1775
The Provost & Fellows of Eton College

[See pp. 92 and 150.] First edition (there were two more in the same year) including first publication of Gray's Lake District *Journal*. The "Memoirs" consist mainly of the poet's letters, divided into sections, and the *Journal* (presented as Section Five, Letter IV) in fact consists of the different letters of Gray's 1769 tour printed "in continuation." From the first the *Journal* had a major influence on visitors to the Lakes, but from 1780 this was greatly increased by its republication as an appendix in West's immensely popular *Guide*. Wordsworth's own *Guide* [Cat. no. 251] was to quote Gray's celebration of Grasmere:

> Not a single red tile, no flaring gentleman's house or garden-walls, break in upon the repose of this little unsuspected paradise; but all is peace, rusticity, and happy poverty, in its neatest and most becoming attire.

235 [Figure 137]

Thomas Hearne
View from Skiddaw over Derwentwater
c. 1777
Watercolour and pencil
7¾ × 10⅝ (18.8 × 27)
Yale Center for British Art,
Paul Mellon Collection

Aerial view of Derwentwater, from high on the shoulder of Skiddaw, sketched on the same tour of 1777 that produced *Sir George Beaumont and Joseph Farington sketching a waterfall* [Cat. no. 178]. As well as producing three versions of the *View from Skiddaw*, Hearne made a more ambitious attempt to capture the whole natural amphitheatre of the lake in panorama. The resulting work (twenty feet (six metres) long, according to Robert Southey) was to be enlarged to decorate a circular room which Beaumont intended to build at Coleorton [see Cat. no. 63]. The work is now lost, and it seems that no enlargement was made.

236 [Figure 123]

Robert Hills
Skelwith Force
1803
Watercolour on paper
14⅝ × 10½ (37.1 × 26.7)
Birmingham Museum and Art Gallery

[See pp. 150–152.] Hills travelled to the lakes with John Glover, whose delicate but sentimental treatments of the area enjoyed considerable success. Hills' broad flat washes are in contrast to his companion's finicky use of the divided brush, and in place of Glover's Arcadian motifs he is concerned with optical effects like those of Cornelius Varley [see Cat. nos. 193–194]. In *Skelwith Force* Hills rejects the conventional technique of moving from dark to light as the picture recedes. As a result the distant Langdale Pikes loom closer, and a dramatic setting is created for the brilliant, turbulent water. Hills' treatment of the landscape should be compared with those of Towne and Constable [Cat. nos. 242 and 217].

237 [Figure 36]

Samuel Palmer
Lane and Shed, Shoreham, Kent
1828
Watercolour
11 × 18 (27.8 × 45)
The Trustees of the Victoria and Albert Museum, London

Related to two other watercolours of 1828–1829, *A Cow Lodge with a Mossy Roof* and *A Barn with a Mossy Roof*, which show Palmer delighting in the mosses and lichens that grow on thatch—examples of what he called, in a letter of Dec. 1828, "the thousand repetitions of little forms, which are part of [Nature's] own genuine perfection." The oak-trees of Lullingstone Park, also drawn in 1828, reveal the same imaginative concern with textural detail.

238 [Figure 144]

William Henry Pyne
Etchings of Rustic Figures for the Embellishment of Landscape
London, 1814–1815
Bound volume of etchings
9¼ × 7¼ (23.4 × 18.4)
Wallach Collection of Art, Prints, and Photographs, The New York Public Library

Intended as a teaching manual for children of the "superior class of society." While there was no shortage of guides to landscape painting, the "study of figures for the embellishment of these scenes [had] not been followed with equal ardour." Pyne's are generalized portraits; he has not attempted "elegant form," but has tried "to sketch the prominent character and habits of the rustic." His figures are shown individually, with up to twenty-five on a plate, or in groups going about their work.

239

William Henry Pyne
Plate 9 of *Etchings of Rustic Figures for the Embellishment of Landscape*
1814
Copper plate
16 × 9¾ (40.6 × 24.8)
Yale Center for British Art,
Paul Mellon Collection

The original copper plate for one of the *Rustic Figures*, revealing Pyne's comic talents, as pigs overturn a barrow of apples.

240 [Figure 129]

**Thomas Rowlandson
and Augustus Charles Pugin**
Bartholomew Fair
1808
Coloured engraving
9⅜ × 11½ (23.8 × 29)
The Wordsworth Trust

[See p. 139.] This joint work plays off the humour and liveliness of Rowlandson's figures—spread across the foreground—against the formal structures of the buildings,

supplied by the architectural draughtsman Augustus Pugin. The revels are at their height in the oldest of London street-fairs, celebrated by Ben Jonson in his play of 1614, and by Wordsworth in *The Prelude*, Book Seven.

241 [Figure 67]

Francis Towne
Elterwater, Westmorland
1786
Pen, brown ink, and watercolour
18⁵⁄₁₆ × 6⅛ (47.7 × 15.5)
The Wordsworth Trust

Two joined sheets, inscribed, "Elter Water August 12th 1786 / light from the left hand / F. Towne," and numbered '19' on the reverse. Interestingly, the inscription and signature are repeated on the back of the original mount, with the addition "London / Leicester Square / 1790;" apparently it was not for four years that Towne coloured his original sketch-book leaves, thus creating the final drawing. The Lake District tour of 1786 produced some of the greatest of Towne's English drawings, and showed the lessons he had learned from handling Alpine landscape in 1781–1782 [see Cat. no. 290]. Towne's visit was probably stimulated by William Gilpin's *Observations on the Mountains and Lakes of Cumberland and Westmorland* (1786), for which John "Warwick" Smith, Towne's travelling companion in the Alps, had prepared the aquatints.

242 [Figure 140]

Francis Towne
Grasmere from the Rydal Road
c. 1787
Pen, brown ink, and watercolour
8⁵⁄₁₆ × 13⅜ (21.2 × 34)
Birmingham Museum and Art Gallery

Inscribed in pencil on reverse, "Lake at Grasmere light from the left hand from 12 till 2 o'clock." Another finished watercolour based on a sketch from Towne's 1786 Lake District tour [see Cat. no. 241], taking in the lake and the village church, with the triangular forms of Helm Crag and Silver How forming a "V" against the level high fells in the background. Towne uses progressively lighter bands of wash to define foreground, middleground, and distance [see also Cat. no. 209].

243 [Figure 139]

Francis Towne
A View from Rydal Park
c. 1786
Watercolour
14¹⁵⁄₁₆ × 10⁹⁄₁₆ (37.9 × 26.8)
Leeds City Art Galleries

Inscribed "Light from the right hand after noon," this does not belong to the numbered sequences resulting from Towne's 1786 tour [see Cat. no. 241]. These unnumbered studies may be commissions, but there were forty-six Lake District views in Towne's London show of 1805, as well as sixty-three based on the still earlier Italian tour. How long it would have taken the artist to stockpile these we cannot

know, but many drawings that are dated to the early tours must in fact belong to the early 1800s.

244 [Figure 130]

J. M. W. Turner
Herriot's Hospital
1816
Watercolour and bodycolour
Private collection, on loan to Manchester City Art Galleries

A bustling street-market scene, with the high terraced houses forming a vista for Edinburgh Castle in the background, signed and dated "JMW Turner RA 1816." *Herriot's Hospital* was engraved in 1822 for *The Provincial Antiquities of Scotland*: Sir Walter Scott, who wrote the text, wanted his friend John Thompson to do all the designs, and resented what he saw as Turner's mercenary attitude. He nevertheless accepted a gift of eight of Turner's drawings for the book (including this one) from his publisher, Robert Cadell.

245 [Figure 150]

J. M. W. Turner
Ullswater
c. 1833–1834
Watercolour
13 × 16¾ (33 × 42.6)
Private collection

A late study, but probably drawing on sketchbooks from Turner's 1797 tour of the Lakes. Compare *Llanthoney Abbey*, 1834 [Cat. no. 190], where Ruskin draws attention to the fact that Turner has gone back to a sketch of 1794.

246

Thomas West
A Guide to the Lakes, in Cumberland, Westmorland, and Lancashire
London and Kendal, 1780
King's College, Cambridge, Bicknell Collection

The second edition, revised and enlarged after the death of West by William Cockin of Burton-in-Kendal. Cockin includes a new frontispiece —an engraving of Grasmere after J. Feary— and eleven Addenda, selected as "the principal detached pieces, which have appeared on the subject of the Lakes." These include *Dr. Brown's Letter, Describing the Vale and Lake of Keswick* [Cat. no. 212], *Extract from Dr. Dalton's Descriptive Poem, Enumerating the Beauties of the Lake of Keswick*, Gray's *Journal* [Cat. no. 234], and *Ode to the Sun, by Mr. Cumberland, Published in 1776*.

247

Dorothy Wordsworth
Description of the Leech Gatherer, *Journal*
3 Oct. 1800
Manuscript
The Wordsworth Trust

[See p. 158.] Dorothy's *Journal* account of a meeting with the Leech Gatherer in Oct. 1800

which in May 1802 became the source of Wordsworth's famous poem. In composing *The Leech Gatherer* [Cat. no. 255], published in 1807 as *Resolution and Independence*, Wordsworth moved progressively away from the facts and pathos of the old man's life—his wife and nine of his ten children were dead; he had been run over by a cart—towards something closer to myth:

> I seemed to see him pace
> About the weary moors continually,
> Wandering about alone and silently. . . .

Wordsworth's poetry offers us a strange imaginative vision; Dorothy's prose tells us what it had been like to hear the old beggar's sad yet uncomplaining voice:

> He had had a wife—"and a good woman, and it pleased God to bless us with ten children"—all these were dead but one, of whom he had not heard for many years, a sailor. His trade was to gather leeches, but now leeches are scarce and he had not strength for it. He lived by begging. . . .

248

William Wordsworth
Letter to Coleridge
24–27 Dec. 1799
Holograph manuscript
The Wordsworth Trust

Letter to Coleridge, with postscript from Dorothy, preserving the Wordsworths' first impressions of Dove Cottage [see Cat. no. 253]:

> We arrived here last Friday, and have now been four days in our new abode. . . . D. is much pleased with the house and *appurtenances*, the orchard especially; in imagination she has already built a seat with a summer shed on the highest platform. . . .

249 [Figure 125]

William Wordsworth
Composed upon Westminster Bridge.
Sept. 3, 1802
1807, composed 1802
Manuscript, hand of Sara Hutchinson
The British Library Board, Add. MS. 47864, fol. 30v

[See p. 136.] Printer's copy for *Poems, in Two Volumes*, prepared by Sara Hutchinson and Dorothy and Mary Wordsworth, and corrected (and misdated) by William, between November 1806 and March 1807. *Westminster Bridge* was written in September 1802 during a stay in London, on the way back from visiting Annette Vallon and Wordsworth's daughter Caroline in France [see Cat. no. 101], and it captures the city in a rare moment of tranquillity:

> This city now doth like a garment wear
> The beauty of the morning, silent, bare. . . .

Dorothy's *Journal* shows the morning in question to have been 31 July: "the sun shone so brightly, with such a pure light, that there was even something like the purity of one of Nature's own grand spectacles."

250

William Wordsworth
Description of a Beggar
1797
Manuscript
The Pierpont Morgan Library, New York

[See p. 153.] Wordsworth's early drafts of *The Old Cumberland Beggar*, completed at Alfoxden in Feb. 1798, and published in *Lyrical Ballads*, 1800. On the reverse is a short passage which anticipates the opening of the 1799 *Prelude* [Cat. no. 200] in its subject, and *Tintern Abbey* in its language:

> Yet once again do I behold the forms
> Of these huge mountains, and yet once again
> Standing beneath these elms I hear thy voice,
> Beloved Derwent, that peculiar voice
> Heard in the stillness of the evening air—
> Half-heard and half-created.

251

William Wordsworth
A Description of the Scenery of the Lakes in the North of England
London, 1823
The Wordsworth Trust

[See p. 150.] The "Fourth Edition, Now First Published Separately with Additions and Illustrative Remarks upon the Scenery of the Alps by William Wordsworth." A revised version of the first separate edition of Wordsworth's *Guide*, written originally as an anonymous Introduction to the Rev. Joseph Wilkinson's *Select Views in Cumberland, Westmorland, and Lancashire* in 1810.

Wordsworth published a revised text under his own name in *The Duddon Sonnets*, 1820, and made further revisions for the 1822 pocket guide, which included a folding map. The 500 copies were soon sold out, and this edition, with more alterations, was published in 1823. The fifth edition of 1835 was the last to be revised by Wordsworth, and was given the now customary title: *A Guide through the District of the Lakes in the North of England*.

Wordsworth's *Guide* makes the conservation and landscaping of the Lake District a central issue. It is here that he first expresses the idea which helped establish the National Park movement, deeming the Lakes "a sort of national property, in which every man has a right and interest who has an eye to perceive and a heart to enjoy."

252

William Wordsworth
"First entry into London" in *The Prelude*, Book Eight
1839, composed 1804
Manuscript, hand of Dora Wordsworth
The Wordsworth Trust

Like Cat. no. 308 ("Mont Blanc"), a single sheet from the final manuscript of *The Prelude*, used as the printer's copy in 1850. As in "Mont Blanc," Wordsworth is concerned to stress the supremacy of the human mind, but so far from being disappointed, as he had been by the

mountain, he is overwhelmed by the "weight and power" that London exerts upon his imagination:

> how strange
> That aught external to the living mind
> Should have such mighty sway!
>
> (1850, viii, 549–551)

253

William Wordsworth
Home at Grasmere
1806, composed 1800
Holograph manuscript
The Wordsworth Trust

[See pp. 150 and 156–157.] Holograph fair copy of central lines in *Home at Grasmere*, preserved in a small home-made notebook belonging to summer 1806, and containing the earliest surviving text of the poem. Writing in March 1800, more than a year after settling in Dove Cottage, Wordsworth evokes the qualities that make Grasmere not just a source of personal contentment, but—as he hopes—an example of happiness that will one day be shared by "all the vales of earth and all mankind":

> 'Tis (but I cannot name it) 'tis the sense
> Of majesty and beauty and repose,
> A blended holiness of earth and sky,
> Something that makes this individual spot,
> This small abiding-place of many men,
> A termination and a last retreat,
> A centre, come from whereso'er you will,
> A whole without dependence or defect,
> Made for itself and happy in itself—
> Perfect contentment, unity entire.

254

William Wordsworth
Kendal and Windermere Railway
Kendal, 1845
The Wordsworth Trust

Proof-sheets of Wordsworth's first letter to the *Morning Post*, 9 Dec. 1844, as reissued by R. Branthwaite and Son, Kendal, 23 Jan. 1845, with corrections in the poet's hand, and a long additional note in that of his son-in-law, Edward Quillinan (D.C. MS. 137). Wordsworth feared not only that the coming of the railway to Windermere would bring tourists in great numbers to the Lakes, but that Windermere would soon be linked by rail—as (mercifully) it never has been—through Ambleside, Rydal, Grasmere, and up to Keswick. His son John's parsonage at Brigham had recently been demolished (and rebuilt) in the making of the Cockermouth-Workington extension, and a Windermere-Keswick link would have passed very close to Rydal Mount. It is difficult not to feel sympathy with the aging poet's agitation. He was, however, very properly (though anonymously) put in his place by the Board of Trade recommendation of 16 April 1845:

> an argument which goes to deprive the artisan of the offered means of occasionally changing his narrow abode, his crowded streets, his wearisome task and unwholesome toil, for the fresh air, and the healthy holiday which sends him back to his work refreshed and invigorated—simply that individuals . . . may retain to themselves the

exclusive enjoyment of scenes which should be open alike to all . . . appears to us to be an argument wholly untenable. . . .

Parliamentary approval was received on 30 June, and the link from Kendal to Windermere opened on 21 April 1847.

255

William Wordsworth
The Leech Gatherer
1802
Manuscript, hand of Sara Hutchinson
The Wordsworth Trust

[See p. 158.] Manuscript notebook—"Sara's Poets"—containing, at one end, holograph fair copies of Coleridge's 1802 poetry, and, at the other, Sara's copies of Wordsworth. *The Leech Gatherer* [see Cat. no. 247], later entitled *Resolution and Independence*, is here preserved in its original version, the latter part of which Sara, in a letter of early June 1802 (now lost), was bold enough to criticize. Wordsworth's answer was first to reproach her with lack of sympathy—"You speak of his speech as tedious: everything is tedious when one does not read with the feelings of the author"—and then to remodel his poem. In the process he created one of his greatest and most characteristic works.

256

William Wordsworth
London, 1802: Milton, thou shouldst be living at this hour
1838, composed Sept. 1802
Manuscript
The Houghton Library, Harvard University

[See p. 145.] One of many examples of Wordsworth in his later years copying out a famous poem as the souvenir of a visit, with his authentication at the bottom of the page: "Transcribed / at / Rydal Mount / Febry 28th. 1838." Published in 1807 under the title *London, 1802*, the poem laments the condition of English society—"a fen / Of stagnant waters"—and invokes Milton to "raise us up— / return to us again / And give us manners, virtue, freedom, power."

257

William Wordsworth
Preface to *Lyrical Ballads,*
with Pastoral and Other Poems, Vol. 1
London, 1802
The Wordsworth Trust

The third edition, in two volumes, once belonging to Wordsworth's late nineteenth-century editor, William Knight. The 1798 *Lyrical Ballads* contained a short "Advertisement" warning that "The majority of the following poems are to be considered as experiments" employing "the language of conversation of the middle and lower classes of society." The Preface for the 1800 edition (revised in 1802) contained a fuller statement of intent:

> The principal object, then, which I proposed to myself in these poems was to choose incidents and situations from common life,

and to relate or describe them, throughout, as far as was possible, in a selection of language really used by men. . . .

258 [Figure 143]

William Wordsworth
Interleaved copy of Coleridge's *Poems* 1796, containing drafts of *Michael*
c. Nov. 1800
Holograph manuscript
The Wordsworth Trust

[See pp. 152–153.] Drafts of *Michael* in an interleaved copy of Coleridge's *Poems* which Wordsworth was using in 1800 as a rough notebook, and which already contained work on *Home at Grasmere*. The love of the shepherd Michael for his son illustrates the point made in Wordsworth's letter to Charles James Fox of 14 Jan. 1801, that "men who do not wear fine clothes can feel deeply":

> Exceeding was the love he bore to him,
> His heart and his heart's joy! For oftentimes
> Old Michael, while he was a babe in arms,
> Had done him female service—not alone
> For dalliance and delight, as is the use
> Of fathers, but full oft with patient mind
> Enforced to acts of love—and he had rocked
> His cradle with a woman's gentle hand.

259

William Wordsworth
Prospectus to *The Recluse* in *The Excursion*
1806, composed 1800
Holograph manuscript
The Wordsworth Trust

[See pp. 145–146.] Fair copy, made in summer 1806, of lines composed c. Jan. 1800, and published in the Preface to *The Excursion* (1814) as the "Prospectus" to *The Recluse*. In its original position as the opening section of *Home at Grasmere*—Book One of the never-completed *Recluse*—the Prospectus expresses the unqualified optimism with which Wordsworth, newly arrived at Dove Cottage, confronted his task. Use of a Miltonic style and of direct allusion ("fit audience let me find, though few") serves to assert Wordsworth's confidence that the humanist *Recluse* will supersede *Paradise Lost*, as Milton's Christian epic had supplanted Virgil and Homer:

> On Man, on Nature, and on human life
> Thinking in solitude, from time to time
> I find sweet passions traversing my soul
> Like music: unto these, where'er I may,
> I would give utterance in numerous verse.
> Of truth, of grandeur, beauty, love, and hope;
> Of joy in various commonalty spread;
> Of the individual mind that keeps its own
> Inviolate retirement, and consists
> With being limitless, the one great life;
> I sing; fit audience let me find, though few!

260

William Wordsworth
She Dwelt among the Untrodden Ways
1828, composed 1798
Holograph manuscript
8½ × 7 (21.6 × 17.8)
Princeton University Library

Wordsworth's haunting Lucy Poem written out in 1828, doubtless as a souvenir. The *Collected Poems* of 1815 had been republished in 1820 and 1827; by this date the early hostility of the critics had been forgotten, and his reputation was at its height.

261

William Wordsworth
The Solitary Reaper in a letter from Dorothy Wordsworth to Lady Beaumont
7 Nov. 1805
Manuscript, hand of Dorothy Wordsworth
The Wordsworth Trust

[See pp. 159–160.] Earliest extant copy of *The Solitary Reaper*, probably composed two days before. The most plangent of all Wordsworth's lyrics is inspired—as Dorothy points out—not by personal experience, but by the manuscript *Journal* of their Quaker friend Thomas Wilkinson:

> Passed a female who was reaping alone: she sung in Erse as she bended over her sickle; the sweetest human voice I ever heard. Her strains were tenderly melancholy, and felt delicious, long after they were heard no more.

The passage was copied by Wordsworth into his Commonplace Book in 1805 (but delicately omitted by Wilkinson when he published his *Tour to the British Mountains* in 1824). The final clause—already perfect in its cadence—was to pass almost unchanged into the poem's concluding lines:

> Whate'er the theme, the maiden sang
> As if her song could have no ending;
> I saw her singing at her work,
> And o'er the sickle bending;
> I listened, motionless and still;
> And as I mounted up the hill,
> The music in my heart I bore
> Long after it was heard no more.

262

William Wordsworth
The World Is Too Much with Us
1807, composed c. 1802
Manuscript, hand of Sara Hutchinson
The British Library Board, Add. MS. 47864, fol. 32v

[See p. 145.] The printer's copy for *Poems* 1807. Like *Milton, thou shouldst be living at this hour* [Cat. no. 256], *The World Is Too Much with Us* condemns the materialism of contemporary England:

> The world is too much with us: late and
> soon,
> Getting and spending, we lay waste our
> powers
> (Little we see in Nature that is ours),
> We have given our hearts away, a sordid
> boon!

263 [Figure 84]

Joseph Wright of Derby
Rydal Waterfall
1795
Oil
$22\frac{1}{2} \times 30$ (57.2 × 76.2)
Derby Art Gallery

[See p. 94.] Beauty-spot recorded by a succession of artists, many of whom would have seen the footnote in Mason's *Memoirs* of Gray [Cat. no. 234], which describes the Lower Fall at Rydal as containing:

> not a little fragment of a rock thrown into the basin, not a single stem of brushwood that starts from its craggy sides, but has its picturesque meaning; . . . the little central stream, dashing down a cleft of the darkest coloured stone, produces an effect of light and shadow beautiful beyond description.

The fact that painters used the viewing hut below the fall means that Rydal is very much a set-piece in any tour of the Lakes. Wright's glowing oil stands out because he refuses to treat the naturally gloomy scene in terms of picturesque chiaroscuro: "Sole light admitted here," Wordsworth writes in *An Evening Walk*, "a small cascade / Illumes with sparkling foam the twilight shade."

6:

Memory, Imagination, and the Sublime

264 [Figure 164]

Sir George Beaumont
Peele Castle
c. May 1806
Oil
$13\frac{3}{8} \times 19\frac{3}{4}$ (33.7 × 50.1)
Private collection

[See pp. 177–179.] Probably the version of *Peele Castle* seen by Wordsworth at Beaumont's house in Grosvenor Square in spring 1806, which moved him to write his *Elegiac Stanzas, Suggested by a Picture of Peele Castle, in a Storm* [Cat. no. 306] lamenting the death of his brother John in a shipwreck in Weymouth Bay the previous year. Beaumont's original drawing of the subject had been engraved by Thomas Hearne in 1783. He also made another, larger oil of the scene.

265 [Figure 170]

William Blake
Vala or *The Four Zoas*
c. 1796–1807
Holograph manuscript with illustrations by the author
23×17 (58 × 42.7)
The British Library Board, Add. MS. 39764

The Greek epigraph is taken from *Ephesians* 6.12: "For we wrestle not against flesh and blood, but against principalities, against powers, against the rulers of the darkness of this world, against spiritual wickedness in high places."

Blake may have begun work on *Vala*, later called *The Four Zoas*, as early as 1796, and the poem seems to have been revised as late as 1807, by which time *Milton* and probably *Jerusalem* had been completed. The manuscript consists largely of proof-sheets from Blake's 1796 engravings for Young's *Night Thoughts*, the *Vala* text being surrounded in many places by massively impressive printed ornamental borders. In addition, no fewer than eighty-four of the total of 132 pages carry illustrations to *Vala* itself, mainly pencil, and designed as the basis for an illuminated copy that was never made. No manuscript in English literature is more complex or more visually exciting. In the early stages, text is entered in the copperplate script associated with Blake's work as an engraver, and corrections are entered neatly over erasure. Later, as Blake's concept of his material changes, additions and alterations are roughly made in an ordinary hand.

Like the exactly contemporary *Prelude* (composed 1798–1805), *Vala* shows the poet working, first in a brief version, finally in a very much longer one, towards a redemptive myth that will assuage his sense of loss. We see Blake reenacting the fall that takes place in *The Book of Urizen*, then struggling to find a means of reversing the downward spiral. Despite containing much great poetry, *Vala* was perhaps at no stage regarded as complete. For us, however, the manuscript provides a unique opportunity to watch the development of Blake's myth, and the workings of his creative process.

266

Edmund Burke
A Philosophical Enquiry into the Origin of Our Ideas of the Sublime and Beautiful, Vol. 1, in *The Works of the Right Honourable Edmund Burke*, 12 vols.
London, 1815 (first published 1757)
The Wordsworth Trust

[See p. 89.] Burke's *Sublime and Beautiful* in the *Collected Works* 1815, signed by Wordsworth in Volume 1, and bound as a "Cottonian" out of dress fabric (by Dora Wordsworth, or more probably the daughters of Robert Southey, who was responsible for the punning reference to the Cottonian Collection of the British Museum). At the centre of Burke's thinking, and of his influence on Wordsworth in the *Prelude* "spots of time," is his emphasis on terror:

> No passion so effectually robs the mind of all its powers of acting and reasoning as fear, for, fear being an apprehension of pain or death, it operates in a manner that resembles actual pain. Whatever therefore is terrible, with regard to sight, is sublime too. . . .

267 [Figure 163]

Lord Byron
Childe Harold's Pilgrimage, Canto Three
1816
Holograph manuscript
Barclays Bank PLC, British Library Loan 70/8

[See pp. 48 and 176–177 and Cat. no. 54.] The earliest of three surviving manuscripts of Canto Three, inscribed "This M.S. was given by Lord Byron to Scrope Davies at Geneva September 2d 1816," and deposited in 1820 at Scrope Davies' bank with other literary material of Byron and his circle. Under the influence of Shelley, who was at the time writing *Mont Blanc* [Cat. no. 288], Byron is shown at his closest to Wordsworth. Stanza vi includes his lines on the value of creativity, and the relation of Harold to his own consciousness:

'Tis to create, and in creating live
A being more intense, that we endow
With form our fancy, gaining as we give
The life we image, even as I do now.

268

Samuel Taylor Coleridge
*Biographia Literaria; or Biographical Sketches
of My Literary Life and Opinions*
London, 1817
The Berg Collection of English and American
Literature, The New York Public Library

[See pp. 170–171 and 186.] First edition of
Coleridge's prose counterpart to Wordsworth's
Prelude, written in 1815 and never republished
in his lifetime. Chapter Thirteen contains his
famous definition of the primary imagination
as a god-like faculty:
 The IMAGINATION then, I consider as
 primary, or secondary. The primary IMA-
 GINATION I hold to be the living power and
 prime agent of all human perception, and as
 a repetition in the finite mind of the eternal
 act of creation in the infinite I AM.
Coleridge goes on to distinguish the secondary
(or poetic) imagination as an "echo" of the pri-
mary, "differing only in degree," and "fancy"
as simply "a mode of memory" receiving "all its
materials ready made" from experience.

269 [Figure 162]

Samuel Taylor Coleridge
Letter to —— April 4, 1802
4 April 1802
Holograph manuscript
The Wordsworth Trust

Fair copy of the *Dejection Ode* in its original
form, addressed to Sara Hutchinson as a verse
letter, and presumably transcribed for the
Wordsworths soon after composition.
Coleridge was unhappily married (his life, he
said, was "gangrened . . . in its very vitals—
domestic tranquillity"), and in love with Sara,
younger sister of Wordsworth's future wife,
Mary Hutchinson. During the summer he
shortened and reordered the poem, removing
its more personal elements, and turning it from
a moving but diffuse love-poem into a compact
lament for the loss of imaginative power. In this
shorter form it was published in *The Morning
Post* as a tribute to Wordsworth (addressed
under the pseudonym Edmund) on his wedding
day, 4 Oct. 1802.

270

Samuel Taylor Coleridge
Dejection: An Ode
1803
Holograph manuscript
The Pierpont Morgan Library, New York

Fair copy of the revised version of *Dejection:
An Ode*, in a letter to Sir George and Lady
Beaumont, 13 Aug. 1803 [see Cat. no. 269].
Above the poem is a transcription, in Dorothy's
hand, of Wordsworth's *Leech Gatherer* [Cat.
no. 255] which, with the opening stanzas of
Intimations (spring 1802), forms part of a
dialogue between the two poets on the nature of

imagination [see p. 172]. Coleridge's own poem
is headed "Dejection, an Ode (Imperfect) April
4, 1802" and addresses Wordsworth directly
as "William" throughout:
 O William, we *receive* but what we *give*:
 And in our life alone does Nature live.
Transcription of the poem breaks off at:
 But O, each visitation
 Suspends what Nature gave me at my birth,
 My shaping spirit of imagination!
with the comment: "I am so weary of this
doleful poem that I must leave off. . . . I have
been very ill."

271 [Figure 172]

Samuel Taylor Coleridge
Kubla Khan
n.d.
Holograph manuscript
The British Library Board

[See Cat. no. 60.] One of the great treasures of
Romantic literature—the only surviving manu-
script of *Kubla Khan*. In a concluding note,
Coleridge has written: "composed in a sort of
reverie—brought on by two grains of opium,
taken to check a dysentery—at a farm house
between Porlock and Linton, a quarter of a mile
from Culbone Church, in the fall of the year,
1797." The poem was composed in early Nov.
1797, just before the first version of *The Ancient
Mariner*. The date of the manuscript is un-
certain, but in addition to spelling Kubla with a
"c," it contains the important early reading,
"Mount Amara" ("Mount Abora" in the prin-
ted text), which shows Coleridge to have been
thinking in his reverie of *Paradise Lost*.

272 [Figure 167]

John Constable
The Coast at Brighton—Stormy Evening
c. 1828
Oil on paper laid on canvas
$6\frac{1}{2} \times 10\frac{1}{2}$ (16.6 × 26.7)
Yale Center for British Art,
Paul Mellon Collection

A product of the last of Constable's visits, during
the period 1824–1828, to Brighton; he said of
the resort in a letter to Fisher (Aug. 1824):
"there is nothing here for a painter but the
breakers and the sky. . . ." The visits were
occasioned by his wife's consumption, and
Coast at Brighton, with its heavy, lowering sky,
reflects his increasing despair at her condition.
Shortly after the date inscribed on the back—
"Brighton. Sunday evening July 20 1828"—
Maria had to be taken back to Hampstead,
where she died four months later. This study
should be compared to the *Seascape Study with
Rainclouds* in the Royal Academy.

273 [Figure 168]

John Constable
Hadleigh Castle
1829
Oil
$48 \times 64\frac{3}{4}$ (122 × 164.5)
Yale Center for British Art,
Paul Mellon Collection
CHS only

[See p. 179.] Exhibited at the Royal Academy
in 1829 as *Hadleigh Castle: The Mouth of
the Thames—Morning after a Stormy Night*.
Constable's election to the Academy had come
(by a single vote) the previous February, three
months after the death of his wife. The presi-
dent, Sir Thomas Lawrence, had made it clear
that as a mere landscape painter he was lucky
to be elected, and Constable was in two minds
about submitting *Hadleigh Castle* for exhibition.
"Can you oblige me with a call," he wrote to
Leslie, "to tell me whether I can, or ought to,
send it to the *Pandemonium* [crossed out, and
replaced by 'Exhibition']. I am grievously ner-
vous about it, as I am still smarting under my
election." The painting is based on a sketch
Constable had made in 1814 while courting
Maria; after drawing the castle, which over-
looked the Thames Estuary, he had written to
her that he was "always delighted with the
melancholy grandeur of a sea-shore." The
original sketch was followed by a small oil
study, and probably by a pen-and-ink drawing
extending the scene to the right. A full-scale
oil sketch, now in the Tate Gallery, London,
brings the twin towers of the castle closer
together, anticipating the composition of the
more clearly defined exhibition picture.

274 [Figure 177]

John Constable
The Lock
1822–1824
Oil
$55\frac{3}{4} \times 48$ (141.7 × 122)
Philadelphia Museum of Art,
John Howard McFadden Collection
NYPL only

Sketch for *A Boat Passing a Lock* (now at Sudeley
Castle), which was a great success at the
Academy in 1824; the fifth in a series of large
Stour scenes Constable had shown, it was sold
on the first day of exhibition. The artist re-
marked of it the following year: "It looks most
beautifully silvery, windy and delicious. It is all
health—and the absence of everything stag-
nant." S. W. Reynolds, the engraver, com-
mented that, "since the days of Gainsborough
and Wilson, no landscape has been painted
with so much truth and originality, so much
art, so little artifice."

This sketch bears the marks of Constable's
unusual decision to paint the scene as an
upright; a piece has been added to the top of the
canvas, and the right-hand edge is cut away.
The only surviving drawing, dating from 1823,
is a horizontal composition—with the keeper
on the further side of the lock—and later
versions of the subject returned to this format;
one, completed in 1826, was Constable's dip-
loma picture for the Royal Academy.

275 [Figure 165]

John Constable
Weymouth Bay
1816
Oil on millboard
$8 \times 9\frac{3}{4}$ (20.3 × 24.7)
The Trustees of the Victoria and Albert
Museum, London

[See pp. 178–179.] Small oil sketch, dating from Constable's honeymoon at Osmington, near Weymouth, for finished paintings now in the Louvre and the National Gallery, London. The stormy sky is carried over into the Louvre version and anticipates, to some extent, Constable's treatment of the Sussex coastline in the 1820s [see Cat. no. 272].

276 [Figure 166]
John Constable
Weymouth Bay from the Downs above Osmington Mills
1816
Oil
22 × 30⅜ (56 × 77.3)
Museum of Fine Arts, Boston,
Bequest of Mr. and Mrs. William Caleb Loring
NYPL and IUAM only

Fisher wrote to Constable on 27 Aug. 1816, strongly recommending marriage to Maria, and a honeymoon spent with him and his wife at Osmington, Dorset: "You shall [have] a plate of meat set by the side of your easel without your sitting down to dinner . . . we never see company, and I have brushes, paints, and canvas in abundance." The Archdeacon married the couple in London in October, and the Constables spent about six weeks, towards the end of 1816, as his guests. This *Weymouth Bay*, like Cat. no. 275, was painted during their stay, and demonstrates Constable's remarkable ability to adapt to a completely new kind of landscape; he had painted Stour scenes almost exclusively over the previous four years.

277 [Figure 183]
David Cox
Mountain Heights, Cader Idris
c. 1850
Watercolour
18½ × 29¼ (47 × 74.3)
Roy and Cecily Langdale Davis Collection

Large study, from one of Cox's many Welsh tours, for the background of an 1850 watercolour, *Cader Idris: Evening, Storm Clearing Off* (30¼ × 40½ inches; 77 × 108 cm.). Painted on the coarse, "Scotch" paper which he favoured later in his career, *Mountain Heights* bears out Cox's statement, in his 1814 *Treatise on Landscape Painting*, that "sublime ideas are expressed by lofty and obscure images."

278 [Figure 97]
John Robert Cozens
In the Canton of Unterwalden
c. 1780
Watercolour
9⅜ × 14¼ (23.8 × 36.2)
Leeds City Art Galleries

[See p. 109.] A product of Cozens' first tour of Switzerland and Italy with the connoisseur and theorist Payne Knight (1776–1779), and one of four surviving versions of this Swiss subject. Cozens' tranquil Alpine watercolours were an important influence on both Girtin and Turner, who copied his works under the guidance of Dr. Thomas Monro.

279 [Figure 154]
John Robert Cozens
Pays de Valais
1780
Watercolour over traces of pencil on paper
16 1/16 × 25 3/16 (41.1 × 64)
Birmingham Museum and Art Gallery

Dated 1780 by an inscription on the original mount, and another product of the first Swiss tour [see Cat. no. 278]. *Pays de Valais* is one of seven watercolours based on a sketch in the Soane Museum, London; the sketch, dated 30 Aug. 1776, in fact contains a list of eight clients for whom Cozens was to produce finished versions. The movement from the dark, stippled brushwork in the foreground to the thin washes of the valley in the distance creates a spectacular effect of distance and scale.

280 [Figure 173]
John Crome
Moonlight on the Yare
c. 1808–1815
Oil
38¾ × 49½ (98.4 × 125)
National Gallery of Art, Washington, D.C.,
Paul Mellon Collection

A characteristically "Dutch" treatment of a local scene, illumined and transformed by the moon on the horizon and the light reflected on the surface of the river. Crome, who was apprenticed to a sign-painter as a youth, and helped to found the Norwich Society of Artists in 1803, was the oldest and—except for Cotman—the most celebrated member of the Norwich School. He was much influenced by works of Hobbema and other Dutch landscapists in the collection of his first patron, Thomas Harvey, and he painted chiefly in oils. Though he visited Paris in 1814 to see the cultural treasures assembled by the Napoleonic armies [see Cat. no. 18], Crome was not, like most of his contemporaries, a touring artist. He was content with subjects drawn from the Norfolk countryside. "Do not distress us with trifles," he told his old pupil James Stark, "but keep the masses large and in good and beautiful lines, and give the sky, which plays so important a part in all landscape . . . the prominence it deserves." *Moonlight on the Yare* may have been exhibited at the Norwich Society in 1817 as *Moon Rising*.

281 [Figure 160]
George Dance
Samuel Taylor Coleridge
1804
Pencil on paper
7¾ × 6⅜ (19.7 × 16)
The Wordsworth Trust

Signed and dated, "Geo. Dance / March 21st. 1804," and presumably commissioned by Sir George Beaumont, as was James Northcote's oil of Coleridge, made a few days later on 25–26 March. Coleridge, who was waiting in London to sail for the Mediterranean in search of a warmer climate and better health, had just suffered what he termed on the 20th "a diarrhoea of incessant fury." It was feared he might

die abroad, and the portraits show the wish of his friend and admirer to preserve his likeness. The drawing was acquired by The Wordsworth Trust from the Beaumont family in 1984.

282 [Figure 174]
Thomas Girtin
On the River Wharfe, Yorkshire
Watercolour
1801
12½ × 20¾ (31.6 × 52.7)
Private collection

[See p. 186.] Unfortunately damaged in the flood at the Tate Gallery in 1928, but still perhaps the most impressive of the great sequence of Wharfedale drawings from the Yorkshire tour of 1801, including *Bolton Abbey*, the two versions of *Stepping Stones on the Wharfe*, and (probably) the British Museum *View of Hills and River*. Painting a year before his death, and at the height of his powers, Girtin in these drawings interprets this bare northern English landscape as no one has been able to do before or since. In him we see at once "the forms / Perennial of the ancient hills," and what Wordsworth so brilliantly called "The changeful language of their countenance" [see p. 72 and Cat. no. 138].

283 [Figure 175]
Thomas Girtin
White House at Chelsea
1800
Watercolour
11¾ × 20¼ (29.8 × 51.4)
The Trustees of the Tate Gallery

[See pp. 56 and 186.] Girtin's most famous picture and most daring composition, based on a pencil drawing inscribed "Battersea Reach" in a sketch-book of 1800. It may be that tonal values have changed, and that the intensity with which the white house stands out from its surroundings owes something to the process of time, but there can be no doubt that it was always the centre of attention, singled out by the sun and by the imagination of this great Romantic artist.

284 [Figure 179]
Benjamin Robert Haydon
William Wordsworth
1818
Chalk
22⅜ × 17⅛ (56.8 × 43.5)
National Portrait Gallery, London

Apparently made as a present for Wordsworth's wife Mary and, like Haydon's more famous *Wordsworth on Helvellyn* (1842), a somewhat dramatized image. The poet himself commented: "your drawing is much admired as a work of art; some think it a stodgy likeness;" but the picture came to be known in the family as "The brigand."

285 [Figure 178]
John Keats
To Autumn

1819
Holograph manuscript
The Houghton Library, Harvard University

Earliest surviving manuscript of *To Autumn*, beginning as fair copy (with "sweetness," instead of the printed "ripeness," in line six of the uncorrected first stanza), but heavily re-worked in stanza two. The first of two in-scriptions on the verso is by Keats' brother George [see Cat. no. 79]: "*original* manuscript of John Keats Poem to Autumn. Presented to Miss A Barker by the author's Brother. Sun. Nov 15. 1839." George had brought the manuscript to America in 1820, and gave it to Miss Barker in return for a flower she had gathered from Keats' grave in Rome. The second inscription notes, "Given to my Granddaughter Elizabeth Ward May 14th. Anna H. B. Ward." From Elizabeth Ward it passed to Amy Lowell, who bequeathed it to the Harvard College Library in 1925.

On 21 Sept. 1819 Keats wrote to J. H. Reynolds, "I never liked stubble fields so much as now—aye, better than the chilly green of the spring. Somehow a stubble plain looks warm—in the same way that some pictures look warm—this struck me so much in my Sunday's walk that I composed upon it."
[See also Cat. no. 199.]

286 [Figure 176]

Samuel Palmer
Cornfield by Moonlight with the Evening Star
c. 1830
Watercolour, gouache, and pen
7¾ × 11¾ (19.7 × 25.8)
The Trustees of the British Museum
NYPL only

Once owned by Lord Kenneth Clark, and among the great achievements of Palmer's Shoreham period, 1827–1834. The over-sized moon and star, the large and immensely evocative "stooks" of corn, the figure with his staff and dog—who seems like Pilgrim about to enter the visionary experience that is the picture itself—are set against a perfectly rendered Kentish landscape. "Despite Nature's perfection," Palmer had written to Linnell in 1828, she "does yet leave a space for the soul to climb over her steepest summits."

287 [Figure 153]

William Pars
The Rhône Glacier and the Source of the Rhône
c. 1770
Watercolour, pen and black ink, with touches of gum arabic over pencil
13 × 19¼ (33.1 × 48.8)
The Trustees of the British Museum
NYPL only

One of eight watercolours exhibited by Pars at the Royal Academy in 1771 as the result of a tour of the Swiss Alps and Haute-Savoie with his patron, the second Viscount Palmerston. Palmerston's journal reveals that the party travelled up the Rhône Valley to its source in late July–early August 1770. On an earlier visit to the continent in 1762–1763, Pars had met Voltaire, and been commissioned to record an archaeological expedition to Asia Minor. He was among the first British artists to portray the scenery of the Alps.

288 [Figure 152]

Percy Bysshe Shelley
Mont Blanc
1816
Holograph manuscript
Barclays Bank PLC, British Library Loan 70/8

[See pp. 163–171.] Fair-copy manuscript note-book from the Scrope Davies collection [see Cat. no. 267]. *Mont Blanc*, in Shelley's hand, and headed "Scene—Pont Pellesier in the vale of Servox," faces the conclusion of *Hymn to Intellectual Beauty*, in the hand of Mary Godwin. The manuscript was taken to England by Davies in Sept. 1817, leaving Shelley with only a draft version from which to copy and revise the poem for publication the following year. A number of variant readings that he might presumably have wished to incorporate are therefore ignored in the printed text.

289 [Figure 171]

Percy Bysshe Shelley
Ode to the West Wind
1819
Holograph manuscript
By permission of the Curators
of the Bodleian Library, Oxford

Only surviving manuscript of Shelley's most famous poem, written at Florence in late autumn 1819, and published with *Prometheus Unbound* the following year. A note in 1820 recalls the poem's composition "in a wood that skirts the Arno" on a day of "tempestuous wind," but here as elsewhere the natural world is linked in Shelley's mind with imagination and political change:

> Drive my dead thoughts over the universe
> Like withered leaves to quicken a new birth!
> And, by the incantation of this verse,
>
> Scatter (as from an unextinguished hearth,
> Ashes and sparks) my words among
> mankind. . . .

290 [Figure 151]

Francis Towne
The Source of the Arveiron:
Mont Blanc in the Background
1781
Watercolour on four sheets, joined
16¾ × 12½ (42.5 × 31.1)
The Trustees of the Victoria and Albert Museum, London

The larger of Towne's two studies of the glacier at Mont Blanc, and one of the most impressive of all eighteenth-century English watercolours. Like Wordsworth in *Prelude*, Book Six—

> That day we first
> Beheld the summit of Mont Blanc and
> grieved
> To have a soulless image on the eye
> Which had usurped upon a living thought
> That never more could be . . .

—Towne seems unimpressed by the mountain itself. He has climbed to a point where the glacier dominates the scene, creating a composition of bold diagonal planes that push the mountain back into relative insignificance. For Towne in Sept. 1781, as for the Wordsworth of 1790, it is the "dumb cataracts and streams of ice," the "motionless array of mighty waves," that seize the imagination. No sketches are preserved for either *Source of the Arveiron*; there can be little doubt that these masterpieces are drawn on the spot—a direct confrontation with the sublime.

291 [Figure 184]

J. M. W. Turner
The Foot of St. Gothard
c. 1842
Watercolour
18⅞ × 23⅞ (48 × 60.7)
Leeds City Art Galleries

Painted with characteristic energy and atmospheric effect on one of the four Alpine tours of the early 1840s, probably 1842. At the centre of the composition, a "vortex," similar to that of the *Valley of Aosta* [Cat. no. 298], replaces the massive solidity of Turner's early treatment of the Alps [see Cat. nos. 292 and 294–295].

292 [Figure 156]

J. M. W. Turner
The Great Falls of the Reichenbach
1804
Watercolour
40¾ × 27½ (102.2 × 68.9)
By kind permission of the Trustees,
Cecil Higgins Art Gallery, Bedford
CHS only

Based on a leaf (now in the National Gallery of Ireland) from the *St. Gothard and Mont Blanc* sketch-book of 1802. Turner has largely retained his original composition, but added the plume of smoke on the left, and the natural debris in the foreground.

Several of the finished watercolours based on the *St. Gothard* sketch-book are of a scale, and richness of colour, which rivals oil painting. *The Great Falls of the Reichenbach*, the *Mer de Glace*, *Source of the Arveiron* at Yale, and *The Passage of the St. Gothard* [Cat. no. 295] were all intended for exhibition alongside oils, either at the Royal Academy or in Turner's own gallery. Nineteen of the series were bought by Walter Fawkes, of Farnley Hall, Yorkshire, who probably met the artist on his 1802 tour.

293 [Figure 114]

J. M. W. Turner
Inverary Pier, Loch Fyne, Morning
c. 1840–1850
Oil
36 × 48 (91.5 × 122)
Yale Center for British Art,
Paul Mellon Collection

One of nine late oils made after subjects in the *Liber Studiorum* [Cat. no. 99]: the pier and shoreline of the loch in the left foreground, and the skyline of Duniquoich beyond, correspond to the *Inverary Pier* mezzotint of 1811. Turner had new impressions made from the original

Liber plates in 1845, and these oils may date from the same period. Although they are strictly "unfinished," it is possible he considered them, like his "colour beginnings" [see Cat. nos. 188 and 192], as completed works in their own right; alternatively, Turner may have planned to turn them into finished exhibition pieces in the halls of the Academy itself, on "varnishing days"—transforming his canvases, as he often did, in full view of passers-by.

Until recently this painting was entitled *Monte Rosa*, and thought to be of a view on the Swiss-Italian border.

294 [Figure 157]

J. M. W. Turner
Mer de Glace, Chamonix, with Blair's Hut
c. 1806
Watercolour
$10\frac{7}{8} \times 15\frac{7}{16}$ (27.6 × 39.2)
Courtauld Institute Galleries (presented by the family of Sir Stephen Courtauld)
NYPL and IUAM only

Among the first of the watercolours based on the *St. Gothard and Mont Blanc* sketch-book [see Cat. no. 292], *Mer de Glace* gives a magnificent impression of the power and suspended motion of the Mont Blanc glacier. Where Pars and Towne [Cat. nos. 287 and 290] convey the scale and substance of the scene from a distance, Turner brings us up close, showing the splintered wreckage of trees in the foreground, and the great boulders of ice moving relentlessly down the valley.

295 [Figure 155]

J. M. W. Turner
The Passage of the St. Gothard
1804
Watercolour
$38\frac{7}{8} \times 27$ (98.5 × 68.5)
Lent by Abbot Hall Art Gallery, Kendal, Cumbria, U.K.

Based closely on a drawing in the *St. Gothard and Mont Blanc* sketch-book [see Cat. no. 292] showing the view from the "Devil's Bridge" which traversed the chasm, with the narrow road of the pass trailing into the distance on the left. As in Cat. no. 292, Turner exploits the upright format to convey the full sublimity of the scene, and uses a sophisticated range of watercolour techniques. In the same year, Joseph Farington described Turner's method of lightening parts of a picture by dampening the layers of darker colour and sponging them off with "blotting paper" and "crumbs of bread." He would also add highlights in bodycolour or white chalk, and scratch through to the white paper with a knife or fingernail.

296 [Figure 159]

J. M. W. Turner
A Swiss Pass
c. 1848–1850
Watercolour
$14\frac{1}{8} \times 20$ (36.2 × 50.8)
The Trustees of the Victoria and Albert Museum, London

An atmospheric Swiss composition of Turner's last years, perhaps related to *The Pass of Faido* (1843), of which Ruskin commented: "the aim of the great inventive landscape painter must be to give the far higher and deeper truth of mental vision, rather than that of the physical facts. . . ."

297 [Figure 68]

J. M. W. Turner
The Upper Falls of the Reichenbach
c. 1810–1815
Watercolour
$10\frac{7}{8} \times 15\frac{7}{16}$ (27.7 × 39.2)
Yale Center for British Art,
Paul Mellon Collection
NYPL only

Close-up view of the waterfall seen from a distance in Cat. no. 292, again based on a leaf from the *St. Gothard and Mont Blanc* sketch-book [see Cat. no. 292]. Like many of the 1802 studies, the notebook sketch is almost monochrome. Here, Turner has lightened the atmosphere of the scene, using warmer colours to soften the mountain's outline; the figure with a dog on the left is added, as are the cattle in the foreground and on the distant ridges. The rainbow, and the spray rising from the falls—produced by scraping away at the watercolour—make this one of Turner's most delicately evocative Alpine studies.

298 [Figure 185]

J. M. W. Turner
Valley of Aosta—Snowstorm, Avalanche, and Thunderstorm
c. 1836–1837
Oil
$36\frac{5}{16} \times 48\frac{3}{8}$ (92.2 × 123)
The Art Institute of Chicago, Frederick T. Haskell Collection
NYPL and IUAM only

[See pp. 196-197.] Probably inspired by Turner's Swiss tour with H. A. J. Munro in summer 1836, and one of the few Alpine oil paintings he exhibited (at the Royal Academy, 1837, and the British Institution, 1841). *Valley of Aosta* shows the region at its most inhospitable. The storm which engulfs the mountainside recalls *Hannibal Crossing the Alps* (1812), as well as anticipating *The Foot of St. Gothard* [Cat. no. 291]. Only the fleeing figures in the right foreground are set apart from the confusion.

A review in the *Athenaeum* of 1841 described Turner as having "loaded his weapon of offence . . . and shot a round of drab, dove-colour, and dirty white, with only a patch of hot, southern-red in the foreground, to heighten . . . the horrors of a snow scene by a few *probable* touches of fire and sunshine." "To speak of these works as pictures," the review continued, "would be an abuse of language." Ruskin, by contrast, regarded the *Valley of Aosta* as one of Turner's "mightiest works."

299 [Figure 158]

J. M. W. Turner
The Valley of Chamonix,
Mont Blanc in the Distance

1809
Watercolour and bodycolour
with scratching out
$11 \times 15\frac{1}{2}$ (27.9 × 39.5)
Whitworth Art Gallery,
University of Manchester

Signed and dated 1809, and again based on a study from the *St. Gothard and Mont Blanc* sketch-book [see Cat. no. 292]. Turner has raised the height of the distant peaks and altered the composition of the foreground, adding the woman, the goats, and the pines (reminiscent of those in the *Mer de Glace, Source of the Arveiron*, at Yale). The short stippled brush-strokes used for the trees on the left recall J. R. Cozens' Alpine scenes [see Cat. nos. 278–279]. *The Valley of Chamonix* was purchased and perhaps commissioned by Walter Fawkes [see Cat. no. 292].

300 [Figure 100]

Cornelius Varley
Llyn Gwynant, North Wales
c. 1803
Watercolour
$10\frac{3}{4} \times 14\frac{13}{16}$ (27.4 × 37.6)
Leeds City Art Galleries

A great Romantic watercolour, painted on the spot with extraordinary power and freedom, either in 1802 or, more probably, in 1803 (when the artist was still only twenty-two). Drawing with a full wet brush, and limiting himself to Cozens' palette of blues, greys, and browns, Varley has achieved in a more sophisticated composition the bold imaginative contrasts of Girtin's *View of Hills and River* at the British Museum. Through his brother John, Cornelius had access to the drawings of both Cozens and Girtin in the collection of Dr. Monro.

301 [Figure 180]

John Varley
Snowdon from Capel Curig
c. 1805–1810
Watercolour
$14\frac{7}{8} \times 18\frac{3}{4}$ (37.8 × 47.6)
The Trustees of the Victoria and Albert Museum, London

An unfinished, and perhaps therefore more impressive, example of John Varley's art in its second phase. The influence of Girtin that lay behind his earlier and most powerful work has been replaced by a concern with form seen in the *Treatise on the Principles of Landscape Design* (1816), and noticeable here in the sculpting of Snowdon. "Every picture ought to have a *look-there*," Varley told his pupils, and the pyramidal form of the mountain, echoed by adjacent peaks, and rising on the flat base of the (uncoloured) lake, gives a quiet majesty to the composition.

302

Dorothy Wordsworth
Journal of a Tour of the Continent
1820–1821
Manuscript
The Wordsworth Trust

An account of "sixteen weeks pleasant rambling," July 1820–Feb. 1821, during which Dorothy, William, Mary, and three (at one period, four) others, visited the scenes of Wordsworth's continental tour of 1790—at times following the precise route, though in the opposite direction, from west to east. Especially important to the poet was his return on 15 Sept. 1820 to the "wondrous Vale of Chamouny"— the Mer de Glace, drawn by Pars, Towne, Turner, and others [Cat. nos. 287, 290, 294, 299], and the site of an important episode of Mary Shelley's *Frankenstein*. "This glacier," Dorothy writes, with much of her old vividness of detail,

> from the steeps, has the appearance of a sea frozen while disturbed by storm; but the view from that distance gives no notion of the height of the waves, or of the depth of the hollows, within which you often look into gulfs of green water, unpierceable, to the bottom, by the sight, though translucent as crystal. . . .

303 [Figure 181]

William Wordsworth
The "Ascent of Snowdon" in *The Prelude*, Book Thirteen
1806, composed 1804
Manuscript, hand of Dorothy Wordsworth
The Wordsworth Trust

[See pp. 193–197.] Lines from the "Ascent of Snowdon" (xiii, 1–65), as transcribed by Dorothy *c.* Feb. 1806 (and later heavily revised by her brother) in MS. A, the first complete manuscript of *The Prelude*. Originally written to open Book Five of the short-lived five-book version of the poem (Jan.–March 1804), these great lines retained their position as the opening of the final book of *The Prelude* when Wordsworth (for a second time) decided to extend his work. No passage in *The Prelude* captures more impressively his sense of the grandeur of the human mind, or of the vital interconnections between the mind and external Nature. A year after composing the lines, Wordsworth added his own inspired comment, claiming it as a meditation experienced while on Snowdon itself in 1791:

> A meditation rose in me that night
> Upon the lonely mountain when the scene
> Had passed away, and it appeared to me
> The perfect image of a mighty mind,
> Of one that feeds upon infinity,
> That is exalted by an under-presence,
> The sense of God, or whatsoe'er is dim
> Or vast in its own being. . . .
>
> (xiii, 66–73)

304 [Figure 169]

William Wordsworth
"An Auxiliar Light" in *The Prelude*, 1799, ii
c. Oct. 1799
Manuscript, hands of Mary Hutchinson, Dorothy, and William Wordsworth
The Wordsworth Trust

A central passage from the two-part *Prelude* of 1799, shown in the original fair copy of Part Two. Completed *c.* Oct. 1799, Wordsworth's lines record not merely his sense of a special imaginative power, but an awareness that paradoxically he values Nature because of his own *superior* creativity—his ability to go one better:

> An auxiliar light
> Came from my mind, which on the setting sun
> Bestowed new splendour; the melodious birds,
> The gentle breezes, fountains that ran on,
> Murmuring so sweetly in themselves, obeyed
> A like dominion, and the midnight storm
> Grew darker in the presence of my eye.
> Hence my obeisance, my devotion hence,
> And hence my transport.
>
> (1799, ii, 417–425)

305

William Wordsworth
"Dedication Scene" in *The Prelude*, Book Four
Feb. 1804
Holograph manuscript
The Wordsworth Trust

Fair copy of lines from the "Dedication Scene" in a notebook of Feb. 1804 (iv, 327–345) standing opposite a page of Marvell's *Horatian Ode* (also transcribed by Wordsworth, and important for *Intimations*, completed in the same month). In an episode that must have taken place in 1788, during his first Long Vacation from Cambridge, the poet records his sense of being chosen—dedicated, as if by some external power, to a life of poetry:

> I made no vows, but vows
> Were then made for me: bond unknown to me
> Was given, that I should be—else sinning greatly—
> A dedicated spirit.

306

William Wordsworth
Elegiac Stanzas in *Poems*, 1815
London, 1815
The Wordsworth Trust

[See pp. 178–181.] Wordsworth's *Elegiac Stanzas, Suggested by a Picture of Peele Castle, in a Storm*, standing in this copy of *Poems* 1815 opposite an engraving of Beaumont's picture by S. W. Reynolds (normally bound as frontispiece). In his poem, of *c.* May 1806—prompted, not by the castle itself, but by a ship that is weltering in heavy seas off Piel Island— Wordsworth says farewell both to his brother, John, drowned off Portland Bill in Feb. 1805, and to an untroubled earlier self whom he now regards as failing to accept the Christian implications of human suffering:

> Farewell, farewell, the heart that lives alone,
> Housed in a dream, at distance from the kind—
> Such happiness, wherever it be known,
> Is to be pitied, for 'tis surely blind.
>
> But welcome fortitude, and patient cheer,
> And frequent sights of what is to be borne—
> Such sights, or worse, as are before me here:
> Not without hope we suffer and we mourn.

307

William Wordsworth
Fragmentary Essay on the Sublime and the Beautiful
c. 1812
Manuscript, hand of Mary Wordsworth
The Wordsworth Trust

A fragment, unpublished in Wordsworth's lifetime, but associated with the *Guide to the Lakes*, and incorporating the most important of his prose definitions of the sublime:

> Power awakens the sublime either when it rouses us to a sympathetic energy and calls upon the mind to grasp at something towards which it can make approaches, but which it is incapable of attaining . . . or . . . by producing a humiliation or prostration of the mind before some external agency. . . .

Almost certainly Wordsworth's thinking at this point reflects Coleridge's reading of Kant, emphasizing the creative faculties of the mind which help to form the sublime experience—an intense consciousness of the unity of mind and world. It is important to note that even in Wordsworth's second instance, where the sublime is awakened by external power, consciousness is not passively overwhelmed by sense perception (as, for instance, when the "soulless image" of Mont Blanc "usurps" upon his "living thought" in *Prelude*, Book Six [see Cat. no. 308]).

308

William Wordsworth
"Mont Blanc" in *The Prelude*, Book Six
1839, composed 1804
Manuscript, hand of Dora Wordsworth
The Wordsworth Trust

Single sheet from Book Six of the printer's copy of *The Prelude*, transcribed by the poet's daughter Dora. The experience recorded took place during the walking tour of 1790. It was not unusual for tourists to express disappointment on viewing Mont Blanc, but only a poet who valued above all the creative power of the human mind could have "grieved" . . .

> To have a soulless image on the eye
> Which had usurped upon a living thought
> That never more could be.
>
> (1850, vi, 526–528)

309 [Figure 161]

William Wordsworth
Ode: Intimations of Immortality
1804, composed 1802–1804
Manuscript, hand of Mary Wordsworth
The Wordsworth Trust

[See pp. 171–174.] One of the most important of all Romantic manuscripts, the original fair copy of Wordsworth's *Intimations*, in the vellum-bound collection of her husband's unpublished poetry which Mary made with Dorothy, Feb.–March 1804, for Coleridge to take with him to the Mediterranean. Begun on 27 March 1802, the poem was completed immediately before transcription in 1804, by the addition of most, or all, of Stanzas v–xi. In 1815, the earlier title, *Ode*, was expanded to

read *Ode. Intimations of Immortality from Recollections of Early Childhood*, and the last three lines of *The Rainbow* [see Cat. no. 141] were added as an epigraph.

In *Tintern Abbey* (1798) Wordsworth can still claim to find "abundant recompense" for the loss of his youthful energy and delight in Nature. Four years later, in the opening stanzas of the *Ode*, there is no such compensation for the loss of visionary power:

> Turn wheresoe'er I may
> By night or day,
> The things which I have seen I now can see
> no more.

The mood of 1804 is different again: "O joy that in our embers / Is something that doth live." In the great central myth of *Intimations*, there is the possibility of a now sadder and wiser form of vision:

> Hence in a season of calm weather,
> Though inland far we be,
> Our souls have sight of that immortal sea
> Which brought us hither,
> Can in a moment travel thither,
> And see the children sport upon the shore,
> And hear the mighty waters rolling
> evermore....

"Though nothing can bring back the hour / Of splendour in the grass, of glory in the flower," there is compensation in the fact of days "Bound each to each by natural piety":

> Thanks to the human heart by which we
> live—
> Thanks to its tenderness, its joys, and
> fears—
> To me the meanest flower that blows can
> give
> Thoughts that do often lie too deep for tears.

310

William Wordsworth
Ode
1807
Manuscript, hand of Sara Hutchinson
The British Library Board, Add. MS. 47864,
fol. 112v, 113r

Printer's copy of the *Ode* (not yet entitled *Intimations of Immortality*), corrected by Wordsworth, for *Poems* 1807 [see Cat. no. 309]. The conclusion of the poem contains an important addition, "In the primal sympathy / Which having been must ever be" (lines 184–185).

311

William Wordsworth
"Oh mystery of man" in *The Prelude*,
Book Eleven
April 1805, composed Feb. 1804
Manuscript, hand of Mary Wordsworth
The Wordsworth Trust

"Oh mystery of man" transcribed by Mary Wordsworth in the earliest fair copy of *Prelude*, Books Eleven and Twelve, April 1805. As might be deduced from their content, the lines belong to Feb. 1804, with the completion of *Intimations*. They were written to be inserted between the newly revised "spots of time," at that stage intended (with the "Ascent of Snowdon" [Cat. no. 303]) for the conclusion of the five-book *Prelude*.

Wordsworth interrupts his narrative of memory with a voice that is fully conscious of the present moment [see p. 171], of the fragility of creative power and the imminence of loss—and so aware too of the necessity of giving life to past experience:

> Oh mystery of man, from what a depth
> Proceed thy honours! I am lost, but see
> In simple childhood something of the base
> On which thy greatness stands....

(xi, 328–331)

312

William Wordsworth
The "Quixote Dream" in *The Prelude*, Book Five
1850
The Wordsworth Trust

Copy of the first edition of *The Prelude* (July 1850) retained at Rydal Mount by Mary Wordsworth (and in places revised for the second edition, 1851), showing the "Quixote Dream," composed in Feb. 1804. Drawing certain hints from a dream experienced by Descartes in 1619, Wordsworth creates a fable embodying his anxieties as poet of *The Recluse*, whose role it is to pass on a redemptive message to future generations. Within the poem he falls asleep beside the sea, reading a copy of Cervantes, and dreams of "an arab of the Bedouin tribes," riding across the desert on a dromedary, "With the fleet waters of a drowning world / In chase of him." Like Don Quixote he bears a lance, but is also carrying two "books" that he hopes to bury, and save for posterity. One is a stone that is at the same time *Euclid's Elements*, and holds "acquaintance with the stars," wedding "soul to soul in purest bond / Of reason." The other (still more precious) is a beautiful shell, through which the dreamer hears:

> A loud prophetic blast of harmony;
> An ode, in passion uttered, which foretold
> Destruction to the children of the earth
> By deluge now at hand.

Symbolic interpretations of the dream have not proved satisfactory, but it is clear that Wordsworth feels a bond with the "semi-Quixote" he has created. "I myself," he writes, "could go upon like errand."

313

William Wordsworth
She Dwelt among th'Untrodden Ways and *A Slumber Did My Spirit Seal*, in *Lyrical Ballads* 1800, with manuscript insertion of *I Travelled among Unknown Men* in the hand of Mary Wordsworth
London, 1800
The Master and Fellows of St. John's College, Cambridge

Copy of *Lyrical Ballads* 1800, inscribed by Mary Wordsworth to Isabella Addison, 13 May 1802, in which Mary has entered alongside two of the original Lucy Poems Wordsworth's recent addition to the group, *I Travelled among Unknown Men*, composed in 1801. Significantly, this is the one case in which Mary's own name could appropriately be read in place of Lucy's.

314 [Figure 131]

William Wordsworth
"The Simplon Pass" in *The Prelude*, Book Six
1806, composed March 1804
Manuscript, hand of Mary Wordsworth
The Wordsworth Trust

"The Simplon Pass," transcribed by Mary Wordsworth in the second of two fair copies of the 1805 *Prelude*, Jan.–March 1806. Among the grandest moments of *The Prelude*, the passage was written in March 1804, and published as a separate poem in 1845 [see Cat. no. 198]. Though magnificent in its evoking of the sublimity of Nature, "The Simplon Pass" in its original *Prelude* context is a tribute to the power of imagination which has reasserted itself in the face of disappointment and anti-climax [see pp. 141–142].

315

William Wordsworth
"Spots of Time" in the 1850 *Prelude*,
Book Twelve
1839, composed *c*. Jan. 1799
Manuscript, hand of Dora Wordsworth
The Wordsworth Trust

[See pp. 174–176.] Wordsworth's central statement of belief, as transcribed by Dora in the printer's copy of the 1850 *Prelude*. Though little changed from the text of 1805, this final version of Wordsworth's famous lines on the restorative powers of memory is both longer and weightier than that written originally for the two-part *Prelude* [see Cat. no. 317]:

> There are in our existence spots of time
> Which with distinct preeminence retain
> A fructifying virtue, whence, depressed
> By trivial occupations and the round
> Of ordinary intercourse, our minds
> (Especially the imaginative power)
> Are nourished and invisibly repaired....

(1799, i, 288–294)

In place of the "fructifying virtue"—the power of memory to make the mind fruitful and enhance creativity—emphasis in the latter text is upon the mind as "lord and master."

316

William Wordsworth
Surprised by Joy in *Poems* 1815
London, 1815
The Wordsworth Collection,
Cornell University Library

Surprised by Joy, in Dorothy's copy of *Poems* 1815. The poet recalled in 1843 that his famous sonnet was composed "long after" the death of his daughter Catharine, on 4 June 1812, but the probable time gap is little more than two years. Catharine, who seems to have had a stroke in 1810, was nearly four years old, and a special favourite. Her father's grief should be allowed to speak for itself:

> Surprised by joy, impatient as the wind,
> I wished to share the transport—oh, with
> whom
> But thee, long buried in the silent tomb,
> That spot which no vicissitude can find?
> Love, faithful love, recalled thee to my
> mind—

But how could I forget thee? Through what
power,
Even for the least division of an hour,
Have I been so beguiled as to be blind
To my most grievous loss? That thought's
return
Was the worst pang that sorrow ever bore,
Save one, one only, when I stood forlorn,
Knowing my heart's best treasure was no
more—
That neither present time, nor years
unborn,
Could to my sight that heavenly face
restore.

Catharine's death was followed in Dec. 1812 by that of her six-year-old brother Thomas; they are buried together in Grasmere Churchyard.

317

William Wordsworth
"Visionary Dreariness" in *The Prelude, 1799,* i
Dec. 1799, composed *c.* Jan. 1799
Manuscript, hand of Dorothy Wordsworth
The Wordsworth Trust

[See pp. 174–176.] First of the two childhood episodes to which the poet himself referred as "spots of time," written for the two-part *Prelude* and transcribed by Dorothy in the fair copy of 1799. It should be noted that the passage in this unrevised form is briefer and more pointed, and that the "spots of time" sequence as a whole— broken up in later versions of the poem—is here seen in its original position as the climax of a single book dealing with the poet's earliest memories.

Chronology 1770–1850

"Wordsworth" is abbreviated to "W"

Wordsworth, and the major British Romantic poets	Contemporaries: philosophy and the arts	The Age: political and scientific events	
W born (7 April), Cockermouth, Cumbria	Goldsmith, *Deserted Village* Chatterton poisons himself (24 Aug.), aged 17 Hegel born (24 Aug.), Stuttgart Beethoven born (16 Dec.), Bonn Pars draws *Rhône Glacier* (c. 1770) Pelham etches *Fruits of Arbitrary Power*	England and its colonies ruled by George III (acceded 1760) Boston Massacre (5 March) Sailing in the *Endeavour*, Cook claims New South Wales	1770
Scott born (15 Aug.), Edinburgh Dorothy W born (25 Dec.), Cockermouth	Gray dies (30 July), Cambridge Henry Mackenzie, *Man of Feeling*		1771
Blake apprenticed to James Basire, engraver Coleridge born (21 Oct.), Ottery St. Mary, Devon	*Morning Post* begins Gilpin tours the Lakes Diderot, *On Man*	First partition of Poland Franklin visits Keswick to conduct experiments with President of Royal Society Priestley, *On Different Kinds of Air* (discovery of gases)	1772
	Johnson and Boswell tour Scotland Goldsmith, *She Stoops to Conquer* Marat, *Philosophical Essay on Man*	Arkwright begins manufacture of all-cotton calico Boston Tea Party (16 Dec.)	1773
	Goldsmith dies (4 April), London Southey born (12 Aug.), Bristol Paine arrives in Philadelphia Goethe, *Werther*	Louis XVI crowned king of France Priestley isolates oxygen	1774
	Lamb born (10 Feb.), London Girtin born (18 Feb.), London Turner born (23 April), London Jane Austen born (16 Dec.), Steventon, Hampshire Johnson, *Journey to the Western Isles of Scotland*	Boone begins Wilderness Road from Virginia to Kentucky Battles of Lexington and Bunker Hill	1775
	Constable born (11 June), Suffolk Barry engraves *Phoenix or the Resurrection of Freedom* Gibbon, *Decline and Fall of the Roman Empire*, I	Paine, *Common Sense* Washington forces British to evacuate Boston American Declaration of Independence (4 July) Cook sails in *Resolution* to find North-West Passage Smith, *Wealth of Nations*	1776
	Priestley, *Disquisition Relating to Matter and Spirit* and *Doctrine of Philosophical Necessity*	Lavoisier recognizes sulphur as an element	1777
W's mother dies (8 March)	Hazlitt born (10 April), Maidstone, Kent Voltaire dies (30 May), Paris Rousseau dies (2 July), Paris Piranesi dies (9 Nov.), Rome Fanny Burney, *Evelina*	Davy born (17 Dec.), Penzance Cook discovers Sandwich Islands (Hawaii); charts Pacific coast of North America	1778
W sent to Hawkshead Grammar School	Garrick dies (20 Jan.), London Reynolds, *Discourses* (May) Johnson, *Lives of the Poets*	Death of Cook in Hawaii (14 Feb.) Crompton invents the "mule" (spinning-machine)	1779
Blake's first exhibit at Royal Academy (May); involved in the attack on Newgate Prison, 6 June	West, *Guide to the Lakes* (enlarged 2nd ed.) J. R. Cozens draws *Pays de Valais* and *In the Canton of Unterwalden* (c. 1780)	Gordon Riots (2–9 June)	1780

	Wordsworth, and the major British Romantic poets	Contemporaries: philosophy and the arts	The Age: political and scientific events
1781	Coleridge's father dies (4 Oct.)	Kant, *Critique of Pure Reason*; Schiller, *The Robbers*; Rousseau, *Confessions* Towne draws *Source of the Arveiron* Fuseli paints *The Nightmare* Mozart composes *Idomeneo*	George Stephenson born (9 June) Herschel discovers Uranus Cornwallis surrenders to Washington at Yorktown (19 Oct.)
1782	Blake marries Catherine Boucher (18 Aug.) Coleridge sent to school at Christ's Hospital School, London (Sept.); meets Lamb	Cowper, *Poems* Cotman born (16 May)	Watt and Boulton patent double-acting steam engine
1783	Blake, *Poetical Sketches* W's father dies (30 Dec.)	Gainsborough tours the Lakes; paints *Langdale Pikes* Hazlitt and parents emigrate to America (return 1787) Crabbe, *The Village*; Beckford, *Dreams, Waking Thoughts and Incidents* (suppressed by Beckford)	Pitt, aged 24, becomes P.M. (until 1801) First balloon ascent by Montgolfier brothers Treaty of Paris, confirming U.S. independence (3 Sept.)
1784	Blake writing *Island in the Moon*	Leigh Hunt born (19 Oct.), Southgate Johnson dies (13 Dec.), London, aged 75	
1785		Cowper, *The Task* De Quincey born (15 Aug.), Manchester Alexander Cozens paints *Sky Studies*, writes *New Method*	
1786	Kilmarnock Burns W at work on *Vale of Esthwaite*, first extensive poem	Goya appointed painter to king of Spain Gilpin, *Observations of Picturesque Beauty in Cumberland and Westmorland* Beckford, *Vathek* Mozart's *Marriage of Figaro* first performed Towne tours Lake District, draws *Elterwater, View from Rydal Park, Grasmere from the Rydal Road* (c. 1787)	
1787	W goes to St. John's College, Cambridge (Oct.)	Farington, *Views of the Lakes* Mozart, *Don Giovanni*	Prussian army intervenes in Netherlands (13 Sept.) American Constitution drafted and signed (17 Sept.)
1788	Byron born (22 Jan.), London Burns composes *Auld Lang Syne* Blake writing *Tiriel*	Schopenhauer born (22 Feb.), Danzig, Prussia Gainsborough dies (2 Aug.), London	Charles Wesley dies (28 March) Warren Hastings impeached
1789	W composing much of *An Evening Walk* during Long Vacation in Lakes Blake, *Songs of Innocence*	Price addresses London Revolution Society *On the Love of Our Country* (4 Nov.)— provokes Burke's *Reflections* (1790) Erasmus Darwin, *Botanic Garden*, II	Estates General meets at Versailles (5 May) Storming of the Bastille (14 July) Washington elected first President of the Republic (till 1797) Lavoisier, *Elements of Chemistry*
1790	W tours France and Alps with Robert Jones (13 July–29 Sept.) Blake writes *The Marriage of Heaven and Hell*	Kant, *Critique of Pure Reason* Burke, *Reflections on the Revolution in France* (1 Nov.) Mary Wollstonecraft, *Vindication of the Rights of Men* (29 Nov.) Gillray engraves *Smelling Out a Rat*	Franklin dies (17 April), Philadelphia French abolition of nobility and titles (19 June); king swears oath to new constitution (14 July) Monroe enters the Senate
1791	W receives B.A. (Jan.) Burns, *Tam O'Shanter* Coleridge enters Jesus College, Cambridge (Oct.) W returns to France (Nov.)	Haydn arrives in England (1 Jan.) Paine, *Rights of Man*, I (22 Feb.; most effective answer to Burke, sells 200,000 copies through working-men's clubs) Boswell, *Life of Johnson* Hauer paints *Lafayette and Madame Roland* Mozart, *The Magic Flute* Mozart dies (5 Dec.)	Wolfe Tone founds Society of United Irishmen (leads unsuccessful rebellion 1798) French royal family attempts to reach frontier; captured at Varennes (22 June) Priestley's house and laboratory burned by Birmingham mob (14 July); painted by Eckstein French Legislative Assembly established (1 Oct.) Jefferson endorses American publication of Paine's *Rights of Man*

Wordsworth, and the major British Romantic poets	Contemporaries: philosophy and the arts	The Age: political and scientific events	
W meets Annette Vallon in Blois, and is converted to the revolutionary cause by Michel Beaupuy Shelley born (4 Aug.), Field Place, Sussex W returns to England intending to raise money on which to get married (Nov./Dec.) Birth of W's natural daughter, baptized Anne-Caroline Wordsworth in Orléans Cathedral (15 Dec.)	Mary Wollstonecraft, *Vindication of the Rights of Woman* Paine, *Rights of Man*, II (17 Feb.) Holcroft, *Anna St. Ives* (May) Mary Wollstonecraft goes to Paris (Dec.)	London Corresponding Society formed Alliance of Austria and Prussia against France Paine charged with sedition; *Rights of Man* banned (21 May) Tuileries stormed by Paris mob (10 Aug.); king imprisoned; September Massacres of royalist and other prisoners in Paris (3–7 Sept.) French victory against Prussians at Valmy (20 Sept.); National Convention begins, republic proclaimed (22 Sept.); moderate Girondins losing control to Robespierre and Jacobins; trial of the king before the Convention (Dec.–Jan. 1793) Paine sentenced to death by English courts (Dec.) Washington re-elected to the presidency	1792
Blake, *America*, *Visions of the Daughters of Albion*, *Songs of Experience* W, *An Evening Walk* and *Descriptive Sketches* (Jan.) W writes, but does not publish, republican *Letter to the Bishop of Llandaff* (c. Feb.) W crosses Salisbury Plain on foot; first visit to Tintern Abbey (July–Aug.) First version of W's *Salisbury Plain* composed Coleridge, in debt and suicidal, joins 15th Light Dragoons as Silas Tomkyn Comberbache (Dec.)	Godwin, *Political Justice* (Feb.) John Clare born (13 July) Benazech paints *Louis XVI at the Foot of the Scaffold*; Gillray engraves *Zenith of French Glory*; Girtin, *Tintern Abbey* (c. 1793)	Louis XVI sentenced to death, by majority of one; executed (21 Jan.); war between England and France, Feb. (till 1812) Committee of Public Safety formed (6 April), with Danton, Robespierre, St. Just, Couthon, as leaders Girondins arrested in Paris (June) Marat murdered in bath by Charlotte Corday (13 July); beginning of Terror Marie Antoinette executed (16 Oct.); Madame Roland and Girondin leaders executed Coalition armies retreat across Rhine (Dec.); Bonaparte gains distinction at French recapture of Toulon Paine imprisoned in the Luxembourg gaol (Dec.)	1793
Blake, *Songs of Innocence and Experience*, *Europe*, *First Book of Urizen* Coleridge returns to Cambridge (April) W and Dorothy at Windy Brow, Keswick (April–May); W revises *Evening Walk* (1794) Coleridge meets Southey in Oxford (June); scheme evolved to found commune ("Pantisocracy") on banks of Susquehanna Coleridge and Southey, *Fall of Robespierre* (Sept.) Coleridge leaves Cambridge (Dec.); meets Godwin in London	Priestley and family emigrate to America (April) Godwin, *Caleb Williams* Robert paints *Corridor at Saint Lazare*; Turner, *Interior of Tintern Abbey*	Robespierre executes Danton and others (March–April) English radicals charged with high treason; *Habeas Corpus* suspended (May) Arrest of Robespierre (27 July); end of the Terror Paine released from Luxembourg gaol (Nov.) English radicals acquitted as a result of Godwin, *Cursory Strictures* (Nov.–Dec.) French invade Holland (winter 1794–1795)	1794
W receives £900 legacy from schoolfriend Coleridge, Political Lectures, Bristol (Jan.–Feb.); Lectures on Revealed Religion (May–June) W meets Godwin eight times in London (27 Feb.–29 July) Coleridge-Southey scheme for Pantisocracy breaks down over summer; meeting of W and Coleridge, Bristol (Sept.); W and Dorothy go to live at Racedown, Dorset (Sept.–July 1797) Coleridge marries Sara Fricker (4 Oct.) Keats born (31 Oct.), London W writes second version of *Salisbury Plain* Coleridge lectures in Bristol against Pitt's "Two Bills" (26 Nov.) Blake engraves *Newton*, *Urizen*, and other important prints	Boswell dies (19 May), London Carlyle born (4 Dec.), Dumfriesshire Wright paints *Rydal Waterfall*	Directory established in France (till Nov. 1799) to confront financial crisis *King Killing* on sale at mass meeting of London Corresponding Society (26 Oct.); king's coach stoned at opening of Parliament (29 Oct.) "Two Bills" outlawing treasonable practices and unlawful assemblies become law (Dec.)	1795

	Wordsworth, and the major British Romantic poets	Contemporaries: philosophy and the arts	The Age: political and scientific events
1796	Coleridge periodical, *The Watchman* (March–May, 10 issues); *Poems* (April) Lamb's sister Mary kills mother, wounds father, in fit of madness (22 Sept.) W begins *Borderers*, his only play; completed *c.* March 1797 Coleridge moves to Nether Stowey, Somerset	Death of Burns (21 July) Gros paints *Napoleon on the Bridge at Arcole* Austen, *Pride and Prejudice* (completed 1797, published 1813)	Bonaparte marries Joséphine de Beauharnais (9 March); commands Italian campaign, defeating Austrians in sequence of battles leading to Peace of Leoben (April 1797) Jenner performs first smallpox vaccination Washington's Farewell Address (18 Sept.) Catherine the Great dies (17 Nov.)
1797	W completes first version of *Ruined Cottage* (*c.* early June) Wordsworths move into Alfoxden House near Coleridge at Nether Stowey (16 July) Coleridge writes *Kubla Khan*, and first version of *Ancient Mariner* (Nov.)	Schubert born (31 Jan.), Vienna Godwin marries Mary Wollstonecraft Burke dies (9 July) at Beaconsfield Turner's Lake District tour Birth of Mary Godwin, daughter of Wollstonecraft and Godwin, future wife of Shelley (30 Aug.) Wollstonecraft dies (10 Sept.) Austen begins *Sense and Sensibility* (published 1811) Bewick, *History of British Birds*, Vol. 1 (Vol. 2 1804)	Adams elected second President of U.S. (4 March) British Navy mutinies at Spithead and Nore (April–June) Evans patents high-pressure steam engine in U.S.
1798	Coleridge, applying for post as Unitarian minister, is heard preaching by Hazlitt at Shrewsbury (Jan.); receives £100 annuity from Wedgwoods, and returns to Stowey Dorothy W, *Alfoxden Journal* (Jan.–May) Coleridge writes *Frost at Midnight* and *Christabel*, I (Feb.–April) W composes bulk of *Lyrical Ballads* (Feb.–May); W painted by Shuter (April) Wordsworths on Wye walking tour (10–13 July); *Tintern Abbey* written *Lyrical Ballads* published anonymously (18 Sept.) Wordsworths and Coleridge travel to Germany (16 Sept.); Wordsworths in Goslar (6 Oct.–23 Feb. 1799); W writes Lucy Poems, *Nutting*, 1799 *Prelude*, I, and much else; Coleridge at Ratzeburg and Göttingen, less productive	Godwin, *Memoirs of Mary Wollstonecraft* Haydn, *The Creation* Austen writes *Northanger Abbey* (published 1818)	French invasion of republican Switzerland (Jan.) shocks British radicals Irish rebellion (May–June) Malthus, first *Essay on Population* Bonaparte invades Egypt (July); wins Battle of the Pyramids; Nelson victorious in Battle of the Nile Bentham, *Political Economy*
1799	Wordsworths return to England (April) Coleridge returns to England (July); W and Coleridge tour the Lakes (Nov.); Coleridge meets Sara Hutchinson 1799 *Prelude* completed; Wordsworths move into Dove Cottage (19 Dec.)	Constable enrols at Royal Academy (19 Feb.) Balzac born (20 May), Tours Pushkin born (6 June), Moscow	*Coup d'état* makes Bonaparte First Consul under a new constitution (9 Nov.) Washington dies (14 Dec.), Mt. Vernon, Va.
1800	W writes *Brothers*, Prospectus to *Recluse*, and bulk of *Home at Grasmere* (March) Coleridge visits Grasmere (6 April–4 May) Dorothy W's Grasmere *Journal* begun (May–June); Coleridges move into Greta Hall, Keswick Coleridge writes *Christabel*, II (Oct.), but cannot finish poem W writes Preface to *Lyrical Ballads* and *Michael* Blake moves from London to Felpham, on coast; at work on extended version of *Vala* and *Milton*	Maria Edgeworth, *Castle Rackrent* (Jan.) Cowper dies (25 April) Macaulay born (25 Oct.) Beethoven composes *Symphony No. 1* Turner paints *Dolbadern Castle*; Girtin draws *White House at Chelsea*	Malta surrenders to British Herschel discovers infra-red rays; Royal Institution founded in London; Volta invents galvanic cell (first electric battery)
1801	*Lyrical Ballads* republished (Jan.) with new second vol.; sent by W to Fox, Whig leader of the opposition	Beethoven composes *Piano sonata No. 14* (*Moonlight*) Girtin draws *On the River Wharfe* and *The Thames from Queenhithe to London Bridge*	Toussaint L'Ouverture takes command of Spanish Santo Domingo, liberates black slaves (Jan.) Pitt resigns, Feb. (end of first ministry) Newman born (21 Feb.), London Jefferson elected third President of U.S.

Wordsworth, and the major British Romantic poets	Contemporaries: philosophy and the arts	The Age: political and scientific events	
W composes *Rainbow* (26 March), opening stanzas of *Ode, Leech Gatherer,* and many other short poems *Lyrical Ballads* (Philadelphia ed.) Coleridge addresses first version of *Dejection* (4 April) to Sara Hutchinson Blake at work on *Milton* Wordsworths visit Annette Vallon and W's daughter Caroline (aged 9) at Calais (Aug.) W writes *Westminster Bridge* (3 Sept.) and other major sonnets W marries Mary Hutchinson (4 Oct.); Coleridge's *Dejection* published in *Morning Post* in version addressed (under pseudonym) to W	Hugo born (26 Feb.), Besançon Turner, Girtin, Farington in Paris to see treasures brought by Napoleon to Louvre Girtin dies (9 Nov.), aged 27 Romney dies (15 Nov.), Kendal Cotman draws *Bedlam Furnace* (c. 1802–1803) Foundation of *Edinburgh Review* and Cobbett's *Weekly Political Register*	Peace of Amiens, 27 March–16 May 1803 (only truce in war with France) Bonaparte becomes Life Consul (Aug.) Health and Morals of Apprentices Act restricts child labour in cotton mills to those over 9, and brings in 12-hour working day	1802
Coleridge, *Poems* republished (June) John W born (18 June) W, Dorothy W, and Coleridge tour Scotland (14 Aug.–25 Sept.)	Emerson born (25 May), Boston Cornelius Varley draws *River Wye* and *Llyn Gwynant* (c. 1803) Hills draws *Skelwith Force*	Toussaint L'Ouverture dies (7 April) in French prison Louisiana Purchase (April) Peace of Amiens breaks down (May) Trevithick constructs first steam locomotive, in South Wales	1803
Coleridge leaves Grasmere for London, and Mediterranean (24 Jan.) W completes *Intimations Ode, Ode to Duty, Daffodils*, at work on *Prelude* Coleridge drawn by Dance; sails for Malta (April) Coleridge private secretary to British High Commissioner at Malta (July) Dora W born (Aug.)	Priestley dies (6 Feb.), Pa. Kant dies (12 Feb.) Hawthorne born (4 July), Salem, Mass. Beethoven composes *Sonata No. 23* (*Appassionata*) and *Symphony No. 3* (*Eroica*) Turner draws *Passage of the St. Gothard, Great Falls of the Reichenbach*; Cotman draws *Cader Idris*	Pitt's second ministry (till 1806) Bonaparte proclaimed emperor (May; coronation Nov.) Spain declares war on Britain	1804
Death at sea of W's brother John (5 Feb.) *Prelude* finished (19 May) in thirteen books W writes *Solitary Reaper* (Nov.) Scott, *Lay of the Last Minstrel*	Palmer born (27 Jan.), London Schiller dies (9 May) Cotman draws *Greta Woods* (1805–1806); John Varley draws *Snowdon from Capel Curig* (c. 1805–1810)	Third Coalition against France (April) Battle of Trafalgar, death of Nelson (21 Oct.) Combined Russian and Austrian armies defeated by Bonaparte at Austerlitz (2 Dec.) Mungo Park drowned, exploring the Niger	1805
W writes *Waggoner* (Jan.) In Rome, Coleridge painted by Allston; meets the Humboldts, Tieck, and Schlegel (Jan.) In London, W meets Fox, sees Beaumont's picture of Piel Castle; has portrait painted by Edridge (May); *Peele Castle* written Thomas W born (15 June) Coleridge returns to Britain still in bad health (17 Aug.) Beaumont lends Wordsworths and Coleridge house at Coleorton for winter	Elizabeth Barrett (Browning) born (6 March), Durham J. S. Mill born (20 May), Pentonville Constable tours Lakes (Aug.–Sept.), draws *Langdale Pikes* and *Helvellyn*; Cotman draws *On the Greta* (*Hell Cauldron*) Turner draws *Mer de Glace* (c. 1806)	Pitt dies (23 Jan.) Brunel born (9 April), Portsmouth End of Holy Roman Empire (Aug.) Fox dies (13 Sept.) Bonaparte defeats Prussians at Jena (14 Oct.) First gas-lighting of cotton mills	1806
Inspired by *Prelude*, Coleridge writes last major poem, *To William Wordsworth* (7 Jan.) Lamb, *Tales from Shakespeare* (Jan.) Blake painted by Phillips (April) W, *Poems in Two Volumes* (May) Coleridge meets De Quincey (Aug.) W composes *White Doe of Rylstone* (Oct.); De Quincey arrives at Dove Cottage	Cotman draws *Road to Capel Curig*	Abolition of slave trading in British ships (March) French conclude Treaties of Tilsit (7–9 July) with Russians and Prussia Davy isolates sodium and potassium Geological Society founded	1807

	Wordsworth, and the major British Romantic poets	Contemporaries: philosophy and the arts	The Age: political and scientific events
1808	Wordsworths leave Dove Cottage (24 May) for Allan Bank, also in Grasmere (till June 1811) Catharine W born (Sept.) Scott, *Marmion*; Lamb, *Specimens of English Dramatic Poets*	Leigh Hunt founds *Examiner* Goethe, *Faust*, I; Clarkson, *Abolition of Slave Trade*	African slave trade prohibited in U.S. (Jan.) Spain invaded by French (March); Joseph Bonaparte made king British under Wellesley (later Wellington) defeat Junot at Vimeiro (Aug.), but conclude disgraceful Convention of Cintra, betraying Portuguese, and evacuating French in British ships French capture Madrid (13 Dec.) Dalton's *New System of Chemical Philosophy* establishes quantitative atomic theory Davy isolates magnesium, calcium, strontium, and barium
1809	Byron, *English Bards and Scotch Reviewers* (9 March) Blake, Exhibition (with *Descriptive Catalogue*), May, incl. *Canterbury Pilgrims* W, *Convention of Cintra* (May), expresses indignation at betrayal of freedom fighters Coleridge, *Friend* (1 June–15 March 1810) Byron sails for the Mediterranean (2 July) W at work on *Excursion* De Quincey moves into Dove Cottage (Oct.)	Poe born (19 Jan.), Boston Mendelssohn born (3 Feb.), Hamburg Charles Darwin born (12 Feb.), Shrewsbury *Quarterly Review* founded (Feb.) Haydn dies (31 May), Vienna Paine dies (8 June), New York Tennyson born (6 Aug.), Lincolnshire Turner draws *Valley of Chamonix*	Moore defeated and killed at Corunna (Jan.) Lincoln born (12 Feb.), Hodgenville, Ky. Madison elected fourth President of U.S. (4 March) Bonaparte captures Vienna (May); excommunicated by the pope (June); pope arrested and imprisoned (July) French victory at Wagram (July), followed by Treaty of Schönbrunn; in Peninsula, Wellesley defeats French at Salamanca (22 July) Lamarck's *Philosophie Zoologique* puts forward theory of evolution
1810	First version of W's *Guide to the Lakes* published as Introduction to Wilkinson's *Select Views of Cumberland, Westmorland, and Lancashire* Lamb visits Blake exhibition with Crabb Robinson (11 June) Montagu precipitates quarrel of W and Coleridge (Oct.) Scott, *Lady of the Lake*	Chopin born (1 March), Warsaw Mrs Gaskell born (29 Sept.), Chelsea Cotman draws *Mousehold Heath*; Turner, *Upper Falls of the Reichenbach* (c. 1810–1815) Crabbe, *The Borough* Goya etching *Disasters of War*	Madison proclaims non-intercourse with England (Nov.) George III's insanity conceded (Dec.)
1811	Shelley expelled from Oxford for pamphlet on atheism (25 March); elopes with Harriet Westbrook (Aug.) Coleridge lectures on Shakespeare and Milton Shelley, *Necessity of Atheism*	Thackeray born (18 July), Calcutta Liszt born (22 Oct.), Raiding, Hungary Austen, *Sense and Sensibility* (begun 1797)	Prince of Wales made Regent (Feb.) Luddite riots in Nottingham destroy textile machinery Bread riots in Nottingham (Nov.); further Luddite uprisings
1812	Coleridge's last journey to the Lakes (Feb.–March); passes Grasmere without stopping to see Wordsworths Catharine W dies (June), aged 4 Godwin and Shelley meet in London Coleridge lectures on Shakespeare Thomas W dies (Dec.), aged 6 Byron, *Childe Harold* (I and II)	Dickens born (7 Feb.), Portsmouth Browning born (7 May), Camberwell Constable paints *Landscape and Double Rainbow* Rowlandson and Combe, *Dr. Syntax in Search of the Picturesque*	Wellington captures Badajoz (March) U.S. declares war on Britain (18 June) Bonaparte invades Russia with 600,000; Moscow burned (by Russians); French retreat (Oct.), with terrible losses
1813	Coleridge, *Remorse*, produced at Drury Lane W obtains civil service appointment as Distributor of Stamps, moves to Rydal Mount, completes *Excursion* Scott declines Laureateship; accepted by Southey Coleridge lectures on Shakespeare and education in Bristol Shelley, *Queen Mab*, published privately Byron, *The Giaour*, *The Bride of Abydos*	Wagner born (22 May), Leipzig Austen completes *Mansfield Park* Leigh Hunt imprisoned for libel (till 1815) Austen, *Pride and Prejudice*	San Martín leads revolution against Spanish rule in Argentina French evacuation of Peninsula; Prague Peace Congress fails (July-Aug.); Bonaparte victorious at Dresden, heavily defeated at Leipzig, rejects peace; Allies cross Rhine (Dec.) Mass Luddite trial in York; many hangings and transportations

Wordsworth, and the major British Romantic poets	Contemporaries: philosophy and the arts	The Age: political and scientific events	
Shelley marries Harriet Westbrook (24 March); elopes with Mary Godwin (28 July) Coleridge, Bristol Lectures on Milton, Cervantes, Taste, French Revolution, and Bonaparte (April) W, *Excursion* Shelley and Mary Godwin return to England (14 Sept.) Byron, *The Corsair, Lara*; Hunt, *The Feast of the Poets*	Beethoven composes final version of *Fidelio* Constable paints *The Vale of Dedham* Scott, *Waverley*; Austen, *Mansfield Park*	Allied armies enter Paris; Bonaparte exiled to Elba (though retaining title as emperor) Washington D.C. captured by British (Sept.) Congress of Vienna Peace of Ghent ends war between U.S. and Britain (Dec.) Inquisition re-established in Spain	1814
Byron marries Annabella Milbanke (2 Jan.) W, *Poems, 1815, White Doe* (2 June) Keats becomes medical student at Guy's Hospital, Southwark (1 Oct.)	Austen, *Emma* (Dec.) Turner drawn by C. Varley (*c.* 1815)	The Hundred Days: Bonaparte enters Paris; defeated Waterloo (June), and exiled to St. Helena Davy devises the safety lamp	1815
Byron separates from his wife (April) and travels to Geneva; joined by Shelley and Mary Godwin and Mary's step-sister, Claire Clairmont (May); Mary writes *Frankenstein*; Byron moves into Villa Diodati (July–Sept.), writes *Childe Harold*, Canto III; Shelley writes *Mont Blanc* W, *Letter to a Friend of Robert Burns* (May) Coleridge, *Christabel, Kubla Khan*, and *Pains of Sleep* (May) Byron arrives in Venice (Nov.) Suicide of Harriet Shelley (7 Dec.); Shelley marries Mary Godwin (30 Dec.) Coleridge, *Statesman's Manual* (Dec.) Keats writes *On First Looking into Chapman's Homer*; is drawn by Haydon Blake working on *Four Zoas (Vala)* Shelley, *Alastor and Other Poems*	Charlotte Brontë born (21 April), Thornton, Yorkshire Austen completes *Persuasion* (Aug.) Constable paints two versions of *Weymouth Bay* Peacock, *Headlong Hall*; Maturin, *Bertram*; Leigh Hunt, *Rimini*	End of Napoleonic Wars followed in Britain by economic depression, unemployment, rise in price of bread; mass meeting at Spa Fields (Dec.), followed by rioting and march on Tower of London	1816
Claire Clairmont has daughter by Byron, Allegra (Jan.) Byron in Rome; *Manfred* published Coleridge, *Biographia Literaria* and *Sybilline Leaves* Hazlitt, *Characters of Shakespeare's Plays*; Keats, *Poems* Haydon's "immortal dinner" with Lamb, Keats, W (28 Dec.) Shelley, *History of a Six Weeks Tour* (incl. first publication of *Mont Blanc*); writes *Ozymandias*	Southey's *Wat Tyler* (written 1794) pirated by radical booksellers (13 Feb.) *Blackwood's Magazine* founded Thoreau born (12 July), Concord, Mass. Austen dies (18 July), Winchester De Quincey marries Margaret Simpson Martin paints *The Bard*	Monroe becomes fifth President of U.S. (March) American Colonization Society founded (transporting free-born and emancipated blacks to Africa)	1817
W in London, drawn by Haydon Coleridge lectures on poetry and drama (Jan.–March) Byron, *Beppo* (Feb.) Shelleys go to Italy with Claire Clairmont and Allegra Byron Keats writes *Isabella, Endymion* Coleridge, *The Friend*, published in 3 vols., revised Keats tours the Lakes and Scotland; George Keats emigrates to America; Tom Keats dies of tuberculosis (Dec.) Coleridge lectures on history of philosophy and literature (Dec.–March 1819)	Mary Shelley, *Frankenstein* Emily Brontë born (30 April), Thornton Austen, *Northanger Abbey, Persuasion*	*Habeas Corpus* restored (Jan.) San Martín leads revolution against Spanish rule in Chile (spring) Marx born (5 May), Trier, Rhine Province, Prussia	1818
Keats writes *La Belle Dame Sans Merci, Eve of St. Agnes*, and Odes W, *Peter Bell* and *Waggoner* (April–May); *Peter Bell* parodied by John Hamilton Reynolds and Shelley (*Peter Bell the Third*) Byron, *Don Juan*, I–II (July) Shelley writes *Ode to the West Wind*	Ruskin born (8 Feb.), London Queen Victoria born (24 May) Whitman born (31 May) Melville born (1 Aug.), New York George Eliot born (22 Nov.) Schopenhauer writes *The World as Will and Idea* (published 1883–1886)	Peterloo Massacre (16 Aug.): at least 400 civilians injured, 11 killed, by militia in protest meeting of unarmed handloom weavers at St. Peter's Fields, Manchester Bolívar becomes president and military dictator of New Granada (Colombia) Jefferson establishes University of Virginia Stethoscope invented by Laënnec	1819

	Wordsworth, and the major British Romantic poets	Contemporaries: philosophy and the arts	The Age: political and scientific events
1820	Keats' first lung haemorrhage (Feb.) W, *Miscellaneous Poems, Duddon Sonnets, Vaudracour and Julia*; portrait bust made by Chantrey Keats, *Lamia, Isabella, The Eve of St. Agnes, and Other Poems* (July) W and family tour the continent (July–Feb. 1821) Shelley, *Prometheus Unbound* (Aug.) Keats sails for Rome (17 Sept.) Scott, *Ivanhoe*	Clare, *Poems Descriptive of Rural Life* Lamartine, *Méditations Poétiques*	Death of George III (29 Jan.), succeeded by son, Prince Regent since 1811, as George IV Revolution in Spain and Portugal
1821	Keats dies (23 Feb.), Rome; commemorated by Shelley in *Adonais* Byron, *Don Juan*, III–V (Aug.), *Cain*	Dostoyevsky born (11 Nov.), Moscow Flaubert born (12 Dec.), Rouen Goethe, *Wilhelm Meister* (completed 1829) De Quincey, *Confessions of An English Opium-Eater* serialized in *London Magazine*	Greek Revolution begins Bonaparte dies (May), St. Helena Independence of Peru proclaimed Faraday builds the first electric motor
1822	W, *Description of the Scenery of the Lakes* (first separate publication of *Guide*), *Ecclesiastical Sketches* Allegra Byron dies (20 April) Shelley writing *Triumph of Life*, drowned (8 July), Bay of Spezia; his remains burned on beach by Trelawny, Leigh Hunt, and Byron (16 Aug.) Henry Nelson Coleridge begins recording *Table Talk* of Coleridge Blake, *Ghost of Abel* (last illuminated book)	Schubert, *Symphony No. 8 (Unfinished)* composed (Oct.) Arnold born (24 Dec.) Constable paints *Trees at Hampstead* and *The Lock* (1822–1824)	Castlereagh commits suicide (12 Aug.); Tory Cabinet joined by liberals Canning and Peel Denmark Vesey leads negro revolt, Charleston, S.C.
1823	Byron sails for Greece with 1000 soldiers to fight for independence from Turkish rule (July)	Berlioz composes *Waverley*	Enunciation of Monroe Doctrine in U.S. (2 Dec.)
1824	First American collected ed. of W published in Boston Coleridge elected Fellow of Royal Society (March) Byron dies (19 April), Missolonghi, from marsh fever and excessive bleeding	Hogg, *Confessions of a Justified Sinner*	
1825	Coleridge, *Aids to Reflection*	David dies (29 Dec.), Brussels Hazlitt, *Spirit of the Age*	Opening of first steam locomotive railway, Stockton-Darlington John Quincy Adams elected sixth President of U.S. (4 March)
1826	Blake gives friend a copy of W's *Excursion*; publication of *Job*; drawings for *Dante* under way	Mary Shelley, *The Last Man* (Feb.) Mendelssohn composes *Overture to A Midsummer Night's Dream* Constable, *Parham Mill* Frederick Church, American landscape painter, born (4 May)	Jefferson dies (4 July), Monticello, Va.
1827	Blake dies (12 Aug.), London	Beethoven dies (26 March), Vienna Sir George Beaumont dies (7 Feb.), Coleorton Audubon, *Birds of America* (completed 1838) Constable, *The Glebe Farm*	Liverpool, continuously P.M. since 1811, succeeded by Canning (30 April); Canning dies (8 Aug.) Fourneyron develops water-turbine
1828	Coleridge, *Poetical Works* Lockhart, *Life of Burns* *Wordsworth's Poetical Works* pirated by Galignani in single vol. (Paris); writes *Power in Sound*	Schubert, *Symphony No. 9 (The Great)* composed (March) D. G. Rossetti born (12 May), London Schubert dies (19 Nov.), Vienna Palmer paints *Lane and Shed, Shoreham, Kent* Noah Webster, *American Dictionary of the English Language*	Wellington becomes P.M. (Jan.) Demands for greater religious toleration lead to Repeal of Test Act (9 May)

Wordsworth, and the major British Romantic poets	Contemporaries: philosophy and the arts	The Age: political and scientific events	
Coleridge, *On the Constitution of the Church and State* (Dec.) *Poetical Works of Coleridge, Shelley and Keats* (Galignani, Paris)	Mendelssohn first visits England and Scotland (spring) Constable paints *Hadleigh Castle, Water-meadows at Salisbury, Waterloo Bridge from Whitehall Stairs* Tennyson, *Timbuctoo* (Cambridge Prize Poem) Balzac, *Scenes from Private Life*	Jackson elected seventh President of U.S. (4 March) Davy dies (29 May), Geneva Catholic Emancipation Act (4 April) Building of Stephenson's *Rocket*	1829
Moore, *Life of Byron*	Hazlitt dies (18 Sept.), Soho, London Christina Rossetti born (5 Dec.), London Emily Dickinson born (10 Dec.), Amherst, Mass. Mendelssohn begins *Symphony No. 3 (Scottish)* (till 1842) Cobbett, *Rural Rides* Palmer draws *Pastoral with a Horse-Chestnut Tree* (c. 1830–1832) and *Cornfield by Moonlight* (c. 1830) De Wint draws *View of a Harbour*	George IV dies (26 June), succeeded by brother, as William IV Republican journalists and deputies in Paris displace Charles X, and proclaim the "July Monarchy" of Louis Philippe (1830–1848) The Whig, Grey, succeeds Tory Wellington as P.M. (16 Nov.), bringing in an era of reform Bolívar dies (17 Dec.), Colombia Lyell, *Principles of Geology* (completed 1833) Joseph Smith founds the Mormon Church	1830
W revising *Prelude* Death of Catherine Blake (18 Oct.) *Poetical Works of Coleridge, Shelley, and Keats* (Philadelphia)	Hegel dies (14 Nov.), Berlin Berlioz, *Le Corsaire* (finished 1852) Hugo, *The Hunchback of Notre Dame* Turner draws *Rainbow over Loch Awe* (c. 1831) Constable draws *London from Hampstead, with a Double Rainbow*	Darwin's first voyage in the *Beagle* (returns 1836) Brunel designs Clifton suspension bridge Negro revolt in Virginia led by Nat Turner	1831
Emerson tours Europe (till 1833), meets W and Coleridge	Manet born (23 Jan.), Paris Goethe, *Faust*, II; dies (22 March) Bentham dies (6 June)	Reform Bill passed First mechanical generation of electricity by Pixii	1832
	Mendelssohn composes *Symphony No. 4 (Italian)* Hartley Coleridge, *Poems*; Browning, *Pauline*; Pushkin, *Yevgeny Onegin*	Slavery abolished in British colonies Babbage conceives an "analytical engine" (large-scale digital calculator) American Anti-Slavery Society founded Keble emerges as leader of Oxford Movement	1833
Coleridge dies (25 July), Highgate	William Morris born (24 March), Walthamstow Degas born (19 July), Paris Lamb dies (27 Dec.) Constable paints *A Farmhouse near the Water's Edge* and draws *Old Sarum* Beckford, *Italy*	Grand National Consolidated Trades Union organized in Britain, with over half a million members; six Dorset villagers, the "Tolpuddle Martyrs," who had formed a lodge of the Union, sentenced to seven years' transportation (pardoned 1836) Poor Law Reform Act (14 Aug.) End of slavery in British empire	1834
W, *Yarrow Revisited*, with important postscript	Browning, *Paracelsus*		1835
	Godwin dies (7 April) Dickens, *Pickwick Papers* serialized Constable draws *Stonehenge* Turner paints *Valley of Aosta* (c. 1836–1837) Emerson, *Nature*	Alamo siege (March); Davy Crockett, among others, killed. Republic of Texas established after Battle of San Jacinto (April) Madison dies (28 June), Montpelier, Va. South Australia established as a British colony	1836
W, *Complete Poetical Works* (Philadelphia ed.)	Pushkin dies (10 Feb.), St. Petersburg Constable dies (31 March) Martin draws *Manfred on the Jungfrau* (after Byron) Dickens, *Oliver Twist* (serialized to 1839); Carlyle, *The French Revolution*	Van Buren elected eighth President of U.S. (4 March) William IV dies, succeeded by 17-year-old niece, as Queen Victoria (June) Patent for electric telegraph	1837
		Great Western steamer crosses Atlantic; first steamship service (England-America)	1838

	Wordsworth, and the major British Romantic poets	Contemporaries: philosophy and the arts	The Age: political and scientific events
1839	W's last revision of *Prelude* *The Poetical Works of Shelley*, ed. Mary Shelley	Poe, *Tales of the Grotesque and Arabesque*	Charter presented to Parliament by National Convention of Chartists (13 May); rejection leads to riots in Birmingham and elsewhere (July) Outbreak of Opium War with China (Nov.)
1840		Thomas Hardy born (2 June), Upper Bockhampton, Dorset Monet born (14 Nov.), Paris Browning, *Sordello* Chopin begins *Fantaisie in F minor* and *Ballade in A flat major* (till 1841) Turner paints *Inverary Pier* (c. 1840–1850) and *Stormy Sea Breaking on a Shore* (c. 1840–1845)	Queen marries her first cousin, Albert of Saxe-Coburg-Gotha (Feb.) Introduction of Penny Post
1841		Schumann composes *Symphony No. 1* (Jan.–Feb.; performed 31 March) Renoir born (25 Feb.), Limoges Browning, *Pippa Passes*; Dickens, *The Old Curiosity Shop*; Carlyle, *Heroes and Hero-Worship*; Emerson, *Essays*	Harrison elected ninth President of U.S. (4 March), dies 4 April; succeeded by Tyler Peel heads new Tory government Fox Talbot patents calotype (new photographic process) Marx receives doctorate at University of Jena, aged 23
1842	W, *Poems of Early and Late Years*, incl. *Salisbury Plain*, 1793–1795 (renamed *Guilt and Sorrow*) and *Borderers*, 1796–1797	Chopin composes *Ballade in F minor* Turner draws *Foot of St. Gothard* Balzac, *La Comédie humaine* (completed 1848); Tennyson, *Poems*; Macaulay, *Lays of Ancient Rome*	Von Mayer states that total amount of energy in universe is a constant (first law of thermodynamics)
1843	W appointed Poet Laureate	Southey dies (21 March) Wagner composes *The Flying Dutchman* Ruskin, *Modern Painters*, I (completed 1860)	Brunel's Thames Tunnel opened
1844	Leigh Hunt, *Imagination and Fancy*	Gerard Manley Hopkins born (28 July), Stratford, Essex Elizabeth Barrett Browning, *Poems*; Dickens, *Martin Chuzzlewit*	
1845	W, *Kendal and Windermere Railway* (Dec.)	Thoreau moves to Walden Pond (spring) Chopin begins *Polonaise-Fantaisie* (till 1846); Liszt begins *Harmonies poétiques et religieuses* (till 1852; based on Lamartine's poetry) Wagner's *Tannhäuser* composed and performed Poe, *The Raven and Other Poems*	Polk elected eleventh President of U.S. (4 March) Newman enters Catholic Church (9 Oct.) Potato famine in Ireland
1846		Dickens edits *Household Words*, first cheap English newspaper; writes *Dombey and Son* Browning marries Elizabeth Barrett (12 Sept.) Mendelssohn's *Elijah* first performed at Birmingham Berlioz composes *Damnation de Faust* Melville, *Typee*; Charlotte, Emily, and Anne Brontë, *Poems by Currer, Ellis, and Acton Bell*	American victory at Palo Alto (May), first battle of war with Mexico, 1846–1848 Smithsonian Institution established by Congress
1847	Ruskin visits Rydal Mount (March) Dora W dies (9 July), aged 42 W, *Installation Ode* (July)	Charlotte Brontë, *Jane Eyre* (19 Oct.); Anne Brontë, *Agnes Grey*; Emily Brontë, *Wuthering Heights* (Dec.) Mendelssohn dies (4 Nov.), Leipzig Tennyson, *The Princess*; Melville, *Omoo*; Thackeray, *Vanity Fair*; Emerson, *May-Day*	Lincoln enters Congress

Wordsworth, and the major British Romantic poets	Contemporaries: philosophy and the arts	The Age: political and scientific events	
	Emily Brontë dies (19 Dec.), Haworth Pre-Raphaelite Brotherhood formed Elizabeth Gaskell, *Mary Barton*	Gold discovered in Calif.; Gold Rush begins (24 Jan.) Marx and Engels, *Communist Manifesto* (Feb.) Second Republic proclaimed in Paris (Feb.); abdication of Louis Philippe, widespread revolutionary movements in Europe June Days (23–26 June), bloody civil war in Paris First ever Women's Rights Convention held, Seneca Falls, N.Y. (July) Louis Napoleon Bonaparte elected President of France (Dec.) Pasteur experiments in stereo-chemistry	1848
W, *Poetical Works*, with final text of poet's lifetime	Arnold, *Strayed Reveller and Other Poems* (Feb.) Maria Edgeworth dies (May) Poe dies (7 Oct.), Baltimore Chopin dies (17 Oct.), Paris De Quincey, *English Mail-Coach*, published in *Blackwood's Magazine* Thoreau, *A Week on the Concord and Merrimack Rivers*	Garibaldi elected deputy in Rome Assembly, proposes a republic (Feb.) Taylor elected twelfth President of U.S. (4 March) Thoreau, *Civil Disobedience* (May) Garibaldi and supporters flee Rome (July) Livingstone crosses Kalahari Desert	1849
W dies (23 April), aged 80; *The Prelude* published by his executors (July)	Balzac dies (18 Aug.), Paris Cox draws *Mountain Heights* De Quincey, *Collected Writings* (completed 1856) Tennyson, *In Memoriam*; made Poet Laureate Hawthorne, *The Scarlet Letter*; E. B. Browning, *Sonnets from the Portuguese*; Browning, *Christmas-Eve and Easter-Day*; Dickens, *David Copperfield*	American Express founded (18 March) Peel dies (2 July) after falling from horse Taylor dies (9 July); Fillmore becomes thirteenth President of U.S. California admitted to Union under 'Compromise of 1850' (Sept.) Bond, using 15-inch refractor at Harvard, takes first photograph of a star	1850

Lenders to the Exhibition

Full credits for lenders, and bequests and collections within particular institutions, are included in the Catalogue entries for individual items. There are, in addition, a number of private owners who wish to remain anonymous.

GREAT BRITAIN

Her Majesty Queen Elizabeth II
Abbot Hall Art Gallery, Kendal, Cumbria
The Visitors of the Ashmolean Museum, Oxford
Iain Bain
Barclays Bank PLC
Thomas Bewick Birthplace Trust
Birmingham Museum and Art Gallery
Blackburn Museum & Art Gallery
The Curators of the Bodleian Library, Oxford
The British Library Board
The Trustees of the British Museum
Courtauld Institute Galleries
Derby Art Gallery
The Provost & Fellows of Eton College
Mrs. Bridget Salisbury Gibbs
The Trustees, Cecil Higgins Art Gallery, Bedford
King's College, Cambridge
Laing Art Gallery, Newcastle upon Tyne, Tyne and Wear Museums
 Service
Leeds City Art Galleries
Manchester City Art Galleries
Moyse's Hall Museum, Bury St. Edmunds
John Murray
National Portrait Gallery, London
The University Library, Newcastle upon Tyne
Michael Pidgley
Royal Academy of Arts, London
The Master and Fellows of St. John's College, Cambridge
Scottish National Portrait Gallery
Sheffield City Art Galleries
The Trustees of the Tate Gallery, London
The Trustees of the Victoria and Albert Museum, London
D. H. Warren Collection
Whitworth Art Gallery, University of Manchester
The Wordsworth Trust

FRANCE

Département de Loir-et-Cher Archives
Paris, Musée Carnavalet
Musée national du château de Versailles

PORTUGAL

Susan Lowndes Marques

UNITED STATES OF AMERICA

American Antiquarian Society
Museum of Fine Arts, Boston
The Art Institute of Chicago
Cornell University Library
Dartmouth College Library
Roy and Cecily Langdale Davis
Detroit Institute of Arts
Harvard University Art Museums (Fogg Art Museum)
The Houghton Library, Harvard University
The Lilly Library, Indiana University, Bloomington
Indianapolis Museum of Art
University of Iowa Libraries, Iowa City
Library of Congress, Washington, D.C.
The University of Michigan Museum of Art
National Gallery of Art, Washington
The Newberry Library, Chicago
The New York Public Library: Astor, Lenox and Tilden Foundations
(Henry W. and Albert A. Berg Collection of English and American
Literature; Carl H. Pforzheimer Shelley and his Circle Collection;
Rare Books and Manuscripts Division; Miriam and Ira D. Wallach
Division of Art, Prints and Photographs); Schomburg Center for
Research in Black Culture
Northwestern University Library
Philadelphia Museum of Art
The Lutheran Church in America, the gift of Florence Foederer
Tonner in memory of her dear parents, Robert H. Foederer and
Caroline Fischer Foederer
The Pierpont Morgan Library, New York
Pretzfelder Collection
Princeton University Library
Harry Ransom Humanities Research Center, The University of Texas
at Austin
Museum of Art, Rhode Island School of Design
The Rosenbach Museum & Library, Philadelphia
Syracuse University Library
Davison Art Center, Wesleyan University
The Beinecke Rare Book and Manuscript Library, Yale University
Yale Center for British Art, Paul Mellon Collection

Photographic Acknowledgments

GREAT BRITAIN

Abbot Hall Art Gallery, Kendal, Cumbria, U.K.: Figure 155
The Visitors of the Ashmolean Museum, Oxford: 106
Iain Bain: 103, 104
Barclays Bank PLC: 152, 163
Birmingham Museum and Art Gallery: 32, 42, 80, 123, 140, 154
Blackburn Museum & Art Gallery: 87
By permission of the Curators of the Bodleian Library, Oxford: 19, 43, 51, 121, 122, 171
The British Library Board: 69, 125, 170, 172
Reproduced by courtesy of the Trustees of the British Museum: 60, 126, 136, 153, 176
Courtauld Institute Galleries: 96
Courtauld Institute Galleries (presented by the family of Sir Stephen Courtauld): 157
Derby Art Gallery: 84
The Provost & Fellows of Eton College: 145, 147
Mrs. Bridget Salisbury Gibbs: 102
The Trustees, Cecil Higgins Art Gallery, Bedford, England: 30, 156
Laing Art Gallery, Newcastle upon Tyne, Tyne and Wear Museums Service: 27, 92, 98, 133
Leeds City Art Galleries: 78, 97, 100, 139, 146, 184
Manchester City Art Galleries: 130
John Murray: 44
National Galleries of Scotland, Edinburgh: 37
National Portrait Gallery, London: 47, 48, 52, 70, 179
The University Library, Newcastle upon Tyne: 59
Michael Pidgley: 89
Royal Academy of Arts, London: 1, 127
Sheffield City Art Galleries: 53
The Trustees of the Tate Gallery, London: 175
The Trustees of the Victoria and Albert Museum, London: cover, 36, 54, 56, 88, 107, 108, 117–120, 151, 159, 165, 180, 182
Josiah Wedgwood & Sons Limited, Barlaston, Stoke-on-Trent: 25
Whitworth Art Gallery, University of Manchester: 101, 158
The Wordsworth Trust: frontispiece, 18, 34, 67, 71–76, 81, 83, 85, 111, 112, 129, 131, 135, 138, 141–143, 160–162, 169, 181

FRANCE

Département de Loir-et-Cher Archives: 12
Paris, Musée Carnavalet (cliché: Musées de la ville de Paris © SPADEM 1987): 7–10, 13–16, 24
Musée national du château de Versailles (cliché des Musées Nationaux – Paris): 17, 26

PORTUGAL

Susan Lowndes Marques: 22

UNITED STATES OF AMERICA

Courtesy, American Antiquarian Society: 3
Bequest of Mr. and Mrs. William Caleb Loring, Courtesy Museum of Fine Arts, Boston: 166
The Art Institute of Chicago, Frederick T. Haskell Collection, 1947.513: 185
The Wordsworth Collection, Cornell University Library: 35, 66
Roy and Cecily Langdale Davis: 183
© Detroit Institute of Arts, Gift of Mrs. Joseph B. Schlotman: 149
Harvard University Art Museums (Fogg Art Museum), Washington Allston Trust: 33
The Houghton Library, Harvard University: 28, 46, 178
Courtesy of the Lilly Library, Indiana University, Bloomington, Indiana: 2, 38, 79
© 1987 Indianapolis Museum of Art. All Rights Reserved: 113
Lessing J. Rosenwald Collection, Library of Congress, Washington, D.C.: 29, 31
The University of Michigan Museum of Art. Bequest of Henry C. Lewis: 6
National Gallery of Art, Washington. Paul Mellon Collection: 173
The Henry W. and Albert A. Berg Collection of English and American Literature, The New York Public Library, Astor, Lenox and Tilden Foundations: 49b
Rare Books and Manuscripts Division, The New York Public Library, Astor, Lenox and Tilden Foundations: 11
Print Collection, Miriam and Ira D. Wallach Division of Art, Prints and Photographs, The New York Public Library, Astor, Lenox and Tilden Foundations: 20, 23, 144
The Carl H. Pforzheimer Shelley and his Circle Collection, The New York Public Library, Astor, Lenox and Tilden Foundations: 21, 41, 50
Special Collections Department, Northwestern University Library: 134
Philadelphia Museum of Art: John Howard McFadden Collection: 177 The Lutheran Church in America, the gift of Florence Foederer Tonner in memory of her dear parents, Robert H. Foederer and Caroline Fischer Foederer: 57
The Pierpont Morgan Library, New York: 40, 45, 65
The Pierpont Morgan Library, New York. Gift of Mr. De Coursey Fales: 39

Robert H. Taylor Collection, Princeton University Library: 49a, 90
Harry Ransom Humanities Research Center, The University of Texas at
 Austin, The Iconography Collection: 58
Museum of Art, Rhode Island School of Design, Anonymous Gift: 77
The Rosenbach Museum & Library, Philadelphia: 5
Davison Art Center, Wesleyan University: 93–95
Yale Center for British Art, Paul Mellon Collection: 4, 61, 68, 86, 105,
 109, 110, 114, 116, 137, 148, 167, 168

Index

Pages including illustrations are shown in *italic*